S0-AIC-804

770.92 Käs Mic
Michaels.
Gertrude Käsebier.

The Lorette Wilmot Library
Nazareth College of Rochester

GERTRUDE KÄSEBIER

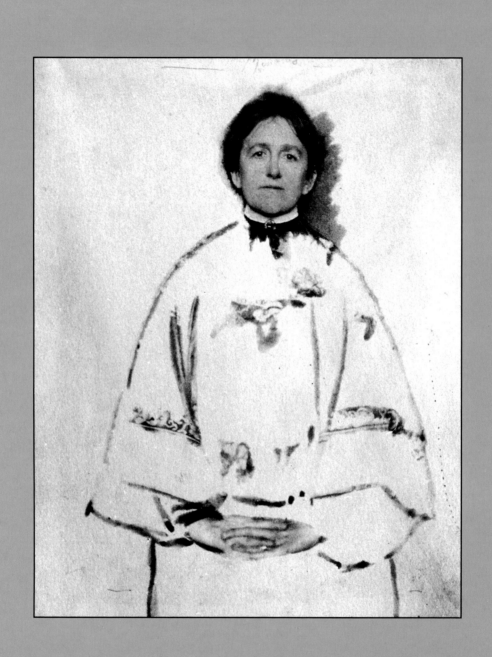

GERTRUDE KÄSEBIER

The
Photographer and Her Photographs

BARBARA L. MICHAELS

HARRY N. ABRAMS, INC., PUBLISHERS, NEW YORK

In memory of six
whom I wish could have lived
to see this book:

My parents Julian Loebenstein and Ruth Winter Loebenstein

My teachers Robert Goldwater and Alan Solomon

And Kate Steichen and Mina Turner,
whose affection for Gertrude Käsebier
helped to make this book possible.

EDITOR: ROBERT MORTON

COPY EDITOR: KAREN T. HWA

DESIGNER: CAROL A. ROBSON

Library of Congress Cataloging-in-Publication Data

Michaels, Barbara L.
 Gertrude Käsebier : the photographer and her photographs / Barbara
L. Michaels.
 p. cm.
 ISBN 0-8109-3505-8 (cloth)
 1. Käsebier, Gertrude, 1852–1934. 2. Photographers—United
States—Biography. 3. Photography—Portraits. I. Käsebier,
Gertrude. 1852–1934. II. Title.
TR140.K37M53 1992
770'.92—dc20
[B] 91-22451
 CIP

Text copyright © 1992 Barbara L. Michaels
Illustrations copyright © 1992 Harry N. Abrams, Inc.

Published in 1992 by Harry N. Abrams, Incorporated, New York
A Times Mirror Company
All rights reserved. No part of the contents of this book may be
reproduced without the written permission of the publisher

Printed and bound in Japan

Page 2: Portrait of the Photographer (Gertrude Käsebier self-portrait). c. 1899. Photograph and ink drawing, 6⅝ × 4⅝". Collection Mason E. Turner, Jr. Photo: Jack Bungarz *Opposite:* Hermine Käsebier Turner photographing Mason and Mina Turner on the roof of Gertrude Käsebier's studio at 315 Fifth Avenue (variant of prizewinning photograph in Kodak advertising contest). c. 1909. Platinum print, 6 × 7¾". International Museum of Photography at George Eastman House, Rochester, N.Y. Gift of Mrs. Hermine M. Turner *Page 6: The Sketch* (Beatrice Baxter Ruyl). 1903. Platinum print, 6¹⁄₁₆ × 8³⁄₁₆". The Metropolitan Museum of Art, New York. The Alfred Stieglitz Collection, 1933. (33.43.136)

770
'92
KÖS
mic

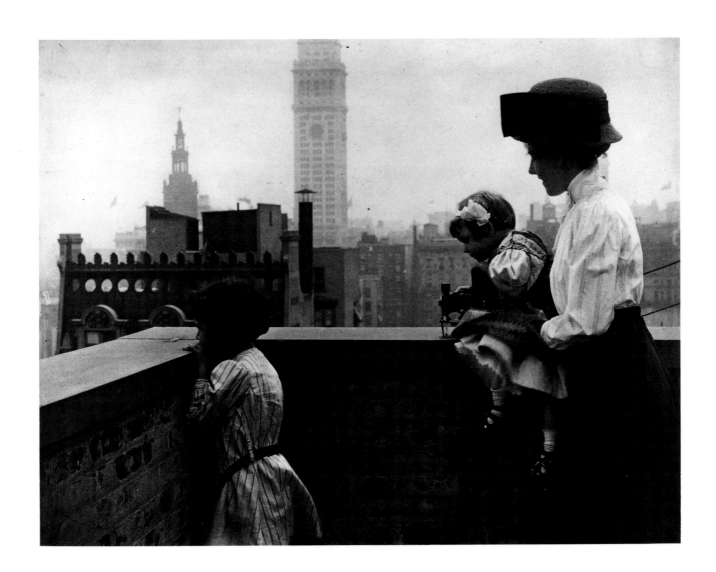

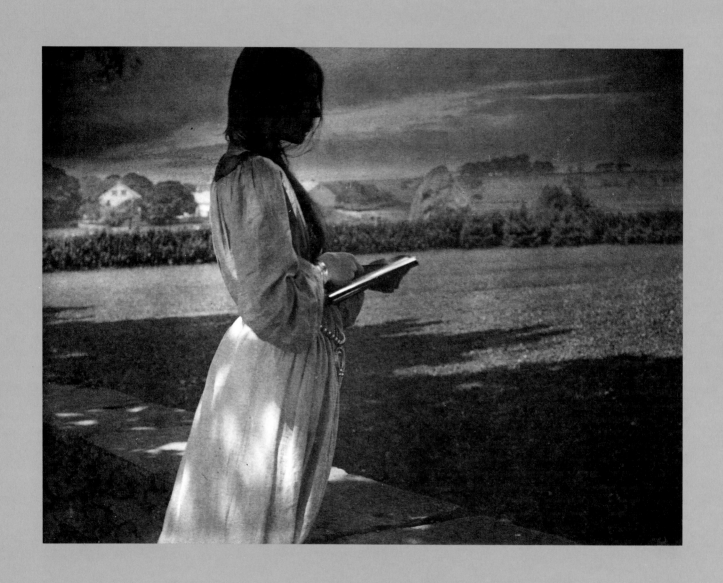

Contents

Acknowledgments

Of the many people who helped to bring this book into being, Gertrude Käsebier's granddaughter, Mina Turner, is at the top of my thank you list. Despite debilitating illnesses, she spent a great deal of time and effort telling me about her grandmother. As a one-time photographer, Mina Turner recognized her grandmother's accomplishments without indulging in ancestor worship. I am grateful, too, that Käsebier's daughter, Hermine M. Turner, even in her nineties, had lucid recollections of her mother's life, work and friends, and that Käsebier's other granddaughter, Elizabeth O'Malley McFarland, could contribute meaningful information. Other Käsebier descendants, including Mason E. Turner, Jr., Patricia Costello, the late Myke Cannon and her husband Dr. William M. Cannon, and Laura Shevlin, have been generous in putting photographs and family records at my disposal.

Kate Steichen and James S. Morcom, Mina Turner's contemporaries who knew Käsebier well, spoke to me at length and enabled me to envision the photographer in her later years. I am grateful to the photographers Imogen Cunningham, Laura Gilpin, Ralph Steiner, Paul Strand and Karl Struss, who shared their memories with me.

Other assistance came from people whose relatives knew or sat for Käsebier, or were otherwise connected with her: Henry Blanchford, Knox Burger, Sarah Brandegee Brodie, Michael John Burlingham, Henry Clifton, Jr., Nina Vitale Cohen, Barbara Ruyl Daugherty, Evan Evans, Phyllis Fenner, Joan B. Gaines, Phyllis Cotton Hamilton, Barbara Ivins, Alida White Lessard, Mrs. John McAndrew, Lawrence Perkins, Wallace Putnam, Francesca Calderone Steichen and Joel Stahmer, Flora Stieglitz Straus, Mrs. Clarence H. White, Jr., Maynard P. White, Jr., Robert White, Ruth (India) Ruyl Woodbury, and J. Riis Owre.

The aid of curators and librarians has been indispensable. In the Museum of Modern Art's Photography Department, I am especially grateful to John Szarkowski for his interest in this project while I was on the Department's staff and since, and to Peter Galassi. Susan Kismaric, Catherine Evans, Nicole Friedler, Lisa Kurzner, Sarah McNear, John Pultz, and Tony Troncale made the Museum's fine, extensive collection of Käsebiers available to me. The Museum's Steichen Archive has been a valuable resource, enhanced by the assistance of its devoted guardian, Grace M. Mayer. Kirk Varnedoe, Anne Umland, Janis Ekdahl, Rona Roob, Robert Evran and Richard Tooke all helped me to obtain information from other departments at the Museum.

I would also like to thank: Richard Hill and Julia Van Haaften at the New York Public Library; Janet Parks at Columbia University's Avery Library; Maria Morris Hambourg at the Metropolitan Museum of Art; Barbara LaSalle and Barbara Head Millstein of the Brooklyn Museum; Sidney Starr Keaveney at the Pratt Institute Library; Robert Sobieszek, Janice Madhu, David Wooters and Rachel Stuhlman at the International Museum of Photography at George Eastman House, Rochester, N.Y.; Donald Gallup, David E. Schoonover, Patricia C. Willis, and others at the Beinecke Rare Book and Manuscript Library, Yale University, New Haven; Saren Langman, Polly Pasternak, Sandy Wheeler and Katharine Warwick at the Hill-Stead Museum, Farmington, Conn.; Carol Johnson, Jerry L. Kearns, Jerald Maddox, and Anne Peterson at the Library of Congress; David Haberstich, Mary Grassick and Sandra A. Babbidge at the Smithsonian Institution; Peggy A. Feerick at the Ar-

chives of American Art, Washington, D.C.; Belena Chapp and Jan Lopez at the University of Delaware Museum; Ellen M. Arvidson, Mary Dean, Patricia J. Fanning and William A. Gifford, at the Norwood Historical Society; Walter Muir Whitehill, Catherine Nicholson, Theresa D. Cederholm and Helen Sevagian of the Boston Public Library; Lucy Flint-Gohlke at Wellesley College; Lisa Backman and Eleanor M. Gehres at the Denver Public Library; Weston Naef and Judith Keller at the John Paul Getty Museum; Valerie Lloyd of the Royal Photographic Society, England; and Hélène Pinet of the Musée Rodin, Paris.

Information and assistance were also provided by Paul R. Baker, Nina Baym, Susan Berlin, Mosette Glazer Broderick, Timothy Burgard, Eleanor Caponigro, Tom Cotton, Diana Edkins, Colin Eisler, James Enyeart, Nancy Escher, Paula K. Feder, Paul Fees, Kenneth N. Gilpin, Jr., Nancy Green, Howard Greenberg, William Innes Homer, Mies Hora, Estelle Jussim, Peggy Kauders, Joy Kestenbaum, Sarah Bradford Landau, Sidney I. Landau, Dennis R. Laurie, Sarah W. LeCount, Mr. and Mrs. Jacques LeMair, Sue Davidson Lowe, Dorothy Norman, Anita Ventura Mozley, Vernon Nelson, Lloyd Ostendorf, Peter Palmquist, Mary Panzer, Elizabeth Pollock, Lewis Hoyer Rabbage, George Rinhart, Jane Mayo Roos, Nancy P. Speers, Toby Quitslund, Jack Stillinger, Elinor Schrader, Geraldine Udell, Barbara Wright, Naomi and Walter Rosenblum, Anne Tucker, Susan Fillin Yeh, and Andrew and Elizabeth Zucker.

I would also like to express my appreciation to the late Robert Ratner, lawyer for the Käsebier-Turner estate, his successor, Lawrence Freedman, and Mrs. Robert Ratner, as well as to Anne Horton and Beth Gates-Warren of Sotheby's and to Claudia Gropper of Christie's. To others who have helped me whose names I never learned or may have forgotten, my thanks.

Some of the research for this book was funded by a grant from the Rockefeller Foundation. I owe much to Peter C. Bunnell of Princeton University who prompted me to turn a budding interest in Käsebier into a book, introduced me to the Turner family, and commented on an early draft. I am similarly pleased to recognize the scholarly expertise and support of Milton W. Brown and Linda Nochlin of the City University of New York when they read previous versions of the book. More recently, at Harry N. Abrams, Inc., Karen T. Hwa and Robert Morton have given me invaluable editorial direction. My thanks, too, to Carol Robson, Barbara Lyons, Christine Liotta and others at Abrams who helped to produce this book.

As children, my sons Kenneth and Daniel must have felt a certain rivalry with Gertrude Käsebier, who took so much of their mother's time, but as young men they have helped with this book in various practical ways. My deepest debt, however, is to my husband, Arthur, who has always found time to offer encouragement, criticism, editorial suggestions, or printing advice, as necessary.

Preface

Although Gertrude Käsebier was one of many late-nineteenth-century women to take up photography, she attained unprecedented success by combining aesthetic sensibility, outspokenness, and a good head for business.

Women had been involved in photography almost since the medium's introduction in 1839, because formal academic training was not necessary to become a photographer, as it was to be an accepted painter or sculptor. Photography was more like writing; some talent, patience and a will to learn were the prime requisites, although, of course, photographic equipment cost more than paper and pen. During the mid-nineteenth century, when photography was still a cumbersome and messy process, the relatively few women photographers tended to be either participants in family photographic businesses or well-to-do ladies like Julia Margaret Cameron, the noted English photographer.

Gertrude Käsebier had begun to take pictures of her family in the late 1880s, when dry plates and hand cameras made photography easier and more accessible for all, and when articles and advertisements in the popular press encouraged women to photograph. By 1900, the number of women photographing for pleasure or money had surged, and Käsebier was preeminent among them.

If Käsebier's entrance into photography was not in itself remarkable, her attitude towards the medium was. In the zeal with which she pursued her photographic career into the twentieth century, Käsebier might be said to exemplify the new woman of the Progressive Era, when work in some fields was becoming almost as acceptable as homemaking. But, the majority of Käsebier's feminine colleagues in professional photography were single. Ambition such as hers was virtually unheard of among well-off married women with families. Moreover, she was among the most acclaimed of a handful of photographers who flouted the convention of her day by insisting and showing that aesthetic interests, which were generally considered the province of amateur photographers, need not be abandoned in a commercial portrait studio.

Käsebier is best known as a Photo-Secessionist—a colleague of Alfred Stieglitz, the great photographer, proselytizer for the art of photography, and founder of the movement. In 1899, Stieglitz called Käsebier the leading portraitist of the day. Within a decade, however, they were at odds. Käsebier continued to be productive until about 1915, but because her later pictures were not publicized by Stieglitz they received less attention than her early ones.

By the time that Käsebier died in the mid-thirties, many considered her photographs to be passé. Her soft-focused, handcrafted images provided little sustenance to a generation that worshipped finely-honed precision and sought objectivity on the one hand or abstraction on the other. Käsebier had once been a model to Imogen Cunningham, Laura Gilpin and Edward Steichen; now they were the ones to whom up-and-coming photographers turned. And compared to the journalistic adventures of Margaret Bourke-White, Käsebier's photography seemed tame and parochial.

Today, Käsebier's photographs reverberate anew. They echo contemporary beliefs that handwork and mixed media are legitimate adjuncts to film and printing paper, and that a photograph may unabashedly render the photographer's feelings rather than seem to view the world neutrally. Yet despite all that has been published about

Stieglitz and his circle, Käsebier has remained as elusive as a figure in a soft-focused Secession photograph.

This book aims to show Käsebier as she was known to family, friends and colleagues. In a reevaluation of her work, Käsebier's noted portraits and studies of mothers and children are examined in relation to progressive ideas of her day, casting new light not only on classic Käsebiers but on some of her more baffling and eccentric pictures. By considering her career as a continuum, this book shows how concerns of her earlier photographs came to fruition in strong, meaningful late ones and reveals that she made some of her most vivid works during those late years that some critics once considered fallow.

Author's note: In captions, photographs are by Gertrude Käsebier unless otherwise noted. Published titles or those assigned by Käsebier appear in italics. Other titles are descriptive.

From early childhood, when she tried to draw with water that had splashed on the floor of her log home, Gertrude Käsebier always loved to make pictures. Although she had no chance to study art until she was a married woman with three nearly grown children, when the opportunity finally came she made up for lost time. By 1898, less than a decade after taking her first art courses, she had reached the peak of her chosen profession as a photographic portraitist. This was an unusual pursuit for a woman in her financially comfortable position, but convention never constrained Käsebier.

Her independence owed much to her upbringing. She was born Gertrude Stanton in Fort Des Moines (now Des Moines), Iowa, on May 18, 1852. When she was eight, she journeyed west with her mother and infant brother, Charles, to join her father, John W. Stanton, who had carted a saw mill to Eureka Gulch, in Colorado Territory, during the 1859 gold rush. Stanton prospered from a building boom and by expanding his mill to extract gold from ore, but his success was not merely financial: in 1860 he was elected the first mayor of Golden, a mining town that was then the capital of Colorado Territory.[1]

Gertrude was one of the first white children to reach Golden. Indian children were among her few playmates, and she often played alone, cultivating an independence and imagination that would last a lifetime. Hers was no usual pioneer family. Hoping to make a musician of their daughter, her parents had a piano carted over the plains, but, her mother recalled, "the child was simply crazy about pictures, while no persuasion or threat could make her take up the study of the piano." A painting that relieved the bare log walls of their parlor/dining room captivated little Gertrude so much that years later her mother remembered finding her "on one knee on the floor . . . viewing it through her small hands, telescope-like, talking to herself mean- while, asking herself if it would ever be possible for her to make such a picture." Similarly, one Christmas the girl ignored a gold ring that hunters and trappers had given her in favor of their gift of an illustrated primer.[2]

However, as skirmishes from the Civil War made pioneer life in Colorado increas- ingly difficult, and as the Stantons yearned to enjoy a more refined life with their newfound prosperity, they moved to Brooklyn, New York, in 1864, when Gertrude was twelve. They settled in a developing area of comfortable homes near the newly landscaped Fort Greene Park, not far from where Gertrude would later attend art school at Pratt Institute. Little can be learned of their Brooklyn years except that John Stanton continued to be involved in processing minerals, apparently as a refiner of sodium carbonate that had been brought from Colorado. Mrs. Stanton provided additional income by taking in boarders.[3] About 1868–1870, Gertrude spent a few years in Bethlehem, Pennsylvania, living with her maternal grandmother and attending the Moravian Seminary for Women, which was one of the first and best women's schools in the United States. No documents or memoirs recount Gertrude's studies at the Seminary, but letters and other writings from her adulthood show that she received a sound basic education.[4] Learning of her Quaker ancestry from her grandmother, Gertrude came to consider herself a Quaker. However, as an adult she did not actively practice any religion. Her Colorado upbringing had been in the

Methodist Church (in 1860 her father helped her uncle, the minister John Cree, to build the local Methodist church), and as a little girl Gertrude had made her mother proud by braving a long aisle, past rows of miners, to receive communion. Only after Prohibition did she wryly recall that she had gone "to the altar to get some of that wine!"[5]

On her twenty-second birthday, Gertrude married twenty-eight-year-old Eduard Käsebier, whom she had met at her mother's boarding house. For a decade the Käsebiers lived near the Stantons in Brooklyn, then moved to a farmhouse in New Durham, New Jersey. Eduard had come to the United States to seek his fortune, though not to escape poverty. His family was financially comfortable and socially well-placed; one sister had married Herman von Bismarck, nephew of the German Chancellor.[6] Mrs. Stanton approved of her daughter's match. She rightly foresaw that this well-bred, industrious young man would become a devoted husband and father and would provide well for his family, and she seems to have hoped that he would temper her daughter's impetuosity. But as Gertrude Käsebier later admitted to a friend, she had married impulsively. It was on the rebound, after some disappointing romance or infatuation with another man, that she accepted the handsome young German's highly formal proposal.[7] In time, she came to rue having "admired his stately gait and legs—and got *legs*," while her genial but hidebound husband, whose training in chemistry and business helped him to prosper as a shellac importer, must have been equally perturbed that neither housekeeping nor children subdued his wife's artistic fervor.[8]

By tacit agreement, she broke loose from household constraints and began art school at the age of thirty-seven, when their three children (Frederick William, born 1875, Gertrude Elizabeth, born 1878, and Hermine Mathilde, born 1880) were approaching adolescence. In the late nineteenth century, divorce was deemed scandalous, so like many incompatible couples of the time, the Käsebiers led largely separate lives. A family portrait (1) showing the five Käsebiers gazing in three different directions—and not at all at each other—symbolizes the gulf between mother and father: Eduard Käsebier, the businessman, peers directly at the camera; Gertrude, the artist, stares afar, as if daydreaming.

She didn't mince words about the marriage. In later life she said, "If my husband has gone to Heaven, I want to go to Hell. He was terrible. I could never cook anything he liked. Nothing was ever good enough for him." It rankled her that at a moment of financial strain he urged her to take in boarders but demurred at the start of her photographic career lest it imply that he could not support her. She admitted that she had never been really in love with her husband and realized that the marriage was not fair to him.[9] The unhappy situation set the stage for her most vivid statement on marriage—a late photograph likening matrimony to the muzzling and yoking of cattle (110, 111).

It must be said that Mr. Käsebier's shellac business supported her handsomely, paying tuition for her art education and subsidizing some, if not all, of her later trips to Europe. Yet she seemed so unwilling to forgive his insensitivity to beauty that she caustically captioned her sketch of him dozing on a long train ride: "Enjoying the view . . . on our way to the worlds fair" (2).

Her photographs of him relaxing with his grandchildren show him more sympathetically. So does her description of him enjoying a vacation "to such an extent that he conducts himself quite like a schoolboy." There were also pleasant evenings when he took her and her studio assistant, Harriet Hibbard, to dinner at one or another German restaurant in lower Manhattan. Hibbard recalled that he was proud of his

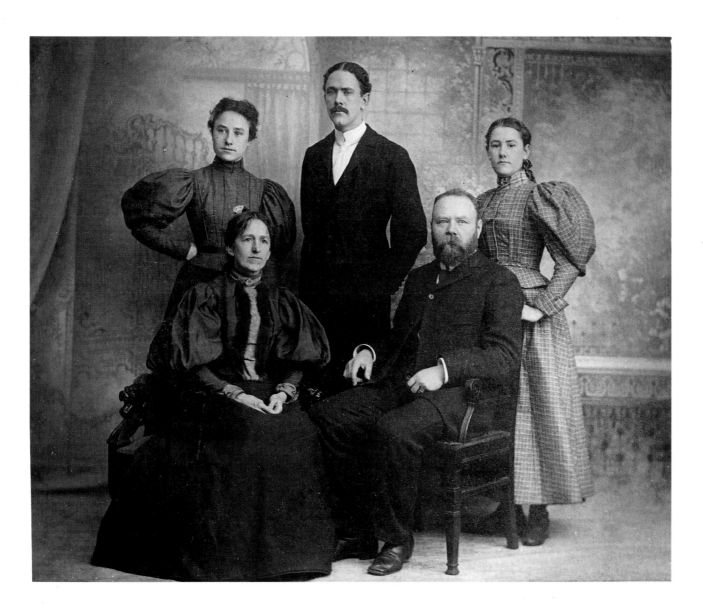

1.
Herman Wunder/M. Hellman. The Käsebier Family in Brooklyn. Seated are Gertrude and Eduard Käsebier. Standing, left to right: Gertrude (Jr.), Frederick, and Hermine. c. 1894. Albumen print, 7¼ × 8¾". Collection Mason E. Turner, Jr. Photo: Jack Bungarz

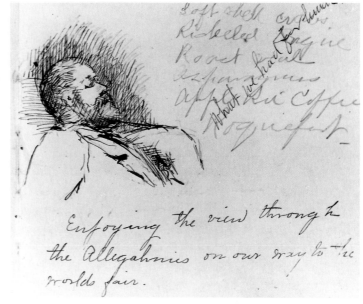

2.
Enjoying the view . . . 1893. Pencil, ink and watercolor on paper, 4½ × 5½". Collection Mason E. Turner, Jr. Photo: Jack Bungarz

wife, though he didn't understand her work.[10] Perhaps, after all, it is a measure of Eduard Käsebier's youthful adventuresomeness that he was drawn to a woman whose upbringing and personality were so unlike his.

Where Eduard was traditional and reserved, Gertrude was original and vivacious. At once sensitive and forthright, she was warm and generous, but knew how to put her foot down when necessary. Her engaging manner captured almost as much attention as her photographs. Here was a sophisticated, urbane artist who peppered her talk with homespun, rural locutions. In 1915 she lived near skyscrapers, but advised photographic novices to: "Dream dreams, have ideals . . . and do not aspire to skim the cream before you have milked the cow."[11]

3.
[First Photograph]. c. 1885. Albumen print, 3¾ × 4⅝". The Metropolitan Museum of Art, New York. The Alfred Stieglitz Collection, 1933 (33.43.140)

Scarlet fever had deafened one ear when she was three, yet her voice never lost its clarity, vibrance, or expressiveness. Time took a toll on her other ear; by seventy she was virtually deaf, finding a hearing aid of little help. Her tendency to see silver linings led her to observe, in later years, that by keeping her from hearing many trivial things, her deafness had been a blessing.[12] Acquaintances knew Käsebier as a raconteur with a sense of humor, a woman with a twinkle in her eye who was even willing to tell a story at her own expense.

In street clothes, about 1900, she would have looked like other upper middle-class matrons: corseted, hatted and gloved. In a fur-trimmed gown in the family portrait (1) or in silvery gray silk and lace with diamond ornaments at her daughter Gertrude's wedding in 1899, she might even have been called elegant. But her hands told another story. Not her palms (though Käsebier, who was interested in spiritualism, might have liked to have had them read), but her fingertips, which bore the marks of her nonconformism: stains from photographic chemicals, and, in later years, tinges of nicotine from the little "Between the Acts" cigars that so embarrassed her pre-adolescent granddaughter. A motion picture of Käsebier made early in her career would have shown an energetic woman carrying herself erectly, moving

quickly, and frequently brushing a stray strand of graying hair from her brow.[21] As it is, the Steichen drawing of about 1901 (57) is among her best likenesses. It confirms a friend's characterization of a "keen faced woman whose eyes meet yours searchingly" creating an impression of "intense vitality . . . a sense of great kindliness—wisdom—comprehension."[13]

Gertrude Käsebier's determination to become a portrait painter was so great that in 1889 she convinced her husband to move back to Brooklyn from New Jersey so that she could enroll at Pratt Institute. Perhaps she told him that Pratt would also be good for their daughters, who eventually took sewing courses there. The Institute had been founded only two years before by Charles Pratt, whose oil fortune enabled him to establish the school with the idealistic aim of providing practical education in such fields as engineering, home economics, teacher training, industrial arts, and fine arts.[14]

Between 1889 and 1893, Käsebier completed Pratt's Regular Art Course, a coeducational program to train artists. No records tell what courses she took, though like other students, she had to prove competent in drawing from casts before progressing to the required three years of drawing and painting from life. Lectures on design, perspective, anatomy, and the history of art supplemented studio courses. Sketching and composition were emphasized, doubtless stimulating Käsebier's lifelong interest in composition.[15]

Although she said little about the school, Pratt affected her artistic and professional development by treating women as serious students, not dilettantes, and by encouraging them to prepare for careers. Käsebier made friends with some of the several women artists on the art faculty and kept in touch with them after her graduation. She and her family entertained students—who were closer in age to her son and two daughters than to her—in their capacious frame home near Pratt, where a room had been turned into a cozy *rathskeller*. She was also a leader in raising scholarship and travel funds for needy students.[16]

Käsebier had begun to take pictures of her family before she entered Pratt, which offered no instruction in photography. Although Käsebier said that Pratt professors discouraged her photographic efforts, they were not totally unsympathetic to the medium. For instance, some photographs by the art department director, Walter S. Perry, illustrate his book on Egypt. Moreover, magazines in the Pratt library carried articles about photography, including one in which Julia Margaret Cameron's photographer-son discussed her portraits. Cameron, who had been active from the mid-1860s until her death in 1878, enjoyed renewed popularity in the 1890s. But if this eminent English woman photographer ever inspired her, Käsebier did not say.[17]

Käsebier probably learned more by studying the hundreds of photographs of old masters in Pratt's art reference collection. Such photographs—made by specialized firms like Alinari, Brogi, Sommer and Braun—were usually studied for their content, but they are also technically interesting. Looking at different views of sculpture or architecture Käsebier would have seen how greatly photographs can be affected by changing light and vantage point. She must also have become aware of tonal nuances and varied printing quality among photographs.

While at Pratt, Käsebier had begun to consider motherhood as a basis for her art. The subject not only had a long tradition in the form of madonnas and children, but it was generally popular in the late nineteenth century. However, Pratt provided a special approach, as it exposed Käsebier to Friedrich Froebel's theories about the role mothers should play in teaching their children and guiding them to independence.

She would later embody these ideas in her mother and child photographs. Froebel's methods were not only taught in Pratt's teacher training school and kindergarten, they were discussed in public lectures and articles in Pratt's magazines. Moreover, Käsebier's instructor, Ida C. Haskell, who would soon introduce Käsebier to the paintings of Arthur B. Davies, herself painted scenes of mothers and children, one of which was shown at the World's Columbian Exposition.[18]

Just a few weeks before her graduation, Gertrude and Eduard Käsebier visited the World's Columbian Exposition in Chicago, which celebrated the four-hundredth anniversary of Columbus's voyage to America. Today, the fair is best remembered for its pristine white neoclassical buildings and vistas along broad avenues and canals. But there were also re-creations of exotic places like a street in Cairo (complete with visiting Arabs) and a section of eighteenth-century Vienna; the scenes that Käsebier sketched there suggest both her wanderlust and her interest in all sorts of people.[19]

The main pavilions contained industrial as well as cultural exhibitions, so that while Mr. Käsebier examined displays of paints and varnishes in one building, his wife could delight in painting and sculpture elsewhere. She would have been impressed and inspired by the foreign and American art on view in the Palace of Fine Arts and by the work of artists in the Woman's Building. Bertha Honoré Palmer (Mrs. Potter Palmer), the art lover and prominent member of Chicago society who served as President of the Board of Lady Managers for the Woman's Building, had arranged to have it designed by Sophia G. Hayden, one of the few women architects of the day. Its displays of women's achievements in fields from science to literature included art ranging from Mary Cassatt's mural *Modern Woman*, to a special exhibition by Pratt alumnae, to baskets and blankets by American Indians.[20]

The Fine Arts Palace housed more than two thousand artworks divided by nationality, except for three rooms with loans of "Masterpieces by Foreign Artists" from American collections. Here (rather than in the academically controlled French section) were the modern French artists, including Monet, Degas, and Barbizon School painters like Millet, though sculptures by her favorite, Auguste Rodin, listed in the catalogue, had been removed from view.[21] Surely the paintings by James McNeill Whistler (six oils, over fifty watercolors) caught Käsebier's attention, and she must have paused at Franz von Lenbach's portrait of Otto von Bismarck (a Käsebier relative by marriage). But, standing before John Singer Sargent's portrait of *Ellen Terry as Lady Macbeth*, could Gertrude Käsebier have dreamed that within a decade the great actress would be patronizing *her*?

After graduation Käsebier continued to study at Pratt until 1896. Reenrollment during 1893–94 allowed her to learn from the new art teachers, Herbert Denman and Frank Vincent DuMond, both of whose paintings had been shown at the Columbian Exposition. DuMond enabled Käsebier to spend a year abroad studying art by selecting her to chaperone the young women at his 1894 summer art school in France. In the fall of 1895, when the artists Arthur W. Dow and Ernest F. Fenollosa brought fresh ideas about the beauties of oriental art and the principles of composition to Pratt, Käsebier enrolled for one last year of study. Dow's emphasis on the organization of dark and light masses would prove applicable to photography. Moreover, he taught students to begin making a picture the way a photographer composes with a camera. In class Dow would "make an unbounded drawing of trees and hills, or perhaps a winding road against the sky. Then he would ask the class to copy the drawing freely and enclose it in a rectangle, to make a horizontal picture or a vertical, as they chose. . . ."[22]

4.
Prize-winning photograph. [1894]. From
The Quarterly Illustrator, April–May–June 1894

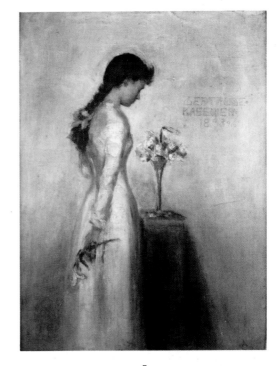

5.
Gertrude Käsebier [O'Malley].
1893. Oil on canvas, 16 × 12″. Private Collection

During the spring of 1894, Käsebier won recognition in two photography contests. She had begun taking pictures by the late 1880s with the mundane aim of recording her growing children. Almost no early work survives except Käsebier's *First Photograph*, a snapshot showing her husband and a boy (presumably her son) in a grassy yard. Many a beginner might have taken such a pleasant but unremarkable family picture (3), yet years later Käsebier still thought it enough of a landmark to give a copy to her colleague, the leading American photographer, Alfred Stieglitz.[23]

Käsebier was but one of the many novices who took up photography during the 1880s, as the process became simpler. Until the late 1870s, most photography involved the cumbersome wet plate technique, which demanded that negatives be

processed immediately after being exposed. This either confined photographers to a studio or compelled them to take a tent or wagon along as a traveling darkroom. As photography became much easier with the invention of dry plates (glass plates that could be developed long after exposure, by either the photographer or a hired technician), the ranks of amateur photographers began to swell. Simplification and portability of cameras reached a peak in 1888 with the Kodak hand camera, which introduced roll film and, in the words of their slogan, allowed total amateurs to "press the button" and let Kodak processors "do the rest"—develop and print the film that was sent to them.[24] With the Kodak, photography became the popular medium that it continues to be to this day.

Käsebier's approach to photography was to place her among an emerging class of photographers known as serious or advanced amateurs, to differentiate them from workaday commercial operators on the one hand and casual snapshooters on the other. Following photography for the love of it, rather than for profit, these devotees joined camera clubs, read photography magazines, and exhibited their work at photographic exhibitions known as salons, after their counterparts in painting and sculpture.

Käsebier evidently began to photograph before the Kodak was available, and, except perhaps while traveling, always used glass plate negatives. Her first photographs did not come easily. With typical Käsebier hyperbole, she called her first camera "a clumsy thing with a non-adjustable tripod at least five feet high." Using it, she "ruined at least thirty" plates before securing a negative. Only after an elderly priest, a Father Wenzel whom she fortuitously met in a photography store, volunteered to teach her at home did she finally learn the craft.[25]

She gave the priest much of the credit when, in 1894, she won a fifty-dollar prize from *The Quarterly Illustrator* for the best photograph of a figure in Greek costume that combined artistic pose and accessories with excellent composition. The two Käsebiers that the magazine published—profile and head-on views of a chiton-draped young lady holding a flower—were the first of many Käsebiers to be reproduced over the years (4). That the judges (who included the eminent portrait photographer, Napoleon Sarony, and the artist Will Low) prized Käsebier's pictures over those with classical backgrounds and props reflects the era's growing preference for mood over historicism. Spurred by success, Käsebier entered the *New York Herald*'s photography contest for its "fair readers." At the time, the contest was surely meant to boost circulation among the growing band of women photographers as much as it was meant to flatter them. Today it shows that segregation of women photographers in contests, as well as in camera club darkrooms, was common during the 1880s and 1890s. Käsebier was runner-up in this contest; two of her pictures were published, though, oddly, her name went unmentioned. (Emilie V. Clarkson, whose pictures would also later appear in *Camera Notes*, won first prize.)[26]

Käsebier's earliest published photographs enable us to see that from the beginning she took divergent directions that she would follow during her career. In its tone, subject, and passive mood, *Are those the Real that blossoms and passes . . .* (4) resembles Käsebier's 1893 painting of her daughter Gertrude (5), apparently the only extant oil by Käsebier. It also points towards her studio portraits, her prepared pictures such as *The Manger, Blessed Art Thou Among Women* and her Rodin portraits, which show a prevailing interest in light tonalities (31, 29, 72, 73). *In Grandpa's Orchard* (6) is an outdoor snapshot of daily activity, like the pictures she was soon to make of French peasants. Later photos of her grandchildren and of Newfoundland folk continued in this vein.

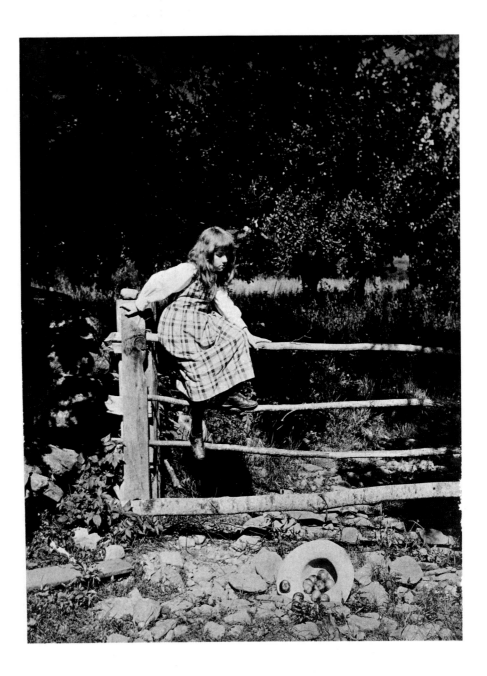

6.
In Grandpa's Orchard (Hermine on a Rail Fence). c. 1893. Silver print, 8⅜ × 6⅛". University Gallery Collection, University of Delaware, Gift of Mason E. Turner, Jr., 1979.
Photo: Butch Hulett

Four years after winning the fifty-dollar prize from the *Quarterly Illustrator*, Käsebier claimed that it had given her neither joy nor satisfaction:

I felt awfully small when the thing appeared in print because it was not more meritorious, and because it found itself in such very questionable company.

The masters under whom I was studying, men whose opinion I was bound to respect, opened their vials of wrath, and labored with me as with one fallen from grace. They so convinced me of my error, that the poor camera again went into retirement, and I was so ashamed that I gave away the fifty dollars.[27]

Playing Lady Bountiful with prize money would have been typical of Käsebier. And she, who was known for making "a wild and wonderful story out of everything," was

likely to distort her recollections to make a point. The pace of Käsebier's activities during the spring of 1894 calls the "retirement" of her camera into question. Between early March and mid-April, she learned of her *Quarterly Illustrator* success, entered the *New York Herald* contest, and took her camera to Europe. The camera's early retirement was more like a few weeks' vacation.

Looking back in 1898, she implied that packing her camera for her European trip had required initiative and independence:

> The time came when I was to go abroad to continue my studies, and the same good people persuaded me that it would be a fatal error to take the camera along, but at the last moment there was a space in a trunk, which must needs be filled, and strange to say, it was just the dimensions of my camera case. You can draw your own conclusions.[28]

Packing camera equipment was no last-minute whim. With two photographic contests behind her, no wonder that she found room for her camera! Käsebier already sensed that she and photography had a future together.

Käsebier's year in Europe began with a vacation in Wiesbaden, Germany, before leaving her daughters there at her in-laws' home. She had visited before and knew that her daughters' lives would be enriched culturally by staying with them while she was in France. Frederick had remained in Brooklyn with his father.

While she reported on the leisurely pace of life in the spa city of Wiesbaden, photography remained on her mind. She found "no end of material for delightful and profitable study. . . . Within easy distances there are many quaint villages with most interesting types of people, children, geese etc., both for brush and Camera."[29] Later, Käsebier recalled photography's having been simply a "pastime" until she began doing indoor portraiture in France, but her reference to "Camera" with a capital C suggests her earnestness about it even before that.

Käsebier spent the summer in the picturesque village of Crécy-en-Brie, about thirty miles southeast of Paris, studying landscape and figure painting with Frank DuMond, while chaperoning his students from Pratt and the Art Students League. DuMond was an artist and illustrator who loved to teach. His emphasis on the formal construction of the head suited Käsebier's interest in portraiture, but even more significant for her future attitude towards photography was DuMond's conviction (informed by Symbolist painting) that an artist ought to convey some personal meaning or mood. After only a week in Crécy, she found her expectations "more than realized" and felt that she was going to learn a great deal.[30]

Undaunted by rain, she turned wet weather to her advantage, and found her calling as a portrait photographer:

> Hitherto I had . . . given to in-door portraiture no attention whatever. But one day when it was too rainy to go into the fields to paint, I made a time-exposure in the house, simply as an experiment. The result was so surprising to me that from that moment I knew I had found my vocation.[31]

She realized that if she could take a good picture by dim north light in a low-ceilinged, dark-walled room, she could do even better under optimum conditions.

Nonetheless, not portraiture but illustrative photography, a branch of what we now call photojournalism, was her greatest photographic venture in Crécy. She wrote and illustrated two articles describing French village and peasant life. Publication of illustrated magazines was burgeoning during the last decade of the nineteenth

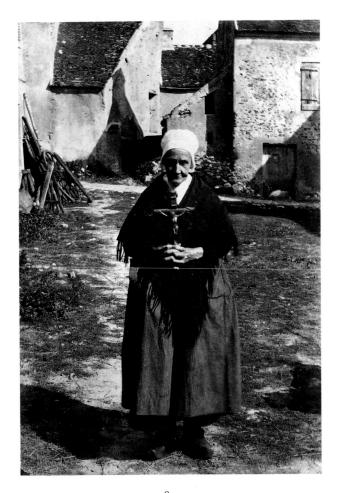

8.
La Grand-mère. 1894. Silver print, 6⅞ × 4¾". Collection
Mason E. Turner, Jr. (Titled *Waiting for the Procession* in
Käsebier's "An Art Village," *The Monthly Illustrator,*
April 1895)

7.
The Old Mower and His Wife. [1894]. From "Peasant Life
in Normandy," *The Monthly Illustrator,* March 1895

century, as halftone printing had made photographic reproduction easy and economical. Photographs helped to fill these magazines' seemingly insatiable appetites for varied illustrative fare. Käsebier would have had no difficulty in realizing that "a particularly attractive and agreeable field is opened to women" in using photography "as a means of illustrating."[32] DuMond, whose drawings illustrated magazines, doubtless encouraged her.

Her articles were well conceived, with text explaining what pictures could not, such as the students' changing reactions to peasants:

> We dared once to pity their women, because they were laborers in the field.
> Today . . . the simplicity, the honesty, the naturalness of their lives makes
> us . . . ask whether they cannot teach us many a lesson in contentment,
> healthfulness, industry, patience and unaffected manners.

Probably owing to their appreciation of Millet's paintings, the students were favorably disposed towards the peasants. Käsebier said: "The farmer-folk made us wel-

come everywhere. . . . There was a sympathy among them that seemed to us a real, instinctive art-appreciation," but in the end their cool farewell made the students feel that peasants' aesthetic sensibilities were "often only skin deep," and that "the peasant has no sentiment!"[33]

Käsebier did not lack sentiment. She had come to France imbued with the notion of peasant as noble savage, and saw the French countryside nostalgically, associating the Brie region with Barbizon paintings that had been made nearby:

> One color, or half-tone, melts into another in the most seductive fashion, whether it be the costumes of the peasants, the stain upon the buildings, or the gray-green of the landscape. It is no wonder that Corot and the followers of his method were captivated by this district.

While posing a mower and his wife for a photograph, she found that "the scene made another *Angelus* in its way, as Millet must have seen hundreds of times before he painted his immortal picture" (7).[34]

Some of Käsebier's later photographic concerns are nascent in the two articles. All of the pictures contain people; several show mothers and children. There are experiments with techniques of art photography, such as soft focus and silhouettes. But there are no indoor or close-up portraits, and her composition awaits refinement: too much space surrounds subjects who pose stiffly and frontally, snapshot style.

Little evidence remains about the rest of her year abroad. Although she spent some time in Paris, studying at the Académie Julian and living with a French family on the rue du Bac where her daughters joined her for about a month, her own recollections of that city say only that "many artists" gave "much encouragement" to her photographic efforts. Then, partly because she spoke better German than French, she decided to return to Germany to improve her photographic technique: "My friends pleaded with me not to do it, predicting that I would lose the quality of my work and become mechanical or too technical. But, realizing the necessity of being able to control my medium, I carried out my idea. I apprenticed myself to a chemist who knew photography."[35] Without naming the chemist, Käsebier damned his pedestrian vision. Evidently referring to *La Grand-mère* (8), she said:

> The first picture I gave to him for a criticism was that of an old woman, standing in strong sunlight.
> Pointing to the interesting shadow cast by the figure, he said, "You must remove that by retouching, and then it will be very fine."
> "What! Remove a shadow, a natural effect, a thing which gives snap to the whole? Never!"
> "Ah, but the public do not like shadows!"
> That was the key to the artistic atmosphere I encountered in Germany.[36]

The German photographic chemist best known to us today is Hermann Wilhelm Vogel, the inventor of orthochromatic film and Alfred Stieglitz's mentor in Berlin during the 1880s. Unlike Käsebier's teacher, Vogel did not deter his pupil when Stieglitz did "nothing according to rote, nothing as suggested by professors or anyone else." In other ways, Käsebier experienced Germany differently from Stieglitz. He absorbed all he could from the culture: operas, concerts, plays, museums, libraries. "Everything available to us was first rate," he recalled. Käsebier was less enthusiastic: "A year there did me no harm," she said sardonically. "One must know all sides to be able to strike a balance. The coffee and some other developers are very good in Germany."[37]

Although Eduard Käsebier was to prove his physicians wrong by a dozen years, in 1896 their predictions that he had only a year to live galvanized Gertrude Käsebier into becoming a commercial portrait photographer.[1] In her youth, running a boarding house, as her mother had done, was one of the few ways a respectable woman could earn money, but changing attitudes had opened new livelihoods to women.

The 1890s were fruitful years for women photographers. The way had been opened by simplification of photographic techniques and a growing acceptance of women working outside the home. Magazine articles encouraged women to photograph. It was widely believed that women's innate sensitivity and good taste qualified them for artistic photography, particularly for photography of women and children.[2] Like Mathilde Weil, Eva Watson (Schütze) and others who had come to photography from art school in the 1890s, Käsebier decried the lifelessness of prevailing studio portraiture and found ways to revitalize it. Luckily, a large enough audience shared these photographers' aesthetic values to make their work worthwhile, financially and critically.

Several factors in Käsebier's life gave her the incentive to succeed in art and business. Both her mother and grandmother had set examples. Käsebier recalled her mother's mother, with whom she had lived in Bethlehem, as a "splendid, strong, pioneer type of women [sic] . . . an artist with her loom" who "made her own designs, and weaved the most beautiful fancies into her fabrics. . . . She was a model to me in many ways, and the beginning of what I have accomplished in art came to me through her."[3]

Käsebier regretted that her own mother hadn't "an atom of artistry in her whole being," but was indebted to her for other reasons. Gertrude Muncy Shaw Stanton (known as Muncy) was an energetic, practical, adventuresome woman who passed more than a sense of humor on to her daughter. As if it were not enough to be a pioneer housewife in Colorado during the early 1860s, Muncy Stanton became something of an entrepreneur who later recalled finding "a source of revenue, equal to a small bank in baking for the boys [miners] and selling milk, which one might literally say was as good as gold." After her husband's firm was through retorting and weighing, it was not uncommon for her and her children "to clean from $4 to $5 in gold from scales and table . . . often having in our respective gold bottles as much as $40."[4]

About 1879, in the midst of another mining boom, the Stantons and their grown son, Charles, returned to the Denver area, but on March 6, 1880, John Stanton suddenly died of pneumonia in Leadville, where he evidently owned a stake in a silver mine.[5] Rather than returning east or simply taking in roomers as she had in Brooklyn, Muncy Stanton began to run hotels. She kept a tourist hotel when Gertrude Käsebier visited around the time of her father's death, and by 1882 she was proprietor of the Stanton House hotel in the mining town of Georgetown. In the mid-1880s, she acted as hostess at the Glenarm Hotel in Denver, while Charles held a variety of jobs until the mid-1890s when he set off for Mexico in search of gold. After meeting with some success and promising to send his mother money to join him, he vanished, presumably the victim of bandits. Although Mrs. Stanton never

gave up hope that her son would reappear, the loss must have contributed to her decision to return east to live with the Käsebiers and to free her daughter from household responsibilities soon after Käsebier opened a portrait studio.[6]

Whatever business sense Muncy Stanton had inculcated in her daughter, Pratt Institute augmented while Käsebier was studying there. Pratt's publications brimmed with advice, information and support for working women. Before going to Europe, for instance, Käsebier could have read the article "Business Principles for Women," which said that although there was no "necessity for distinction of sex in commercial transactions," many business women felt that

> to do this or that in a certain manner would have a savoring of masculinity, which of course no refined woman desires to acquire. Such "notions," for they deserve no better appelation, should be banished at once. A womanly woman is such for all time and all places, and it will not mar her delicacy one jot or tittle that she knows which end of a check to endorse and does it without any preliminary hesitating expressions of "Let me see," and "Oh! yess—this is the right place!"[7]

The article also urged women to speak concisely and without hesitation, to be careful and accurate, and to arrange work systematically. While many women were being squeezed into the coy and helpless mold of the 1890s, Pratt fostered independence and directness.

Bolstered by her mother's experience and Pratt's ideals, Käsebier set out to succeed in the male-dominated business of portrait photography. She chose Samuel H. Lifshey, a neighborhood portrait photographer in Brooklyn, as her photography tutor because he was competent and successful. That his work was artistically undistinguished did not matter; she could provide the art. Her apprenticeship turned into a lifelong friendship, and, as her aesthetics rubbed off on Lifshey, he was said to have gained as much from Mrs. Käsebier as she did from him. But no one would have predicted that at their first meeting one rainy day in 1896 when Käsebier appeared at his shop, drenched and bedraggled, to declare her intention of standing behind the camera. An apprenticeship was impossible, he insisted, naming an exorbitant price to ward her off. But when she returned with her portfolio, he recanted.[8]

Käsebier recalled her apprenticeship:

> I spent some months of working days . . . in a photographic establishment in New York, for the sake of knowing the view point of the other fellow. I served in the skylight; I developed; I printed; I toned; I mounted; I retouched. I acquired the knack of handling materials in quantities, and caught the swing of business.[9]

With Lifshey's help, she set up a practical darkroom at her Willoughby Avenue home in Brooklyn.

Käsebier understood that to be treated as an artist, it was necessary to act like one. Exhibiting her photographs was the first step. She began by showing at the Boston Camera Club in November 1896, probably through the influence of Arthur W. Dow (9), the Pratt instructor who maintained close ties to Boston's world of art and photography. (Dow was to champion Käsebier's work in *Camera Notes* during 1899, the same year that his famous book, *Composition*, was published.) In Boston, a critic (probably Ralph Adams Cram, who, before achieving renown as an architect, was art critic of the *Boston Transcript*) praised her portraits for a "quaintness of character"

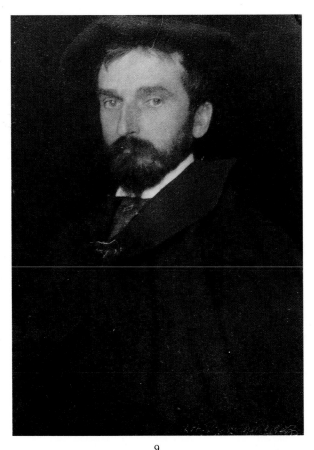

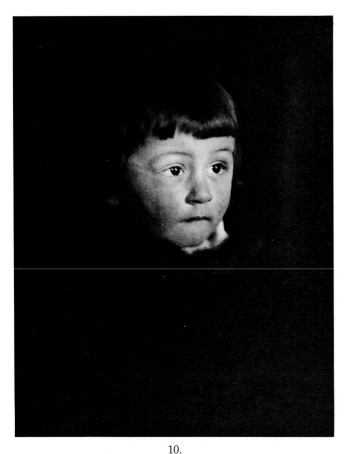

9.

Arthur W. Dow. [1896–98]. Platinum print, 6 × 4″. Arthur W. Dow Papers, Archives of American Art, Smithsonian Institution, Washington, D.C.

10.

Portrait of a Boy. 1897. Platinum print, 6⅛ × 4⅞″. Library of Congress, Washington, D.C.

and "gravity of expression which recall the sobriety and genuineness . . . of some of the old masters in painting."[10]

In February 1897 the same group of 150 pictures, most of which were portraits, caught New Yorkers' attention when they were shown at Pratt Institute as *Art Studies in Photography.* Käsebier dismissed further comparisons of these photographs to old master paintings: "People sometimes say they recognize this or that from the old masters in my work, but I am never conscious of any such imitation. I simply study to bring out what I feel to be a characteristic strong point, and to make an interesting picture." Considering her penchant at the time for using canvas-textured backgrounds, as well as for dressing child subjects in Titianesque fur-collared velvety gowns and placing them against dark backgrounds (as in *Portrait of a Boy,* 1897, (10), her response seems disingenuous. Intentionally or not, her hours at the Louvre and other museums shone through her photographs with their allusions to Holbein's portraits (9), among others. Käsebier's ability simultaneously to make a recognizable portrait likeness and to evoke the sitter's personality—a quality for which she was to be praised repeatedly—is first mentioned in a review of the Pratt exhibitions.[11]

During a showing of her work at the Photographic Society of Philadelphia early in 1898, Käsebier lectured about her artistic and photographic education, decrying the artlessness of contemporary commercial portrait photography and setting forth her vision of photography's creative potential. Acknowledging that she felt "diffident in speaking . . . about photography" because she had not "followed the beaten paths,"

and because she "had to wade through seas of criticism" on account of her "heretical views," she forcefully recounted some of these views and spurred listeners to greater independence and originality:

> Why should not the camera as a medium for the interpretation of art as understood by painters, sculptors and draughtsmen, command respect? Why should it not be required of the photographer, desiring to be known as an artist, that he serve an apprenticeship in an art school? . . . There is more in art . . . as applied to photography, than startling display lines, on mounts and signs announcing "Artist Photographer," "Artistic Photographic Studio," etc. . . .
>
> The key to artistic photography is to work out your own thoughts, by yourselves. Imitation leads to certain disaster.
>
> New ideas are always antagonized. Do not mind that. If a thing is good it will survive.

Then she gave her most quoted advice:

> I earnestly advise women of artistic tastes to train for the unworked field of modern photography. It seems to be especially adapted to them, and the few who have entered it are meeting with gratifying and profitable success. If one already draws and paints, so much the better the equipment.

And ended with a characteristic Käsebier pun: "Besides, consider the advantage of a vocation which necessitates one's being a taking woman."[12]

For many women of her day, a portrait business at home would have been accomplishment enough, but for Käsebier it was merely a stepping stone. In late 1897 or early 1898, Käsebier opened her first New York studio, a room on an upper floor of the Woman's Exchange at 12 East 30th Street, off Fifth Avenue. The Exchange helped "gentlewomen" who were obliged to support themselves by selling their handicrafts and foods in the Exchange's ground floor shop and tearoom. Käsebier was not affiliated with the Exchange, but she benefited from its genteel clientele and from the congenial atmosphere among women artists in its studios.[13] Moreover, the Exchange was at the hub of the New York photographic world, near the most fashionable, most expensive portrait photographers. Käsebier strove to become one of them by seeking clients from the higher echelons of New York society, while remaining manifestly different in style.

Neither fancy backdrops nor elaborate furniture cluttered her studio, for, as she had told her Philadelphia audience, "one of the most difficult things to learn in painting is what to leave out. How to keep things simple enough. The same applies to photography. The value of composition cannot be overestimated: upon it depends the harmony and the sentiment." Simplifying the composition and background of portraits was one way that Käsebier saw to bring studio portraiture out of the overstuffed Victorian era into the age of the Arts and Crafts movement. She made her point by disparaging a portrait by the Chicago photographer, W. J. Root, that had appeared in the annual *Photo-Mosaics* (80):

> We have here a painted, scenic background, a palm, a gilt chair, and something which looks like a leopard-skin, though why it is introduced I cannot imagine, as summer seems to be indicated; perhaps it is to cover the legs of the chair, perhaps it is used because "fur takes well." I presume if an elephant had been handy the "artist" would have tried to work it in. Something should always be left to the imagination. We do not always see people

under a search light. There is also a girl in the picture. She cuts the space in two. There is no center of interest; the eye wanders about from one thing to another, the fur rug seems to be most important because it is out of place and superfluous.[14]

Her second goal was more difficult; she sought to make "not maps of faces, but pictures of real men and women as they know themselves, to make likenesses that are biographies, to bring out in each photograph the essential personality that is variously called temperament, soul, humanity."[15] The words are pure Käsebier: attracting attention by pushing a point to the brink of credibility. Käsebier could not have expected photographs to rival written biography.

But photography's ability to suggest personality is not unlike painting's, and Käsebier was certainly familiar with paintings that incorporated clues to a sitter's life or personality. After all, she was contemporary with some great American portraitists—John Singer Sargent, William Merritt Chase, James McNeill Whistler and Thomas Eakins—as well as being familiar with the old masters whose work informs her earliest portraits. Although Käsebier was far from the first photographer to try to introduce individuality into portraiture, the idea was not prevalent in New York when she began.[16]

While Käsebier attracted her share of proper New Yorkers as subjects, early in her career she also invited Sioux Indians from Buffalo Bill's troupe to pose for her. She did this out of nostalgia for the Plains Indians she had known as a child in Colorado. Even after her years in the East, Indians still intrigued her. "Granny loved the Indians," her granddaughter, Mina Turner, recalled. "She felt they were the only truly honest people she knew."[17]

Käsebier was not alone in her fascination with Native Americans. Artists, and then photographers, had been picturing them since early explorations of the New World, with varying attitudes ranging from anthropological to romantic.[18] But especially after the massacre of the Sioux at Wounded Knee, South Dakota, in 1890, Americans came to realize that the old Indian ways were doomed. Instead of being viewed as a threat, Indians began to be seen as an endangered species. Käsebier was at the forefront of sympathetic interest in Indian arts, crafts, and culture that burgeoned from the mid-1890s through the first two decades of the twentieth century, as shown, for instance, by Indian images and motifs in the Arts and Crafts movement,[19] as well as by photographs. Käsebier's contact with Quaker and Moravian ideology may also have fostered her sympathy for Indians, as both religious groups were involved in bettering life for Native Americans. However, so little is known about Käsebier's connection to Quakers or Moravians that it is impossible to assess the impact of their beliefs on any aspect of her life.

Käsebier's Indian photographs, which are among her earliest and most remarkable portraits, fall into two groups. More than forty of them portray Sioux members of Buffalo Bill's Wild West Show; these are mostly studio portraits of Indian men but include some portraits of their wives and families and of life in Buffalo Bill's temporary Indian village in Brooklyn. The other group consists of at least nine photographs of the beautiful, accomplished young Sioux, Zitkala-Ša, a teacher, writer, violinist and later a crusader for Indian rights, who was also known as Gertrude Simmons Bonnin.

During the 1890s, Buffalo Bill's Wild West, a touring troupe of cowboys, Indians, sharpshooters and other performers, publicized its arrival in New York by marching through the streets to Madison Square Garden, where their show would dramatize

and glorify frontier life that had already become history. Buffalo Bill (William F. Cody), who had been a Pony Express rider, Army scout and buffalo hunter, had become a legendary subject of dime novels and melodramas, even before he turned showman. Seeing the parade from her studio in 1898, Käsebier was inspired to write to Buffalo Bill, asking his Indians to sit for her. Friends warned against it, saying that if she opened her doors to them once, the Indians would always feel welcome and would return without warning. "Let them come," was her blithe, hospitable reply, "I shall be glad to see them." From 1898 until about 1912, she intermittently played hostess to Indian friends, at home as well as at her studio.[20] Mina Turner said "it bothered her not at all that the neighbors stared from their windows and shook their heads over that crazy Käsebier woman" bringing home a band of colorfully costumed Indian men and women. Her grandson, Charles O'Malley, remembered his "consternation and fright," when, as a six-year-old, he set eyes on Indians in full regalia outside the Long Island home his parents shared with the Käsebiers. Unaware that these were his granny's friends, he feared they were coming to capture him. Adults had been only slightly less startled to find moccasin-footed Sioux padding about the halls of the Woman's Exchange, waiting for Käsebier to arrive at her studio.[21]

Käsebier seems to have had two concurrent if conflicting aims in photographing Indians from Buffalo Bill's troupe. On the one hand, as with other sitters, she wanted to capture individual personalities. On the other hand, she wanted to suggest an archetypal Indian.

The Red Man (11), her most famous single Indian photograph, distills her vision of Indians. As she told it, this photograph, whose subject remains unidentified, "was the last of a hundred." The Indians had visited her studio many times, yet, she said, "I never could get what I wanted. Finally, one of them, petulant, raised his blanket about his shoulders and stood before the camera. I snapped and had it."[22]

Unlike Edward Curtis, whose multi-volume study of American Indian culture has made his name seem almost synonymous with Indian photography, Käsebier was more interested in physiognomy and expression than customs and costumes. Curtis obliterated evidence of white culture and outfitted his subjects to make them look more "Indian"—sometimes even putting them in an alien tribe's garb.[23] Käsebier did the opposite, removing genuine ceremonial accessories to reach her idea of Indian authenticity.

"I want a real raw Indian for a change. . . . The kind I used to see when I was a child," she said, and she found him in Chief Iron Tail. He was the oldest and most famous of the Indians to visit her, having reputedly fought in the battle of Little Bighorn in 1876. Of the Indians who visited her, he best represented the "old Indian" who was almost untouched by white civilization. *Everybody's* called him "typical of the wild Indians . . . still part of the wild life, undegenerate, tall and straight like pine trees. In saying this, the article expressed a not uncommon nineteenth-century notion that Indians were "noble savages," wild but innocent children of the American landscape.[24] Käsebier's photographic session with him was described by an observer:

Quite at random she selected Iron Tail, and proceeded to divest him of his finery. Feathers and trinkets were removed, and amid a dead silence she placed him before the camera and secured the most remarkable portrait of the whole collection. He never said a word, but obeyed instructions like an automaton. In the wonderful face . . . it is perhaps not fanciful to read something of the misery which he was really undergoing. For the truth was

11.
The Red Man. 1902. Platinum and gum bichromate print from c. 1900 negative, 8⅛ × 6⅛". Courtesy, Christie's, New York

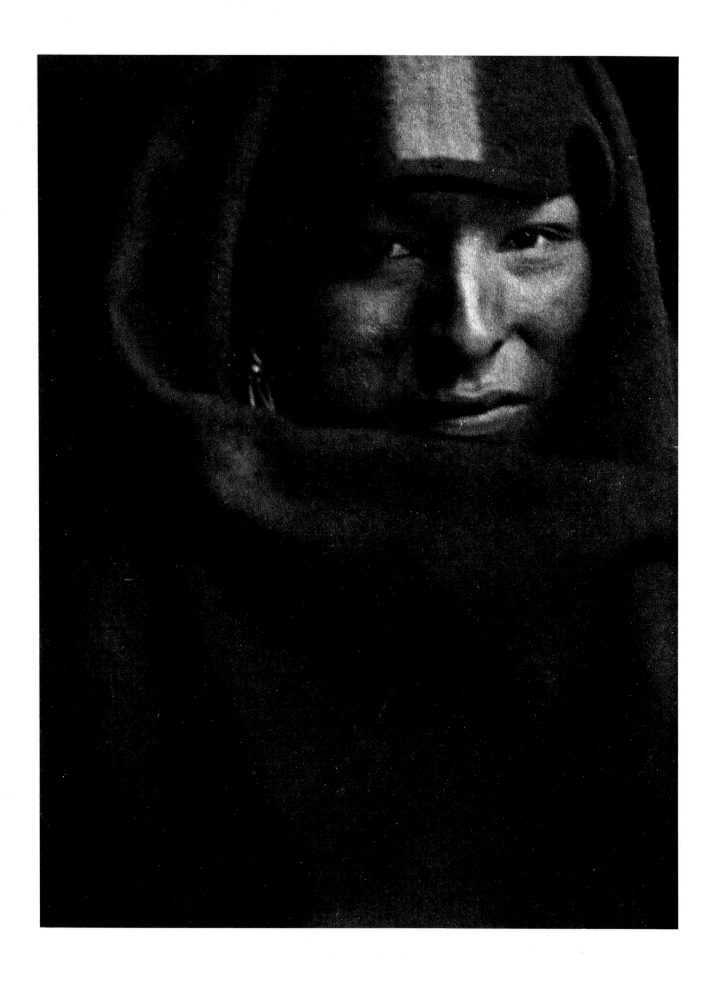

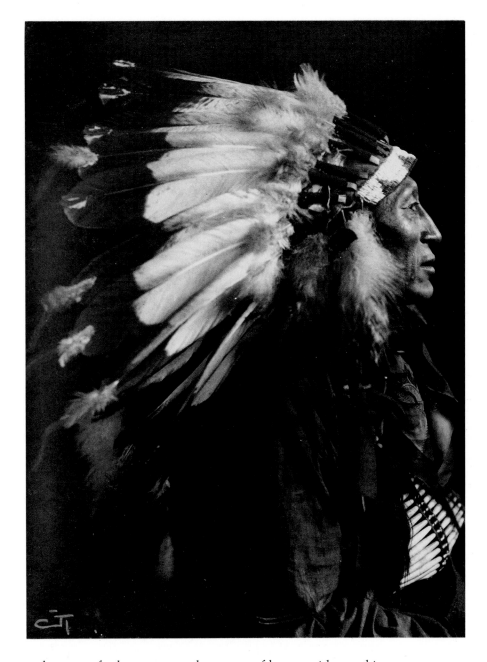

12.

Profile of Iron Tail with head-dress. [1898]. Platinum print, 7⅞ × 5⅞". Division of Photographic History, National Museum of American History, Smithsonian Institution, Washington, D.C.

that every feather represented some act of bravery either on his own part or that of his ancestors. . . . When the portrait was handed to him some days later, he tore it in two and flung it from him. Luckily, however, an explanation and a second sitting in full regalia entirely restored his peace of mind.[25]

Käsebier's depiction of Iron Tail without his headdress (13) shows her atypical attitude to Indians and to Iron Tail in particular. Writers liked to describe him in "full regalia." *The New York Times*, for instance, mentioned "his superb raiment of beads, feathers and paint."[26] The newsletter of the Carlisle Indian Industrial School, which taught young Indians English, mathematics, history, music and art as well as vocational skills such as baking and plumbing (14), bemoaned his native dress. It claimed that Iron Tail (who visited his son at the Carlisle School in Carlisle, Pennsylvania, when the Buffalo Bill show played nearby) "would in a minute adopt the civilized dress in its entirety if it paid him better to do so, than it does to wear the clothes in which he now adorns himself." The writer believed that Iron Tail could

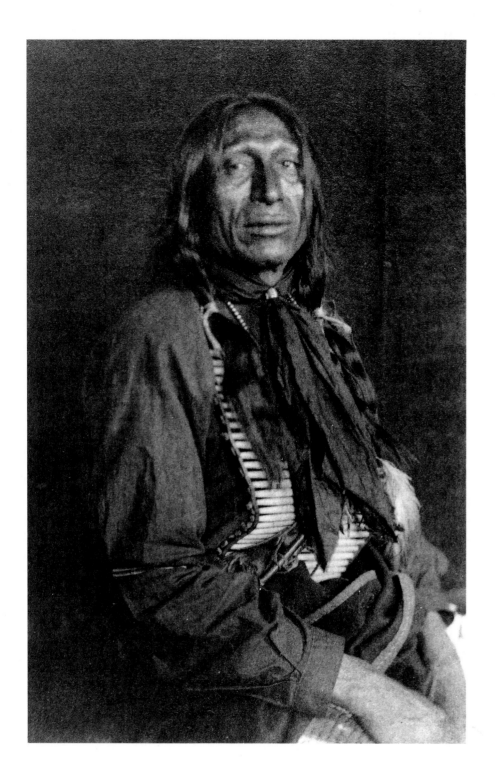

13.
Iron Tail. [1898]. Platinum print, 7⅜ × 4½". Division of Photographic History, National Museum of American History, Smithsonian Institution, Washington, D.C.

learn to speak, read and write some English and "become a useful citizen" if he were "properly encouraged." But, "Buffalo Bill pays him 20, 30 or possibly 50 dollars a month for several summer months, and all expenses, to remain Indian, to wear the scalp-lock, blanket, and all the glittering toggery in which it is possible for an Indian to bedeck himself."[27]

Like the newsletter, but for her own reasons, Käsebier wished to see Iron Tail minus his "glittering toggery." By removing distracting accessories—which to her were marks of a show Indian—she makes the viewer see the "raw" Indian's lank hair, glistening lined face, prominent bony structure, and almost quizzical expression. This individuality is lost in her otherwise magnificent iconic profile of him (12). Iron

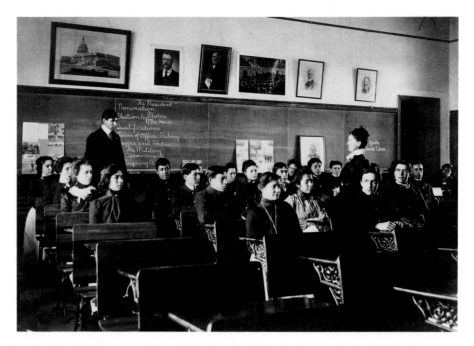

14.
Frances Benjamin Johnston.
Class at Carlisle Indian School.
[1901–1903]. Cyanotype,
7³⁄₁₆ × 9⁵⁄₁₆″. Library of Congress,
Washington, D.C.

Tail was to become one of the models for the profile Indian head on the Buffalo nickel (coined 1913–1938), but there is no evidence that Käsebier's photograph was used in its design. The sculptor J. E. Fraser made and amalgamated several Indian busts in preparing the nickel. Like Käsebier, Fraser found Iron Tail to be an exemplary model, declaring his "the best Indian Head I can remember."[28]

Perhaps it took Käsebier many sittings to typify Indians because she was inclined to see the Sioux, like her other sitters, as individuals. She treated Indians as friends, and their repeated visits bred a familiarity totally unlike customary cursory meetings between Indian subjects and their photographers.

Contemporary Western photographers of Indians, such as F. S. Rinehart in Omaha, Karl Moon in Grand Canyon, Arizona, and Edward Curtis in Seattle, as well as W. H. Jackson in Denver before them, prepared their photographs for commercial distribution. In 1900, for instance, Rinehart had his Indian photographs "on the market in thousands."[29] Käsebier's Indians were done more for pleasure than for financial gain. Except for *The Red Man* (which was difficult to print, and could not have been produced in quantity) Käsebier seldom sold copies of Indian photographs.[30] Although their publication as a group in *Everybody's Magazine* (1901), as well as occasionally in *Camera Notes* (April 1899), *Photographic Times* (May 1900) and elsewhere attracted attention, she did not care to cater to popular taste or preconceptions about Indians, as her Western contemporaries did. Nonetheless, she valued her Indian pictures highly, mounting them carefully on colored paper and lovingly titling and signing the mounts.[31]

She photographed her favorite Indians repeatedly, and a comparison of her pictures of Samuel Lone Bear (15, 17) with those of Joseph Black Fox (18, 19) shows how she distinguished between individuals. She made at least three portraits of Joe Black Fox and at least five of Samuel Lone Bear. Neither is a "typical" Indian; they are not stolid nor fierce and warlike. Nor are they fanciful and arbitrary, like Heyn and Matzen's vision of Sammy Lone Bear (16), which shows the extremes to which photographers would go in emphasizing the purported primitiveness of Indians. In their portrait of about 1900, Sammy Lone Bear is stiffly posed, naked to the waist, while his lower torso has been modestly girdled in fur. He resembles some imaginary caveman more than the Sioux that he is.

15.
Samuel Lone Bear. [1898–1901].
Modern print from original glass
plate negative, 6½ × 8″. Library of
Congress, Washington, D.C.

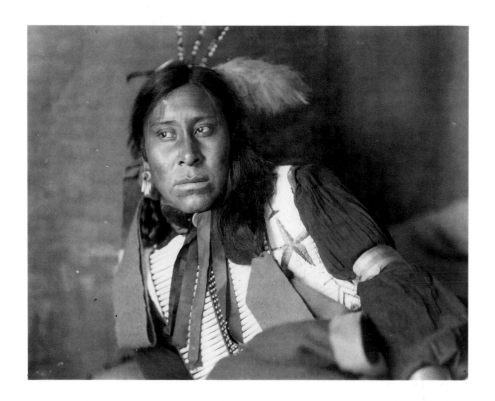

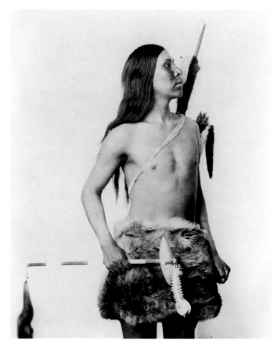

16.
Heyn and Matzen. *Samuel Lone Bear.* 1900.
Silver gelatine print, 9⅝ × 7¹¹⁄₁₆″.
Library of Congress, Washington, D.C.

17.
Samuel Lone Bear. [1898]. Platinum print, 7½ × 4⅞″.
Division of Photographic History, National Museum of
American History, Smithsonian Institution,
Washington, D.C.

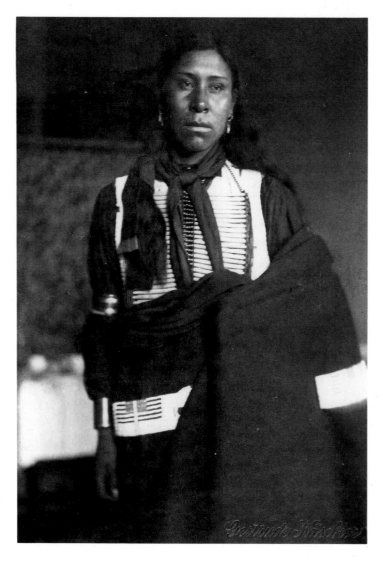

A *New York Times* reporter visiting Käsebier's studio saw Sammy Lone Bear primarily as a costumed figure in his "jacket of old rose velvet, a jacket set at intervals on the back with boars' teeth, with a breastplate of more teeth arranged in horizontal rows, a feather with tips matching the old rose and the bright purple and yellow, with a strip of porcupine quills hanging from the back of his head." Käsebier saw beyond the outfit and the show Indian to depict the plight of young Native Americans adrift between a life in Buffalo Bill's Wild West and life on a barren reservation. Emblems of Sammy Lone Bear's cross-cultural conflict can be seen in the American flag motifs on his beaded blanket (17). His letters to Käsebier, sometimes in broken English and sometimes in Sioux, also reveal his cultural ambivalence. Today, his comment, "I have good time when fourth of July," seems ironic and poignant.[32]

At twenty when he met Käsebier in 1898, Sammy Lone Bear was among the most educated and Americanized of Buffalo Bill's troupe, and had visited Europe with them. He was a favorite of Käsebier's; for some years he was a devoted correspondent, combining a charmingly imperfect literacy with a letter-writing disposition. Mina Turner remembers that after seeing a Buffalo Bill performance in about 1911, her granny entrusted her to Sammy Lone Bear, who "lifted me up on the horse and with his great strong arm squashing my middle, rode around the deserted ring. I was too terrified and surprised to cry out, but I caught reassuring glimpses of Granny waving and smiling as I whizzed by."[33]

In Käsebier's photographs, Sammy Lone Bear's pensive melancholy gaze and downcast head engage our attention because he is so unlike stereotypical Indians. In one photograph (15), we see him reclining, the antithesis of his father, Chief Lone Bear, whom Käsebier depicted sitting upright, in a full headdress, holding a bow and arrow: a profile of an old-time Indian. The reclining pose is one that Käsebier otherwise reserved for friendly creative colleagues like Edward Steichen, Adolf de Meyer and Robert Demachy, and perhaps she thought of Sammy in the same vein.

Chief Joe Black Fox was another Käsebier favorite, but one about whom less is known.[34] Apparently young and educated enough to sign his name in script, he, too, is shown pivoting between cultures, smoking a cigarette, and atypically for photographs of the Sioux, almost smiling (18). Unlike Sammy Lone Bear, he never lets his guard down. His mischievous, canny expression, which Käsebier caught several times, must have charmed her, and she saved several of his drawings.

Käsebier photographed Indian children, but only after several years' acquaintance with the Sioux, whose superstitions held that making a portrait of a child would kill it. In fact, bad luck struck after she photographed Mary Lone Bear, Sammy's sister; the little girl suddenly died six weeks after her photograph was made.[35]

But her portrait of Willie Spotted Horse is perhaps her consummate photograph of a Native American. Käsebier's talent for putting children at ease carries through in this picture of a small boy dwarfed by his headdress (20). Sorrowful, static and self-contained, he is the antithesis of Käsebier's typical child subjects who delight in exploring a receptive world. Unlike the boy in *The Road to Rome* (66), who appears to have the world before him, Willie Spotted Horse seems overwhelmed by the emblem of his heritage—a crown of feathers.

Käsebier's colleague, Joseph Keiley, who also appreciated Native American culture, photographed some of the same Sioux as she did. His impersonal attitude towards them is shown in generalized titles like *A Sioux Chief* and *Indian Head*. His photographs are softer in focus and more painterly than Käsebier's. They are taken closer to the subject than most of hers and show less interest in Indian costume, but at the same time they are not psychologically individualized portraits. Although

18.
Joe Black Fox. [1898–1901].
Platinum print, 7¾ × 5⅞". Division of Photographic History, National Museum of American History, Smithsonian Institution, Washington, D.C.

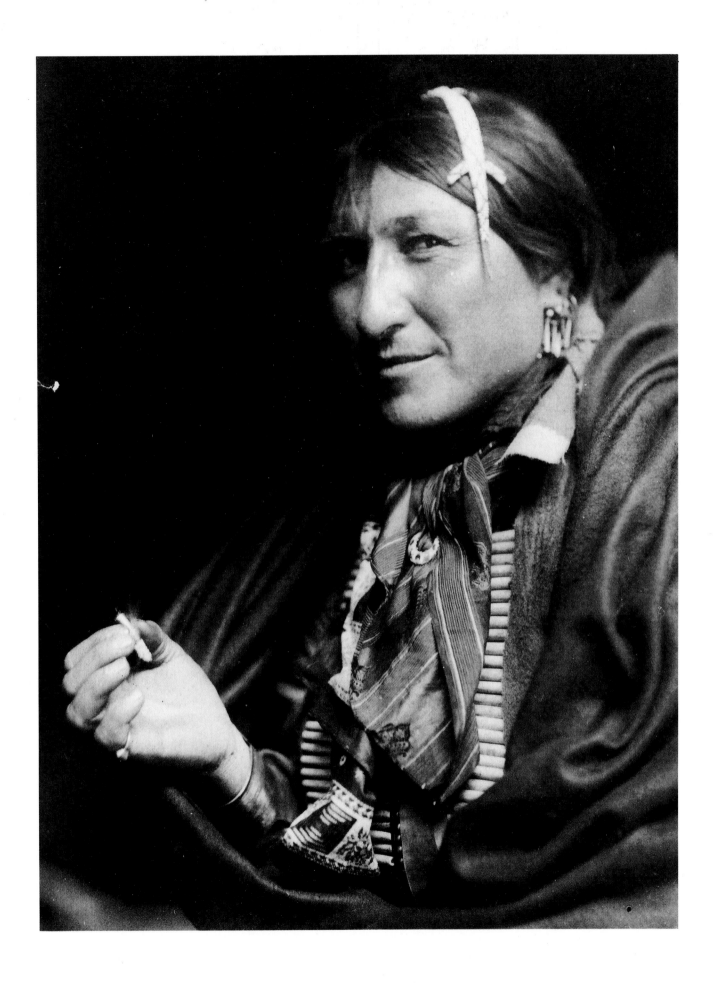

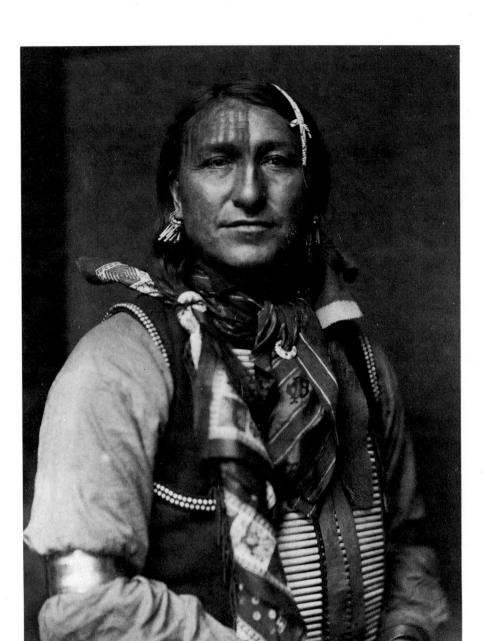

19.
American Indian Portrait (Joe Black Fox). [1898–1901]. Platinum print, 8 × 6″. Collection, The Museum of Modern Art, New York.
Gift of Miss Mina Turner

Käsebier had been the instigator in photographing Buffalo Bill's Indians in 1898, she seldom showed or published those pictures until 1900. Keiley's had been exhibited from 1898 on, so that when Käsebier's *Red Man* was first shown in 1900, a colleague expressed concern that her picture would be considered an imitation of Keiley.[36] There was no need to worry. Today, at least, we can see *The Red Man* as a tougher, more formal image than any of Keiley's Indian heads.

Käsebier's work has always stood on its own. Although the critic Sadakichi Hartmann recognized that Curtis was "*the* photographer of Indians, and will live as such," he called her Indian photographs "way ahead artistically." Curtis photographed under entirely different conditions from hers, working in the field for months at a time. Portraits were made in a photographic tent or more often outdoors "in the soft light of the morning or the intense glare of the mid-day sun."[37] Curtis emphasized his subjects' connection to nature, whereas Käsebier revealed the disparity between the traditionally costumed figures and contemporary life—as for instance in her photograph of Indians drawing in front of her studio window, with skyscrapers showing in the distance (21).

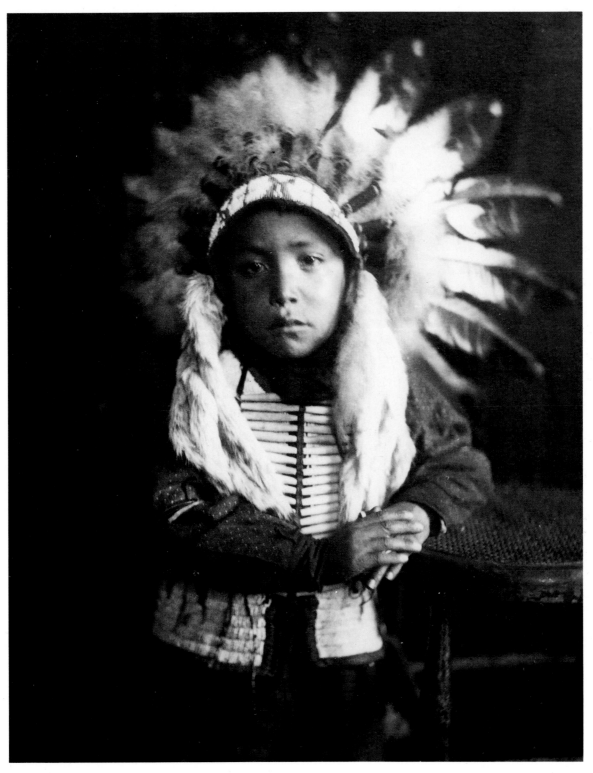

20.
Willie Spotted Horse. c. 1901. Platinum print, 8¼ × 6¼″.
Division of Photographic History, National Museum of
American History, Smithsonian Institution, Washington,
D.C.

Other comparable contemporary photographers of Indians include Rinehart, who also printed photographs of the Sioux (among others) in platinum but nullified any artistic effect by putting homely inscriptions of title, date, negative number and his name across the bottom of each picture. Moreover, his subjects tend to be sharply focused, evenly lit, and centered against old-fashioned studio backdrops. Karl Moon, on the other hand, made some simple, close-up studies of heads against dark backgrounds, like Käsebier's, but he worked only in the Southwest. Despite a purported ethnologic interest, titles like *American Arab* and *An Indian Samson* betray a lack of real concern with Native Americans, either individually or culturally.[38]

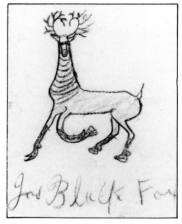

Samuel Lone Bear. *Catch Girls.* c. 1899. Drawing, 4⅜ × 7". Joe Black Fox. Untitled. c. 1899. Drawing, 7 × 4½". Division of Photographic History, National Museum of American History, Smithsonian Institution, Washington, D.C.

21.
Indians Drawing in Käsebier's Studio. c. 1900. Platinum print, 6⅞ × 6". Collection, The Museum of Modern Art, New York. Gift of Miss Mina Turner

22.
Opposite:
Zitkala-Ša. [1898]. Platinum print, 6³⁄₁₆ × 4½". Division of Photographic History, National Museum of American History, Smithsonian Institution, Washington, D.C.

Although Adam Clark Vroman also photographed only in the Southwest, this amateur photographer's personal approach to portraiture was akin to Käsebier's. Vroman returned to some sites for several years, so that "the Indians became his friends. He never forgot to bring them the promised prints, and they looked forward to his return year after year."[39] If the psychological intensity of his close-up platinotype portraits is reminiscent of Käsebier, the style is different; his likenesses tend to be taken frontally, outdoors against light backgrounds that reveal the sun's intensity. Vroman's portraits, however, must be seen as part of his field study (1895–1904) of the lives, homes, crafts and ceremonies of his Hopi and Zuni subjects.

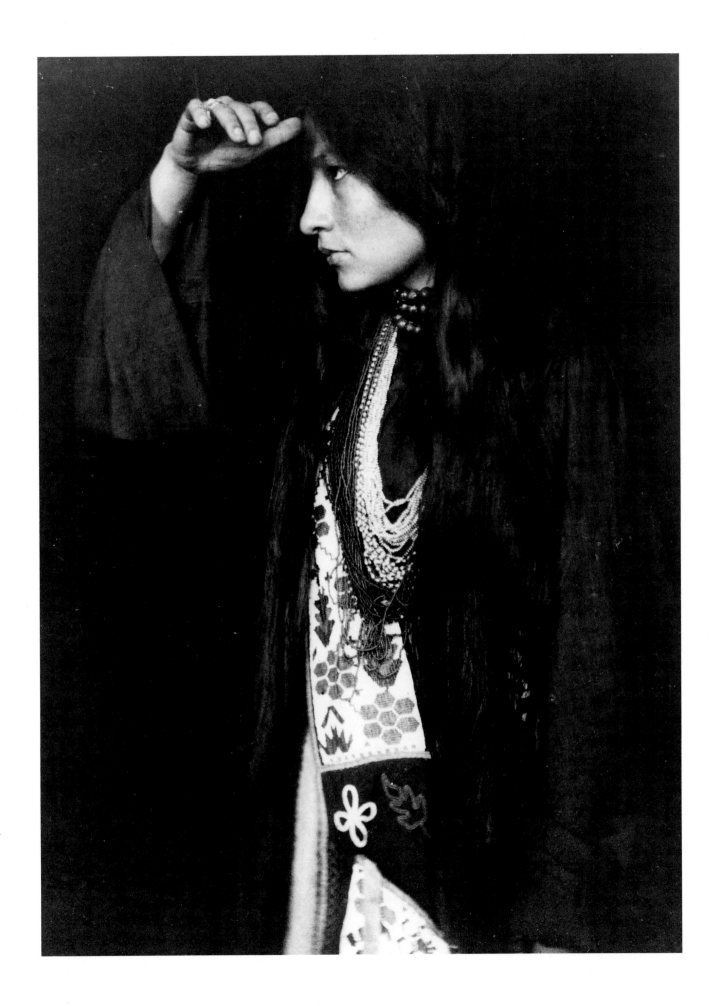

Käsebier's Indian photographs are outnumbered by those of the best-known western photographers of her day, but they are not surpassed by them. Käsebier's are an engrossingly diverse group of empathetic portraits that remain all the more remarkable because they were made so far from the western plains. Of the thousands of people throughout the United States and Europe who watched Buffalo Bill's Indians, it seems that, at least among photographers, only Käsebier had the imagination to see behind the feathers and fake war dances and to offer them hospitality and a chance to be known as the proud, displaced individuals that they were.

Of the many Sioux she photographed, Käsebier knew none better than Zitkala-Ša, the cultured young woman who spent several years in Boston about 1900, becoming celebrated for her musical and literary accomplishments. Later, she was known as a crusader for Indian rights. In 1900, *Harper's Bazaar* described and pictured her among "Persons Who Interest Us," who included Siegfried Wagner, the composer and son of Richard Wagner, and Mrs. Potter Palmer, the Chicago social and cultural leader who had been in charge of the Woman's Building at the Columbian Exposition.[40]

Although she was not well-known when she sat for Käsebier and Keiley in 1898, Zitkala-Ša soon became one of Käsebier's most famous subjects (one who, like Käsebier herself, is now listed in *Notable American Women*). How they met is undocumented; presumably, Zitkala-Ša came to New York (from the Carlisle Indian School where she taught) to see Indian friends or pupils in Buffalo Bill's Wild West. Käsebier not only enjoyed photographing her, but considered her a friend, as did Frederick Käsebier, who was about Zitkala-Ša's age, and who corresponded with her for a while. Käsebier also transcribed and saved Zitkala-Ša's tales of "How the Indians Came on Earth," and "Why the Indians Have Red Stripes on Their Faces When Going to War."[41]

Zitkala-Ša, whose childhood was spent on an Indian reservation, had already distinguished herself by 1898. While a student at Earlham College in Indiana, she won a statewide intercollegiate oratorical contest. A talented pianist and violinist as well, she was in charge of the Carlisle School Indian Band. During 1899 and 1900, she studied violin on scholarship in Boston, where (probably thanks to an introduction from Käsebier) the photographer and publisher F. Holland Day, and his acquaintances, befriended her. Evidently they encouraged her to write her memoirs, which the *Atlantic Monthly* published in installments during 1900 and 1902.[42]

During 1900, Zitkala-Ša was also lauded for concert appearances and for a recitation of Longfellow's "Hiawatha" while she was raising money for the Carlisle Band's projected trip to the Paris World's Fair—a trip that was eventually canceled for lack of funds. Zitkala-Ša, who had always felt a clash between her eastern education and her Indian heritage, returned west in 1901 and lost contact with Käsebier and her colleagues.[43]

Gertrude Käsebier's portraits reflect the cultural duality that Zitkala-Ša reveals in her articles and letters. This duality is symbolized even by her two names: Zitkala-Ša (or Red Bird) as a Sioux; Gertrude E. Simmons (and later, married, Gertrude Simmons Bonnin) in official or legal matters. As Zitkala-Ša, she performed, she published, and she signed letters to F. Holland Day. To the Bureau of Indian Affairs, and sometimes even to friends, she was Miss Simmons.[44]

Just as she had two ethnically different names, Käsebier's photographs portray her in two ways: as an Indian and as a serious young Americanized woman. Two profile photographs show her adorned with beads, in Sioux costume. One, a simple profile

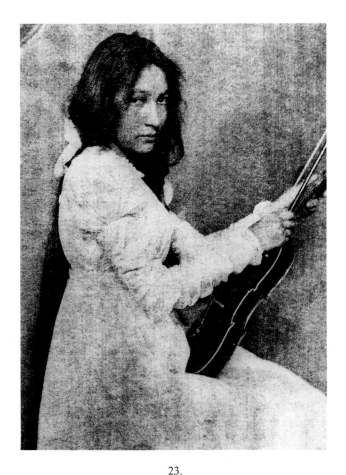

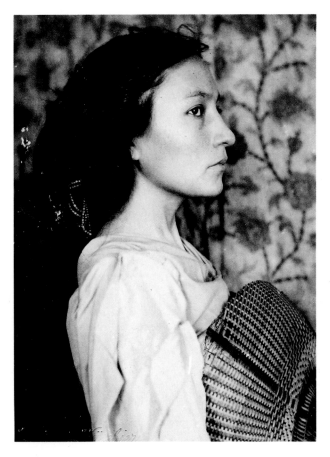

23.
Zitkala-Ša. [1898]. Platinum print, 7¾ × 5⅜″. Division of Photographic History, National Museum of American History, Smithsonian Institution, Washington, D.C.

24.
Zitkala-Ša. [1898]. Platinum print, 6½ × 4⅞″. Division of Photographic History, National Museum of American History, Smithsonian Institution, Washington, D.C.

that once belonged to Joseph Keiley, is distinguished by glowing printing and affectionate presentation: the mounted platinum print fits in a yellow paper folder autographed by Käsebier and Gertrude E. Simmons, as well as Keiley, Käsebier's friend, the illustrator Frances Delehanty, and others. The folder is fastened by a narrow blue ribbon, adorned by small black feathers.[45]

In the second (22), Zitkala-Ša shades her eyes, as if shielding off glare on the open plains she loved. Western childhoods were a bond between the two women. Just as Käsebier recalled her youth in Colorado, where "the vast altitudes and spaces . . . appealed to me in an unforgettable way," Zitkala-Ša, in Boston, wrote: "Oh—for space enough for a good breath of pure inspiration! . . . I love to see the banks of snow. It recalls days of my childhood which were spent in the Dakota prairie."[46] In light of this, Zitkala-Ša's gesture becomes more than a conventional Indian pose, but an expression of yearning for the West with which Käsebier empathized.

In seven other pictures, Zitkala-Ša is not recognizably Indian; she wears a pale dress and holds a violin or a book. Without knowing anything about Zitkala-Ša, one might mistakenly class these photographs with Clarence H. White's white-gowned ladies (47), or James McNeill Whistler's, or Thomas Dewing's.[47] But Zitkala-Ša's props are not generic symbols of art and culture; they are personal references to her career as a violinist and to her literary leanings (23).

The most poignant and personal of Käsebier's photographs (24) refers to the psychological and cultural conflict between Zitkala-Ša's refined East Coast life and

the harsh poverty she left behind in South Dakota where her mother and brother lived at the Pine Ridge Agency, an Indian reservation. That picture—a profile like the two in Indian costume—shows her in contemporary dress. But she clutches an Indian basket to her breast, suggesting that despite the veneer of modern clothing, she cherishes her Indian heritage.

If Käsebier's studio portraits of Zitkala-Ša seem restrained and subtle compared to pictures she might have made had she documented the plight of Indians on reservations, their acuteness is revealed by contrasting them to Keiley's. Although four of his photographs show Zitkala-Ša in the same Indian outfit as Käsebier's, his pictures are moodier, softer in focus and more manipulated. Most show only her head and shoulders: no hands, no props. Her eyes are dreamy, unfocused (25).[48]

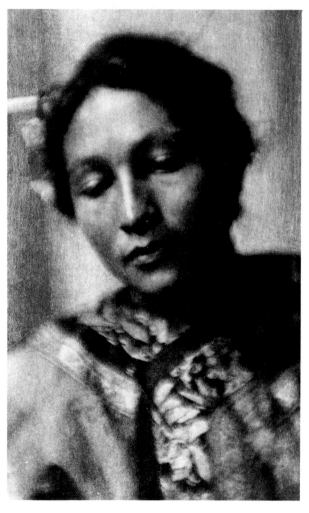

25.
Joseph T. Keiley. *Zitkala-Ša.* 1898. Glycerine developed platinum, 7⁷⁄₁₆ × 4⁷⁄₁₆". The Metropolitan Museum of Art, New York. Gift of Alfred Stieglitz, 1933 (33.43.146)

As with his portraits of Indian men, Keiley tended to give symbolic or generalized titles to those of Zitkala-Ša, so that she is seen as a type, rather than an individual. His triptych of her portraits is *An American;* one of these portraits alone was alternately titled *Indian Girl* or *Sioux Indian Girl,* while a variant was named *Zitkala.* Keiley's profile of her (published in Charles Caffin's *Photography as a Fine Art*) was called *An Indian Madonna* for no discernible reason. Moreover, his four photographs of her in Chinese dress (*Asia* and a triptych titled *Chinese Studies*) indicate that he perceived her as an exotic to be costumed at will.[49] On the other hand Käsebier's portraits of Zitkala-Ša—like the portraits she was to take of other talented women—were governed by her knowledge of her subject's abilities, personality and background.

Käsebier's studio at the Woman's Exchange was a block away from the New York Camera Club, where Alfred Stieglitz's presence as a photographic tastemaker loomed increasingly large. In 1898, a year shy of thirty-five, he was already internationally famous for his own original photographs, and, as editor of the Camera Club's journal, *Camera Notes*, he set demanding artistic standards of photographic excellence. Käsebier introduced herself to Stieglitz early in June of that year, probably while encountering him near the Camera Club. Later, she accounted for her forwardness and cemented their acquaintance with this letter:

12 Thirtieth Street, East

Dear Mr. Stieglitz

I feel it due to myself to explain why I ran you down. I am a photographer in distress. I have some out of door work to do on the eighteenth, which is of serious importance to me. I am not at all familiar with snapshots out-of-doors and I felt sure you could and would give me some valuable suggestions. Of course, I shall be delighted, if you will call upon me at my studio, and have long wished that chance—not my necessity—would enable me to meet you personally. I have known you through your work for a long time.

Very sincerely

Gertrude Käsebier[1]

Could Gertrude Käsebier, whose scenes of Crécy-en-Brie had been published, have so desperately needed advice about outdoor snapshots? Did playing helpless seem, even to this ordinarily bold woman, the most tactful or promising way to make Stieglitz's acquaintance? Or did she truly need assistance from the acknowledged expert on using a hand camera, whatever the light or weather, for serious outdoor photography?[2] (26).

Whether or not she dissembled at their first encounter, Käsebier and Stieglitz were soon good friends and strong advocates of each other's work, united by a belief that photography could be an art equal to any other. In 1899, Käsebier joined the Camera Club of New York, where Stieglitz had organized a solo exhibition of her photographs in February.[3] At the Club (where she could attend photography exhibitions and slide lectures, read the latest photo books and magazines, or talk shop with other photographers) she soon became part of Stieglitz's aesthetic coterie.

Stieglitz was not the first photographer to conceive of photography as an art, but he was surely its staunchest and most enduring supporter. From the 1880s until his death in 1946, Stieglitz advocated photography as a medium of personal expression; the concept was flexible enough to allow vast changes over the years in subject and style.

A movement for pictorial photography, "whose aim and end is to give aesthetic pleasure"[4] (as opposed to scientific photography, whose goal is to increase knowledge) arose while Stieglitz was studying and photographing in Europe during the 1880s. In England, Peter Henry Emerson, an American-born amateur landscape

photographer who had trained as a physician, sought to separate himself from old-fashioned anecdotal "art photographers" like Henry Peach Robinson. He adapted physicist Hermann von Helmholtz's theory of vision and propounded the idea that artistry in photography involved careful selection and the suppression of excessive detail (though not the exceedingly soft-focus photography that many photographers later adopted).

Although Emerson soon retracted his contention that photography could be art (he came to think that a photographer did not have as great control over photographic tones as he had first believed), his book, *Naturalistic Photography*, went through several editions from 1889 to 1899. Emerson's ideas took root and spread through England, Europe and, owing largely to Stieglitz, the United States.

26.
Alfred Stieglitz. *Winter—Fifth Avenue*. 1893. Photogravure from *Camera Work*. Library of Congress, Washington, D.C.

Emerson's followers separated themselves from non-pictorialists, in part by emphasizing the artistic quality of the fine photographic print. Instead of commercially prepared paper with glossy albumen or gelatine emulsion, matte drawing papers became the preferred base for hand-coated emulsions. The platinum print (also known as platinotype) was prized for its ability to render subtle gradations of tones from the darkest gray to the lightest. Gum printing introduced texture and sometimes color; these prints could resemble charcoal, pastel, or paint. Photogravure (or photo-etching) was admired for the fidelity with which it could reproduce a photograph in printer's ink.

Along with the concept of photography as a means of personal expression went the pictorial photographer's self-conscious stance as an artist—and the establishment of exhibitions, or salons, at which pictorial photographs were exhibited. Like the Pictorial movement itself, the Salon movement was inaugurated in Europe, then spread by way of camera clubs to the United States.

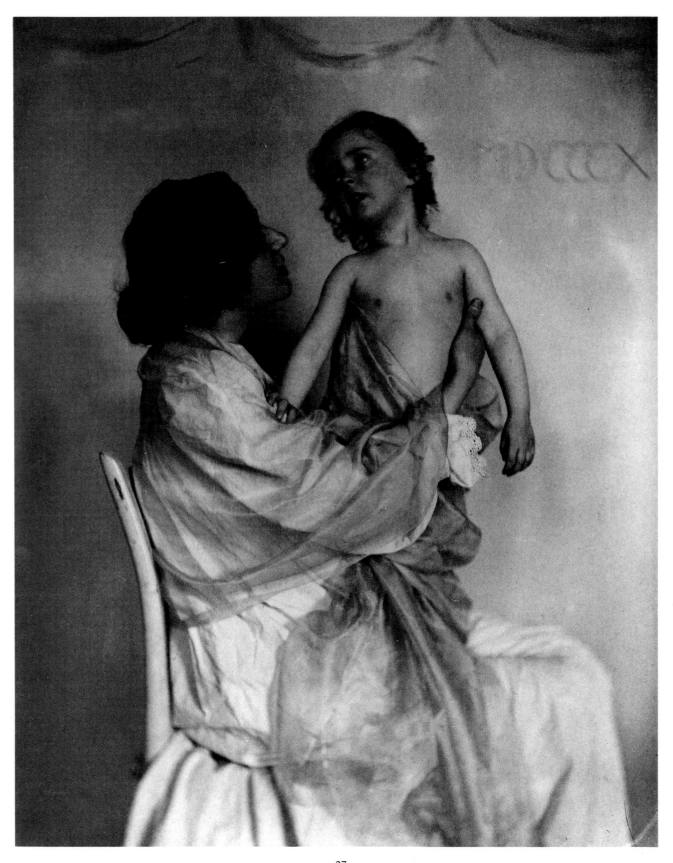

27.
Mother and Child (alternately titled *Adoration* and *The Vision*). 1897. Brown platinum print, 7⅝ × 6″. International Museum of Photography at George Eastman House, Rochester, N.Y. Gift of Mrs. Hermine M. Turner

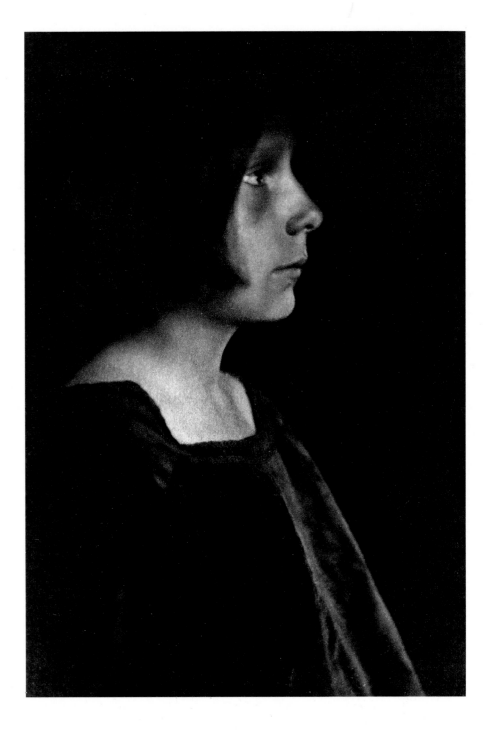

28.
Flora (alternately titled *Portrait Study, The Velvet Mantle,* and *Florentine Boy*). c. 1897. Platinum print, 6×4". Library of Congress, Washington, D.C.

No photography exhibition in the United States had shown such consistently excellent work as the first Philadelphia Photographic Salon in 1898.[5] It was the major photographic event of that year for the world of artistic photography in the United States and for Gertrude Käsebier herself.

What set this apart from earlier American photography exhibitions was the decision of its sponsors, the Photographic Society of Philadelphia and the Pennsylvania Academy of the Fine Arts, to run it along the lines of recent European art and photography exhibitions, and thus to treat photography as a fine art. Traditionally, American photography exhibitions had accepted all entries, categorized them (as landscapes, portraits, technical inventions, etc.) and awarded prizes to those that the judges deemed best. At the Philadelphia Salon, acceptance was the sole award. A jury

of painters and photographers, including Stieglitz, picked "only such pictures produced by photography as may give distinctive evidence of individual artistic feeling and execution." Standards were so stringent (259 entries were chosen from more than 1200) that one magazine wryly observed "the great numbers of pictures submitted were thinned out like a file of soldiers facing a machine gun . . . what is left ought to be worth seeing."[6]

Käsebier's photographs came through with flying colors. Ten—the most allowed an exhibitor—were shown, putting her on a numerical par with Stieglitz. One of the judges, William Merritt Chase, who was among America's most distinguished painters, called Käsebier's work "as fine as anything that VanDyck has ever done." Keiley recalled Käsebier's one-year ascent from unknown to "first and unrivaled in the entire professional world," Charles H. Caffin, the English-born art critic who was to extol and later deride Käsebier's work, was pleased by the "individuality . . . the force and distinctiveness of her style."[7] Käsebiers at the 1898 Salon for which prints can now be identified, including *Mother and Child* or *Adoration* (27), *Portrait of a Boy* (10), and the dense, velvety *Study* (28), demonstrate the spareness of her early work, as well as her preference for profile portraits and for extremes of light and dark.

Large exhibitions like the Salon allowed photographic colleagues to meet and see each other's work. In Philadelphia Käsebier struck up a friendship with the aesthetic photographer, F. Holland Day. They got together again in April 1899 when fifteen of her portraits were shown at the Arts and Crafts Exhibition in Boston, his hometown.[8] Day introduced her to Francis Watts Lee, a printer in the William Morris tradition, whose photographs were on view at the same exhibition, and his wife, Agnes Rand Lee, the poet and author of children's books. On a visit to their home, Mrs. Käsebier photographed Mrs. Lee and her daughter, Peggy; the picture was to become Käsebier's best-known photograph: *Blessed Art Thou Among Women* (29).

On the most obvious plane, *Blessed Art Thou Among Women* is a generic picture of loving motherhood. Formally it is a well-composed arrangement of shapes and white tones against a light background. But it is also a biographical portrait of Agnes Lee, whose work included poems about motherhood and a children's book, *The Round Rabbit*, which is reminiscent of Robert Louis Stevenson's *A Child's Garden of Verses* in showing the author's ability to enter the world of childhood.

The conventional way to portray an author would be to show her writing or displaying some of her books. But Käsebier's photographs of Mrs. Lee refer not to her profession so much as to her personal life, her personality, and the content of her poems. In the early part of this century, viewers would immediately have been struck by this picture's sympathies to the Aesthetic and Arts and Crafts movements. For instance, Agnes Lee's unfitted, freeflowing gown indicates her interest in clothing reform. The elongated cropping of *Blessed Art Thou*, as well as its pale tonalities, were obvious reminders of Whistlerian portraits, which were much admired by aesthetically minded people like the Lees.

The print of the Annunciation behind the mother and daughter not only echoes their forms. Acquaintances would have seen it as emblematic of Agnes Lee's husband, Francis Watts Lee, the amateur photographer who was devoted to Christianity as well to the aesthetics of William Morris and the Arts and Crafts movement. The print of the Annunciation, circumscribed by the Biblical quotation, "And the angel came in unto her, and said, Hail thou that art highly favoured, the Lord is with thee: blessed art thou among women," was created by the English Arts and Crafts artist,

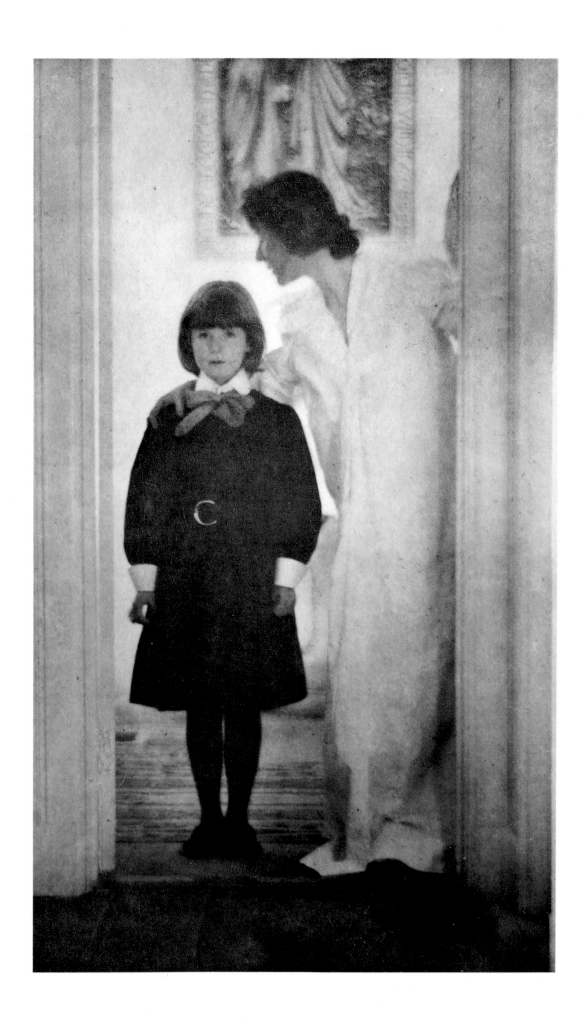

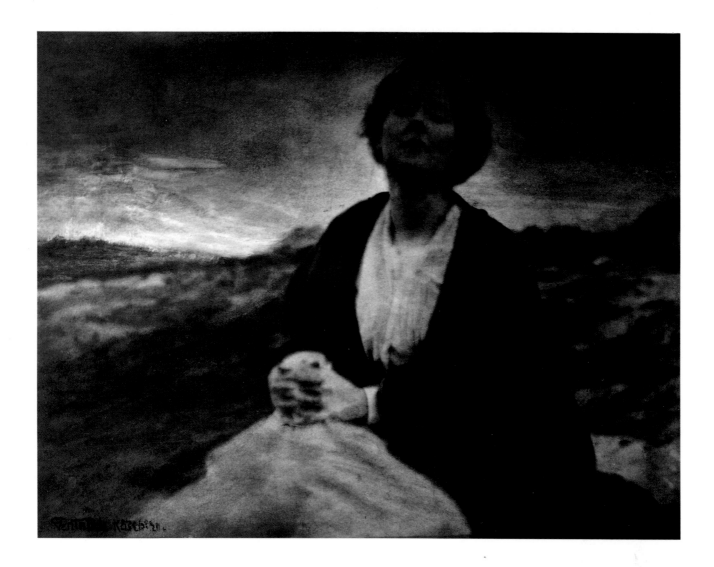

30.
The Heritage of Motherhood.
[1904]. Gum bichromate on plati-
num, 9¼ × 12⁷⁄₁₆″. Collection, The
Museum of Modern Art, New
York. Gift of Mrs. Hermine M.
Turner

29.
Opposite:
Blessed Art Thou Among Women.
[1899]. Platinum print on Japanese
tissue, 9⅜ × 5½″. Collection, The
Museum of Modern Art, New
York. Gift of Mrs. Hermine M.
Turner

Selwyn Image. Like Lee, Image was a devoutly religious artist.[9] Image's prints, and
especially his participation in the English publication *The Hobby Horse* (for which
he designed the first cover) impressed Lee, who was employed as a printer at the
Boston Public Library. Along with other aesthetically inclined Bostonians, Lee had
been involved in publishing *The Knight Errant,* a short-lived quarterly modeled after
The Hobby Horse.

Shortly after *Blessed Art Thou Among Women* was taken, tragedy struck. Peggy
Lee, who appeared in the photograph, died, and the same illness permanently
deafened her sister. As if that were not enough, Mr. Lee came to believe that the
disaster was a curse visited upon him for not having become a clergyman. The Lees'
marriage ties strained and ultimately snapped. In the summer of 1904, at perhaps
the point of utmost tension, Käsebier made her determinedly poignant picture of
motherly sorrow, *The Heritage of Motherhood* (30).[10]

This picture shows Agnes Lee seated alone in a barren landscape, at water's edge.
Everything about her pose and expression—closed eyes, upraised head and clenched
hands—indicates that this is a picture of mourning and meditation. Like *Blessed Art
Thou Among Women, The Heritage of Motherhood* works on several levels. Most
obviously, her demeanor and her timeless dark cloak suggest a contemporary
Lamentation scene. Käsebier emphasized the religious aspect of the picture in one
print by drawing three crucifixes in the background to the left of Mrs. Lee. She may

have been alluding in part to Agnes Lee's religious devotion, to ideas that Lee was expressing in poems like "Motherhood," which concerns sorrow for "a child beloved and lost" and dramatizes enduring, unqualified maternal love by comparing the Virgin Mary's love for Jesus with Judas Iscariot's mother's love for her son.[11]

By omitting the crosses in other copies, Käsebier achieved a subtler yet more intense result, a picture that recalls the Romantic and Symbolist tradition of showing a solitary contemplative person alone in an uninhabited landscape, in paintings ranging from Caspar David Friedrich's to those of her friend, the American painter Arthur B. Davies. In 1916, she even cropped much of the landscape, turning the picture into a more expressionistic psychological portrait.[12]

It is said that when Käsebier took *The Heritage of Motherhood*, Agnes Lee was so absorbed in her thoughts that she was unaware of being photographed. Käsebier was not given to posing a person to fulfill a preconceived idea but kept a theme in mind and chose a photographic situation to fulfill it. The concept of *The Heritage of Motherhood* preceded its creation by some fifteen years, not long after Käsebier entered Pratt and only a few years after she herself confronted tragedy when her pre-adolescent son was temporarily blinded. After one physician called the situation hopeless, another performed an operation to cure the cataract-like problem, though slits in her son's eyes replaced his normally round pupils.[13]

Käsebier had long been aware that grief from children's sickness and death was an inevitable part of nineteenth-century motherhood. When she was a girl out west, an infant sibling had died accidentally. While her mother was carrying the baby on horseback her horse bucked, threw the baby from her arms and trampled it before she could dismount.[14] By the time Käsebier made *The Heritage of Motherhood*, she knew the heartache that the loss of an adult child could cause—her mother never gave up hope that Charles would somehow turn up safe after his Mexican adventure. Thus, with the help of an evocative title, Käsebier turned Agnes Lee's solitary mourning into a universal statement of the trials and sorrows of motherhood.

For all her awareness of life's misfortunes, Käsebier was not a gloomy person. When there was cause for happiness, she did not hold back. Returning to New York after her visit to Boston, she gloated to Day in April 1899: "I have been desperately busy and am still. Mr. Käsebier says if I do not stop working so hard he will put his foot down. But to work is such a joy."

She boasted of photographing Louis Comfort Tiffany's five children, saying that "the result as well as orders received are record breakers"[15] (33). Tiffany was at the height of his career creating stained-glass windows and floral-shaped glass objects from the iridescent Favrile glass that he had invented. His name stood for innovation and Aestheticism as much as his father's firm, Tiffany and Company, stood for quality in jewelry. Käsebier had reason to be proud.

Stieglitz used his position as editor of *Camera Notes* to draw attention to her work. He reproduced five of her prints in the April 1899 issue, including a full-page rendition of *Mother and Child* (51), and brought critical acclaim to a peak in July by proclaiming Käsebier "beyond dispute the leading portrait photographer in this country."[16] He sparked controversy by pitting laudatory articles by Arthur W. Dow and Keiley against a negative one by Sadakichi Hartmann.

Reflecting on the artfulness of her work, Dow even mused "whether such portraits as Mrs. Käsebier's are likenesses," then decided "unhesitatingly that they are" because they "often reveal traits and expressions that we had not noticed before."

31.
The Manger. 1899. Platinum print on Japanese vellum, 12¾ × 9½". Collection, The Museum of Modern Art, New York. Gift of Mrs. Hermine M. Turner

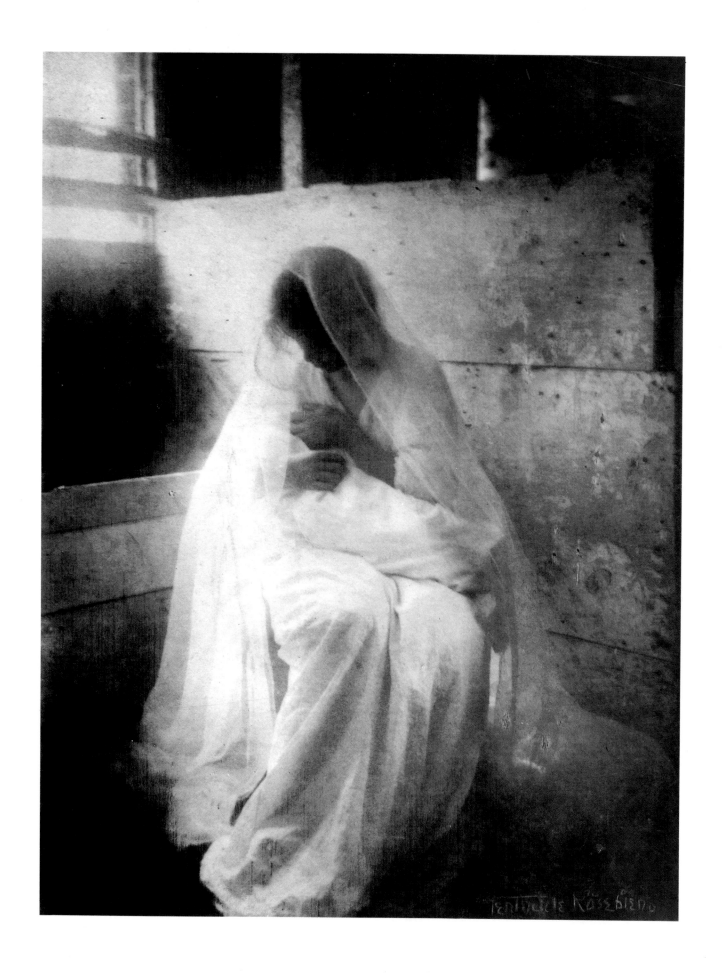

LORETTE WILMOT LIBRARY
NAZARETH COLLEGE

53

Keiley praised Käsebier's February Camera Club exhibition, noting that "of the hundred and some odd pictures shown, over eighty were of men, women and children, attired in the conventional costume of the day." He felt that "the manner in which this modern dress was handled, subordinated, and made to play its proper part in the composition" revealed her artistic feeling. On the other hand, Hartmann censured Käsebier for imitating, rather than adapting, the old masters, and for failing to master modern garb. As far as he was concerned, she was "unable to make a satisfactory likeness . . . without a slouch hat, or a big all-hiding mantle. . . . a shawl or a piece of drapery."[17] The articles in *Camera Notes* represent prevailing judgments of Käsebier in 1899. Although a few found her work artificial and derivative, the artistry of her work was widely acclaimed, and her sensitivity to personality and composition were generally applauded.

Like other commercial portraitists of her day, Gertrude Käsebier closed her New York studio during the summer lull and followed wealthy clients and prospects to fashionable Newport, Rhode Island. By renting a "cottage" called Long Meadow in Middletown, just adjacent to Newport, Käsebier mixed business with pleasure during the summer of 1899. In letters brimming with respect and admiration, she kept in touch with Stieglitz. She admired the photogravures in *Camera Notes*, thanked him for his praise of her work (acknowledging that a few words from Stieglitz meant more than pages by a lesser light), and dismissed Hartmann as absurd.[18]

Entreaties did not entice Stieglitz to visit her in Newport, but there were visits from Boston friends, including F. Holland Day, Agnes Lee and Zitkala-Sa. Käsebier's daughters, her mother, her former Pratt teacher Ida Haskell, and artist friends Frances Delehanty and Adèle Miller came too.[19] Eduard Käsebier vacationed there in July, when preparations for young Gertrude's October wedding to Joseph O'Malley began to occupy the family.

At Long Meadow, as at Crécy-en-Brie, aesthetic excitement in rural surroundings (and separation from her husband) stimulated her imagination and her creativity. She compared each place to a fairy tale or dream. Long Meadow was "like the palace in the sleeping-beauty story," and "a veritable Garden of Eden." She declared, "I live truly in the spirit. Would that I need never wake," much as she had exulted from Crécy, "I am so content I feel like a sinner. I feel as if it were all a dream and wish I might never wake." Still, she was clear-eyed about her work, recognizing that "if I can get the public, I have in my surroundings the opportunity of my life."[20]

In order to get the public, Käsebier placed exemplary photographs in showcases throughout Newport. In succeeding years, a single such display outside her New York studio would be her sole advertisement, but during the summer of '99 Käsebier saturated Newport with ten. Some of them, apparently, lured the summer's first sitter, a young man who commissioned a portrait for his first volume of poems.[21]

Direct solicitation, by writing to noted social leaders such as Mrs. Potter Palmer, worked too. On July 23, Käsebier unabashedly told Stieglitz, "My season seems to have begun. Three millionaires have honored me with their patronage this week. I am to do Miss Grant and Mrs. Potter Palmer says she will mention me to her friends etc. etc. etc." A word from Mrs. Palmer, the Chicago socialite and art patron who was summering in Newport, was better than any paid advertisement, but, by any standard, photographing Julia Dent Grant was a plum of an assignment. This attractive young woman was not only Mrs. Palmer's niece; she was President Ulysses S. Grant's granddaughter. (Mrs. Potter's sister had married the President's

son.) Miss Grant's engagement to Prince Michael Cantacuzène, a lieutenant in the Russian Cavalry Guards, was the talk of Newport.[22]

However, not every client was satisfied. "I have my own troubles pleasing them," Käsebier confessed to Stieglitz. "I had a print turned down this week that is one of the best things I ever did. It is a cruel shame that I can not show it." And not that all visitors were refined clients. In what Käsebier called "a very startling experience . . . a carriage full of men came to the house" —at one A.M. on a weeknight. Doubtlessly drunk, they made sport at the notion of a woman photographer, saying they had "come to call," but retreated swiftly when Käsebier, with frontier manners, told them to "leave if they did not wish to get shot." At dawn of another day, she was quick on the trigger, firing blanks at a man she took to be the thief who for days had been pilfering from the peach orchard. Self-satisfaction lasted only until breakfast, when the cook announced that the hired man had quit after being frightened while gathering peaches for breakfast.[23]

F. Holland Day's summer trips to Newport fanned their professional friendship. Day, at 35, was a slender, dandyish bachelor, who, with inherited wealth, had traveled through Europe and become a noted collector of manuscripts by and about

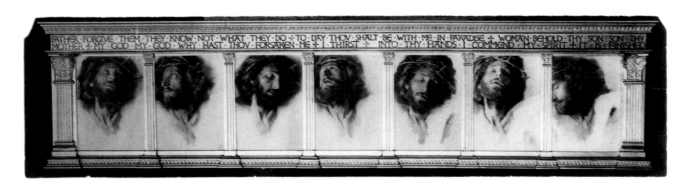

32.
F. Holland Day. *Seven Last Words.* 1898. Combination/platinum print, 3¼ × 13⅝". Library of Congress, Washington, D.C.

his favorite poet, John Keats. Day was a leading figure in Boston publishing; his firm, Copeland and Day, was known for distributing the American edition of *The Yellow Book* and Oscar Wilde's *Salomé*, illustrated by Aubrey Beardsley, as well as the magazine, *The Hobby Horse.* His affinity for Aestheticism was evident by the early 1890s, when he belonged to the Visionists, a coterie of Boston aesthetes that included Ralph Adams Cram, Bertram Goodhue and Francis Watts Lee. Their appreciation for medieval and oriental arts and admiration for Oscar Wilde shows in the pages of their magazine, *The Knight Errant.*

Day took up the camera in the mid-1880s and pursued photography with a fervor that overwhelmed his interest in publishing: after only six years in business, Copeland and Day disbanded in 1899.[24] Day's visits to Käsebier that summer betoken his new commitment to photography. Although most of Day's photographs were studio portraits of friends and acquaintances, including the young Kahlil Gibran and a black American whom Day posed as *An Ethiopian Chief*, his greatest fame (and notoriety) came from his photographic series of *The Crucifixion* and *The Seven Last Words of Christ*, in which he—long-haired, bearded and half-naked— played the part of Christ (32).

Drinking from a flask and dressed in a cloak, Day posed for Käsebier in Newport. His interest in costume pictures and in religious scenes may have been behind the staging of *The Manger*, (31) for which Frances Delehanty posed that summer in a whitewashed stable in Newport. So convincing was this apparent nativity scene (and

so great its viewers' belief in photography's truthfulness) that no one noticed that the infant, "so swathed about that its general outline alone could be distinguished," was indeed only swaddling. There is no child in one of Käsebier's most admired mother and child pictures![25]

The white robe that Delehanty wore in *The Manger* may have been the angel's robe that Day had a penchant for dressing up in, even without a camera on hand. Day traveled with a trunk full of costumes, and one night, in response to tales that Long Meadow was haunted, he draped himself in white and cavorted around the lawn playing ghost. The next day, the maid, the milkman and other tradespeople were nowhere to be seen; word had gone out in Newport that the ghost had been dancing at Long Meadow.[26]

F. Holland Day and the Lee family, for all their Aestheticism, were happy to indulge Käsebier's vices by sending her and her daughters a thank-you gift of cigarettes, candies and beer, addressed with the outrageous pun: "One case of beer to another." The Käsebiers retaliated with corny doggerel:

> What can we do, what can we say,
> Your spiritual message to repay?
> "One case of beer to another," tho' an atrocious pun,
> Made, from express man down, no end of fun.[27]

The summer had provided a restorative respite between a hectic spring and the demanding season ahead.

Back in New York City, Käsebier opened a full-fledged studio in the fall of 1899. Situated on Fifth Avenue between 29th and 30th Streets, her workplace stood at the heart of New York's artistic, social and photographic worlds.[28] Like the townhouse she occupied, the neighborhood was in transition from residential to commercial. Rowhouses and churches were giving way to skyscrapers and institutional buildings. This busy area, not far from Madison Square Garden (and, before long, the Flatiron Building) was ideal for her business. People strolling from nearby hotels, restaurants, private clubs and art galleries could not help noticing Käsebier's sidewalk showcase, where four examples of her recent work were always on display.

Passersby who liked the subtle beauty of the photographs they saw there were equally pleased with the uncluttered, yet homey, atmosphere of Käsebier's studio and with the personal attention she devoted to sitters (see 34). The moment one set foot inside, Käsebier's originality became apparent. While most turn-of-the-century portrait studios were "tricked out with several drop-curtain backgrounds, a buxomly upholstered chair with a thicket of fringe all round," and more,[29] Käsebier's place was so simple that:

> There was really nothing to see. A chair or two, a few screens, patternless
> and of a quiet greenish shade, on the walls some framed photographs, were
> all that could be seen. There was a skylight, it is true, but it looked as if it
> were there to light the room in the ordinary course. . . . The usual para-
> phernalia which one associates only with the photographer, the Inquisition
> and the dentist, were not to be seen.[30]

Remarking on her "common tripod camera, in a plain room with ordinary light and quiet furnishings," Arthur W. Dow made the aesthetic judgment that "art always shows itself in doing much with few and simple things."[31] Different though it was from other photo studios, Käsebier's place at 273 Fifth Avenue reflected her taste for the contemporary Arts and Crafts style.

33.
Dorothy Trimble Tiffany (Burlingham). [1899]. Platinum
print, 8 × 6″. Collection Michael John Burlingham

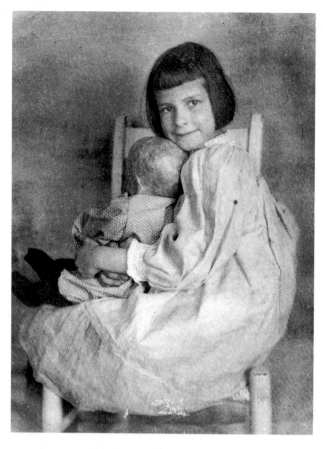

34.
A.K. Boursault. *Under the Skylight* (showing Gertrude
Käsebier photographing Harriet Hibbard, her studio
assistant from about 1901 to 1907). c. 1903. Proof for
reproduction in *The Photographer*, May 7, 1904. Collection,
The Museum of Modern Art, New York. Gift of Miss
Mina Turner

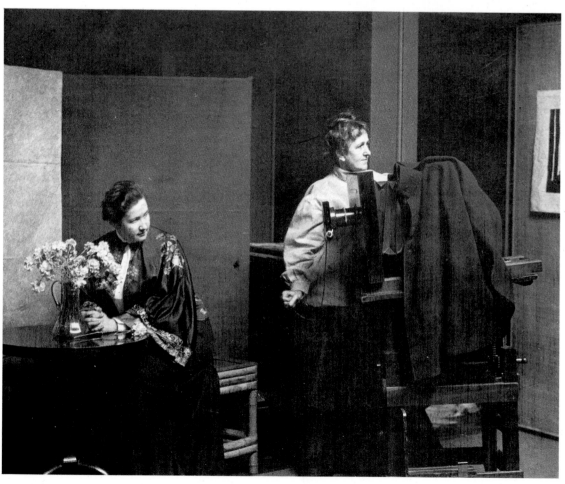

Like some other photographers of her era, Käsebier was known for her hospitality in serving tea or coffee in her studio. Vases of flowers and decorative pitchers added so greatly to the domestic effect that it can be difficult to tell which pictures Käsebier made in a subject's home and which in her own studio. Even her smaller but lighter skylit studio atop an eleven-story office building at the corner of Fifth Avenue and 32nd Street (December 1907 to mid-1914) seemed "like somebody's living room," the photographer Imogen Cunningham recalled.[32]

One of the bedrooms in Käsebier's 71st Street apartment (mid-1914 to 1920) was set up as a studio with a model stand and a few screens, but Mina Turner wrote that her grandmother preferred to photograph in the comfortable, natural surroundings of the dining room, or the living room, where she displayed several Chinese paintings (a gift from Arthur B. Davies) and the bronze sculpture and four water-colors that Auguste Rodin had sent her in appreciation for her portraits of him.[33]

All the aesthetic touches in her studios, including the silk Japanese kimono she often wore, reminded clients that Käsebier was an "artistic" photographer. So did a picture like *Mother and Child* (51), with its obvious debt to the composition and tonality of Whistler's *Arrangement in Gray and Black No. 1*, which was reproduced under its more familiar title, *Whistler's Mother*, in the July 1899 *Camera Notes*. Photographs were also presented with flair. Early on, she mounted them on board, blindstamping her name in script, as in 9, 17, 24. (Presumably, blindstamping her name upside down on Dow's portrait was a jest concerning principles of composition, rather than a mistake.) About 1898, she took to gluing photographs onto multiple dun-colored mats whose tones echoed those in the photograph—a method favored also by Day and others of the period. An angular monogram, making decorative use of the umlaut in her name, was her favorite signature about 1898–1900, but about 1900 she also sometimes stamped mounts with the same compact insignia of monogram and lens stop that adorned her letterhead. Throughout her career, but especially after about 1905, she inscribed her bold unslanted signature on photographs or mats.

Such mountings and signatures typified the new wave of photographers about 1900.[34] By using graphic signatures (which were reminiscent of, for instance, Whistler's butterfly hallmark), Käsebier and her colleagues declared an affinity to painters and to the Aesthetic movement, while separating themselves from old-time commercial photographers and their mass-produced cardboard mounts.

Käsebier also distinguished herself from run-of-the-mill photographers by disdaining photographic equipment and technique, an attitude shown as much by the small size of her darkroom as by her saying, "You can give an idiot a diamond studded gold pen, but he won't write poetry." Of all the photographers to work or apprentice in Käsebier's studio—Alice Austin, Alice Boughton, Alvin Langdon Coburn, and the Parrish sisters among them—only Spencer B. Hord (also known as Chippendale) mentioned her methods in any detail, humorously describing her seemingly haphazard way of mixing developer, but recognizing that "she professes greater ignorance than her results warrant."[35] Although Käsebier was enough of a perfectionist to aim for negatives that could be printed without retouching, she said so little about her methods that even Hermine Turner, who made many of her mother's platinum prints from about 1900 to 1903 and again in later years, could provide little technical data.[36]

Käsebier even went so far as to hide her camera behind a screen until her subject began to feel at home in the parlor-like studio. She took more time with subjects than most commercial photographers; two-hour sittings were not rare. Nor was it

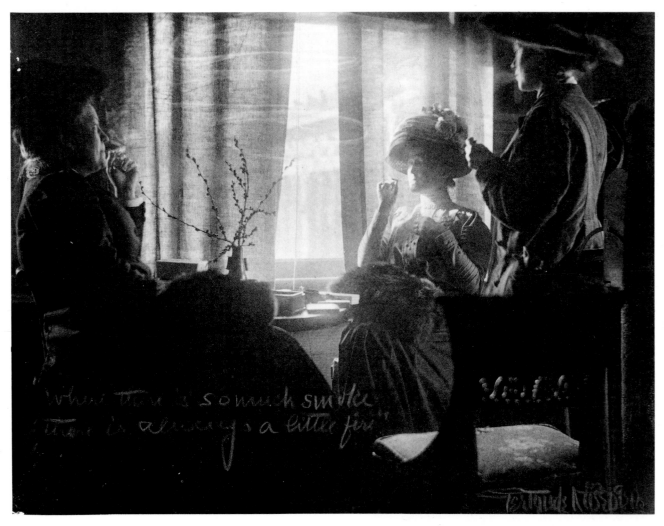

35.

"Where there is so much smoke there is always a little fire." c. 1906. Platinum print, 6 × 8″. Collection the Wellesley College Museum. Gift of Miss Mina Turner

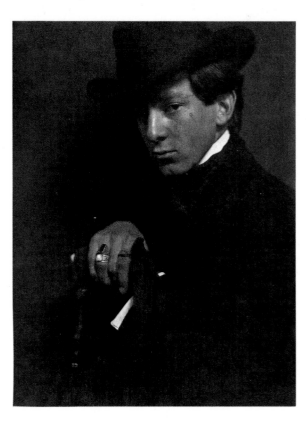

36.

Alvin Langdon Coburn. c. 1902. Platinum print, 8 × 6″. International Museum of Photography at George Eastman House, Rochester, N.Y. Gift of Alvin Langdon Coburn.

uncommon for her to make six exposures in different parts of her studio, varying lighting and pose until "the sitter began to lose self-consciousness and his temperament began to reveal itself." Her odd habit of looking away while exposing a plate also helped to keep subjects at ease (34). As Mary Fanton Roberts wrote: "Her real work is done with the sitter—not in the darkroom."[37]

Alvin Langdon Coburn (36), the most famous of her students, spent much of 1902 working in Käsebier's studio; at twenty, he had already been photographing for a dozen years. From 1898 to 1901 in Boston, London and Paris, he had learned from his distant cousin, F. Holland Day. As Coburn admired Käsebier's talent for posing and lighting portraits, it was logical for him to train with her, too. No record remains of Coburn's activities in the studio, but watching Käsebier photograph notable clients surely helped to pave the way for Coburn's own great success with eminent sitters.[38]

Käsebier's close friends as well as distinguished guests tended to drop into the studio every day. An air of camaraderie filled the workroom too, when at busy times artist-friends like Frances Delehanty and Adèle Miller came in to help her mount photographs. Harriet Hibbard said that Käsebier "worked like a Trojan and played like a kitten. . . . After a hard day's work G.K. would call out, 'Come on, Hibbard, it's four o'clock, stop work, let's smoke.'"[39] They would then return to work until six o'clock, after a cigarette and some coffee—and it is evidently a similar coffee klatch that Käsebier captured and drolly titled *Where there is so much smoke there is always a little fire*" (35), with smoke swirls that are a product of Käsebier's hand and imagination.

CHAPTER

IV

COLLEAGUES,
CRITICS
CELEBRITIES
AND
CHILDREN

Prominent though Käsebier was on the New York photographic scene, between 1899 and 1901 no event there enhanced her renown as much as four exhibitions in other cities. Philadelphia was the site for two: the Photographic Salons of 1899 and 1900. The others took place abroad in 1900: Frances Benjamin Johnston's exhibition of women photographers was organized for the Paris Exposition, and F. Holland Day's collection of the "New School of American Photography" opened in London, then traveled to Paris in 1901.

Since photography's earliest days in the mid-nineteenth century, Philadelphia had been a leading center. The Photographic Society of Philadelphia, co-sponsor of salons from 1898 to 1901, was one of the first such clubs in America when it was founded in 1862. By 1900, leading pictorialists considered the Philadelphia Salon to be "the exhibition of the year in the United States," and among the few great ones anywhere.[1] The significance of the Philadelphia Salons cannot be overstated.

They were prestigious because they were held at a major art museum, the Pennsylvania Academy of the Fine Arts, and because the judges' selections were rigorous, excluding not only incompetent photographs, but those deemed to be too literal or pedestrian. Only photographers served as judges for the 1899 and 1900 exhibitions (painters had been included in 1898), and Käsebier served both years. A tintype shows her with the 1899 jurors: Frances Benjamin Johnston, F. Holland Day, Clarence H. White, and Henry Troth (37). No method of photography was more remote from the artistic photography of the nineties than the tintype. These photographs on metal had peaked in popularity during the Civil War but were still being made as souvenirs about 1900. Produced quickly and cheaply, they were as lacking in finesse as they were in pretension, so it was a lark for the judges to have a tintype made during a break from the two or three days that they spent judging.[2]

The judges took their work seriously. After the exhibition, Käsebier even counseled photographers by publishing some of her negative reactions in *Camera Notes*, explaining in aesthetic rather than technical terms why she had rejected photographs. With encouraging words, she concluded: "Think more. Make half the number of negatives and come again next year. If your heart is in your work you cannot stop."[3]

Käsebier owed much of her fame abroad, as well as in the United States, to repeated successes at the Philadelphia Salons. In both 1899 and 1900, she took advantage of the rule permitting salon judges to exhibit ten pictures without jury review. Each time one of her pictures outshone the other nine. In 1899, *The Manger* (31) made its debut and became the star of the salon. Critics and public alike admired its beauty, technical perfection and religious aura; Stieglitz said it was "generally considered the gem" of that exhibition. *The Manger* was widely praised for its spiritual or holy qualities, although Käsebier's avowed aim had been secular: to study white tones photographically.[4]

At the 1900 Salon, *Blessed Art Thou Among Women* (29), which had also sprung from the desire to depict white against white, drew the spotlight. Although Käsebier had taken the picture before *The Manger*, she had delayed releasing it out of sympathy for the Lees when their daughter died. The picture was well received from the first. Keiley called it "unquestionably one of the most perfect and beautiful

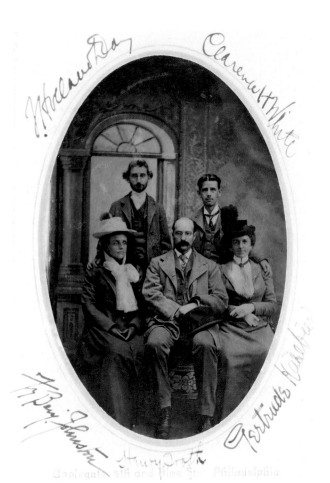

37.
James R. Applegate. Jury of Philadelphia Photographic Salon (F. Holland Day, Clarence H. White, Frances Benjamin Johnston, Henry Troth and Gertrude Käsebier). 1899. Tintype, mat 4 × 6″, oval opening 3 × 4½″. Library of Congress, Washington, D.C.

38.
Zaida Ben-Yusef. Untitled. From *Photographic Times*, October 1900. Library of Congress, Washington, D.C.

39.
Eva Watson Schütze. *Alice, Jane and Gordon Dewey*. c. 1902. Platinum print, 5¾ × 7½″. The University of Chicago Archives

pictures of the Salon."[5] *Camera Notes* (July 1900), had already published a gravure reproduction of it, and an original would soon appear in Day's exhibition.

Eduard Steichen (as he then spelled his name) was the leading newcomer of 1899, combining his flawless sense of design with ideas borrowed from Impressionist and Symbolist art. Steichen had begun his career in painting and photography in Milwaukee, where he grew up. He soon quit working for a lithographic company in order to study art in Paris and became fast friends with Käsebier.

The Salon's advocates considered the shows memorable for introducing little-known, innovative photographers. But when serious Philadelphia amateurs saw their favorite aesthetic—finely crafted platinum prints of landscapes—consistently rejected in favor of novel experimental techniques and extremely soft focus, they fought for less restrictive exhibition rules in 1901 and won. It was a Pyrrhic victory. Because of it, Stieglitz and his allies boycotted the 1901 Salon, and, with the formation of the Photo-Secession in 1902, New York became the acknowledged photographic center in the United States. After 1901, no more salons were held in Philadelphia.

Although Käsebier's work had been seen and admired in Europe by 1899,[6] Johnston's and Day's exhibitions firmly established Käsebier's reputation on the continent. Whether in context with American women photographers of varying aesthetic persuasions (as in Johnston's show) or among the "New School" of Americans (as in Day's), Käsebier's work stood out.

Like Käsebier, Washington, D.C.-based Johnston had set out to be a painter but found it expedient to turn to photographic magazine illustration, when halftone reproduction made photography the favored medium. She also wrote articles to accompany her pictures. Theodore Roosevelt and his family, Susan B. Anthony, and John Philip Sousa were among her many portrait subjects. She had photographed the Columbian Exposition and flirted with pictorial photography. About 1900, she became an expert in photographing schools, and today her name is synonymous with the deliberately composed platinum prints of the Hampton Institute in Virginia that won a gold medal for photography at the 1900 Paris Exposition. Either as an outgrowth of her work at Hampton, or because of Käsebier's influence, she was to take more than a hundred pictures of classes and various activities at the Carlisle Indian Industrial School (14).[7]

Johnston's exhibition of photographs by American women, commissioned to complement her lecture to the International Photographic Congress in Paris, contained none of her own work, but that of twenty-eight other women: serious photographers from California to Rhode Island, including Käsebier. Johnston organized her exhibition on such short notice that Käsebier, overwhelmed with other commitments, initially said that she had no time to make prints. But Johnston, considering Käsebier's contribution to be essential, would not take no for an answer. She called at Käsebier's studio and, resorting to tears in a melodramatic scene, even tried to buy a print that Käsebier had just sold to a client.[8] Meeting persistence that more than matched her own, Käsebier wisely acceded. The importance of Johnston's show lay beyond individual photographs; it produced a powerful cumulative impression of numerous talented American women photographers, many of them professionals, among whom Käsebier was a leader. No comparable group of women photographers existed in Europe.

Of the women in Johnston's show, Käsebier was the most inventive, versatile and prolific. Aside from that, and despite her seniority by more than a dozen years,

Käsebier had a good deal in common with the others. Several had studied art before turning to photography; quite a few practiced portraiture. Zaida Ben-Yusef had opened a studio in New York at about the same time as Käsebier. While Käsebier photographed varied genres, Ben-Yusef limited her work to portraits, especially those of celebrities. Like Käsebier's, her portraits employed relaxed poses and eschewed old-fashioned studio props (38). After about 1901 the two women chose differing paths, as Ben-Yusef pursued photojournalism.[9]

The Philadelphia contingent—Eva Lawrence Watson (later, Watson Schütze), Amelia Van Buren and Mathilde Weil—had all studied art at the Pennsylvania Academy of Art, and all were primarily interested in portraiture and figure studies. Watson Schütze, who like Amelia van Buren had studied with Thomas Eakins, is the best known of the three, both through her affiliation with the Photo-Secession and by persisting in portraiture after marriage and a move to Chicago, where her husband, Martin Schütze, taught German literature at the University. Like Käsebier, Watson Schütze asserted herself not only to make her art pay but to rebut Stieglitz. She remonstrated to him about the cliquishness of New York Secessionists as well as his conservative choice of her photographs in *Camera Work*. She admired Käsebier and saw her as a model. Both women took studio portraits and studies of children (see 39), but Watson Schütze's pictures tend to have a more languid quality than Käsebier's, and, while Käsebier abandoned painting around 1910, Watson Schütze returned to it as her primary medium.[10]

Other photographers in the exhibition were indebted to Käsebier. While still an amateur photographer in Brooklyn about 1898, Alice Austin (not to be confused with the better-known Alice Aust*en*, who traveled from her Staten Island home to photograph people on Manhattan streets) came under Käsebier's influence. Her mentor's thinking can be found in Austin's "endeavor to obtain the personality of my sitter and at the same time turn out a photograph which may lay some Claim to Art." However, a critic found Austin's photographs to be "not so full of mystery as those of her teacher."[11]

Rose Clark said she owed Käsebier "any success she had with a camera." When Käsebier's work inspired her, Clark was already an accomplished painter and designer, whose painting *Mother and Child* may have caught Käsebier's eye at the Columbian Exposition. Another admirer was Sarah Sears, whose portraits later appeared in *Camera Work*. She and her daughter sat for Käsebier, and she owned a print of Käsebier's *The Heritage of Motherhood* (30).[12]

Johnston's exhibition was so well received that it was routed to St. Petersburg and Moscow, before its finale at the Photo-Club de Paris in January 1901. Though one critic noticed that Käsebier had not sent prime examples to Johnston's exhibition, the French photographer and critic Robert Demachy found kind words for her work.[13]

The contrast between Johnston's show and Day's underscores the differences between the photographers themselves. Johnston, the journalist, worked pragmatically, under pressure, towards a definable goal of exhibiting her female colleagues' work. Day, the wealthy amateur, had the imagination and leisure to gather and publicize his concept of the "New School of American Photography" and to publish a catalogue of titles. Day wanted to show Europeans the accomplishments of innovative American photographers like Clarence White, Edward Steichen, Frank Eugene and Käsebier, to say nothing of his own. (Over one hundred Day photographs comprised more than a quarter of the London exhibition. The Paris version was abbreviated.[14]) Ben-Yusef, Johnston, Watson, Weil and Sears were all represented; there was also a large sampling of worthy, though now less familiar, photographers.

40.
Portrait of the Photographer (Gertrude Käsebier self-portrait). c. 1899. Photograph
and ink drawing, 6⅝ × 4⅝". Collection Mason E. Turner, Jr. Photo: Jack Bungarz

But the work of the best-known American photographer was not to be seen.

Stieglitz had not only refused to participate in Day's enterprise, he had tried to prevent it altogether. The show's original sponsor was the Linked Ring, the group of advanced photographers who had split from the old-guard Royal Photographic Society in 1892. Stieglitz got them to back out by cabling them that Day's selection was second-rate. But Day was as resilient as Johnston had been in the face of Käsebier's refusal; he turned the tables and presented the show under the auspices of the Royal Photographic Society, the Ring's conservative rival from which it had seceded. Jealousy seems to have lain behind Stieglitz's actions. Both Steichen and Demachy attested to the quality of Day's "New School" selection, much of which Stieglitz had not laid his eyes upon, as he refused to visit Day in Boston. As Estelle Jussim has shown, Stieglitz saw Day as usurping his self-appointed role as American photographic impresario and tastemaker. Käsebier tried to mediate, defending Stieglitz to Day as "one of the fairest, broadest, finest men I ever knew,"[15] but when her efforts failed she steadfastly stayed friendly with each.

Day represented Käsebier handsomely with thirty prints at the London showing of the "New School of American Photography" (twenty-nine in Paris). Käsebier and Day had prepared the group with the exhibition in mind; she told Johnston that she could not lend a set of photographs because she had given Day a collection for almost the identical purpose. As with most exhibitions of this period, all of its contents can no longer be identified. However, it appears that the exhibit represented Käsebier fairly. Portraits predominated, including the boy's head (10) that had appeared in *Camera Notes* and would soon be reproduced in Charles Caffin's *Photography as a Fine Art*. The profile titled *Study* at the 1898 Philadelphia Salon (28) was renamed *The Velvet Mantle* for this exhibition.[16] *Blessed Art Thou Among Women* was there but surprisingly not *The Manger*. Her portraits of Clarence White and Day complemented their photographs. Käsebier's self-portrait (40) montaged clear photographs of her own face and hands to a sketchily drawn Chinese-style gown, emphatically demonstrating her philosophy that, in a portrait, the face and hands should be given priority. To acquaintances who saw the portrait reproduced in *Camera Notes* (April 1900), the combination of media would have recalled Käsebier's switch from painted portraiture to photography, while suggesting her continued willingness to keep a brush at hand to alter or enhance photographs. However, the picture dismayed an English critic who complained, "Alas! . . . the face is very flat, the body is only outlined, perhaps done with watercolour, or else selective development of a platinotype print. In either case it's a thing to avoid." Most British reviewers disliked the soft focus and low tones of American artistic photography, whether in Day's show or at the concurrent salon and Linked Ring exhibitions. It was praise indeed for a British reviewer to "perceive much beauty and power in some of the works shown by Mrs. Käsebier." In France, on the other hand, Day's exhibition was warmly received, and Käsebier's work in particular was appreciated.[17]

Although no major exhibition of her work appeared in Germany, Käsebier's photographs, seen in salons and reproductions, were so well regarded there by 1900 that Ernest Juhl, the editor of *Photographische Rundschau,* sprang to her defense against Sadakichi Hartmann's contention that she was a second-rate photographer whose photographs resembled reproductions of old masters. In Germany, Juhl said, she was considered "among the first-rate artistic photographers."[18]

Today, such reviews of turn-of-the-century salons and exhibitions enlighten us about a photographer's development and critical reaction to it. About 1900, however, exhibitions and reviews gave essential publicity to artistic photographers.[19] Understanding this, Käsebier seldom declined to exhibit; her initial refusal to Johnston was exceptional. Acclaim at exhibitions brought more than personal satisfaction; it attracted clients to her studio. Even harsh criticism like Hartmann's called attention to her work.

The critical seal of approval for her studio came in 1901 when a laudatory article by Charles Caffin, one of America's leading art critics, appeared first in the widely circulated *Everybody's Magazine* and later in his book, *Photography as a Fine Art.* Out of growing respect for Stieglitz and his protégés, Caffin had been turning his attention to photography. In "Mrs. Käsebier and the Artistic-Commercial Portrait," he observed Käsebier's rare ability to be both artistic and commercial in a world where photographers were expected to be either/or. He praised her capacity to make "the whole composition a beautiful pattern of line and form and color, contriving at the same time that this pattern shall help to elucidate the character,"[20] as it does in her portrait of Caffin himself (41), where a bookcase enhances the literary atmosphere but does not detract from the subject, who browses through a book and holds a

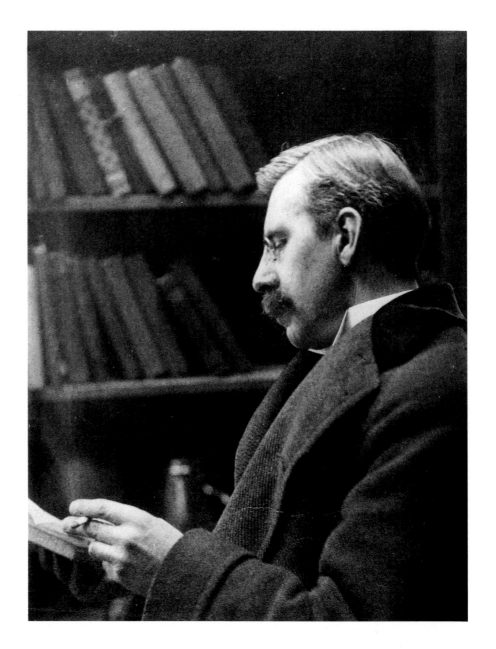

41.
Charles H. Caffin. c. 1900.
Platinum print, 8 × 6″. Charles H.
Caffin Papers, Archives of American Art, Smithsonian Institution,
Washington, D.C.

cigarette. Reading Caffin's sympathetic essay about Käsebier, it is hard to foresee that only six years later he would maliciously parody Käsebier's artistic approach to commercial portraiture.

Instead of paying to advertise (as many purely commercial photographers did), Käsebier received payment for celebrity portraits and story illustrations in popular magazines. By 1901, prospective clients who had never been to New York would have recognized her photographs from reproductions in *Everybody's Magazine*, *The World's Work*, and *The Ladies Home Journal*.

As Käsebier's ability as a studio portraitist became known, she was regularly commissioned to photograph notables for *The World's Work*, a magazine of the arts and public affairs that was among the most serious and outstanding in the new genre of photo-illustrated magazines spawned by the invention of halftone illustration.[21] The portraits that she made for them, published between November 1900 and May 1902 (and those that she later made for the art magazine *The Craftsman*), comprise datable groups of portraits that help to show the stylistic evolution of her portraits.

From 1896 to 1898, most Käsebier portraits were neck- or bust-length shots, like *Portrait of a Boy* (10), *Flora* (28), and *Arthur W. Dow* (9). Then, during 1898 she began to show personality through stance and gesture, as well as through facial expression. Her portrait of Dorothy Trimble Tiffany (33) from the spring of 1899 is an early example of her seated portraits. It is the sort of spare, natural picture that made people notice Käsebier, so uncommon was it in the Gilded Age to photograph a little heiress (or indeed, any child) casually perched sideways on a Hitchcock chair, cuddling a life-size doll. It is some measure of the picture's success that the subject, who as an adult rejected much of her New York upbringing when she went to live abroad (becoming a noted child psychiatrist and associate of Anna Freud), kept the picture until her old age.[22]

Käsebier's continuing efforts to make compelling portraits may have been spurred by an editor's request. An editor of *World's Work* asked Frances Benjamin Johnston (and presumably also Käsebier, for whom no *World's Work* correspondence survives) to provide "something very striking and unusual" for the magazine.[23] Käsebier's earliest photograph for *World's Work* (December 1900), a portrait of Mark Twain (42), still alludes to paintings like those of Sargent or William Merritt Chase. Twain stands before a dark ground; his face and hands get the greatest emphasis. Only the slight turn of Twain's head and the projection of his hand and pipe indicate depth; the background is murky, undefined. Within this simple format, Twain holds our attention as though he were in a spotlight, about to spin one of his fantastic tales.

When she made her perceptive study of Jacob A. Riis (43), she struck up an acquaintance with the muckraker-journalist who took photographs himself to document slum conditions. She respected him so much that she saved some brief notes he wrote her in 1905 and 1908.[24] In the portrait reproduced in *World's Work* (March 1901), Käsebier depicts the author of *How the Other Half Lives* as a tense man too busy to sit down, even too preoccupied to have had his suit pressed. His portrait, like Twain's, is centered, but tension has been raised by defining space only with the angle of Riis's stance and with his shadow, so that he seems squeezed between backdrop and picture plane. In this taut portrait, Käsebier reached an early success in portrayal through pose, composition and gesture.

The *World's Work* portraits, which accompanied articles by or about their subjects, were reproduced one to a page, each page being almost as large as Käsebier's original 6½ × 8½-inch negative. It was more than the monogram that made these pictures distinctive; Käsebier soon arrived at a recognizable style, characterized by asymmetrical placement of a seated figure and by graded areas of tone.

Käsebier introduced each subject as though we had been granted a private interview. Booker T. Washington (44) from *World's Work* (January 1901) appears in a typical Käsebier pose: seated to one side with an arm (or back) parallel to the vertical edge of the picture, forearm parallel to the bottom, so that the figure fills a lower corner of the plate. There is a neutral background (usually dark, as here; sometimes middle-toned). Unlike earlier pictures in which she generally placed a subject parallel to the picture plane (for instance, Dorothy Trimble Tiffany, 33), Käsebier has begun to show her subjects coming forward from an undefined back plane.

The pose became almost a formula for a while, because resolving the placement of the figure within the frame let Käsebier devote greater attention to a subject's face and hands.[25] Käsebier always tried to learn about famous subjects before photographing them, so it is not surprising that her portrait of Booker T. Washington caught the solemn expression and powerful hands of the educator whose autobiography, *Up From Slavery*, recalled: "There was no period of my life devoted to play."

42.
Mark Twain. From *The World's Work,* November 1900.
General Research Division, The New York Public Library,
Astor, Lenox and Tilden Foundations

43.
Above right:
Jacob A. Riis. From *The World's Work,* March 1901.
General Research Division, The New York Public Library,
Astor, Lenox and Tilden Foundations

44.
Booker T. Washington. From *The World's Work,* January
1901. General Research Division, The New York Public
Library, Astor, Lenox and Tilden Foundations

To Käsebier, men's faces seemed "much more interesting than women's, for they are the ones out in the world doing things." She claimed that she didn't like taking portraits of women because "fussy clothes" and "bare necks and arms . . . complicate matters and eliminate simplicity and sincerity." The average woman considered retouching to be the photographic equivalent of powdering her nose, but Käsebier disdained retouchers, who "in an endeavor to improve upon the Creator removed the anatomy." She contended that "it is safer to have freckles than no bones" and scoffed at women's determination "to be made to look young and handsome no matter how old or ugly they may be."[26]

Epitomizing her aversion to vapid clients is the tale of the young woman—Thomas Edison's daughter, according to Käsebier's family—who arrived at the studio with a half-dozen gowns to pose in. After several changes of costume and fifteen minutes of posing to no avail, Käsebier told the sitter to go home. "But Mme. Käsebier, you haven't made a single picture," she complained. "I know," lamented the photographer, "there is nothing there."[27]

In fact, despite her grumbling about the *average* sitter, Käsebier relished photographing active, accomplished women who, like men, were "out in the world doing things." Many compelling pictures of talented friends and acquaintances came from her camera, bearing witness to a portion of Käsebier's world for which few written accounts remain: her association with other creative women. These pictures, which deliberately alluded to their sitters' lives, now provide clues to Käsebier's contacts outside the Stieglitz circle.

Harmony (45) is nominally of the Brandegee family (and is sometimes called *Family*), but it refers most specifically to the central figure, Susan Lord Brandegee, and her triple role as musician, mother, and wife. Mrs. Brandegee was a professional cellist, best known for becoming in 1909 the first woman to play with the American String Quartet in Boston. Her husband here literally plays second fiddle. Robert Bolling Brandegee painted portraits and landscapes and did some photography; for him, the cello was but a hobby. Although the couple is shown standing, holding their cellos rather than actually playing, the title—*Harmony*—refers to the marriage, as well as the string duet that has just been completed or is about to begin. Käsebier's picture complements the comment, in a 1971 catalogue of Brandegee's paintings, that the couple's "lives together appear to have been extremely happy and revolved entirely around music and art."[28]

Another Käsebier of 1901 shows Mr. Brandegee at work on his portrait of Theodate Pope (Riddle), one of America's first woman architects, who, like the Brandegees, lived in Farmington, Connecticut. She had first gone there as a student in Miss Porter's exclusive finishing school, where Brandegee taught art. After graduation, she convinced her mother and her father, Arthur Atmore Pope, the Cleveland steel magnate and art collector, to move to Farmington. She studied architecture privately, and in conjunction with the firm of McKim, Mead and White she designed much of Hill-Stead, their Farmington home. Hill-Stead is today a house museum, displaying the fine collection of paintings by Degas, Manet, Monet, Whistler and others that Mr. Pope had begun to buy during the 1880s.

By 1901, the Pope family had become patrons of Käsebier's work, too. In 1902 Mr. Pope lent copies of *The Red Man* and a *Mother and Child* of 1900 to the first Photo-Secession exhibition.[29] Today, Hill-Stead's archives contain versions of *Mother and Child* or *Adoration* (27), *Real Motherhood* (56), and *Portrait of a Boy* (10), as well as of Brandegee painting Theodate, and thirteen other photographs of the Popes at Hill-Stead and in Käsebier's studio.

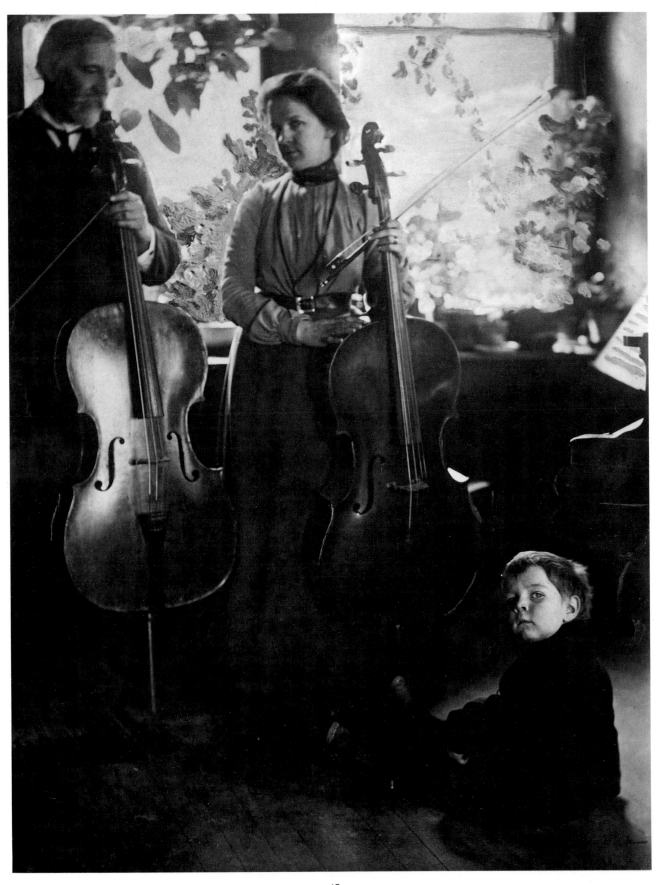

45.
Harmony (*Family*). 1901. Platinum print, 12⅝ × 9⅝".
Collection, The Museum of Modern Art, New York, Gift
of Mrs. Hermine M. Turner

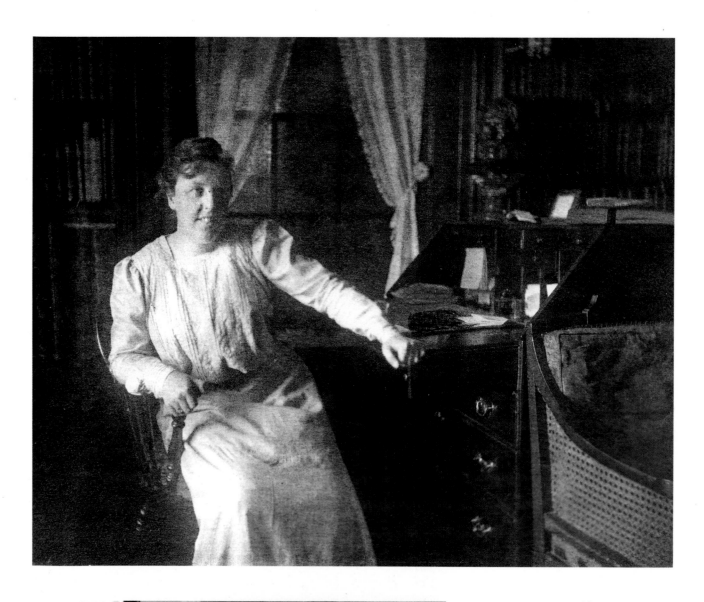

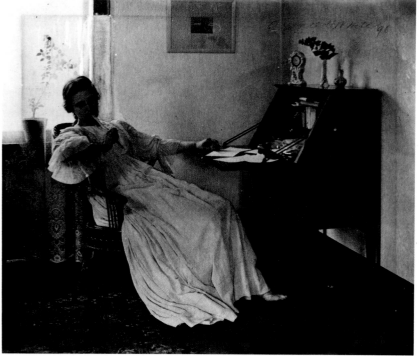

46.
Theodate Pope. [1902]. Platinum print, 6¼ × 8″. From the Archives of the Hill-Stead Museum, Farmington, Conn.

47.
Clarence H. White. *At Her Writing Desk (Julia Hall McCune)* (originally titled *What Shall I Say?*). 1896. Platinum print, 6⅜ × 7¾″. The Cleveland Museum of Art. Gift of John Flory, Elizabeth Flory Kelly, and Phoebe Flory, 80.130

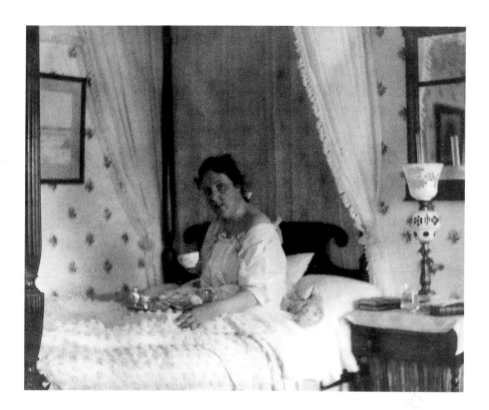

48.
Theodate Pope. [1902]. Platinum print, 6¼ × 8″. From the Archives of the Hill-Stead Museum, Farmington, Conn.

The prestige of having photographs in a collection like the Popes' cannot be overestimated, especially as Käsebier appears to have been the only photographer whose work the family collected. One can only imagine Käsebier's thrill at knowing that her mother and child pictures were housed along with those of Mary Cassatt and Eugène Carrière (52, 53).

Käsebier's *Portrait of Theodate Pope* (46) conveys the earnest dignity of this remarkable heiress who chose social reform and architecture over the frivolities of high society, just as she had, as a teenager, discarded her insubstantial given name, Effie, for the firm classical dactyl of Theodate, her grandmother's name. To show a woman in a white dress seated at a desk was a turn-of-the-century cliché, but Käsebier's portrait seems to have chosen that common form in order to transform it. Unlike Clarence White's *What Shall I Say?* (47) and pictures of women seated at desks by such artists as Thomas Dewing, Käsebier shows no languid lady in reverie. Miss Pope greets the viewer forthrightly from a desk. Where similar pictures tend to associate women with flowers or a single book, Theodate's attributes are a Roman portrait bust and shelvesful of books in the library of the home that she helped to plan.

During the sittings, the women must have discovered a rapport based on their love of animals and their mutual interest in spiritualism. Like others in their day, including the philosopher William James, they were intrigued by ideas of thought transference and telepathy. Theodate loved animals so much that she maintained a pet cemetery at Hill-Stead. Appropriately, Käsebier posed Theodate seated beside her cottage fireplace, a cat in her lap and her dog lying nearby. But why did Käsebier photograph Theodate taking breakfast in bed? It is possible that the picture (48) is partly an homage to the Popes' friend Mary Cassatt. Cassatt's painting of a mother and child taking *Breakfast in Bed* is one precedent for this photograph; Cassatt also painted a number of pictures of women at tea.[30]

Another creative woman who admired Käsebier's work was Ellen Terry, the great English actress whose own art had made her wealthy in the 1880s and '90s. She was no newcomer to photography. In her youth, Lewis Carroll and Julia Margaret Cameron had photographed her. Her visual sensibilities were further honed by the painter George Frederic Watts (during a brief, mismatched marriage) and by years of living with Edward Godwin, a leader of the English Aesthetic movement. By the early 1890s she was taking snapshots herself, and by 1896 her correspondence with George Bernard Shaw included an analysis of Frederic H. Evans's portrait of the playwright. Then, while performing in New York in the fall of 1899, Terry purchased a print of *The Manger* for a hundred dollars.[31]

Ellen Terry had probably been introduced to Käsebier by the artist-illustrator Pamela Colman Smith, who had acted in the Lyceum theatre group with Terry before leaving England in 1893 to study at Pratt Institute. While studying with Arthur W. Dow and Ida C. Haskell at Pratt, Smith became friendly with Käsebier. After returning to England in June 1899, Smith evidently urged Ellen Terry to meet Käsebier while she was in New York.[32]

News of the hundred-dollar sale sparked rumors about the cost of Käsebier's portraits. Twenty dollars for a single portrait was not unusual, said an English journal in 1900. *Wilson's Photographic Magazine* soon rebutted that, explaining that Käsebier charged ten dollars for a sitting and two prints. Additional prints were five dollars each. Observing that "a print of hers means much careful thought, and often much individual work," *Wilson's* wondered how, even at Käsebier's prices, her work could pay. But pay it did: in the early years of the century Käsebier must have been making an average annual gross income of $4,000 to $6,000—roughly comparable to $60,000 to $90,000 in today's terms. (Because no record of her expenses remains, it is impossible to estimate her net income, but it should be remembered that no income tax would have diminished those earnings.) Yet, as *Wilson's* pointed out: "Mrs. Käsebier is not a 'fashion.' She owes her position as a professional photographer not to the 'multi-millionaire,' but to the large number of educated and 'refined people' who can in a measure understand and appreciate her work."[33]

Alfred Stieglitz himself was among those educated and refined people who paid to have Käsebier photograph his family (50). She charged five dollars a print, and another ten to photograph in the Stieglitz home; a frame was one dollar.[34] Whether Stieglitz paid for his own portrait is doubtful; photographers' pictures of each other were usually complimentary. But this, like other details of Käsebier's business practices, remains a mystery. Käsebier's appointment books, ledgers, negative lists, and virtually all her business correspondence no longer exist.

Stieglitz was among the first of Käsebier's photographer colleagues to sit for her. Apparently she printed only three negatives of Stieglitz; of these, original prints seem to remain for only two. An early portrait of Stieglitz known from a reproduction in the *Photographic Times* (February 1900) conforms to Käsebier's early portrait style by presenting Stieglitz in profile, as he studies an unidentifiable photograph. A more specific reference to his photography appears in her print (c. 1899, Princeton University Art Museum) showing Stieglitz seated with a copy of his photograph *The Net Mender* hanging behind him.

Käsebier's 1902 portrait of Stieglitz seems to have been the favorite of both photographers. Characteristically, she has turned her sitter's jacket into a dark triangular form, which, arrowlike, forces the viewer towards the sitter's face and eyes. Atypically, she has omitted her subject's hands, evidently in order to direct full attention to his head: the source of Stieglitz's perceptive and intellectual powers.

49.
Alfred Stieglitz. 1902. Platinum on tissue, 13¼ × 9⅝". The Metropolitan Museum of Art, New York. The Alfred Stieglitz Collection, 1949 (49.55.170)

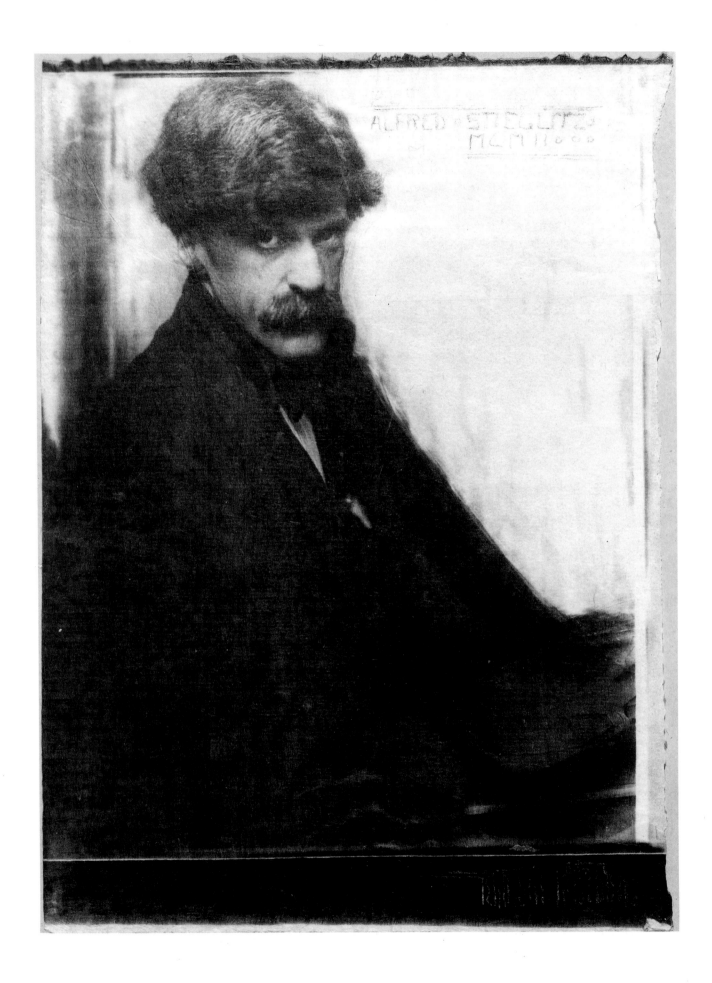

Stieglitz's attributes, a portfolio and a porkpie hat of the sort he perennially favored, are barely discernible.[35] As if to emphasize her subject's importance, she has embellished the blank upper right corner of the photograph with the name Alfred Stieglitz and the date of the photograph.

There is no doubt that Stieglitz appreciated this portrait, which flattered more than his looks. He owned at least two copies: one (dated 1902) is in the Metropolitan Museum's Stieglitz Collection (49); the other (dated 1906) is in the Stieglitz Collection at the Art Institute of Chicago. A light, almost ethereal version is at the International Museum of Photography at George Eastman House, and three versions are at the Museum of Modern Art: one about 9×12 inches with a light brown watery background, a smaller pale uninscribed version, and a still smaller oval variation, showing just head and shoulders against a pitch-black background. It would seem that for Stieglitz, whose interest in the expressive possibilities of photography equalled her own, Käsebier made a special effort to explore the diverse effects that one negative could yield. Her methods were not Stieglitz's; he would not have brushed in painterly backgrounds as she did. However, her choice to print on different weight papers is analogous to Stieglitz's proclivity for repeating an image on different papers, in gravure or on glass lantern slides. Thus, in several ways, Käsebier's portrait embodies her early devotion to Stieglitz. If she did indeed write "the only man I ever loved" on the back of his photo, as she later said she had, it must have been a copy of this picture.[36]

Käsebier had also been making a name for herself as a photographer of mothers and children. While the poses of these pictures vary, the majority of them suggest that a mother must simultaneously protect her child and grant its independence. Commenting on *Blessed Art Thou Among Women*, Keiley observed

> . . . the beautiful solicitude of the delicate, charming mother, and the almost indifference of the child, who accepts the maternal devotion as a matter of course, and looks straight ahead, as though forgetful of the mother in the contemplation of what is before it. . . .[37]

Most artists of her day emphasized a baby's bond with its mother, but instead of clinging, Käsebier's infants tend to turn away, as if to explore the world. In photograph after photograph, a mother looks affectionately at her child while the child looks out or away from its mother in curiosity. As early as 1897 the motif occurred in *Mother and Child* (27, later also called *Adoration* or *The Vision*), and it continued in *Blessed Art Thou Among Women* (29), in *Decorative Panel* (54), the portrait of Stieglitz's wife Emmeline with their daughter Kitty (50), and in *Mother and Child* (51), among others.

Käsebier and the French Symbolist Eugène Carrière had common concerns, such as the tonal description of the world and motherhood, but while Carrière repeatedly emphasizes the link between mother and child (53), Käsebier's baby sees beyond its mother and pushes away, rather than embraces her (27).

Mary Cassatt's paintings show mothers involved in a variety of daily routines: bathing, feeding and comforting children. Käsebier's pictures have less diversity, but her mothers grant independence more readily than Cassatt's. While a typical Cassatt baby gazes unswervingly into its mother's eyes and is united physically and emotionally with her, Käsebier's alert seated child perches on its mother's lap, regarding the world inquisitively (52 and 51).

Children's desire for self-reliance and independence becomes more evident in

50.
Emmeline Stieglitz and Katherine (Kitty) Stieglitz. [late 1899–early January 1900]. Platinum print, $6\frac{5}{8} \times 5\frac{7}{8}$". The Art Museum, Princeton University. Clarence H. White Collection

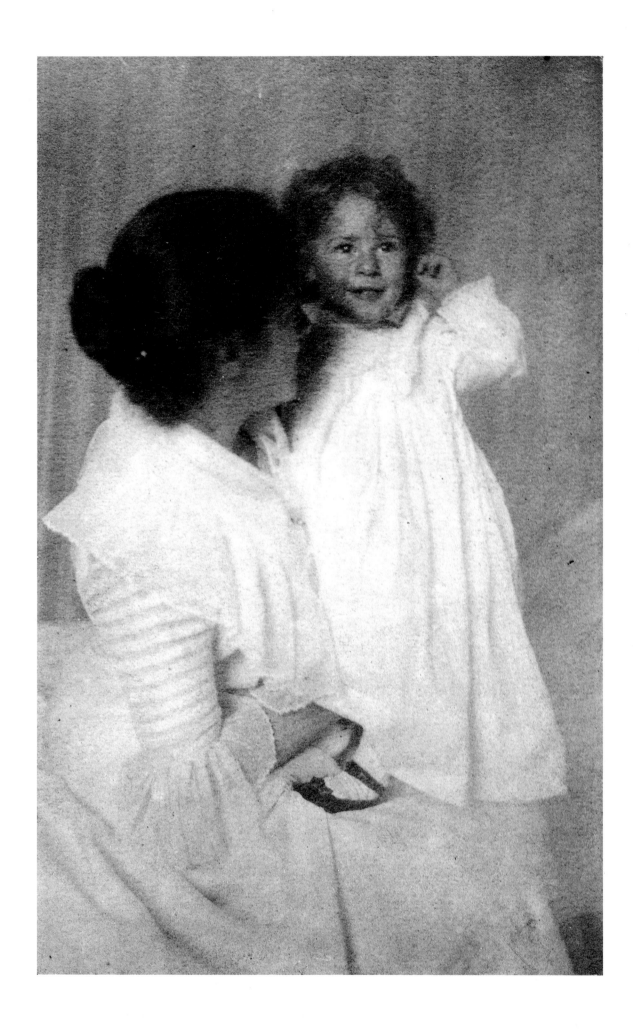

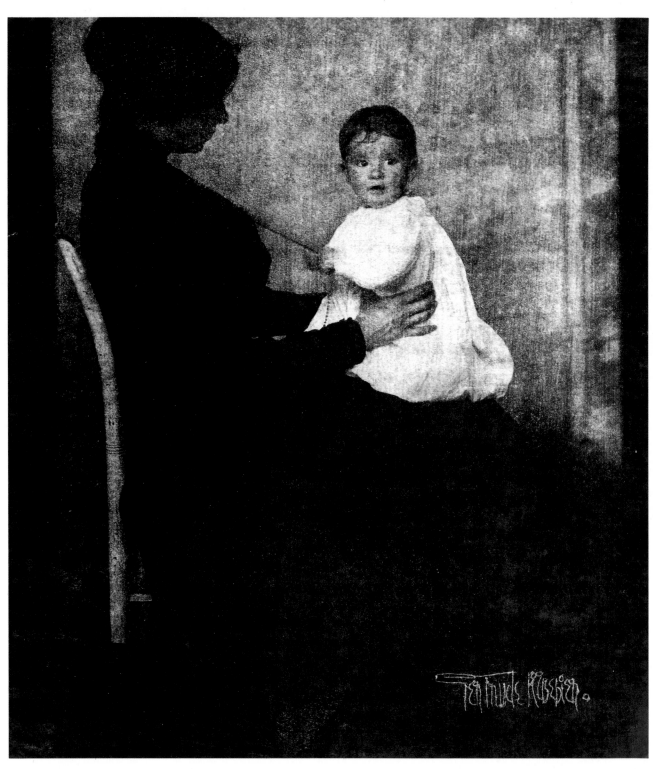

51.
Mother and Child (Mrs. Ward and Baby). c. 1903. Gum
bichromate print, 8½ × 7¹¹⁄₁₆″. Library of Congress,
Washington, D.C.

Käsebier's pictures of older children. In photographs like *Decorative Panel* (54) and *Blessed Art Thou Among Women*, Käsebier's mothers protect their children without restricting them, while the children approach the world with confidence, standing upright and gazing steadily ahead. As subtle as Käsebier's images of independence sometimes are, no other turn-of-the-century artist so regularly represents middle- or upper-class children as outgoing as hers.

In *Decorative Panel*, the mother, her face unseen because of her bowed head, helps her toddler daughter to walk ahead. The daughter looks directly out with an independent spirit. It is possible that Käsebier, admiring Millet as she did, found inspiration for this photograph in the similarly posed Millet, *The First Steps* (*Les premiers pas*), which she could have known in reproduction. But while Millet's child goes from the security of its mother to that of its father's outstretched hands, Käsebier's little girl typically walks to an undefined space. Her forthright expression and sturdy stance also lend her nudity an innocence and timelessness that are quite unlike the coy nudity and Lolita-like precocity of girls photographed by Käsebier's colleague, the French photographer Robert Demachy.[38]

In *Blessed Art Thou Among Women* (29), Agnes Lee protects and directs her daughter by placing her arm on the child's shoulder. As in *Decorative Panel*, the child confronts the viewer frankly while the mother devotes herself to the child. Käsebier consistently saw or awakened confidence and self-assurance in children, while her contemporaries in painting and pictorial photography tended to evoke clinging

52.
Mary Cassatt. *Mother About to Wash Her Sleepy Child*. 1880. Oil on canvas, 39½ × 25¾". The Los Angeles County Museum of Art. Mrs. Fred Hathaway Bixby Bequest

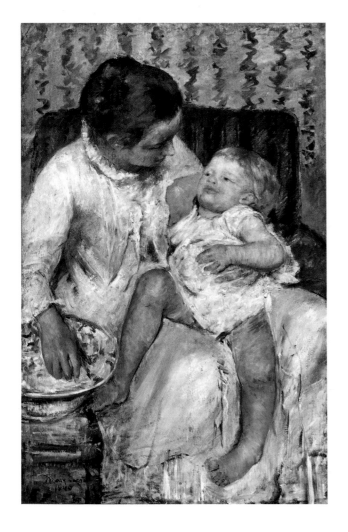

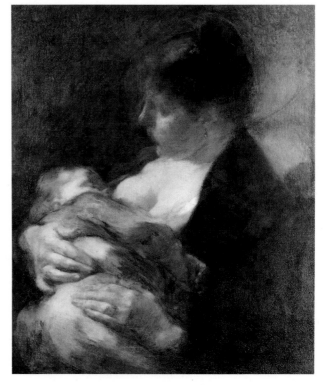

53.
Eugène Carrière. *Maternity*. 1880–1890. Oil on canvas, 22 × 18¼". Collection, Hill-Stead Museum, Farmington, Conn.

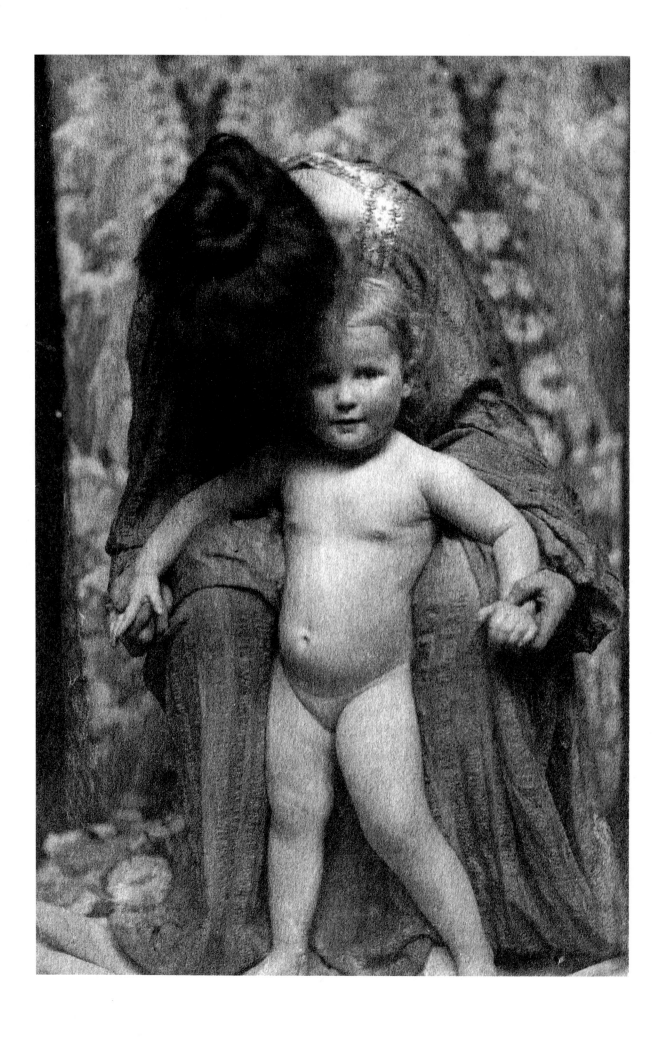

Opposite:
54.
Mother and Child (Decorative Panel). 1899, Platinum print, 7¹⁵⁄₁₆ × 5⅛". The Metropolitan Museum of Art, New York. The Alfred Stieglitz Collection, 1933 (33.43.141)

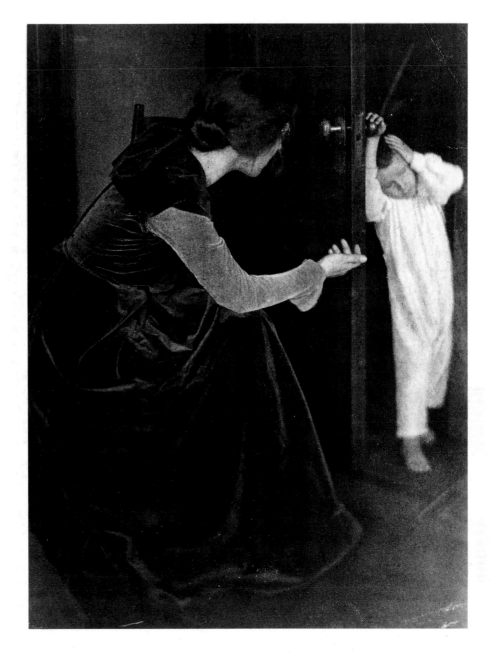

55.
Clarence H. White. *Bashful Child*. 1899. Platinum print, 8 × 6". Library of Congress, Washington, D.C.

behavior. Although he also depicts a mother, child and doorway, Clarence H. White's *Bashful Child* (55) is psychologically unlike *Blessed Art Thou Among Women*; Mrs. White beckons her son to join her, but he shyly remains on the far side of the door, refusing to face the camera.

Eva Watson Schütze came closer to the spirit of Käsebier's work in her portrait of *Alice Dewey, Jane, and Gordon* (39) because she was portraying John Dewey's family and was aware of the philosopher's progressive ideas about education. As Jean F. Block wrote, "the emphasis on the naturalness of the child reflects the Deweys' attitude toward childhood. The composition of the figures, with the smaller child encircled by her mother while the older one gazes out onto the world, makes a psychological as well as an aesthetic statement."[39] Yet the reticence and modesty that Watson Schütze captures in Gordon would be uncharacteristic of a Käsebier.

Blessed Art Thou Among Women (known through reproductions if not from its exhibition at the 1899 Philadelphia Salon) may have influenced Zaida Ben-Yusef to make a similar picture about a year later (38). The two standing figures recall

Käsebier, but Ben-Yusef typifies her era by emphasizing the link between mother and child. The girl's head tilts towards her mother, and she shows no urge to move, perhaps because her mother's restraining hand forestalls her. Conversely, Agnes Lee gives gentle encouragement to Peggy, who seems ready to cross the threshold of the room, and, symbolically, to traverse the boundary between youth and adulthood.

While Käsebier's children are not retiring, neither are they rebellious. They are always the attractive, well-behaved counterparts to mothers who appear to be good, kind and patient. In Käsebier's idealized world, granting independence to children seems to be part of a mother's duty. That is understandable, because Käsebier seems to have embodied some of the precepts of Friedrich Froebel in her photographs, and Froebel, the German founder of the kindergarten movement, believed that mothers as well as teachers should foster children's intellectual growth and independence beginning at infancy. During the 1890s, Froebel's ideas took hold in American homes as well as kindergartens, and articles on the kindergarten movement appeared regularly in many general-interest magazines. A magazine reader like Käsebier could not have missed these articles, which included one illustrated by Frances Benjamin Johnston.[40]

At closer hand, Pratt Institute was among the leading educators of kindergarten teachers. Two training kindergartens were near the art studios, and, while Käsebier was at school, pieces about the kindergarten program and kindergarten theory appeared regularly in Pratt newsletters alongside reports on the art program. Froebel's way of thinking suited Käsebier's own philosophy of independence: she believed that the key to artistic photography was to work out one's own thoughts alone, and that "if you want to have real art you must go it on your own."[41]

Käsebier became a grandmother in July 1900, when Charles O'Malley was born. The event pleased her so greatly that friends took to calling her Granny. She had learned to photograph too late to capture her children's early years, but her four grandchildren were to make up for that: Charles's sister, Elizabeth, was born in 1907; Mason and Mina Turner were born in 1905 and 1907. (The Käsebiers' son, Frederick, married but had no children.)

Real Motherhood, taken soon after Charles's birth, is one of the relatively few pictures in which Käsebier portrays a benign, passive relationship between a quietly embracing mother and a peaceful inactive infant (her pictures of this sort usually depict newborns). This picture is a pendant and complement to *The Manger* (56), which Käsebier also called *Ideal Motherhood*. The *Manger/Ideal Motherhood* connotes archetypal perfect motherhood (and, as no child was photographed in it, the ideal child literally does not exist). Käsebier knew from experience that motherhood was not all sweetness and light. "Children," she said, "they're an awful bother. But a woman never reaches her fullest development until she's a mother. You have to pay the price."[42] Still, *Real Motherhood* is about motherhood's serene moments, not its trials. Speaking about it, Käsebier reflected the kindergarten movement's attitude that motherhood created a bond between women:

> While posing my daughter there suddenly seemed to develop between us
> a greater intimacy than I had ever known before. Every barrier was down.
> We were not two women, mother and daughter, old and young, but two
> mothers with one feeling; all I had experienced in life that had opened my
> eyes and brought me in close touch with humanity seemed to well up and
> meet an instant response in her, and the tremendous import of motherhood
> which we both realized seemed to find its expression in this photograph.[43]

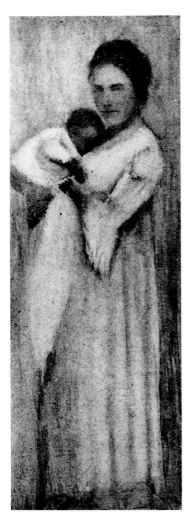

56.
Real Motherhood. 1900. From
The Craftsman, April 1907. General Research Division, The New York Public Library, Astor, Lenox and Tilden Foundations

For the first time since her student days, Käsebier returned to Europe in the summer of 1901 with Hermine as traveling companion. First stop was London, where Käsebier met fellow members of the English Linked Ring society. (The year before, she had been one of the first two women to be initiated.) The conservatism of most English colleagues' photographs disappointed her as much as their inability to understand the more advanced new American work. However, she did strike up a friendship with Frederick H. Evans, the bookdealer turned photographer whose platinum prints of English cathedrals were already widely acclaimed. Evans admired Käsebier's work, and one of her portraits of him gained the admiration of George Bernard Shaw, who wrote photography criticism in addition to plays.[44]

During several weeks in Paris Käsebier found a kindred spirit in twenty-two-year-old Edward Steichen. Tall, handsome, dynamic Steichen had already spent a year there studying art. Stopping in New York en route from Milwaukee, Steichen had met and impressed Stieglitz, who bought three of his photographs for the "princely price" of fifteen dollars. Allaying Stieglitz's anxieties that in Europe painting might overtake Steichen's interest in photography, the young man vowed never to abandon the camera.[45] After some vacillating, he fulfilled that promise in a long career as pictorial photographer, commercial photographer and Director of the Photography Department at the Museum of Modern Art in New York.

Despite an age difference of more than twenty-five years, the Käsebier-Steichen friendship was to last, with ups and downs, until her death. During the summer of 1901 similar photographic concerns, buoyant temperaments, and esteem for Stieglitz united them, but Steichen's future was a subject of disagreement. He thought that Whistler's success with both etching and painting set a precedent for succeeding in two media.[46] Käsebier thought Steichen should devote himself to either painting or photography, and her urging lay behind his eventual decision to quit painting. It may also be said that her portrait studio in New York set an example for Steichen's later American portrait practice.

In France, they described each other in words and pictures. He called Käsebier "one of the best strong steel beams in the ship," meaning she was a central figure among Stieglitz's American photographic allies—the group that within the year would be dubbed the Photo-Secession. He said that she "has been goodness itself . . . and pumped much new energy and enthusiasm into me," and showed that liveliness in a sketch of her handling one of the 6½ × 8½-inch glass negatives that distinguished her work when most other photographers used 4 × 5 or 8 × 10 inch formats[47] (57).

Käsebier wrote Stieglitz that she and Hermine had been having a "double superlative time in Paris . . . with Steichen every day and how I have enjoyed him. He is a corker!"[48] Her photographs capture his tenderness as well as his exuberance. If Käsebier's portraits seem restrained compared to Steichen's self-conscious Whistlerian and Titianesque visions of himself (*A Life in Photography,* plates 3, 18), they are truer informal records of him reclining on a bed or perching on a wall with knees tucked up (58).

Some of the lighthearted times that Käsebier, Steichen and friends shared during 1901 are recalled by a scrapbook mostly of Käsebier portraits of Steichen that was apparently compiled by both of them.[49] Many of these portraits uphold Steichen's self-image as a painter by showing him in a smock or holding a paintbrush. A strikingly sensual platinum print shows Steichen nestling his mouth in his cat's furry neck. Only Steichen's face, his hand and the cat emerge from the velvety dark background, which Käsebier enlivened with arcs and lines of black crayon. Another

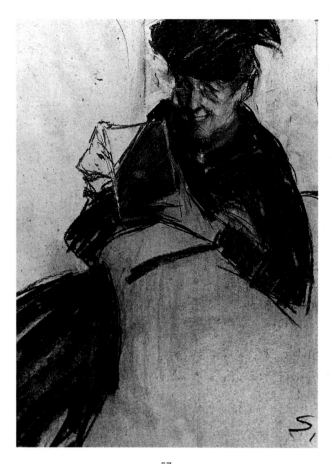

57.
Edward Steichen. *6½×8½.* c. 1901. Charcoal and white
chalk on paper, 17½×12". Collection Mason E. Turner, Jr.
Photo: Jack Bungarz

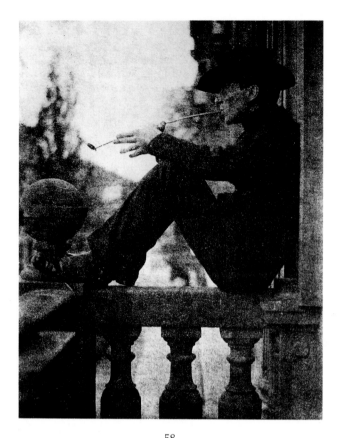

58.
Edward Steichen. [1901]. Gum bichromate print, 8×6¼".
Collection, The Museum of Modern Art, New York. Gift
of Mr. and Mrs. Eugene M. Schwartz

picture, initialed "GK" and titled *Blessed Art Thou Among Women* at the bottom, shows Steichen seated in front of Käsebier's famous photo of the same name, contemplating the paintbrush in his hand. The picture, which seems infused with an air of mock solemnity, reminds us that Steichen was indeed blessed among women on jaunts to the French countryside that summer.

The picnic scene, *Serbonne* (59), is today the best-known record of those excursions. It shows Steichen accompanied by the artists Frances Delehanty and Charlotte Smith, as well as Hermine Käsebier—with Gertrude Käsebier only a camera's distance away. Charlotte's sister, Clara (later Steichen's first wife), also met them for painting excursions, as did the former Pratt student, Willard Paddock, who was courting Charlotte.[50]

The composition of *Serbonne* may have been a playful variation on familiar paintings: Manet's *Le déjeuner sur l'herbe* and/or the *Concert champêtre* in the Louvre (now attributed to Titian but then considered a Giorgione). In *Serbonne* the three women are seated in a glade, deployed like the three seated figures in the Manet and the Titian. Steichen, standing on the left, replaces the standing figure in the Titian.

Despite the many differences between the photograph and the paintings (the horizontal format of the paintings, their juxtaposition of two nude women with two fully dressed men, and differences in poses chief among them), the reference might have been made by Käsebier, or Käsebier in collaboration with Steichen. Steichen

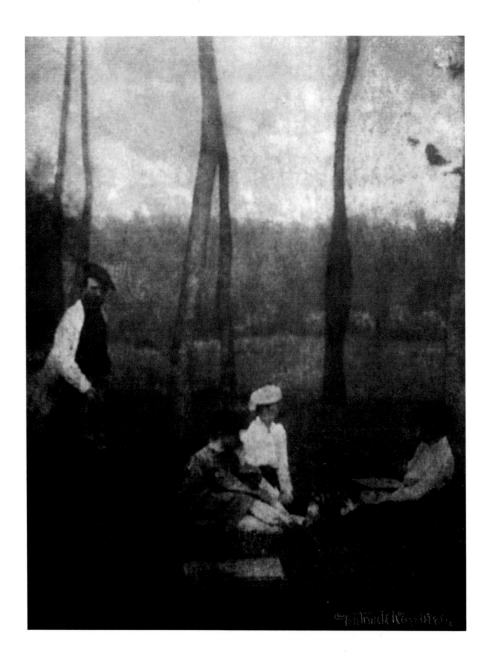

59.
Serbonne (A Day in France).
1901. Gum bichromate print.
12⅜ × 9⁵⁄₁₆″. Collection, The Museum of Modern Art, New York.
Gift of Mrs. Hermine M. Turner

would have seen the Manet at the 1900 Exposition in Paris; Käsebier would have seen reproductions of it. Both would have known the *Concert champêtre* from the Louvre. Steichen had already made oblique reference to a sixteenth-century Italian painting when he photographed himself in what he hoped would be "photography's answer to [Titian's] 'Man with a Glove.'"[51]

Though *Serbonne*'s composition speaks of tradition, its shallow space and impressionistic surface and vague Symbolist ambience do not. Printed in gum on grainy paper (in the version at the Museum of Modern Art) the photograph recalls Seurat's conté crayon drawings, monotone reproductions of pointillist painting—and early Steichen photographs. How much any of these influenced Käsebier is hard to say, because her remaining letters of the time say nothing about art, old or new.

Käsebier's gum bichromate printing matured during her 1901 European visit. During the summer, she began to conceive negatives destined for the broadness and texture that gum could give. Like *Serbonne*, her portrait of Steichen (58), and the later photograph, *Bungalows* (92), such pictures often employed flattened, silhouetted areas which sacrificed detail to painterly or charcoal effects.

Gum printing had come into vogue in Europe after 1895, when Robert Demachy in particular revived the process in France. Publications by the Austrian photographers Hugo Henneberg, Heinrich Kühn and Hans Watzek, as well as Demachy, popularized the process, which Stieglitz introduced to American readers of *Camera Notes* in October 1898.[52]

Käsebier began to try the method by the spring of 1899, but at first she used it much as she had platinum. An early 1901 article on gum bichromate printing praised the medium for giving special effects rather than literal facts, but the accompanying Käsebier illustration scarcely suppresses details.[53] Gradually Käsebier became at home with the soft, textural qualities that gum printing permitted. Until the emulsion of a gum print dried, a photographer could remove parts of the image (as one might rub rubber cement off a piece of paper). It was also possible to incorporate tones and colors into the emulsion, as she sometimes did.

Although Käsebier would have seen some European gum prints in New York, her French visit must have expanded her knowledge of Demachy's and photographer Constant Puyo's sketchy and textural gum prints. She would have been impressed by the broad tonal areas in Austrian work; Henneberg, Kühn and Watzek were members of the Linked Ring whose work she must have seen in London. Most significantly, Käsebier would have had the opportunity of working side by side with Steichen, who had already absorbed the work of his European colleagues and was becoming an all-time master of the gum process.

After Käsebier and Hermine visited her in-laws in Wiesbaden, they went to Munich, where Käsebier's creativity might have been stimulated by the paintings of Franz Stuck and other Munich Secessionists that were on display in the International Art Exhibition at the Glaspalast. She met Steichen in September when he came to Munich to see the Secessionist exhibit; the two artists seem to have taken in the show together. At the Glaspalast, the idea of secession was symbolized in the arrangement of paintings: the Secessionist works hung together in a special group of galleries at one end of the exhibition hall.[54] It was as graphic an introduction to artistic secession as two future Photo-Secessionists could have wished.

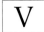äsebier had found success and fame before Alfred Stieglitz endorsed her work in 1899, and she maintained her reputation after breaking with Stieglitz and the Photo-Secession in early 1912. Yet to say that Käsebier would have been a major photographer without Stieglitz's support is not to deny the essential part he played in her life: it was largely through Stieglitz's efforts that her work and that of her Photo-Secession colleagues became widely known and accepted as art.

The Photo-Secession was formed in 1902 as a group of American photographers dedicated to the promotion of photography as a fine art. Stieglitz was its leader; Käsebier, Keiley, Steichen, and White were among its founding members. The organization drew inspiration from European artistic Secession movements, such as those in Munich and Vienna, whose artists broke from the academic establishment. In photography, the English Linked Ring provided another precedent.[1]

Stieglitz diplomatically maintained that he and his associates were simply seceding from "the accepted idea of what constitutes a photograph."[2] However, those familiar with the world of amateur photography knew that Stieglitz and his corps were actually separating themselves from the conservative element of the New York Camera Club and the Philadelphia Photographic Society. Stieglitz and the Secessionists sought more than technical excellence in photography; they saw photography as a means of personal expression. Stieglitz felt photography ought to be treated as an art equal to any other. He promoted the work and ideals of the Photo-Secession through the publication of the elegant magazine, *Camera Work* (1903–1917), and through exhibitions.

The first exhibition of the Photo-Secession at the National Arts Club in March 1902 marked a turning point in Käsebier's career as well as in photographic history.[3] Photography as art had numerous nineteenth-century proponents, but not until the Photo-Secession did a group of photographers unite, under strong leadership, to promote photography's artistic and expressive potential. Stieglitz's guidance made the difference between the diffuse artiness of the English Linked Ring and the taut and ambitious aestheticism of the Photo-Secession.

Although the Photo-Secession was only an idea when Stieglitz named it about a month before the exhibition opened, it soon became what Stieglitz envisioned: a group of "camera workers" (as he liked to call them), espousing the cause of photography as art. The seeming offhandedness with which Käsebier was inducted into the group has gone down in photographic history through Stieglitz's often-cited recollection:

> At the opening, when Käsebier appeared—it was a blizzard night—she said to me, "What's this Photo-Secession? Am I a photo-secessionist?"
> My answer was, "Do you feel you are?"
> "I do."
> "Well, that's all there is to it," I said.[4]

The National Arts Club exhibition, which was widely publicized and praised, contained large groups of pictures by Stieglitz's favorites: Steichen, Käsebier, White, Keiley, Frank Eugene, Day, and himself, but it also included small groups of prints by photographers throughout the country to indicate the pervasiveness of "the

spirit of the modern movement." Geographical representation ran from Maine to California, with a strong showing from Philadelphia. Stieglitz deliberately arranged the pictures monographically

> to enable the visitor to make a comparative study of the individual work and scope of the photographer. Great care had been taken to so place each picture that its tone, color, and line would harmonize with its surroundings, and in consequence many of the pictures which had already been shown at previous exhibitions were imbued with new beauty and their full worth was for the first time displayed.[5]

Stieglitz's aim in the first Photo-Secession exhibition, as well as in succeeding exhibitions and publications, was not necessarily to exhibit new material but to exhibit the best and to show it to its greatest advantage. Thus, it is not surprising to find Käsebier's tried and proven favorites, *The Manger* and *Blessed Art Thou Among Women* (31, 30), leading the list of her fourteen entries in the National Arts Club catalogue. Also included were *The Red Man, Serbonne,* and *Harmony* (11, 59, 45).

After the exhibition, Stieglitz's advanced colleagues encouraged him to continue Photo-Secession activities. When the rear guard of the Camera Club elected a new slate of officers who criticized Stieglitz's editing of *Camera Notes,* Stieglitz turned in his resignation. His plans for a new and independent magazine — *Camera Work* — were soon underway.[6]

In its concern with photographic aesthetics rather than technique, *Camera Work* was a radically new journal. Its interest in beauty extended to perfectionism in reproduction. As editor of *Camera Notes,* Stieglitz aimed to achieve better design and production than those of any American photography magazine; in *Camera Work* he aspired to even greater excellence. The magazine's format was quietly stylish, with bold type and heavy textured paper recalling books and magazines by William Morris and his followers in the Arts and Crafts movement. Almost all reproductions were printed full page in photogravure by the most skilled craftsmen available.[7]

It was not only because he admired her work, but because he adhered to the maxim "ladies first," that Stieglitz featured Käsebier in the first issue. At least, that is what he told Steichen, according to the Käsebier family story.

In August 1902, Stieglitz met with Steichen and Käsebier to divulge his plans for *Camera Work.* Stieglitz intended to devote the first issue to Käsebier, the second to Steichen, but Steichen hankered to be first. Knowing that Käsebier was quite deaf (and thinking her out of earshot as they traveled back from Long Island to New York City on the railroad), Steichen asked Stieglitz to devote the first issue to him, arguing that his talent, youth, poverty, and need to establish his reputation qualified him. Käsebier, he said, required no more publicity or clients. Stieglitz refused, saying that she was the pioneer, and besides, he had promised her the issue. But Käsebier's deafness sometimes seemed to vanish, as Steichen discovered when he later inquired about Käsebier's coolness to him and learned that she had overheard the entire conversation.[8]

This anecdote is more than a vignette of Steichen's unabashed ambition, Stieglitz's idealism and Käsebier's outspokenness; it is a vivid dramatization of evidence that Stieglitz always intended to devote the first *Camera Work* to Käsebier, not F. Holland Day, as some have said. Stieglitz did hope to devote the third issue to Day. Despite their differences over the "New School of American Photography" exhibition and the 1901 Philadelphia Salon, Stieglitz continued to admire Day's photographs and

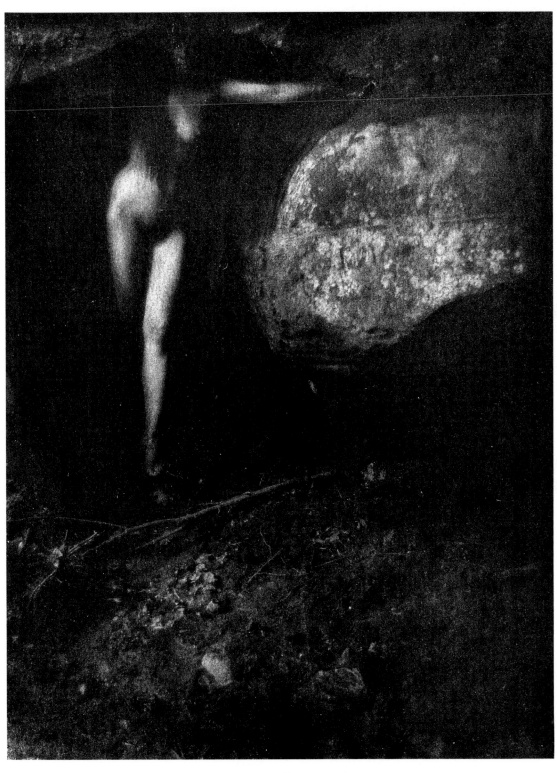

60.
The Bat. 1902. Gum bichro-
mate print, 8×6″. Musée Rodin,
Paris

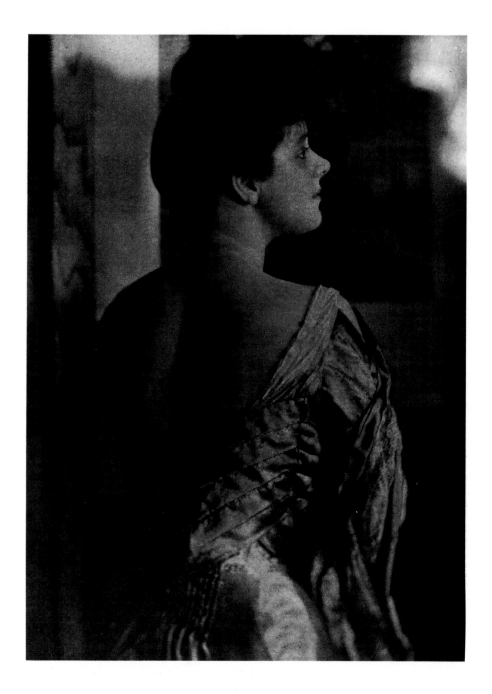

61.
Portrait—Mrs. Philip Lydig.
c. 1904. Photogravure from *Camera Work*, April 1905. Private Collection

included some in the National Arts Club exhibition. Day, however, vetoed Stieglitz's further bids for photographs.[9]

The first *Camera Work,* dated January 1903, actually appeared late in 1902.[10] Most of the illustrations were by Käsebier: two articles and an editorial note concerned her, but the issue was not a Käsebier monograph. In addition to two other reproductions (Stieglitz's *The Hand of Man* and A. Radclyffe Dugmore's photograph accompanying his article on bird photography) there were articles on recent exhibitions and on photographic aesthetics (including one by Steichen), as well as a few brief poems.

The six Käsebier photographs reproduced were meant to signify her versatility in subject and handling. There were varied portraits: *Dorothy* (a child), *Portrait (Miss N.)* (Evelyn Nesbit, the glamorous showgirl), and *The Red Man,* (79, 11). Although they had already been featured in *Camera Notes, The Manger* and *Blessed Art Thou Among Women* made an encore in *Camera Work* because Stieglitz thought that

excellent pictures deserved repeated exposure, and because he understood that pictures were viewed differently under different circumstances.[11] The editors (for which read Stieglitz) rightly apologized that the halftone of *Serbonne* (59) did not do full justice to the original gum print.

The other reproductions were photogravures, produced from Käsebier's original negatives. The editorial note assures us that these are "absolutely straight photography, being in no way faked, doctored or retouched."[12] Four of the gravure reproductions were printed on Japanese tissue, translucent, fine-grained paper that is compatible with the delicacy of the motherhood prints and female portraits. By contrast, Stieglitz printed *The Red Man* on heavy, dark tan paper to complement the deep tones of the Indian's complexion. The slight roughness of the paper enhanced the woolly texture of his blanket and suited the simple, broad design of the portrait.

Stieglitz chose prominent figures as essayists: Caffin, the art editor of the American section of *International Studio* and art critic of the *New York Sun*, and Johnston, whose renown as a photographer then equaled or exceeded Käsebier's. Each was a known quantity; each had already published a laudatory piece about her. For the *Ladies Home Journal*, Johnston had emphasized the "tender grace" of Käsebier's motherhood photographs, but for *Camera Work* she stressed the national influence of Käsebier's portrait style on professional portraitists, "many of whom may not even know her name." In both articles, Johnston described Käsebier's talent for photographing people: her artistic ability, her sincere feeling, and her patience and sympathy.[13]

Like Johnston, Caffin praised Käsebier's portraits and mentioned her sympathy for her subjects, but Caffin was more interested in aesthetics than Johnston. Although he was less specific or critical than he had been in his earlier, longer essay on Käsebier, he was concerned about explaining her artistic accomplishment. He praised her handling of light and shade, tone and textures to make an artistic ensemble and singled out *The Manger* to prove "how abundantly Mrs. Käsebier possesses the picture-making faculty." Although some considered the Johnston and Caffin essays to be too laudatory (one critic called them "effusions"), they complemented the Käsebier reproductions to form a coherent whole.[14]

For two years the quarterly issues of *Camera Work* followed a similar format, with about a half dozen full-page gravure reproductions and an essay devoted to each featured photographer, including Steichen, White, Frederick H. Evans, Demachy, Coburn, Eva Watson Schütze, and others. A few more photographs (with a Stieglitz here and there), some verse, and articles on various aesthetic, photographic and whimsical topics completed each issue.

By the tenth issue, Stieglitz had run the course of his favorites and was ready to return to Käsebier. But, although the April 1905 *Camera Work* reproduced six of her photographs, Käsebier could not have been satisfied; it contained fewer than a hundred words about them. Käsebier's work was central to the first issue but oddly tangential to the tenth, which combined an unfavorable review of a Steichen painting exhibition with articles on artistic and photographic aesthetics that were likewise unrelated to her. There is virtually no record of transactions between Käsebier and Stieglitz in compiling *Camera Work* Ten. However, Stieglitz was under a great deal of strain at the time, and his comment that he had had "quite a session at Käsebier's studio" suggests that the two were wrangling over the magazine's contents.[15] Stieglitz had already begun to favor Steichen's ideas and photographs, giving the young man's photographs precedence over Käsebier's in group exhibitions. By 1905 Käsebier and Stieglitz had ceased to see eye to eye.

Her pragmatic approach to photography was at odds with the ideals of most of her fellow Secessionists, as shown by a dispute that occurred during the summer of 1904 when Käsebier had an opportunity to sell hundreds of photogravures from the first *Camera Work*. She felt no qualms about asking Stieglitz (who was in Europe) and his New York associates to make extra offprints for her. They refused. Even Steichen, who was usually not averse to making a dollar, was upset, telling Stieglitz that she "had the cheek to ring up . . . and order some prints from the photogravure plates."[16]

The Käsebier photographs that Stieglitz did not publish in *Camera Work* Ten are at least as instructive to consider as those that he did, because Stieglitz omitted all photographs that Käsebier had reworked—on the negative or in other ways—although she was well known and admired for them. Among these was *The Heritage of Motherhood* (30), which Keiley had called "one of the strongest things that she has ever done, and one of the saddest and most touching that I have ever seen."[17] Keiley commented that his taste differed from his associates'; presumably Stieglitz was one with whom he differed.

However, Stieglitz did not (or could not) always reject those photographs that Käsebier manipulated; *The Road to Rome* (66), *Black and White* (68) and *The Heritage of Motherhood* were shown at several Photo-Secession exhibitions. He even owned a copy of *The Bat* (60), the enigmatic and atypical photograph taken when Käsebier visited the Clarence Whites at their Newark, Ohio, home in August 1902. The bat (posed by Mrs. White) is a nude woman with outspread wings (a dark veil). Stieglitz wrote: "White claims that he and Mrs. K. did [*The Bat*] together. That it was his idea." Yet Käsebier always signed and exhibited the picture as her own. A gesture as bold as that of Jane White's in *The Bat* is not to be found in her husband's photographs around 1902, when he depicted women in demure, contained, static poses, and seldom nude (see 47, 55). While White may have guided Käsebier to the wooded site and suggested the nude subject, which was virtually unique in Käsebier's work, the vision of an unreserved woman seems to be Käsebier's alone. It is also characteristic of Käsebier, but rare for White, to use obvious handwork in her images, as she has in the area around the "bat." In its depiction of a figure melding into murky, ambiguous space, *The Bat* resembles Steichen's Symbolist-influenced photographs that Käsebier had seen in Paris the year before as well in New York after Steichen's return during the summer of 1902. Whether Käsebier was influenced by Steichen or by some of the same sources that had influenced him, pictures like *The Bat* were known to appeal to Stieglitz, who, around 1900, owned reproductions of German Symbolist art.[18]

But *Serbonne* had taught Stieglitz the difficulty of reproducing Käsebier's manipulated gum prints, so in *Camera Work* Ten he advanced other values, pointing out that "individuality, strength and feeling are possible *without the slightest manipulation other than lens, lighting, developing and printing*"[19] (my italics).

The photographs he chose in the service of his idea comprise a diverse and uneven group. Stieglitz's admiration for Käsebier's portraiture remains evident in two portraits of women—Miss Minnie Ashley and Mrs. Philip Lydig (61). A close-up of two cows peering over a stone wall recalls Barbizon School-like cattle photographs by Stieglitz, Käsebier and others, but its title, *My Neighbors*, personifies the inquisitive creatures. The scene was the first of several in which Käsebier was to use animals to cast aspersions on human foibles. *Pastoral,* an asymmetrically composed landscape with Hermine Käsebier and her fiancé William Mason Turner posed affection-

62.
Happy Days. 1903. Gum bichromate print. 12⅝ × 10″.
Library of Congress, Washington, D.C.

ately in the distance, is the only Käsebier in *Camera Work* Ten to be printed on heavyweight paper and tipped onto tissue; all others are on Japanese tissue.

Happy Days and *The Picture Book* (62, 64) are the images that best convey the "individuality, strength and feeling" that Stieglitz sought to show in this issue. Consciously or not, Käsebier envisioned *The Picture Book* to embody Arthur Dow's precepts on asymmetric yet balanced design, but she must have composed *Happy Days* in the ground glass viewfinder of her camera. With a vision doubtless primed by cut-offs in Degas, Whistler and Japanese prints, Käsebier cut off part of each figure on all four edges of *Happy Days*. The "decapitation" of the center girl was caricatured in France (63), where a conservative critic quipped that "she amuses herself by systematically chopping people off; in *The Sketch* only the tip of the head is missing, but *Happy Days* is a real massacre."[20] More perceptive viewers would have seen *Happy Days* as a prime example of Käsebier's innovative vision, her ability to adapt modern compositional devices, like cropping and shallow space, to photography.

63.
L. Rudaux and P. Dent. *Etude de vivisection*. Parody of *Happy Days* from "Le Salon Comique," *Photo-Gazette*, May 25, 1904. General Research Division, The New York Public Library, Astor, Lenox and Tilden Foundations

Happy Days, *The Picture Book*, *Pastoral*, and *My Neighbors* had been the result of a second productive summer's work in Newport during 1903, when colleagues and family often posed outdoors for Käsebier. Some of that summer's family photographs, like the graceful triptych of Gertrude O'Malley and Charles (65), never left the family. Others did double duty and were widely published or exhibited.

As an appealing toddler, Charles became the protagonist in many photographs. Since his birth Käsebier had been fulfilling her earliest aim in photography: to record her growing family. In *Happy Days* she may even have been rethinking the problem of her very first photograph (3), to depict figures in a grassy field. Instead of half camouflaging the subjects as she once did, she used a filigree of flower stems and grasses as a net uniting Charles O'Malley with his friends.

With its winding road and flattened trees, stylistically *The Road to Rome* (66) is another 1903 photograph that pays homage to Arthur W. Dow. Its meaning, however, derives from "The Roman Road," a story by Kenneth Grahame, who is best known for *The Wind in the Willows*. In "The Roman Road," the protagonist, looking back on his youth in an English town, recalls taking a "solitary ramble" along a country road that neighborhood children deemed special, because

> if from any quarter at all, it would be down this track we might some day
> see Lancelot and his peers come pacing on their great war-horses. . . . "All
> roads lead to Rome," I had once heard somebody say; and I had taken the
> remark very seriously, of course, and puzzled over it many days. There
> must have been some mistake, I concluded at last; but of one road at least I
> intuitively felt it to be true.[21]

On the road, the boy is amazed to meet a friendly artist who actually lives in Rome part of each year. The boy confides his fantasy, not only of seeing Rome, but of finding an unpopulated city where "you go into the shops and take anything you want—chocolates and magic-lanterns and injirubber balls—and there's nothing to pay; and you choose your own house and live there and do just as you like, and never go to bed unless you want to!" Returning home, the boy "went down-heartedly from the man who understood me, back to the house where I never could do anything right. How was it that everything seemed natural and sensible to him, which these uncles, vicars, and other grown-up men took for the merest tomfoolery?"[22]

Käsebier would have known "The Roman Road" from *The Yellow Book,* copies of which she treasured for years.[23] Today, the magazine is best remembered for exemplifying the English Aesthetic movement in its Aubrey Beardsley illustrations, but it also published literary pieces, including many stories by Grahame.

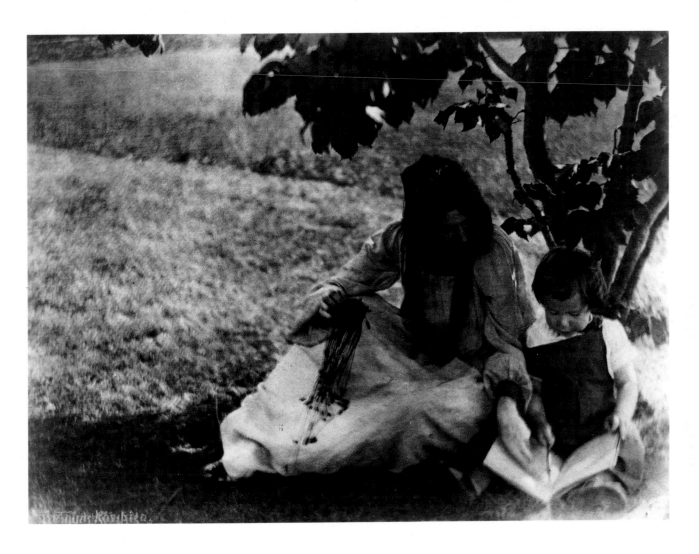

64.
The Picture-Book (Beatrice Baxter Ruyl and Charles O'Malley). 1903. Gum bichromate print, 9¼ × 12½". Library of Congress, Washington, D.C.

Although Käsebier's version of "The Roman Road" is not literal (Grahame's story concerns a boy several years older than her grandson), she nonetheless meant it to evoke the story's appreciation of the imaginative capacities of children and artists. In 1930, she told a newspaper reporter that *The Road to Rome* remained one of her favorites, and that it was allegorical. In the picture, she said, her grandson sees "a wild rose. There is also a lamb tethered to a bush, and a duck idly floats on the water." Yet no rose, duck or lamb can be seen in the blackness of the photograph. A glossy workprint of *The Road to Rome* at the Princeton University Museum shows how she painted over the print, which she then rephotographed. Was her obvious handwork, the painting with which Käsebier transformed the landscape, a device to symbolize the way in which a child's freewheeling imagination or an artist's hand can create an imaginary world? Even to a viewer with no knowledge of the Grahame story, the title suggests that in a child's mind, a path might point to faraway places (though a map shows that Valley Road merely connects Newport with the adjacent community of Middletown). The solitary boy in an empty landscape may also have reminded Käsebier of her own unfettered childhood, when she "played alone among the rocks

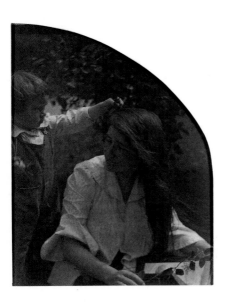

65.

Gertrude O'Malley and Charles O'Malley, Newport, R.I. 1903. Triptych. Platinum prints, 7⅜ × 5⅞",
7⁹⁄₁₆ × 5¹¹⁄₁₆", 7⁷⁄₁₆ × 5¹³⁄₁₆". Collection of the J. Paul Getty Museum, Malibu, Calif.

of Colorado" where "the vast altitudes and spaces appealed to me in an unforgettable way."[24]

Colorado would have been on her mind because the illustrator Beatrice Baxter Ruyl, a native Coloradan, visited Newport that summer. *The Picture Book* (also sometimes called *Instruction*) concerns Beatrice Ruyl as much as it does Charles O'Malley, whom she is helping to draw in her sketch book. Although a casual observer might take this for a mother and child picture, it and *The Sketch* (67), which shows Ruyl at work, should be considered among Käsebier's visual "biographies" of accomplished women. Ruyl had studied art in Boston and Paris where she became friendly with Day and Steichen as well as Käsebier.

Back in Boston, Beatrice Ruyl became an illustrator specializing in pictures of children, and Käsebier's picture of her with Charles bespeaks her love for others' children. Beatrice's right hand holds a clue to her interest in crafts: at home she made bobbin lace and wove on a large loom; in *The Picture Book* she appears to be making a small, Indian-style grass basket, a skill she may have learned while living among Zunis during her honeymoon with the artist Louis H. Ruyl. In both pictures, she wears the Native American jewelry and toga-like gown that she favored over corseted styles of the day.[25]

Just as Käsebier had taken *Blessed Art Thou Among Women* as a portrait and a study in white tones, in the summer of 1903 she conceived *Black and White* (68) as an informal portrait and an exercise in contrasts. The picture nods to tradition, harking back to numerous French paintings of laundresses and more specifically referring to the bent figures of Millet's *Gleaners*. The photograph also synthesizes Käsebier's earlier photo of a white laundress with an 1893 sketch of a black train porter that she also considered a study in black and white.[26]

The laundress's checked apron and gap-toothed grin echo the dark stockings hanging against white linens. Handwork on the negative of this gum bichromate print has darkened and emphasized the stockings, which seem to be kicking at the confines of Victorian prudery, as if Käsebier anticipated the criticism she would receive for turning laundered undergarments into the stuff of art.[27]

Käsebier's portraits of Adolf de Meyer, the cosmopolitan photographer whom she had just met in Newport, cast him as sybaritic and self-dramatizing.[28] In one picture he lies on grass, gently touching the low branches of a tree that shades him (IMP/GEH). In another lush image that she printed in several variants (Musée Rodin, IMP/GEH), he stands at a wall, hand on hip; a flowered field fills most of the foreground (69).

Photographs are our greatest evidence of this prolific season. Almost no letters remain. The following summer was less fruitful, yielding only one major photograph, *The Heritage of Motherhood*, which she took during a visit to F. Holland Day's summer place in Maine.

In July 1905, Käsebier told Day that a specialist had diagnosed her as suffering from mental strain rather than overwork. The first half of 1905 had been hard on her. Added to the tensions between her and Stieglitz in publishing *Camera Work* was her husband's decision to move to Oceanside, Long Island. The Käsebiers' son-in-law, Joseph O'Malley, who was involved in real estate, had bought the large frame house set on two-and-a-half acres of land near the shore, just beyond the New York City boundary. Eduard saw it, fell in love with it and bought it, with the proviso that the O'Malley's live with them.[29] But because Eduard took none of his wife's suggestions for artistic remodeling, the house became a source of discord between them.

However, cruising the Mediterranean with Frances Benjamin Johnston provided a much-needed rest. The two women got along "capitally," as Johnston put it. Their

66.
The Road to Rome. 1903.
Platinum print, 9¼ × 13⅛". Collection, The Museum of Modern Art, New York. Gift of Mrs. Hermine M. Turner

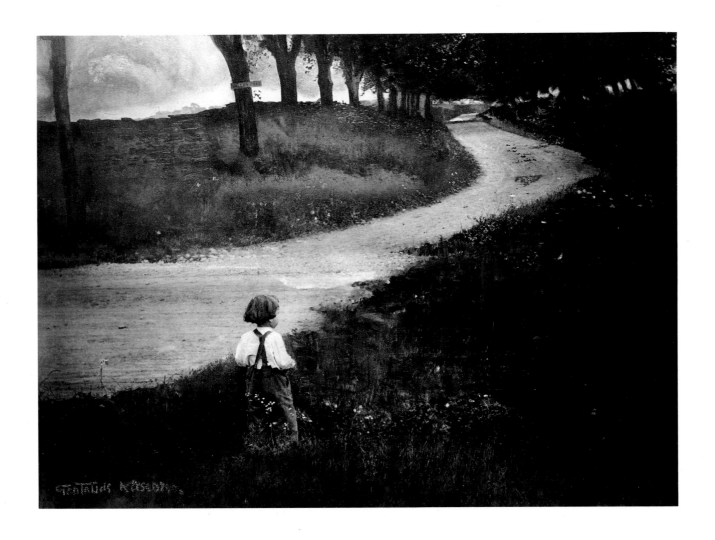

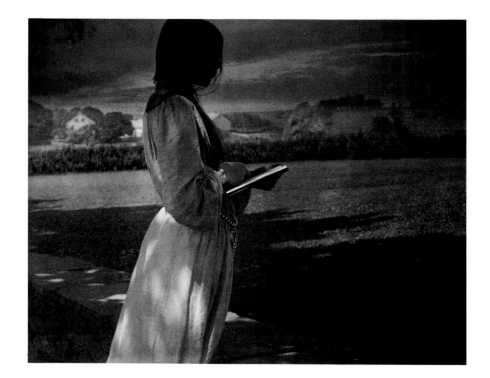

67.
The Sketch (Beatrice Baxter Ruyl). 1903. Platinum print, 6¹⁄₁₆ × 8³⁄₁₆″. The Metropolitan Museum of Art, New York. The Alfred Stieglitz Collection, 1933. (33.43.136)

acquaintance dated to 1899 when they had been co-jurors at the Philadelphia Salon, but except for occasional professional encounters, the two women seldom corresponded or met until 1905, when Johnston opened a New York branch of her studio. Despite their limited contact, Johnston's article in *Camera Work* revealed that by 1902 she had assessed her colleague's temperament, her "intuition, tact, sympathy and infinite patience."[30]

The two spent days "wallowing in the charm of Venice" where they visited de Meyer. A decade later he would become America's leading fashion photographer. Baron de Meyer welcomed both women to the Palazzo Balbi Valier, the ample palace on the Grand Canal that he and his wife Olga rented for several seasons. Photographing de Meyer among the palazzo's handsome furnishings, Käsebier drew attention to his elegant slimness and distinctive profile (MOMA). Käsebier often downplayed men's clothing, but not de Meyer's. To her at the palazzo, he seemed "a gorgeous vision in rich deep pink silk blouse and linen trousers, against a background of stately marble columns." Her photographs make him seem so affected and foppish that Steichen's first response to meeting de Meyer was that the baron was not as bad as Käsebier had depicted him.[31]

Little has been written about de Meyer's early career, so it is enlightening to learn that Johnston found him "a most charming man who is immensely rich and quite well known as an amateur photographer." He was also "an enthusiastic admirer of Mrs. K.," and she of him. He generously placed all his apparatus and his darkroom at both women's disposal.[32]

They photographed Venice and each other in casual postcard shots and some larger, more formal pictures. It was probably at this time that de Meyer took his remarkable profile portrait of Käsebier (70). If the portrait were not so firmly identified, we might scarcely associate it with her, so thoroughly has de Meyer etherealized the sturdy fifty-three-year-old photographer, who not long before had written, hyperbolically, "I am getting so fat I expect my legs and arms soon to disappear and to roll like a ball."[33]

It is not just that this portrait shows de Meyer's incomparable ability for photographic flattery. The picture is not mere flattery in the service of glamour (as some of his later fashion photographs would be) but, rather, a compliment that evokes the subject's fine sensibilities. One feels that de Meyer has seen beyond the practical-looking woman with a camera to picture her, mysteriously shrouded and removed from the cares of daily life, as mistress of her dreams and fantasies. He has taken her out of time and context. Soft focus deletes wrinkles. A dark semitransparent veil replaces her usual large hat or wispy bangs and chignon. Instead of the firmly set, determined jaw so characteristic of her in most photographs, de Meyer shows her openmouthed, half smiling. This is the embodiment of the woman who, on an earlier vacation, could exclaim, "I wander about and dream and dream and am unconscious of material conditions. I live truly in the spirit. Would that I need never wake."[34]

68.
Black and White. [1903]. Gum bichromate print, 8¼ × 6⅞".
Collection, The Museum of Modern Art, New York. Gift
of Mrs. Hermine M. Turner

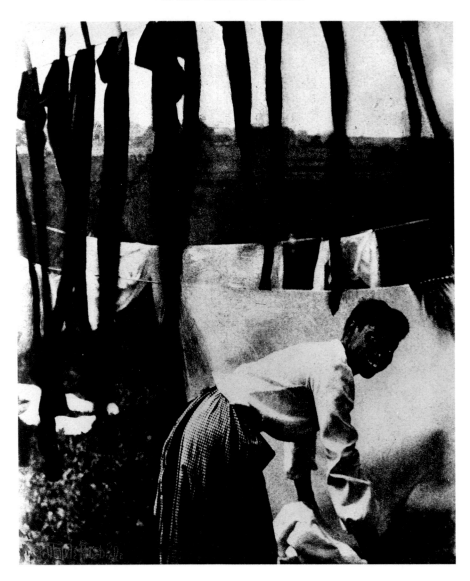

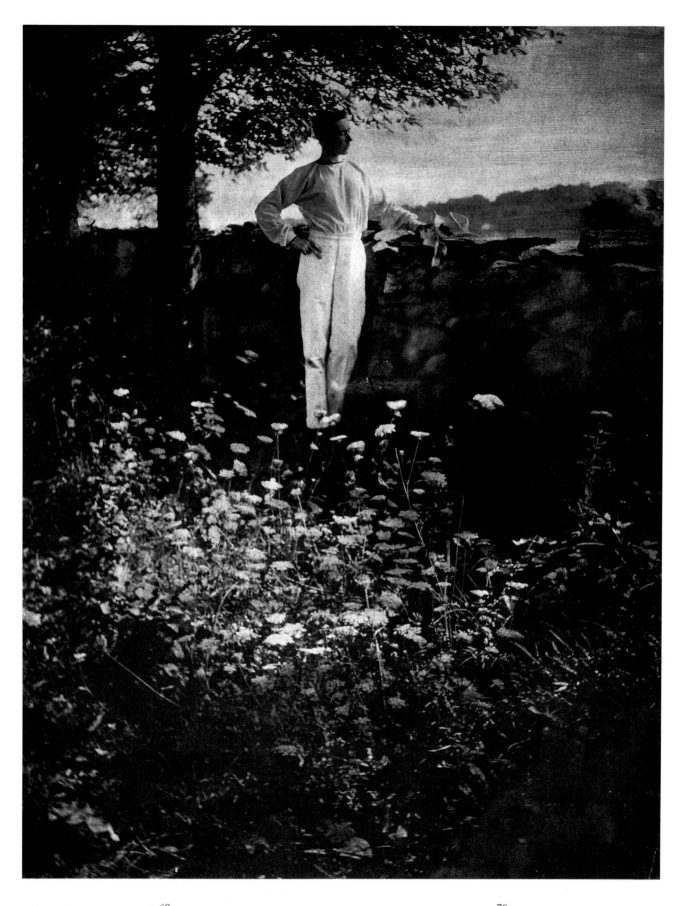

69.
Portrait of Baron de Meyer. [1903]. Gum bichromate print,
13⅜ × 10". Collection, The Museum of Modern Art, New York.
Gift of Miss Mina Turner

70.
Opposite: Baron Adolf de Meyer. *Profile of Gertrude Käsebier.*
c. 1905. Silver print, 14 × 10". Collection the Wellesley College
Museum. Gift of Miss Mina Turner

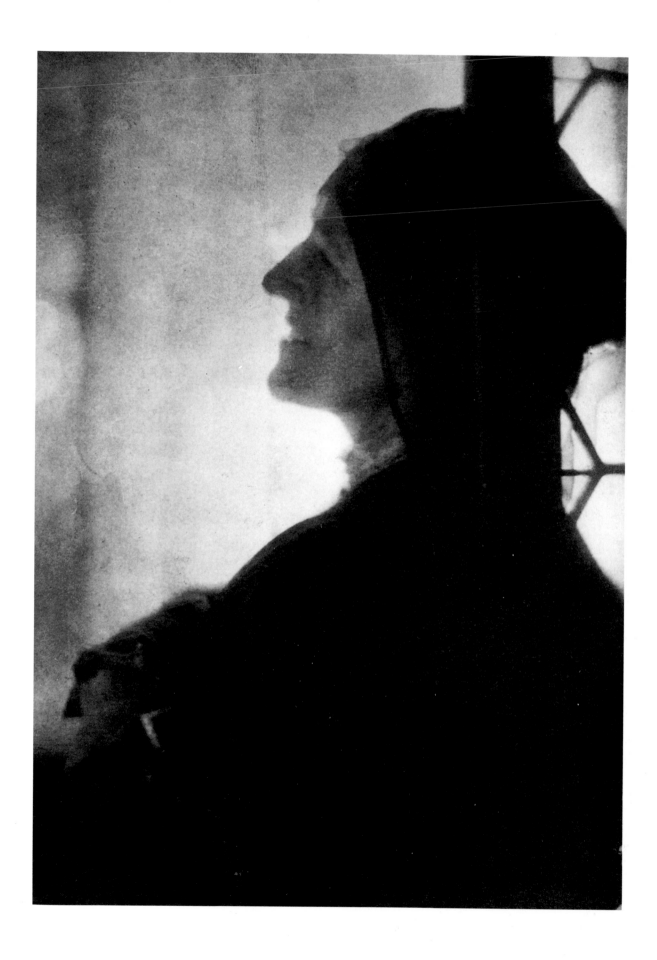

After Venice, Käsebier and Johnston went separate ways for a few weeks. While Johnston visited the Lumière family (in part to learn about their new color photography process),[35] Käsebier headed towards Paris with de Meyer's letter of introduction to the French sculptor, Auguste Rodin.

It is ironic that Rodin, who could transform clay and stone into lifelike forms, seemed to become petrified by a camera. In every other way, Rodin was a perfect subject. Full beard, stocky frame, and fame contributed to a commanding presence. Urging Alvin Langdon Coburn to photograph him, George Bernard Shaw wrote: "No photograph yet taken has touched him: Steichen was right to give him up and silhouette him. He is by a million chalks the biggest man you ever saw; all your other sitters are only fit to make gelatine to emulsify for his negative." Critics have long considered Gertrude Käsebier's portraits to be among the most sensitive likenesses of the great sculptor, but only as documents about their friendship have

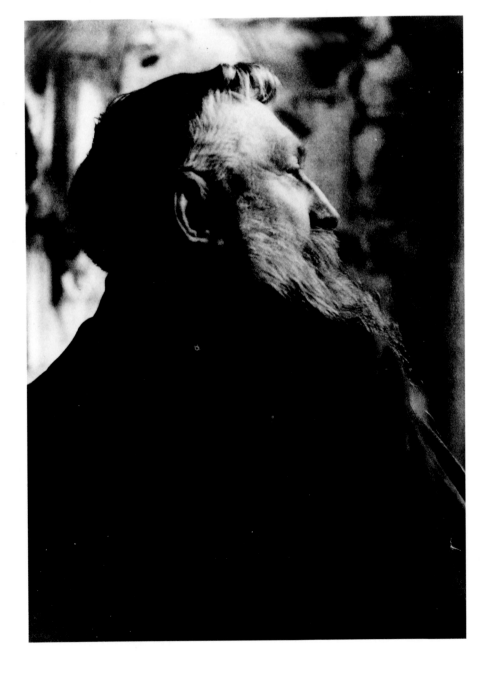

71.
Auguste Rodin. 1905. Platinum
print, 8½ × 6¼".
Musée Rodin, Paris

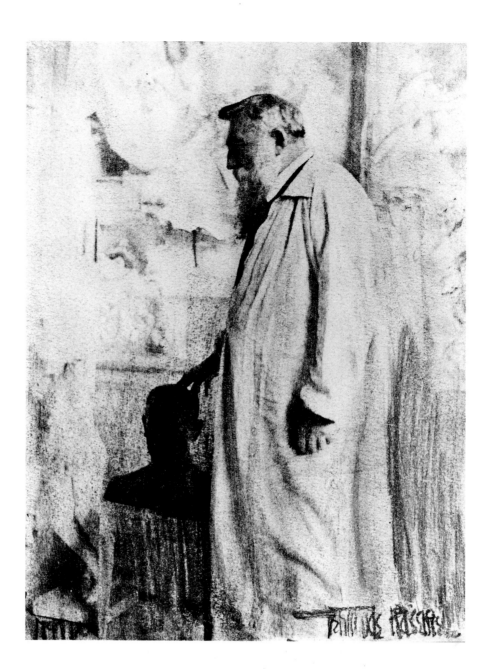

72.
Auguste Rodin. 1905. Gum bi-
chromate print, 8⅞ × 6⅞″. Musée
Rodin, Paris

become publicly available has it become possible to comprehend Rodin's admiration for Käsebier's talent and her reverence for his creative genius.[36]

At the turn of the century, Rodin was the world's most famous living artist. Sculptures like *The Thinker* and *The Kiss,* as well as his controversial monument to Balzac, were known to European and American art lovers when a pavilion devoted solely to his sculpture at the 1900 Paris Exposition brought him new eminence. Devotees ranging from artists to aristocrats sought to meet Rodin at his Parisian studio or, better still, at his home in Meudon, less than half an hour's train ride from Paris, where guests were welcomed on Saturdays. There, after 1900, visitors could see Rodin's sculpture in the spacious pavilion that had been transplanted from the Exposition to become his studio and museum, housing some of his antiquities and exotic art. Other examples were to be seen in his garden.

Photographing Rodin was one of the goals of Edward Steichen's first trip to Paris, but he did not meet Rodin until the fall of 1901—after Käsebier had returned to New York. He had the opportunity to visit the sculptor weekly for a year, and thus to

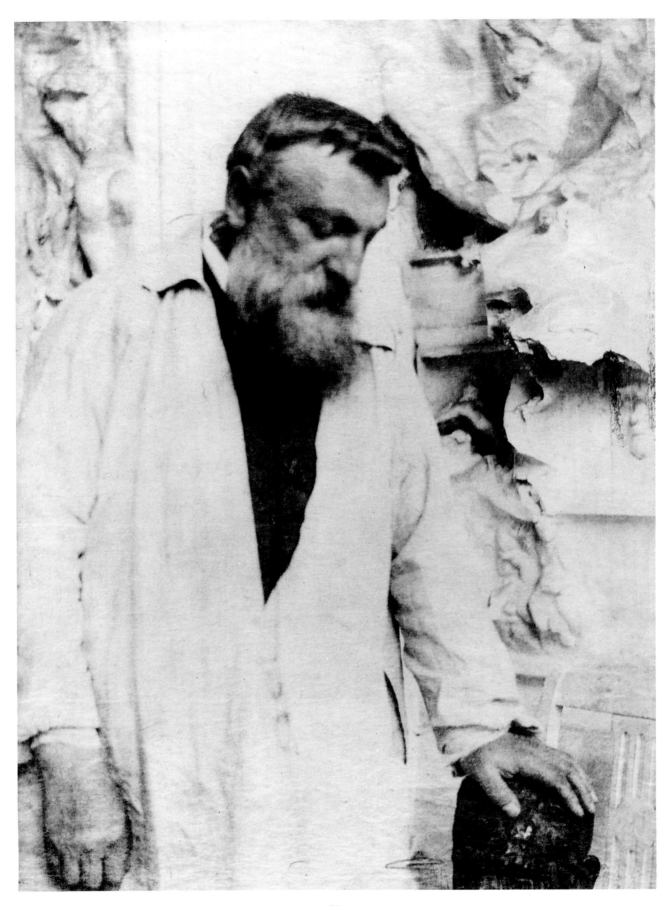

73.
Auguste Rodin. 1905. Platinum print. 13 × 9⅞″. Musée
Rodin, Paris

know him quite well before taking the pictures of Rodin and his sculpture that are among Steichen's finest early photographs.

Like Rodin's more celebrated friendship with Steichen, Rodin's acquaintance with Käsebier testifies to the sculptor's appreciation of talented photographers. De Meyer's flowery letter of introduction flattered both the sculptor and the photographer and assured Rodin that she

> has the greatest wish to become acquainted with you and to see your work at Meudon. . . . She is a very artistic woman and appreciates all that is great and beautiful in Art. She is perhaps the *greatest* photographer in America, certainly in her genre the equal of Mr. Steichen, and I believe that in permitting her to visit you, you are not opening your door to someone unworthy of the honor that you grant.[37]

During September, Käsebier photographed Rodin and the grounds and studio at Meudon. Because she revered Rodin—and because she called him the most restless subject she had ever photographed—Käsebier counted her pictures of him among her greatest accomplishments. As if to highlight her achievement, as well as to protect her financial interests, she copyrighted her Rodin pictures.

In later years, Käsebier maintained that

> Rodin was a terrible man when it came to photographs. When he knew he was going to be photographed, he'd stiffen into the most grotesque and absurd postures. . . . [But] I caught him in one of his moments. He was relaxed and brooding. He didn't know he had been photographed until it was all over. A connoisseur came over to me one day after seeing the picture and said: "Mme. Käsebier, you flatter Rodin. I doubt if there is all the tenderness and gentility about him that is in your portrait."[38]

The connoisseur was Arthur Jerome Eddy, a Chicago lawyer with an adventuresome love of art, who must have met Käsebier in 1913 while he was in New York purchasing more than two dozen items (including paintings by Marcel Duchamp and Francis Picabia) from the Armory Show. In 1898, Eddy had been the first American to sit for a portrait by Rodin, but Käsebier perceived an aspect of the sculptor that he hadn't. To Eddy's accusation of flattering Rodin, she unhesitatingly replied: "You haven't got it quite right, Mr. Eddy. That is Rodin in the presence of a woman!"[39]

Käsebier was not alone in noticing that Rodin behaved more graciously towards women than towards men. Even behind the camera, being a woman helped, because Rodin believed that, "in general, women understand me better than men. They are more attentive." Moreover, Rodin's acceptance of women as artists would have helped him to appreciate Käsebier.[40]

Over the years, Rodin's notoriety for womanizing has run a close second to his fame as a sculptor. Yet Käsebier's friend, Adèle Miller Clifton, who spent many hours visiting Rodin with her, did not perceive Rodin as a licentious man, though he would often kiss Käsebier on the forehead or hand in response to her apt remarks in comprehension of his work. Flattered though Käsebier was by Rodin's admiration, she dismissed his kisses as a French convention. She saw beneath his physical demonstrativeness to an aesthetic affinity at the core of their friendship—a relationship that they sustained despite a language barrier and infrequent encounters. Albert Elsen has observed that "the bond between Rodin and his photographers was their joy in and love of light as the means by which they could achieve expression." Käsebier felt such a bond. From Frederick Lawton's *Life of Rodin* (a copy of which she

kept in her studio waiting room), she quoted Rodin: "Light and shade are all a sculptor needs, if his structural expression is right." This quotation, she told Day, explained "the law and also the reason I have found favor with the great Sculptor quite unconsciously."[41] Like a sculptor, Käsebier dealt not in color but in modulation of light and dark.

Käsebier would have recognized another affinity with Rodin: their mutual interest in the emotive possibilities of hands. Auguste Rodin liked to sculpt hands alone as an expressive artistic device, as a study in which a part of the body stands for the whole. When Käsebier visited Meudon, she undoubtedly saw such fragmentary sculptures in his studio. However, even before she met Rodin, Käsebier had experimented with printing photographs of hands and feet, probably by enlarging sections of more complete portraits. None of these pictures seem to survive, except as an English visitor to her studio described them in 1903:

> A casual remark of ours about hands brought out half a dozen big sheets
> of paper on which were mounted in succession, hands and nothing but
> hands—the hands of a poet, a coquette, Mark Twain, a laborer, a plutocrat,
> a civilized Indian, a musician, a political economist, a playwright, an actor.
> "There is far more to be seen in hands than many people think. Look at
> Mark Twain's hands," said Mrs. Käsebier, "one can see in them alone the
> enervating effect of European luxury upon the once energetic nervous
> American. You Europeans have quite spoiled him."[42]

In photographing Rodin, Gertrude Käsebier "sought to understand him, to make the portrait show his greatness as a sculptor and an artist," but she encountered difficulties not unlike Rodin's in depicting Honoré de Balzac. Rodin had struggled to reconcile Balzac's chunky body and nineteenth-century clothing with the heroic sculptural image of a great writer, and had finally settled on showing the author in a timeless-seeming robe, like the one that he had actually worked in.[43]

Describing her problems in photographing Rodin, Käsebier explained that "an awful business suit" had emphasized his large belly, and that he had an unflattering habit of throwing his head back. She told her daughter that Rodin had self-consciously presented one profile and then the other, until Käsebier threatened: "I shall never come again" (but probably in English, which he did not understand).[44] Eventually, she got the portraits she wanted by camouflaging Rodin's suit with his smock and by waiting until he lowered his head meditatively for two photographs (72, 73) and gestured, as in conversation, for another (Rodin Museum). But first, she made the most of the situation at hand. By moving her camera behind Rodin and composing the image with broad areas of light and shade, she disguised his dull suit and made his upraised head seem heroic in a bust-length portrait that recalls Rodin's own sculpture busts (71). Partial backlighting silhouettes Rodin's head and shoulders. The face and beard are clearly lit; a sliver of light defines the nose. This strongly conceived profile is supported and dramatized by the dark area.

Rodin approved of similar backlighting in photographs of his sculpture, as in Druet's 1898 photograph of *The Kiss* (Elsen, *In Rodin's Studio*, plate 109), where a ribbon of light outlines the left side of the sculpture. Whether the portrait's lighting was Käsebier's idea, or whether Rodin collaborated by suggesting it (as he gave advice and direction to Druet and Steichen[45]), the picture exemplifies Käsebier's and Rodin's mutual interest in photography's interpretive and expressive capability.

Käsebier's favorite Rodin portrait (73) is one of three she made of Rodin in his smock, standing in front of his model for *The Gates of Hell*. The picture is unusual

among portraits of Rodin, because it shows him as he might have been seen in his studio. Käsebier has caught what observers say was a characteristic pose: Rodin caressing a sculpture—in this case his bust of Baron Paul d'Estournelles de Constant, the French diplomat and pacifist.[46]

Käsebier's portrait is atypical, as Rodin portraits go, for its predominantly light tones. Rodin worked surrounded by the whiteness of clay and plaster sculptures. Even when one was cast in bronze, the plasters remained in the studio. Yet photographs of Rodin in this white ambience are rare. It appears that only Käsebier, and later Steichen in a 1907 autochrome (reproduced on the cover of the *Metropolitan Museum of Art Bulletin*, Spring 1981), portrayed him in his pale surroundings. To Käsebier, the light shimmering on *The Gates of Hell* was an appropriate, challenging

74.

Gertrude Käsebier(?). Auguste Rodin in his Meudon studio with his assistants. Photograph on postcard stock, 3½ × 5½". From Gertrude Käsebier's postcard and photograph album of European travels, 1905. Collection, The Museum of Modern Art, New York.

Gift of Miss Mina Turner

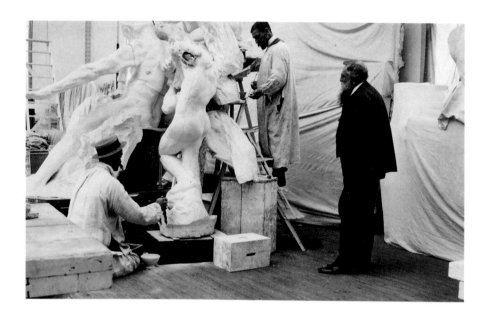

background. If the idea to pose in front of it came partly from Rodin (who liked to have his sculptures photographed there[47]), it was equally congenial to Käsebier, who had so successfully portrayed white forms against white backgrounds in *The Manger* and *Blessed Art Thou Among Women.*

Indeed, it is worth comparing the Rodin portrait to *Blessed Art Thou Among Women* (29), not only for tonal similarities, but for formal analogies. Both Rodin and Agnes Lee wear light-colored clothing and reach out to caress a dark, rounded form—a sculpted head, a daughter's shoulder—that they have had a part in creating. Each figure faces forward, yet turns to look tenderly down towards the sculpture or child. The artworks behind Rodin and Mrs. Lee are emblematic of their lives. Despite the difference in subject, these two Käsebier photographs have a strong tonal, formal and emotional kinship.

The similarities end, however, in Käsebier's approach to printing the negatives. *Blessed Art Thou Among Women* was finished almost exclusively in platinum, with little tonal variation from one print to another, while the Rodin was made in platinum or gum, with differing tone, detail and size. For instance, she sent Rodin two signed prints of his favorite negative. The larger is dark gray-brown platinum on thin, smooth Japanese tissue backed by white paper to add luminosity. The smaller is a sepia gum print on heavy, dull paper, with textured painterly effects such as brush strokes in the smock area. These deliberate variations suggest that just as Rodin and his contemporaries might produce the same sculpture in plaster, marble or bronze,[48]

Käsebier considered different versions of a photograph equally valid. This is not the only instance of Käsebier's printing variants of a negative, but it is the most telling because the Rodin portraits clearly are not intended as experiments towards a single ideal version but as finished presentation copies for the sculptor.

Käsebier's portraits differ from those of her colleagues Steichen and Coburn. None of their portraits is as informal as hers of Rodin outdoors beside his sculpture, *Adam*, mimicking the bent knee and tilted head of his own sculpture (Musée Rodin, Paris). Käsebier preferred to have Rodin look down or away from the viewer, whereas Coburn and Steichen often have him cast his intense gaze outwards.[49] Steichen's most famous picture of Rodin (75), a composite photograph in which the artist is silhouetted facing his sculpture, *Le Penseur*, with a cast of the Victor Hugo monu-

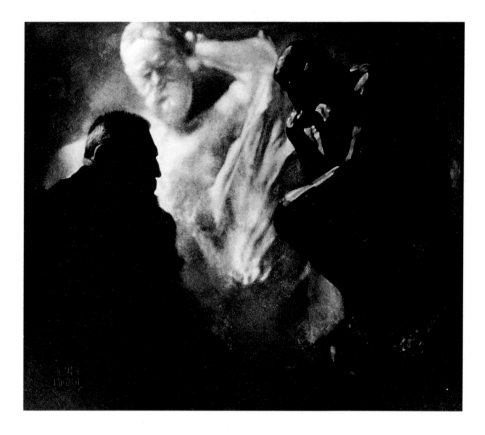

75.
Edward Steichen. *Rodin—Le Penseur.* Photogravure from *Camera Work*, Steichen Supplement, April 1906. The Metropolitan Museum of Art, New York. The Alfred Stieglitz Collection, 1933. (33.43.420–469)

ment between them, is, as Steichen himself said, "more a picture *to* Rodin than it is *of* Rodin, because after all, it associates the genius of the man with that expressed by his work." Steichen shared Symbolist tendencies with Rodin, one factor that must have influenced Rodin, while defending photography as an art in 1908, to call Steichen "a very great artist and the leading, the greatest photographer of the time." If Käsebier did not win the blue ribbon from Rodin, she nonetheless remained high in his estimation, and in 1913 he sent her a gift of a small bronze crouching figure.[50]

At Meudon, Käsebier never photographed Rodin's sculptures by themselves as Steichen had, but she did render Rodin's garden and studio. She gave Rodin a fine print of swans on the grass under a birch tree in his garden (Musée Rodin) and dedicated a study of reflections in the duck pond to Mme. Rodin. These large-format photographs must have been made with the same borrowed or rented camera that she used to take Rodin's portraits. On her 1905 trip, Käsebier carried only a hand camera which she used to make souvenir snapshots. Käsebier mounted five snapshots of Rodin's studio and garden at Meudon in her photo album of that European tour. The

photo of Rodin supervising his assistants (74) is a rare bit of visual evidence suggesting the supporting role that Rodin's practitioners or assistants played in the production of his work, and it complements Judith Cladel's verbal description of Rodin's studio, where one could watch the "dry blows of the practitioners' chisels carving the marble, smoothing the stone, beneath the downfall of white dust that made the room seem like a large hour glass."[51]

In 1906, Käsebier began to study French in the hope of conversing with Rodin on a future voyage; he had invited her to stay in one of the cottages at Meudon. Whether she did so on her final European visit in 1907 goes unrecorded. However, on that trip Rodin autographed a number of her portraits of him, and some of these she later gave as gifts to friends. Through a sporadic exchange of letters and gifts, Käsebier and

76.
Unidentified photographer. Gertrude Käsebier, Robert Demachy, and Mme. Demachy at Demachy's château. 1905. Photograph on postcard stock, 5½ × 3½". From Gertrude Käsebier's postcard and photograph album of European travels, 1905. Collection, The Museum of Modern Art, New York.
Gift of Miss Mina Turner

77.
Major William Cooke Daniels (?). Gertrude Käsebier and Mrs. Daniels in France. 1905 or 1907. Platinum print postcard, 3⅝ × 5¼". Personal–Miscellaneous (Käsebier), Rare Books and Manuscripts Division, The New York Public Library, Astor, Lenox and Tilden Foundations

Rodin kept in touch until 1915, two years before his death. Käsebier treasured his every letter. In conformity with her desire to understand personality through gesture and appearance, she even had Rodin's handwriting analyzed. The result could only have confirmed her own perceptions of his extreme imagination, originality, and "spiritual sense of form."[52]

To Alfred Stieglitz Käsebier had been "beyond dispute the leading portrait photographer in this country," but when Rodin wrote Käsebier "from one artist to another artist" he equated their roles.[53] If Stieglitz's praise had been a feather in Käsebier's cap, Rodin's was surely a crown.

In late September 1905, Käsebier resumed her travels to visit two photographers. William Cooke Daniels is today best remembered as a Denver department store magnate, soldier, and explorer, but he was also one of Denver's leading amateur photographers. Käsebier knew him either through her family or through camera club connections, and he welcomed her warmly more than once at his turreted château near Tours.[54]

Käsebier rejoined Johnston to visit Robert Demachy's estate on the Normandy coast near Trouville, the elegant French resort. Like de Meyer, Demachy was a serious amateur photographer of independent means. Demachy's invitation to the two women he scarcely knew (he had met Johnston during her trip to Paris in 1900 but had only corresponded with Käsebier) shows how much he valued his English and American colleagues. France had no photographic community comparable to theirs, and Demachy's fluent English made communication easy.[55]

On their visit, a professional friendship developed between Käsebier and Demachy, who had already written favorably about her work. Afterwards, he sent her a soft-focus lens like his, and gave her pictures a further boost in France by publishing a thoughtful appraisal of her work. Her photo album records light moments at the Demachy's—taking joy rides in his automobile and pantomiming for the camera. Photograph 76 shows Demachy, his wife and Käsebier mugging with a canine friend. Not surprisingly, she told Day that Demachy was a charming man.[56]

Before she had left New York in July, Käsebier may have heard that Stieglitz and Steichen were planning to create a gallery for the Photo-Secession. But while she was abroad, she wrote no letters to Stieglitz about this or any other matter.[57] Returning to her studio in October, she learned the galleries were about to become a reality: a new era was beginning for the Photo-Secession.

CHAPTER

VI

EMOTIONAL
ART · AND
ARTISTS

The opening of the Little Galleries of the Photo-Secession in November 1905 gave the Photo-Secession both a headquarters and a gallery where the public could see changing exhibitions of innovative photography and art. Like Käsebier's studio a block to the south, the Photo-Secession Galleries at 291 Fifth Avenue (which were soon nicknamed "291") occupied part of a converted townhouse. Stieglitz presided over the exhibitions, conversing with visitors and cultivating an idealistic non-commercial atmosphere. Stieglitz would sell a piece only if he felt a purchaser truly appreciated it.

The two small galleries, designed by Steichen, were modern both in their austerity and their use of electric lights in metal reflectors. While museums and galleries still tended to show art against lavish red velvets and brocades and often skied pictures one above the other, "291" hung photographs in a row at eye level, against muted olive and gray tones and rough textured fabric. In its simplicity, the décor had affinities with the American Arts and Crafts movement, but Steichen said his chief inspiration was, appropriately enough, the Viennese Secession architect, Josef Hoffmann.[1]

The galleries opened with a group exhibition of photographs by more than three dozen Secessionists, including Stieglitz, Steichen, Clarence White, A. L. Coburn, Joseph Keiley, Eva Watson Schütze, Alice Boughton and Sarah Sears. Among the eight Käsebiers—nearly a tenth of the exhibition—were two moody pictures of women, *The Bat* and *The Bride* (60, 109), as well as the more straightforward Newport pictures *Happy Days* and *The Sketch* (62, 67). In February 1906, Clarence White and Käsebier shared the galleries in a joint exhibition. Despite some critics' reservations about Käsebier and Clarence White's use of soft focus, this was deemed a show not to be missed by anyone following the progress of modern photography. Each photographer's group of twenty-seven characteristic prints was said to complement the other's, setting Käsebier's "strong portrayal of character" against White's "incisive poetical feeling."[2]

The wide-ranging Käsebier group, evidently a collaborative choice by her and Stieglitz, included mother and child pictures that were becoming classics—*Blessed Art Thou Among Women, The Manger* and *Mother and Child* (27, titled *The Vision* for this show)—and about a half dozen from the summer of 1903, including *The Picture Book, The Sketch, Black and White* and *The Road to Rome*. One of Käsebier's Rodin portraits made its debut here.

There was a likeness of Stanford White, the eminent New York-based architect, and of two of his architectural clients, Rita de Acosta Lydig and Mrs. James A. Stillman. White had designed the Stillman townhouse at 9 East 72nd Street; his partner, Charles Follen McKim, made the plans for remodeling the National City Bank, of which Mr. Stillman was president.

Of the many elegant homes and public buildings that Stanford White had built in New York, none was better known than Madison Square Garden, whose vast amphitheater could seat at least five thousand at popular performances like Buffalo Bill's Wild West. From atop the building's tower, visitors could scan New York's changing skyline. Within the tower, in White's lavishly decorated studio, the architect threw extravagant parties for his Bohemian and theatrical friends; at other

times, he used the studio or snuggery for the most private of entertainments. Evelyn Nesbit (79) was among those who had dallied there.

The portrait of the architect that Käsebier exhibited at 291 was shown in a frame designed by White himself. Presumably it was the version shown in 78, a brown-

78.
Portrait of Stanford White.
c. 1903. Gum bichromate print, 9½ × 7½" in gilded frame 14½ × 12½" designed by Stanford White. Collection Alida White Lessard

toned print that succeeds in capturing his kind, intelligent gaze as well as hinting at his ruddy hair and complexion. Flecks of pencil or charcoal discreetly suggest the graying of his moustache, while a little more gray handwork enhances the background to the right of his head.

White, who introduced a number of sitters to Käsebier, was discerning about portraits of others and merciless about those of himself. For instance, when Rudolf Eickemeyer, the portraitist and New York Camera Club member, made unsatisfying portraits of him, he told the photographer to make a permanent print of each—and "then smash the plate, for they are the darndest looking things I have ever seen."[3]

Käsebier had found White to be such a difficult subject that when she finally produced one good print of him no amount of money could persuade her to part with it. In the spring of 1903 she made this tantalizing proposal:

My dear Mr. White.
 I have a gum-print of you of which I am not ashamed. It is not for sale but I should like to have you see it.
 Yours
 Gertrude Käsebier[4]

79.
Portrait (Miss N.) [1902].
Platinum print, 8 × 6". National Gallery of Canada, Ottawa

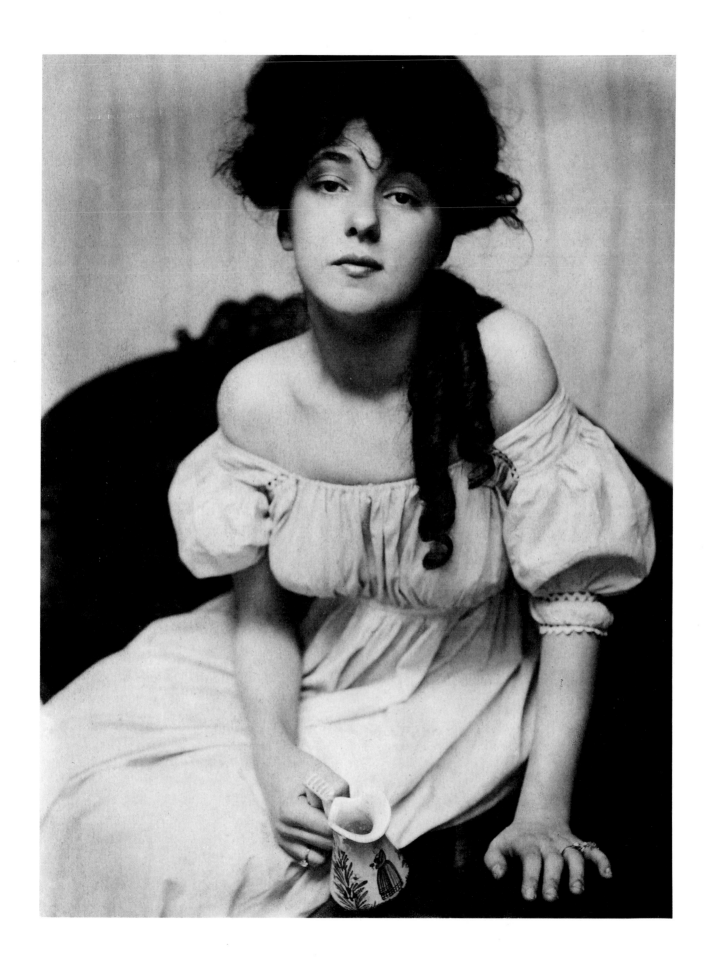

Yet six months passed before he responded, and then only after Mrs. Lydig raved to him about the portrait. Writing to Käsebier, he claimed that if he had seen her letter, preoccupation with business had put it out of his mind. "In any case I will take it," he wrote, peremptorily asking for the print. "Either send it down to me, or I will come up to see it at your studio if you wish."[5]

When White at last went to the studio, Käsebier's refusal to relinquish the portrait made him all the more covetous. The architect, who often bought beautiful objects by the dozens, was not about to let this one get away. In a slapstick chase of a scene, he grabbed the print and ran out of the studio, with Käsebier after him. They compromised on a loan, but it was short-lived. Before Thanksgiving, Käsebier asked to have the picture back for a little while (perhaps as an example for another print), then wrote teasingly again early in January[6]

My dear Mr. White.
　　How does the portrait wear?
　　　　　　Yours
　　　　　　Gertrude Käsebier

Before long White not only returned the photograph but affirmed that the picture "certainly wears very well, and is one of the most wonderful photographs I have ever seen." In May, Käsebier asked White's advice on framing the picture for an exhibition in London. Two months later the busy architect volunteered to make a drawing for the frame, but only after he had kept the portrait during 1905 did he act. Returning the picture for the Käsebier-Clarence White Exhibition at 291, the architect wrote his last letter to her: "I send you back the photograph, which you see I have had put in a specially made and carved frame. I am not on the whole, however, satisfied with it."[7]

His reservations aside, the frame was a trophy for Käsebier, an indication to all who saw it at 291 that she might be classed with artists like Augustus Saint-Gaudens and Thomas W. Dewing, for whom White had designed sculpture bases and frames. No wonder she declared that "White was to me one of the best of men." When White died, the framed portrait was in her possession, but she later gave it to his son.[8]

White had discussed Käsebier's work with the socialite Rita de Acosta Lydig while he was designing the interior of her townhouse during 1903, and it was undoubtedly then that he encouraged her to pose for Käsebier (61). Käsebier was one of many painters, photographers and writers to be impressed by her beauty, her original taste in clothing and home furnishings, as well as her good nature and intelligence. After her divorce from Captain Philip M. Lydig, in the years before the first World War, she was a familiar figure in her box at the Metropolitan Opera. Frank Crowninshield, the editor of *Vanity Fair*, evoked her "surrounded by men, with her miraculous back, bare almost to the waist and half turned to the audience, her jet black hair and flashing eyes, impudent chin and *retroussé* nose in the air, and a great black fan in her hand" and said that "people were ready to swear that no woman in that curving horse-shoe would ever again be so arresting or so magical."[9]

Mrs. Lydig had begun to impart this image by the time that Käsebier photographed her in 1903 or 1904. Taking Mrs. Lydig from behind, Käsebier not only captured her pert profile, but featured the daringly *décolleté*-backed gown—a style that Mrs. Lydig had initiated and was to make fashionable. The photograph was probably taken in the Lydig's Stanford White-designed house on 52nd Street. By showing her with a sampling of the furnishings and paintings she collected, Käsebier added another personal dimension to this portrait.[10]

Also in the Käsebier-Clarence White exhibition at 291 were two portraits of actresses whom Stanford White had sent to her studio. One, *Josephine* (82), was called "an excellent example of what Mrs. Käsebier is doing now, and in its repose and composition as good as an old master." The second, *The Black Hat: Miss Nesbit*, can no longer be identified with certainty, though Evelyn Nesbit herself is probably the only one of Käsebier's female sitters who is widely known today, thanks largely to the showgirl's fictionalized role in E. L. Doctorow's novel, *Ragtime*."[11]

Sixteen-year-old Evelyn was the most striking of the bevy of showgirls whom the married Stanford White fancied and befriended. After photographing her at his behest early in 1902, Käsebier drew White aside, challenging him for taking so young a "protegé." White (who was a generous man) explained that he had "bought her," to rescue her from neglect and exploitation by her widowed mother who had hired her out as an artist's model at an early age and was now "selling her to the highest bidder." In a relationship that was avuncular as well as sexual, White paid for her dental work and gave her lavish gifts. In the fall of 1902, he financed a year in boarding school, hoping to make a lady of her.[12]

That was not to be. Harry K. Thaw, the mentally unbalanced heir to a railroad and coal fortune, had had his eye on Evelyn since noticing her in the hit musical *Florodora* in 1901. Despite what she had observed of his sadistic tendencies and cocaine addiction during months traveling with him in Europe as his mistress, Nesbit married him while he was on his best behavior. But he soon became so obsessed by the idea that she had been seduced by White that he shot the architect dead in June 1906, during the premiere of a mediocre musical show in the roof garden of Madison Square Garden. When the paranoid Thaw stood trial, the press made White seem to be more of a villain for infidelity than Thaw was for murder.[13]

It had been White's habit to have his favorite actresses photographed. In the sugar-daddyish mix of altruism and self-gratification that seems to have marked his relationships with these young women, they would be given a generous number of publicity prints, and White would order some for his own delectation. Similarly, in 1908 the newspaper columnist Dorothy Dix observed that White had taught Nesbit "how to be beautiful, how to dress. . . . In the big $500 book of photographs that he had taken of her you see this proved on every page."[14]

Of the many fine photographs that Eickemeyer took of Evelyn Nesbit none is better known than *In My Studio* or *Tired Butterfly* (81). This photograph of an innocent-looking young woman in *déshabillé*, lying passive and vulnerable on the skin of a wild animal whose open mouth implied physical and sexual danger, seemed titillating in 1902. Yet Käsebier's *Portrait (Miss N.)* was innately more subversive and sexier. Among numerous drawings and photographs of her, none so fully suggests her ripe, youthful beauty as Käsebier's *Miss N.* (79). Käsebier presents her as a coquette, recalling those in Alphonse Mucha's posters and other popular turn-of-the-century pictures, pictures that Nesbit may even have modeled herself after. In *Miss N.* she seems unnervingly close to the viewer, an effect that Käsebier achieved by cropping the top of her head and by photographing slightly from above. Her upturned head seems about to offer a kiss while her right hand proffers a small Quimper pitcher. Yet her torso recedes, so that this temptress seems both to move forward and to resist. Although her Empire-style gown suggests the past, and some observers have seen Greuze echoed in the portrait, the direct gaze shows that Evelyn Nesbit is no coy eighteenth-century maiden.[15]

On another level, *Portrait (Miss N.)* seems to be a visual rejoinder to the Root portrait (80) that Käsebier had ridiculed. Both pictures begin with a young brunette

80.
W. J. Root. *A Delsartean Pose.* 1898 or before. From
Photographic Mosaics, 1898. General Research Division,
The New York Public Library, Astor, Lenox and
Tilden Foundations

81.
Rudolf Eickemeyer, Jr. *In My Studio* (alternately titled
Tired Butterfly). 1902. Carbon print, 19 × 24". Collection,
Hudson River Museum, Yonkers, N.Y.

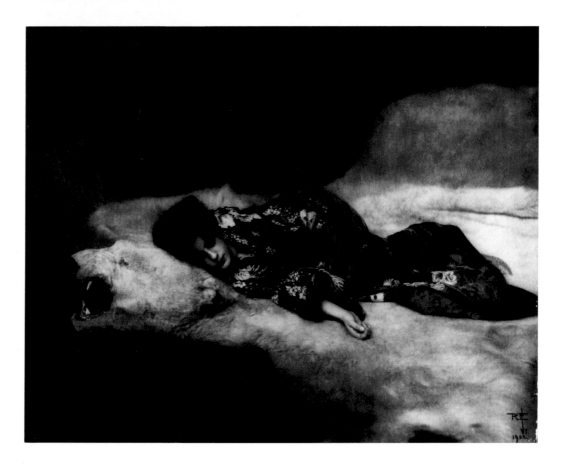

in a white *décolleté* gown. But *Miss N.* tempers the excesses of Root's portrait: there is no scenic background or other distractions; there are only the dark curves of the sofa behind Nesbit, and these draw our eyes back to her dark curly hair and to her face. No one could mistake the center of interest in this picture.

Portraits that Käsebier made a few years later show how she matured as a portraitist by using more varied poses and more complex compositions than in her earlier work. While her earliest portraits took cues from painting, the later ones seem conceived in the ground glass. Beginning by radically simplifying portraiture, Käsebier continually challenged herself so that her vision gradually became more complex, encompassing deep space, and incorporating varied shapes and light and dark areas. These later portraits also evince her acquaintance with many New York artists and illustrators.

In 1908, Käsebier's portraits accompanied an article publicizing an exhibition of paintings by Arthur B. Davies, Robert Henri and other members of The Eight — better known as the Ash Can School because of the group's many unglorified depictions of city life and popular culture. As the painter William Glackens described it to his wife, "The *Craftsman* has come out with all of us à la Käsebier. They evidently got proofs from her. They are awfully silly." In his aversion to the pictures, Glackens held a minority view. But comments on Gertrude Käsebier's recognizable style are not uncommon. Ten years before, Charles Caffin had noted the "distinctiveness of her style."[16] While "à la Käsebier" does not define her work, Glackens would have realized that he was in a typical Käsebier pose (83): sitting to one side of the pictures, his shoulders slightly angled away. Atypical is his rigidity, his seeming immunity to Käsebier's wiles. Having a subject hold his hat or cane as a prop relaxed most subjects. Not Glackens. Käsebier, always a stickler for composition, made the best of the situation by turning the upright walking stick into a decorative motif, one of several vertical lines to echo Glackens's stiff-backed posture.

About 1906, Käsebier tended to place her subjects against deeper, more complex backgrounds than she had before. John Sloan (84), for instance, sits sideways on an angled chair between a foreground that is defined by a small table holding his hat, some photographs, and a magazine (perhaps one that he illustrated) and a three-toned background. Sloan, who sometimes photographed his own paintings, dismissed most soft-focus photographs as "art 'phuzzygraphy,'" but in 1907 he thought Käsebier was doing "some fine things in photography." He admired an Indian head and deemed proofs of Robert Henri to be the "best photographs of him yet. . . . She knows her profession, sure gets you at your ease." The fact that he kept her portraits of him and his colleagues in The Eight throughout his life speaks for his enduring respect for her work.[17]

Käsebier's continuing efforts to make biographical portraits can be seen in two pictures of Henri that suggest alternate aspects of his personality. In the portrait reproduced by the *Craftsman* (85) we sense the spiritual leader of The Eight, the author of *The Art Spirit*, and the man who for many years was the leading painting teacher in the United States. This forceful portrait depends on Henri's direct gaze and a variety of shapes such as the outline of his body, the splayed fingers of his right hand, his umbrella, and his hat. Conversely, a gum print of him (MOMA) suggests the thoughtful artistic side of Henri's personality by showing him with averted gaze and emphasizing his relaxed long-fingered hands to symbolize thought and dextrous creativity. This large print owes its allure to qualities that are lost in reproduction, including textured paper and rich blacks that were doubtless achieved with multiple

printings (made by recoating the paper with gum bichromate emulsion, realigning the negative, and exposing it again).

Similarly, the *Craftsman* reproduced Käsebier's portrait of Arthur B. Davies seated against a plain background—a picture that, over the years, he reordered for other publications. But a more complex and personal likeness (86) reminds us that Käsebier and Davies were friends. As Käsebier was to say: "I worshipped his work and bought some of his pictures at a time when he was very poor. He often came to see me. He never cared about photography but always discussed his paintings."[18] Käsebier's portrait shows Davies reading in his studio; his table holds one of his paintings as well as examples of the antique and exotic objects that he collected. Bow tie, rimless glasses and restrained demeanor imply that Davies was proper and prim. If Käsebier tested her self-proclaimed mind-reading ability on Davies—if she even *suspected* that some of this artist's apparent shyness and furtiveness was the result of his leading a double life (married, as Davies, to a wife in the suburbs, and as David Owen to one in New York[19])—she guarded her friend's secret.

Käsebier's portrait of Everett Shinn shows him standing casually; we sense that he will shift weight soon again, and take another drag on his cigarette. Comparing Shinn's lighthearted sketch to her photograph (87, 88) reveals that his nonchalant attitude, spontaneous as it looks, was the result of trial and error. In picturing Shinn, Käsebier has again returned to the problem faced by W. J. Root (80): to photograph a figure in a furnished studio. But her studio has none of the pretentious trappings she condemned in the earlier portrait; it is bare save for objects of her own taste and making. There is the striped Indian rug, which defines the space Shinn stands in, and her portrait of Rodin, whose pose echoes Shinn's stance.

Several mid-decade portraits of artistic women exhibit traits similar to her portraits of The Eight. Like the portrait of Shinn, Käsebier's portrait of Rose O'Neill is obviously set in the photographer's studio. Just as the Rodin becomes a symbolic Käsebier signature in Shinn's portrait, a print of *Real Motherhood* signifies Käsebier in the complex setting of O'Neill's. O'Neill was the most famous of Käsebier's illustrator friends; her invention of the kewpie doll has guaranteed her immortality in American popular culture. Early in her career as an illustrator, she had drawn the pictures for Agnes Lee's book, *The Round Rabbit*, published by Copeland and Day. Whether that connection brought her to Käsebier's studio, or whether their acquaintance was simply a coincidence of the close-knit American art world around 1900, is not known.[20]

Whatever brought O'Neill to Käsebier, the photographer later considered her portrait memorable enough to keep its negative in a group she saved when she disposed of thousands of others.[21] Viewers around 1905 would have perceived O'Neill's Bohemianism in her unusually relaxed pose, her oriental-style vest and her long, uncoiffed hair. Another Käsebier of Rose O'Neill also conveys the illustrator's anti-establishment views by showing her smoking a cigarette.

While the soft focus and brushwork lend an element of fantasy to *The Silhouette*, (90), the photo is one of a series recording the dresses that Virginia and Minnie Gerson wore to an Assembly Ball (familiarly known as the Crinoline Ball on account of mid-nineteenth-century outfits that guests were expected to wear) at New York's old Astor House in April 1906. The Gerson sisters traveled in the artistic circle around their brother-in-law, the painter William Merritt Chase. Virginia Gerson wrote and illustrated children's books that were charming (if too heavily indebted to Kate Greenaway) and sometimes designed theatrical costumes.[22]

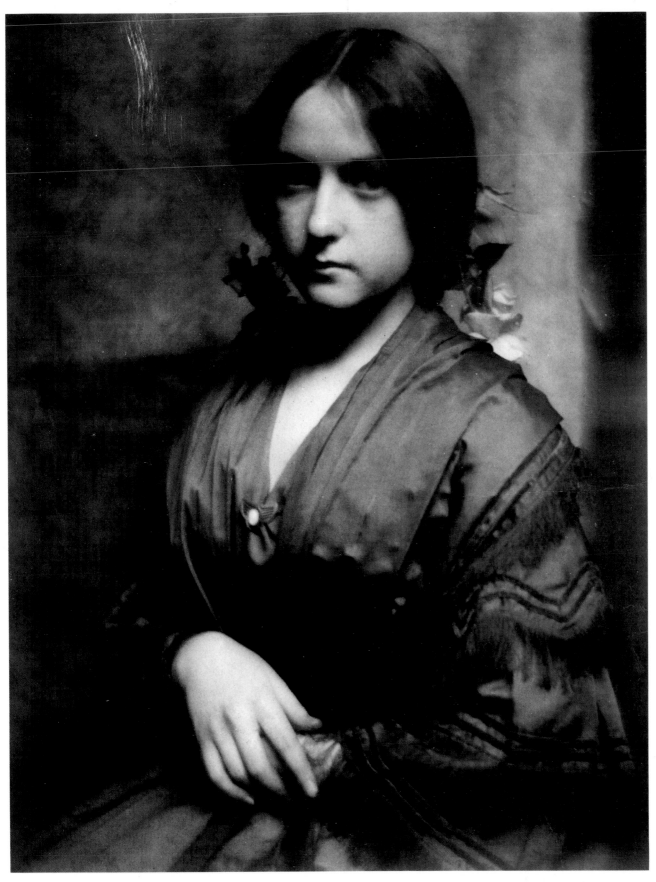

82.
Josephine (Portrait of Miss B.). 1903. Platinum print,
11½ × 8¹³⁄₁₆″. Collection of the J. Paul Getty Museum,
Malibu, Calif.

Käsebier's five variant poses, capturing the dresses from front, side and rear, suggest that these gowns may have been designed by Virginia Gerson. Käsebier must have admired the dresses; her photographs are more like fashion plates, glorifying the gowns, than they are physiognomical portraits. Here is one instance when Käsebier had reason to emphasize the fussy clothes and bare necks and arms that she normally abhorred. The oblique title, *The Silhouette*, refers to the small oval-framed profile of Käsebier which, like her photographs in the Shinn and O'Neill portraits and like the large oil portrait in Käsebier's photograph of Eulabee Dix (91), is another example, about 1906, of Käsebier's figuratively putting herself in the picture.[23]

Even without a special event at hand, in the early part of the century dressing up in old-fashioned clothes was an affectation of artistic women like the Gerson sisters and their friend, the miniaturist Eulabee Dix. Several photographs that Käsebier made of Dix about 1905 show the miniaturist's penchant for self-dramatization in hand gesture and clothing; her daughter has no doubt that it was Dix's idea to dress up when she posed for Käsebier. But behind Dix's glamorous facade lay an abrasive personality. The painter John Butler Yeats, who was for many years a friend of Dix's, once told her he "would not envy the man that she married, for she would be sure to devour him."[24] Käsebier may have wanted the sidelong glance and determined set of the lips to suggest the self-serving side of this beautiful, talented woman.

Käsebier's work was a regular feature of any Photo-Secession exhibition. It was seen in the second exhibition of members' work at 291 in late 1906, as well as in exhibitions billed as "arranged by the Photo-Secession" and lent to museums in the United States and Europe.[25] To anyone attending these exhibitions, Käsebier's soft-focused, carefully matted pictures of an untroubled world must have seemed quint-essentially Photo-Secessionist. But behind the scenes, trouble was brewing. Personality clashes, as well as a conflict between Käsebier's commercial attitude to photography and Stieglitz's idealistic, anti-materialistic stance, caused ill will.

Some of her resentment arose from Stieglitz's lax management (between 1902 and 1912, Day, Watson Schütze, Käsebier, and White each complained that Stieglitz failed to return borrowed prints or neglected to pay for sales[26]). For a man of such artistic sensibility, Stieglitz was oddly careless of people's feelings.

Käsebier was not blameless. By boasting of her successes, and by exaggerating her woes to evoke sympathy, she sometimes antagonized male Photo-Secession colleagues.[27] As much as Käsebier was accepted as one of the best photographers of her day, she remained a "woman photographer." For his era, Stieglitz was exceptional in giving opportunities to women photographers and artists. They were full-fledged voting members of the Photo-Secession, not secondary citizens, like the women of the English Linked Ring. Stieglitz understood the importance of women photographers as well as anyone of his day. In 1900 he had told Frances Benjamin Johnston: "The women in this country are certainly doing great photographic work and deserve much commendation for their efforts." Yet in 1912, he criticized Clarence White for allowing himself "to be deified by his stupid pupils, mostly women." Stieglitz saw women as emotionally different from men. In praising Käsebier's portraits he wrote, "Their strength never betrays the woman," and when Keiley was perplexed by Käsebier's behavior late in 1901, Stieglitz explained that "Käsebier is a queer creature; she's touchy like all women."[28]

In 1907 latent problems became manifest. At first, Käsebier simply sensed a growing alienation from Photo-Secession colleagues. For instance, the Whites

Top left:
83.
William Glackens. c. 1907. Platinum print, 8½ × 6¼". Delaware Art Museum, Wilmington, Del. Gift of Helen Farr Sloan

Top right:
84.
John Sloan. [1907]. Platinum print, 8¼ × 6⅜". Delaware Art Museum, Wilmington, Del. Gift of Helen Farr Sloan

Bottom left:
85.
Robert Henri. c. 1907. Platinum print, 8¼ × 6¼". Delaware Art Museum, Wilmington, Del. Gift of Helen Farr Sloan

Bottom right:
86.
Arthur B. Davies. c. 1907. Platinum print, 8⅜ × 6½". Collection I, Archives of American Art, Smithsonian Institution, Washington, D.C.

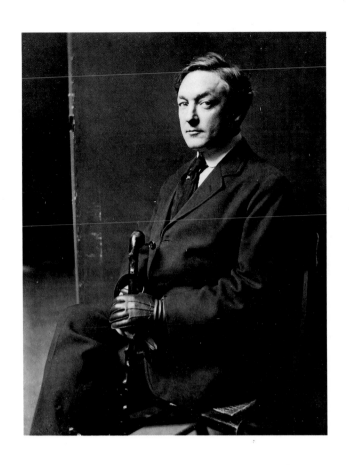

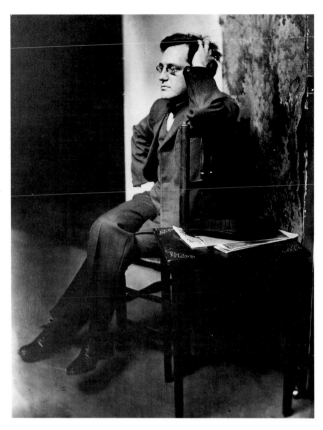

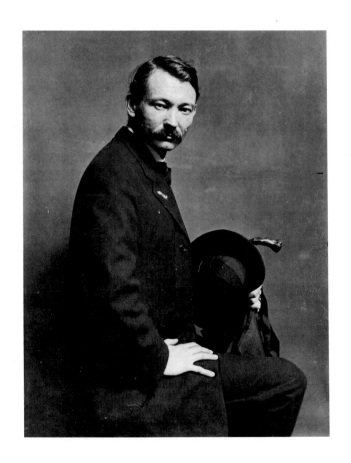

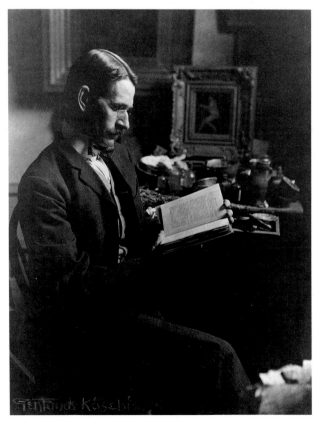

87.
Everett Shinn. [*Gertrude Käsebier Photographing Shinn*]. c. 1907. Ink and watercolor, 5¼ × 7¾". Delaware Art Museum, Wilmington, Del. Gift of Helen Farr Sloan. Shinn sent a note with this sketch to his friend John Sloan: "Dear Sloan: Was up to be photographed today. Great fun, being an artist with temperament. They are very good of all the boys.
Yours, Everett Shinn"

seemed to be cold-shouldering her. Her acquaintance with Clarence White dated back nearly ten years; her 1902 visit with his family in Newark, Ohio, had been more than cordial. Yet she felt that a number of friendly advances she made to them after they moved to New York in 1906 were not warmly received. The friendship was to revive once the Whites settled in, but meanwhile she confided to Day: "It was so stimulating to see you and have a free exchange of ideas about our work. I so hunger for just that interchange. I do not know why it is denied me here, but it is."[29]

By May, in an apparent effort to gain such an exchange of ideas, Käsebier joined the Professional Photographers of New York.[30] An appropriate idea, on the face of it: Käsebier was a professional. But, because the commercial goals of the professional photographers' organization were at odds with the Photo-Secession's aesthetic aims, Stieglitz saw her decision as an act of infidelity.

During a jaunt to France late that summer, Käsebier visited Rodin in Meudon and spent time with Steichen in Paris. Like all photographers, she was excited about the Lumière autochrome process, the first form of commercial color photography, that had just come on the market. Why not try the new medium by sitting for one another, she asked Steichen. His unusually evasive response puzzled her until he revealed the results of her posing a few days earlier.[31] One can only imagine Käsebier's consternation in seeing the color transparencies he had shot when, despite the unusually long exposure, he had led her to believe that ordinary black-and-white plates were in his camera (Naef, fig. 517A). If she later experimented with autochromes, the results have not come to light.

The October 1907 *Camera Work* carried two articles about Käsebier but, strangely, no reproductions of her work. Why Stieglitz chose to reprint Joseph Keiley's flattering, informative biography of Käsebier three years after it had appeared in the British magazine, *Photography*[32]—and why he hadn't used it to accompany the Käsebier photographs in the April 1905 *Camera Work* Ten—is a puzzle. Perhaps he thought that worthy essays, like fine photographs, bore repetition.

Perhaps he also wanted a sober, gracious counterpoint to Caffin's acerbic parody of the article that Mary Fanton Roberts had published in the April *Craftsman* under her

88.
Portrait of Everett Shinn. c. 1907. From *The Craftsman*, February 1908. The Rush Rhees Library, University of Rochester, Rochester, N.Y.

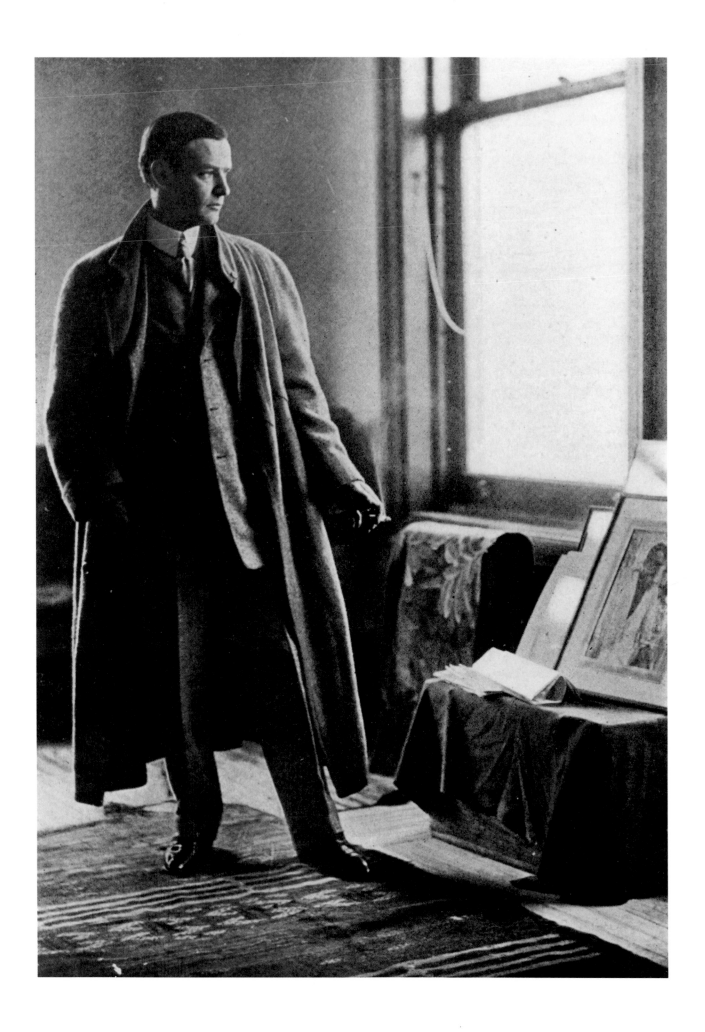

pseudonym, Giles Edgerton. Roberts/Edgerton, who often wrote for the *Craftsman*, was a proponent of the Arts and Crafts, of women artists, and of artistic photography. The *Craftsman*, while not as high-flown or exclusive as *Camera Work*, was nonetheless a serious, handsome art magazine, with wide margins and bold type in the William Morris tradition. "Photography as an Emotional Art: A Study of the Work of Gertrude Käsebier" was an earnest biographical and interpretive essay, emphasizing the expressiveness of her photography, especially the motherhood photographs.

Caffin's piece, "Emotional Art (After Reading the 'Craftsman,' April 1907)," lampoons Edgerton on two levels. In general it pokes fun at the vogue for expressive handworked gum printing. More pointedly, it mocks Käsebier, transforming her into a blowhard of a photographer named Theodosius Binny. Scholars have not noted the parallel, but Käsebier saw the connection all too clearly: she, who ordinarily had a hearty sense of humor, was not amused. "I am 'Mr. Binney [*sic*],'" she wrote to Day, condemning "that vulgar Mr. Binney article."[33] Her anger is understandable. Edgerton writes:

> To be an artist is to suffer through nature, and to think suffering a
> little price for great emotional opportunity. . . . [Käsebier said] "my
> development came slowly through much suffering, much disappointment
> and much renunciation. I have learned to know the world because of what
> the world has exacted of me."[34]

But Caffin has Mr. Binny

> burst out in a kind of prolonged sob: "But it is out of the suffering of the
> body that the artist reaches up to the emotionalism of his soul. It is only,
> when the whole fabric of his flesh collapses into a palpitating confusion of
> pain, that his spirit is disengaged and rises to sublimity. That is why we
> artists glory in our missions, cherish our weaknesses, and are in love with
> pain."[35]

If Caffin had gone no further, Käsebier might have seen the article as publicizing her and art photography as *Patience* had done for Oscar Wilde and the Aesthetic movement. But Caffin indirectly insulted both Mr. and Mrs. Käsebier by writing "what Mrs. Binney suffered for the 'cause' is another story. It is no light matter, I take it, to be the sleeping partner of an emotional artist."

Then Caffin let loose, lambasting her portrait of Stanford White. The *Craftsman* had reproduced Käsebier's Dorian Gray-like version of photograph 78, aging the talented architect with grizzled hair and a shadowed face, as if to show him towards the end of his life when he was often ill and in pain. Edgerton had written:

> The photograph of Stanford White . . . was laboriously achieved by
> printing and reprinting during a period of two years. "I could not seem to
> get into the print," Mrs. Käsebier explained, "what I had seen through the
> camera . . . and then . . . at a last trial, I realized that the real person, the
> man of fundamental kindness, of great achievement, had found his way into
> the picture. For a long time Stanford White would not come and see the
> photograph. He said it would be too ugly, and that he did not like looking
> at pictures of himself, but at last he came over one day, and then begged for
> it, but I had worked so long over it that I could not sell it, or give it up, so
> I used to loan it to him. . . . He once said to a friend that he thought it
> was the greatest portrait through any medium that he had ever seen.[36]

Ridiculing Käsebier's unwillingness to relinquish the photograph as well as her lack of humility, Caffin has Mr. Binny brag:

"Were it not that, like all artists, I shun recognition and abhor self-praise, I would tell you of the solemn, almost saintly observations of one of my clients. It was Mr.—no, I won't mention his name, but he was one of the magnates of Standard Oil. 'I myself,' he said 'have made some trifling success in oils, as Titian did; but you, Mr. Binny, have harnessed to your tripod nature's own illuminant . . . eternal, inexhaustible sunshine. Only the photographer, who has risen to the supreme heights of emotional expression, as you have, Mr. Binny, is the real master-magician of the universe. . . .'"[37]

Mr. Binny continued:

"this beautiful enthusiasm had been aroused by the sight of my emotionalized gum portrait of himself. At first he could not be induced to look at it. He was appalled by the anticipation of its beauty. . . . So we arranged a compromise, and my client, for a consideration, gives himself the occasional rapture of borrowing the print. He hangs it in his bathroom, that his excess of admiration and the worship it inspires may not cause his trousers to bulge at the knees."[38]

Undoubtedly this paragraph, describing her sitter kneeling naked in his bathroom to worship his photograph, most infuriated her, and was one reason she called the article vulgar.[39] It was more than the imagery that bothered Käsebier, who could be earthy and irreverent. Even though he had not mentioned his name, Caffin had posthumously libeled her friend Stanford White.

Because Thaw's trial for White's murder had resulted in a hung jury in the spring of 1907, the yellow press had kept playing White's peccadillos for headlines. In view of this relentless sensationalizing, Caffin's mocking of White, however oblique, struck a raw nerve in Käsebier.

Camera Work had published humorous pieces before Caffin's, and more would follow. As Jonathan Green has observed, "the comic imagination is an integral facet of the critical, skeptical intelligence that animates *Camera Work*." Usually, that "humor, born of conviviality and mutual respect, reinforced the exclusiveness of the group."[40] But in this case, Käsebier, the butt of a joke, felt ostracized and aggrieved.

Over the next months, she continued to be piqued by articles that criticized, or worse, omitted her from discussions of the Photo-Secession. About one, she complained to Day:

Stieglitz has certainly loosed all his dogs of war on me and why I do not know. It is a poor return for my years of loyalty. Neither he nor White have been near me, or showed any sign of feeling in all the great strain I have been passing through.[41]

The strain was personal, financial and professional. "Grave trouble came to one of my children," she wrote Day, with no explication. Also, some of her funds had been in the Knickerbocker Bank, which failed. Late in 1907, with little warning, she was dispossesed from her studio at 273 Fifth Avenue, because she had been subletting from a tenant who neglected to pay his rent. Although her new place was only two and a half blocks away atop an eleven-story office building at 315 Fifth Avenue, being forced to move in December meant losing much Christmas business. Perhaps because

of the move, perhaps because of disagreements, or perhaps because she had devoted extra time to her daughters when their own daughters were born in 1907, only four of her photos hung in 291's year-end exhibition. [42]

Early the next year at the National Arts Club, the Photo-Secession participated in a "Special Exhibition of Contemporary Art" that set a precedent in equating paintings and sculpture with photographs. Käsebier knew and had photographed

90.

The Silhouette (The Gerson Sisters). [1906]. Gum bichromate print, 11¾ × 9⁵⁄₁₆″. The Art Institute of Chicago. Gift of Miss Mina Turner, 1973.33. photograph © 1991, The Art Institute of Chicago. All Rights Reserved Gum bichromate prints like the one above were made on drawing paper coated by the photographer. Käsebier has printed the photograph so that the watermarks form an interesting textured design in the empty spaces beside the figures.

89.

Opposite:

Portrait of Rose O'Neill. c. 1907. Platinum print, 8 × 6″. University Gallery Collection, University of Delaware. Gift of Mason E. Turner, Jr., 1979. Photo: Butch Hulett

91.

Portrait of Eulabee Dix (Becker). c. 1905. Platinum print, 7¾ × 6¼″. Collection Joan B. Gaines, Seattle, Wash.

many of the artists in the show, including members of The Eight (see 83–88), the sculptors Solon Borglum and Chester Beach and the painters John Twachtman and Van Dearing Perrine. Four drawings by Pamela Colman Smith were included; Käsebier had known her from Pratt Institute, years before her work was first exhibited at 291 in 1907. And Käsebier must have been pleased to see her work hanging in the same show as Mary Cassatt's. But there were only two Käsebier photographs, compared to Clarence White's six, Stieglitz's three, and Steichen's five paintings and five photographs.[43]

As the rift between Käsebier and Stieglitz grew, de Meyer tried to mediate. "I can quite realize she may have been irritating and trying, but that is often caused by ill health," he wrote Stieglitz from London in late 1908. De Meyer thought she suffered from "age and fading energy in creating new work" and felt "sorry for the old lady, who has done much for photography and much for me. . . ."[44]

Ailments and family obligations may have slowed Käsebier's pace around 1907 and 1908, but de Meyer's view of the fifty-six-year-old photographer was distorted. Just a year before, John Sloan had described her as a "very pleasant, middle aged lady."[45] Behavior that some colleagues saw as irritating was probably a result of her tendency to act forcefully on her own behalf. In fact, as she may have understood in adopting the nickname "Granny," seniority could allow her to speak with authority that men would have balked at, had it come from a younger, unmarried woman. However, De Meyer's well-meaning letter could not restore Käsebier to a central place in the Secession. Differences between her and Stieglitz had become too great. She did not exhibit in the 1908 year-end exhibition, the last of this type at 291.

During 1908 and 1909, Käsebier increasingly cast her lot with professional photographers. In this, she must have been motivated by more than anger at Stieglitz. As her husband became sicker (he was to die in late 1909), Käsebier's interest in her own business seems to have grown. Her need to prosper was as much psychological as financial, though, since her husband left her well-off. She might have lived comfortably without additional income, but her career was her life. She told Lord Northcliffe, the prominent English newspaper publisher who sat for her at about this time and became a friend, "I love to work. I would pay for the privilege." As her recollections made plain, what she relished was not cold cash, but indepen-dence and authority: "I thought [Stieglitz] was grand. When I saw he was only hot air, I quit. I remember saying to myself. . . . I earn my own money. I pay my own bills. I carry my own license."[46] Looking back on her career, she castigated Stieglitz for sponging off income from his late father-in-law's brewing business, while she "didn't have a brewer's daughter for my cash register." Käsebier was referring as much to the fact that Stieglitz's wife, Emmy, gave Stieglitz "an allowance of sorts to take his cohorts and cronies to lunch" at the Holland House, on Fifth Avenue near 291, as to the fact that the Stieglitz household was run extravagantly on proceeds from her inheritance.[47] While the Käsebier home was supported by Eduard, and he may have helped to establish Gertrude's studio, there is every evidence that her photography business soon became profitable.

In her attitude that monetary reward was a real measure of success, Käsebier was at poles from Stieglitz. In a vicious cycle, Stieglitz deplored Käsebier's commercialism (as he would later denounce Steichen's and the painter Max Weber's desire to earn money). Stieglitz believed passionately that artists could fulfill their promise only by excluding thoughts of financial reward. Thus, it was a deliberate, obvious slight when, during the reorganization of the Secession in 1909, Käsebier was not made a top-ranking Fellow of the Directorate.[48]

Perhaps in retaliation, Käsebier contributed to the Professional rather than the Artistic Photography Section of the Dresden International Photography Exhibition. Stieglitz, who had been gathering photographs on behalf of Heinrich Kühn, the Austrian photographer and European director of the Artistic Photography Section at Dresden, could not contain his rage that she did not give him prints for the show:

> Her excuse is that she is not satisfied with her work. She is afraid that
> her prints might injure her fame. Actually she rarely makes good prints
> now—she has become the business woman through and through. But just
> imagine; she sent five prints to the professional section in Dresden. . . .
> Now she must leave the Secession. Rarely have I heard of anything so low.
> I'd rather give up the whole thing than have anything further to do with
> such rabble.[49]

Steichen, whose loyalty to Stieglitz was temporarily stronger than his friendship with Käsebier, was also prepared to ask her to resign. In time, each man simmered down; *Camera Work* even acknowledged Käsebier's award for professional photogra-phy at Dresden. Sheepishly, Keiley admitted that Käsebier's lecture to the Photogra-phers' Association of America annual convention had shown that professionals recognized the Secession as a distinct force. That Käsebier's apparently anti-Secession move had boomeranged struck Keiley as ironic but did not lessen his growing antipathy to her. No shred of their friendship remained after Keiley defended Caffin's "Mr. Binny" article.[50]

During 1909 Käsebier continued to separate herself from former colleagues by

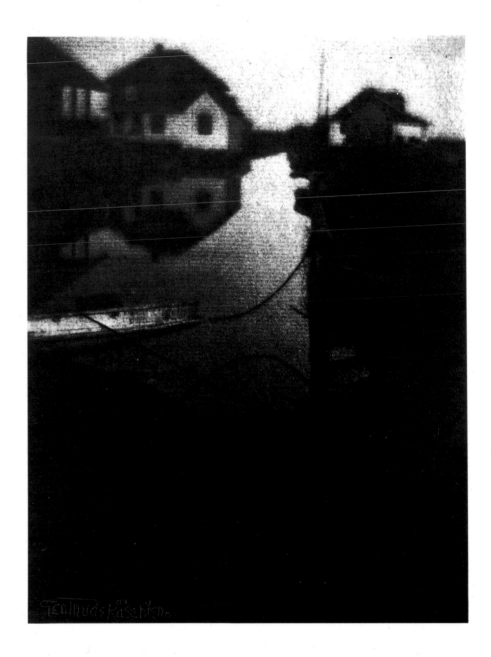

92.
Bungalows. c. 1907. Gum bichromate print, 8¹⁄₁₆ × 6″. Collection, The Museum of Modern Art, New York. Gift of Mrs. Hermine M. Turner

refusing to resign from the Linked Ring when they did in May. However, by October that group's declining standards led her, too, to quit. For the first time in years, she entered and won a photography competition—$250 for third prize in a Kodak advertising contest—a picture of her daughter Hermine with her children Mason and Mina Turner on the roof of Käsebier's studio (96). Then, during the winter of 1909–1910, she taught free classes in composition to women photographers under the auspices of the Women's Federation (of the Photographers' Association of America) that she had been instrumental in forming.[51]

More than Käsebier's affiliation with the Secession was changing during these years. There is little record of Käsebier's reaction to her husband's death on December 17, 1909, or to that of her elderly mother the following August. Käsebier did not believe in funerals and did not attend the full Masonic funeral service given to Mr. Käsebier in New York. Instead she simply followed his coffin to the railroad station near Oceanside, where, alone in a surrey, she bade farewell to her companion of thirty-five years.[52]

But if Käsebier did not put her feelings into words during those trying years from about 1908 to 1910, she put them into pictures of her family at home. Her early Oceanside pictures had been unpopulated landscapes that alluded to Arthur W. Dow and the Arts and Crafts movement. In *Bungalows* (92), the flat silhouetted treatment of the reflections and the composition luring the viewer towards the high horizon echo Dow's prints and posters. Bungalows were informal, usually single-story homes favored by Arts and Crafts advocates, and by using charcoal-like gum bichromate emulsion on grainy laid paper Käsebier gave the photograph an appropriately craftsy, handmade look.

Beyond its Dow-like shaded marshy landscape and surface pattern, Käsebier meant *The Simple Life* (93), to stand for her own isolation in Oceanside. Like the duck on the field of grass, Käsebier found life in Oceanside lonely, static, and dull. She spent most weekday nights in her Fifth Avenue studio. One weekend she created this, her photographic revenge. In her day, the title would have been readily understood to mean the "simple life" touted by a turn-of-the-century bestseller. While simplicity was a feature of the Arts and Crafts movement that generally suited Käsebier's taste, she did not like the aspect of the movement that advocated suburban and country living, especially for herself. In printing *The Simple Life*, Käsebier must have chuckled at the irony of having, years before, sold about two dozen of her photographs to illustrate a magazine feature and a serialized novel advocating country living.[53]

Käsebier's family photographs, taken indoors at Oceanside and at the Turner's home in Waban, Massachusetts, from about 1908 to 1911, show how she enlarged upon her studio experiments with light and depth to create psychologically effective groupings in atmospheric and sometimes sun-spotted rooms.

Thanksgiving, Oceanside (94) may be seen as a bittersweet view of the Käsebier family. As much as Käsebier complained about Oceanside, there were happy moments there, and this picture captures the warmth and serenity of a family gathering.[54] But in this more than any other photograph, Käsebier encapsulated her mixed emotions about her family. Her favorites are featured: Gertrude O'Malley (center) and Hermine Turner (right) tend their daughters, while Charles and Mason share their own table in the foreground. In Käsebier's hierarchy, the men are given lesser roles. Neither her sons-in-law nor her son (whom she seems to have considered a disappointment and rarely photographed) can be identified. The ailing Mr. Käsebier presides, impressive but disquietingly featureless in a silhouette that, along with the shadowy edges of the picture, lends a tension to the image.

In her photograph of Gertrude O'Malley playing billiards at Oceanside (95), Käsebier seems to expand upon the empathy she felt with her daughter while taking *Real Motherhood*. Here, however, the connection between the women is metaphorical. As Eugenia Parry Janis has observed, Käsebier's daughter's absorption in one of her favorite pastimes, billiards, can be considered akin to her mother's "devotion to the camera's aligning art." Janis enumerates this photograph's parallels to photography: the sequence of rooms "that open up like a bellows, and into which apertures admit streams of light"; the "body aligned along the cue as a singular directing force."

Indeed, the parallel to photography becomes even plainer when the image is compared to Käsebier's photograph of Hermine helping her daughter Mina to take a photograph (96). Both pictures include a male who gazes away from the activity. Both show how women "might possess mental as well as physical space in exercising an art or gift." Like the billiard photograph, Käsebier's picture of her daughter and

93.
The Simple Life. c. 1907. Gum bichromate print, 8¾ × 11″.
Collection the Wellesley College Museum. Gift of Miss
Mina Turner

94.
Thanksgiving, Oceanside. Before 1910. Platinum print, 4⅝ × 8⅝″.
University Gallery Collection, University of Delaware.
Gift of Mason E. Turner, Jr., 1983. Photo: Butch Hulett

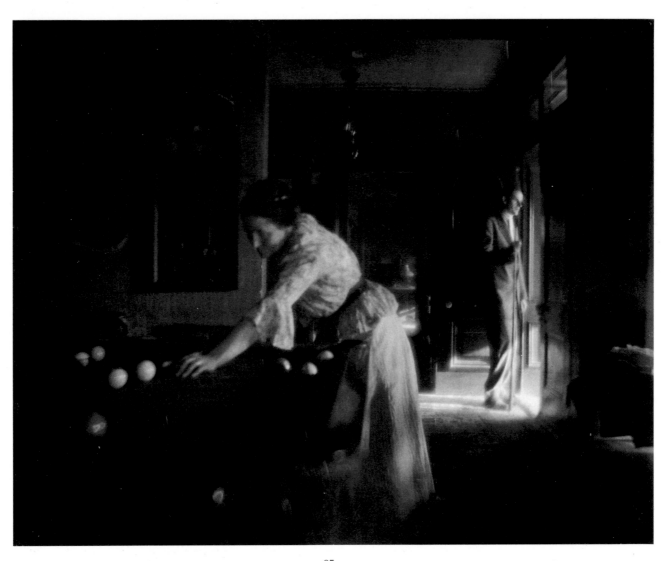

95.
Gertrude Käsebier O'Malley playing billiards with William
M. Turner standing in doorway. c. 1909. Platinum print,
7¾ × 9¹¹⁄₁₆″. Collection of the J. Paul Getty Museum,
Malibu, Calif.

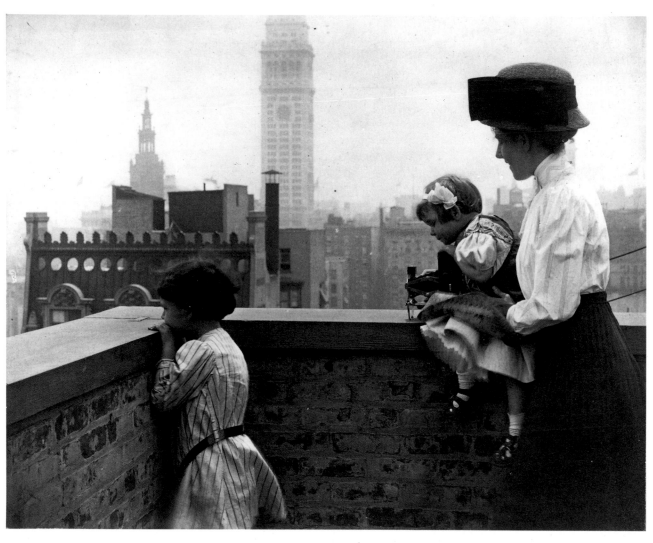

96.
Hermine Käsebier Turner photographing Mason and Mina Turner
on the roof of Gertrude Käsebier's studio at 315 Fifth Avenue
(variant of prizewinning photograph in Kodak advertising contest).
c. 1909. Platinum print, 6 × 7¾″. International Museum of Photography
at George Eastman House, Rochester, N.Y. Gift of Mrs.
Hermine M. Turner

granddaughter surveying a boundless rooftop panorama is "a paragon of preoccupation" which, less subtly than the billiard picture, "proposes a mystique of female vision, performance, and control."[55]

Within the family, Käsebier's control of the camera was taken for granted. Her grandchildren grew accustomed to her sneaking up

> when we were playing in the sand pile, or having a story read to us . . .
> or just sitting on the stairs sucking lollypops. . . . The front leg of the tripod
> which held the camera would wave around jabbing the floor, the rug, the
> ground, for a good grip and the right angle, as if it had a life of its own.
> Then the bellows would move in and out, and Granny would emerge from
> under the focusing cloth and say: "Now———still." . . . We were neither
> bored nor excited by the picture taking; it was just one of the things that
> happened, like sneezing or brushing your teeth: a minor annoyance to
> be got over with as quickly as possible, and the quickest way was to sit still.[56]

On one such day in 1910, when the sun painted pale stripes across the stairs of the Turner home, Käsebier photographed her granddaughters sucking lollypops and cuddling a kitten on the bottom step (97). Even as she captured this perfect moment, Käsebier once again upheld ideas growing out of the kindergarten movement, for Hermine Turner's distant but attentive gaze seems to exemplify child-rearing articles that advised mothers against watching their children too closely and smothering their individuality.[57] As with the best of Käsebier's photographs, the composition, lighting, and sensitivity to human relationships create an ineffable effect that releases this family photograph from the specific and temporal into the realm of the universal and enduring.

In late 1910 Käsebier participated in what turned out to be the final Photo-Secession photography exhibition. It was not planned as such, although Stieglitz did conceive the exhibition at the Albright Art Gallery (now the Albright-Knox Gallery) in Buffalo, New York, as a summing up of artistic photographic accomplishments. A total of 560 photographs were divided into two sections; open and by invitation. The invited photographers, selected by Stieglitz from Europe and the U.S., were said to represent the best that had thus far been accomplished in pictorial photography.[58] The majority of them were names familiar to *Camera Work* readers.

Many of the individual exhibitions, such as Käsebier's, were retrospective. Of Käsebier's twenty-two prints, fourteen were based on negatives made before 1908; eight photographs, chiefly portraits, were made during 1910. Most old favorites were there; Käsebier printed copies of *Blessed Art Thou Among Women*, *The Manger*, *The Red Man*, *The Bat*, and a Rodin portrait especially for the exhibition, fulfilling her promise to support Stieglitz in the Buffalo show.[59]

Much of the criticism of the exhibition was political. Many people in the photographic world were angered that it included only Stieglitz's choices, and the rival Photo-Pictorialists of Buffalo shunned the exhibition entirely.[60] Generally, however, praise outweighed criticism, with many writers recalling Stieglitz's accomplishments and discussing the Photo-Secession as a group. Keiley, however, leveled a vitriolic, personal attack at Käsebier, accusing her of

> artistic irresponsibility and indifference to mere technique . . . curious
> impulsiveness . . . inner blind groping to express the protean self within—
> that finer bigger self that cannot always find a voice and that resents any
> seeming lack of appreciation on the part of others.[61]

97.
Lolly Pops. 1910. Platinum print, 11¼ × 8⅜". Collection, The Museum of Modern Art, New York. Gift of Mrs. Hermine M. Turner

These comments seem gratuitously nasty since Keiley had formerly admired many of the photographs that he now condemned outright. He appears to repudiate his former admiration for *The Manger, Blessed Art Thou Among Women* and *The Heritage of Motherhood*. Käsebier's technique may not have been above reproach, but another writer dealt with it mildly and constructively by saying that she could improve her pictures by discontinuing her use of a yellow tint.[62]

In an unprecedented recognition of photography by an American art museum, the Albright Art Gallery bought photographs from the exhibition for its permanent collection. However, in order to obtain as many pictures as possible for the Albright's allotment of three hundred dollars, Stieglitz exacted sacrificial prices from his colleagues. In December Käsebier agreed to sell a copy of her famous hundred-dollar print, *The Manger*, to the Albright Gallery for only thirty-five dollars. When by February 3 she had not been paid for this and for four other prints that had been sold to collectors, she lost patience and wrote curtly:

My dear Mr. Stieglitz:
When do I get my money
for prints sold in Buffalo?
 Yours sincerely,
 Gertrude Käsebier[63]

Stieglitz's defensive, unapologetic reply suggests the edgy relations between the two photographers:

There has been a great deal of delay, excusable if one knows conditions as I do, on part of collecting moneys and the return of prints on part of the Buffalo people.

Of course I am undoubtedly considered the culprit by those photographers whose prints have not yet been returned, or who have not received the moneys due them for prints sold.

I can assure you that the moment I receive the cash belonging to you I shall forward it to you without delay.[64]

Stieglitz evidently thought it naive, if not crass, to expect to be paid on time; Käsebier considered it good business.

The differences between the two imaginative idealistic photographers now far outweighed past sympathies. While Käsebier's interest remained rooted in photography, Stieglitz's had shifted towards modern art. Both *Camera Work* and exhibitions at 291 illustrate his new preferences: Rodin, Matisse, Cézanne and Picasso among them. Stieglitz sought advanced art not only because he felt photographers like Käsebier and White were stagnating, but because he had become intolerant of conventionalism. Exhilarated by the 1909 Parisian Salon d'Automne which included vibrant paintings by Matisse, Vlaminck and Kandinsky, Stieglitz had written to his sister:

I hate tradition for tradition's sake,—I hate the half-alive; I hate anything that isn't real. I never knew I had the ability to hate in me but I find that as I grow older a hatred not against individuals but against customs, traditions, superstitions, etc. is growing fast and strong & I am not trying to throttle it.[65]

Käsebier drew away entirely in 1911. Early that year, Clarence White joined Max Weber (who had already quarreled and fallen out with Stieglitz) in having the

Newark Museum present an exhibition of "Modern Photography," including Coburn's and Käsebier's. Uninterested though he was in their photography, Stieglitz was unwilling to let disciples lapse. On March 1, 1911, a month before the Newark show opened, Stieglitz sent members an ultimatum which, in effect, demanded faith in the Secession or excommunication from it. A bill for Photo-Secession dues declared: "Those who are not in full sympathy with the present activities of the "Photo-Secession" are in honor bound to return this bill unpaid and have their names stricken from the list of members."[66]

98.
The Rehearsal. c. 1912. Gum bichromate print, 9½ × 12⅜".
Collection, The Museum of Modern Art, New York. Gift
of Mrs. Hermine M. Turner

Reactions to this note are unrecorded. However, later that year, Stieglitz softened unexpectedly, apparently trying to win back some of his former adherents. But it was too late and too little. On January 2, 1912, Käsebier made a definitive break (perhaps fulfilling a New Year's resolution). Her terse note read: "I present to you my resignation from the Photo-Secession."[67]

Stieglitz demurred. Referring to Käsebier's difficulties, which included the destruction of her sidewalk photo showcase by workmen during a widening of Fifth

Avenue, a severe eye infection, and a now-forgotten financial problem, he wrote:

> Through Mrs. Stieglitz I had heard of your troubles and the load you
> were carrying. When you cancelled your subscription for *Camera Work*
> I interpreted it as meaning that you were forced to economize. When now
> I also receive your resignation from the Photo-Secession without any
> explanation I assume that it is for the reason you wish your name dropped.
> Inasmuch as membership to the Secession is not dependent upon payment of
> dues,—you being one of the very few who paid them regularly, *I cannot
> accept your resignation without knowing that you are no longer in sympathy
> with the Secession's work, nor believe in its aims and activities.* [my italics][68]

Diplomatically, Käsebier declined to satisfy Stieglitz with rancor. She had the last
word on January 6, making it clear that this decision was not impetuous:

> I thank you for your generous offer which I cannot accept. I have
> contemplated the step which I have now taken for a long time. Please let
> my resignation go through with dignity and without bitterness. It is final.[69]

CHAPTER

VII

O N

H E R

O W N

xcept for simplifying her life in 1914 by merging home and studio in a large apartment on West 71st Street, Käsebier's day-to-day life changed little for several years after her break with Stieglitz. Through the mid-teens her portrait business thrived, and, freed from the burdens of marriage and 291, Käsebier led an independent life, bolstered by family and friends in an America whose spirit was not yet muted by war.

Käsebier's late work has not received its due because, until recently, it was little-known, undated, or misdated. Only as pictures have been dated in the course of writing this book has it become evident that Käsebier did not stagnate when she fell out of favor with Stieglitz. Nothing makes the quality of her late work clearer than the fact that many of the Käsebiers admired by curators and critics since the 1970s turn out to have been made during her last years in the Secession, and after.[1]

From the 1890s on, outdoor photography had been a favorite summer occupation of Käsebier's. In 1912 she grappled with the challenge of Newfoundland's dim, gray light, making pictures whose stylistic departures reflected her flexible nature. The trip had been proposed by John Murray Anderson, a Newfoundland native who ran an antique shop near Käsebier's studio until he succeeded in show business during the late teens. Later, Anderson became known for producing such theatrical extrava-ganzas as the Rockettes at Radio City Music Hall and the Aquacade at the 1939 World's Fair.[2]

When Käsebier first photographed him, he was amusing the cream of New York society with seventeenth-century French court dances that he had learned in Europe. He made a name for himself performing for the socialite Mrs. Stuyvesant Fish, who, in a futile campaign against the fashionable tango (which she considered too sexy), promoted minuet-like dances with little physical contact. *The Rehearsal* (98) shows Anderson and a partner in seventeenth-century costume practicing for one of Mrs. Fish's after-dinner entertainments or some similar *soirée*. The soft-focus photograph looks like a costume piece staged for the camera—an event like the *tableaux vivants* that Käsebier and her fellow students had enjoyed at Pratt, or like the photographs that F. Holland Day costumed and directed.[3] In fact it is a record of staged entertainment, analogous to a movie still, although there is no evidence that it was used for publicity.

In 1912 Käsebier visited Anderson's family in St. Johns, Newfoundland, while he scouted for antiques. Anderson may have commissioned her to photograph his family, but what is now known of the trip constitutes an outdoor productive streak for Käsebier, who compiled a photojournal of scenic snapshots with handwritten and often ironic commentary (102), and made more than two dozen 8 × 10 inch views.[4] The Newfoundland pictures, in which figures are subordinated to landscape, are characterized by simplicity, boldness and angular structure. Some show an interest in repetition of geometrical forms that is unprecedented for her.

Käsebier's style may have changed partly in response to Newfoundland's duski-ness. She wrote:

> I began to get my bearings and tried photographing without sunlight. The weirdness of it all seemed like a stage setting. The quality of the light and

the coloring of the landscape in consequence was different from anything which I had ever seen in nature.

She felt as if she were looking through smoked glass.

> The heavens were always gray with beautiful cloud effects; the scrubby pine trees were black against the mountains of dark gray; the many lakes reflected in turn the gray of the sky. . . . A paradise for the painter, the etcher. A great despair to the photographer, because of the darkness.[5]

From early in her career, Käsebier had thought of photography as a medium of light. Her pictures were often composed by tones, whether contrasted, as in *La Grand-mère*, or pale against pale, as in *Blessed Art Thou Among Women* and her portraits of Rodin. When Newfoundland's "weird" light did not conform to her tonal approach, she adopted a more linear, architectonic style. Some of her formality and asymmetry harks back to examples in Dow's book, *Composition*, but the Newfoundland pictures have an angular, restless quality that may have been induced by Cubist paintings shown at 291 or by Coburn's increasingly geometric style. Whatever the source, colleagues and critics immediately recognized the merits of her Newfoundland photographs. Referring to pictures that included *Wharf Rats* (101), a *New York*

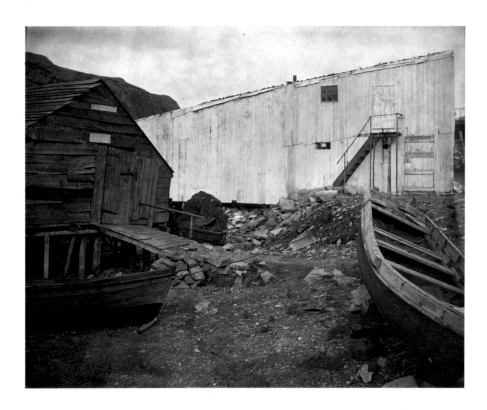

99.
Fishing Banks, Newfoundland.
1912. Platinum print, 7⅝ × 9½".
International Museum of
Photography at George Eastman
House, Rochester, N.Y. Gift of
Mrs. Hermine M. Turner

Times reviewer wrote: "Her fine little harbor scenes, with their distant horizons and their subtly graduated planes are landscapes of a quality that might be envied by many a modern painter attempting to lure from nature the secret of her charm."[6]

In early 1913 the Armory Show was the first exhibition to bring modern European and American art, including Cubism and Post-Impressionism, to a large American audience. At the vast armory at Lexington Avenue and 25th Street, an unconventional but central site for displaying art, the names of Picasso and Matisse, Redon and Duchamp first became familiar to the American public. Käsebier's old friend Arthur B. Davies was the president of the anti-academic Association of American Painters

and Sculptors and the moving force behind this exhibition. At his request, she agreed to lend her Rodin drawings and sculpture to the show.[7]

She also seems to have gotten one of her granddaughter's drawings hung—at least for a while. Mina Turner recalled that, at the age of six or seven, she made

> a drawing of 2 men and 2 dogs drawn in straight lines on a piece of black paper . . . with orange and yellow pastels Granny had given to me.
>
> Granny enthused greatly over this artistic effort, and shortly afterwards took me to the [Armory Show] in New York. She met a lot of people she knew there and they led me around to the "Nude Descending the Staircase," to get my reactions. . . .
>
> Imagine my surprise when Granny asked her group of friends to come with her to another picture, and it turned out to be [mine], properly framed, numbered and hung. . . .
>
> Granny asked her friends their reactions and after much discussion as to whether the influence was Picasso or Early Egyptian they asked her her opinion. "Oh, I like it very much. You see she made it for my birthday," she said. She chuckled all the way home, relishing her joke, but assured me that my drawing was worthy to be hung.[8]

100.
Newfoundland. 1912. Platinum print, 7½ × 9¾". International Museum of Photography at George Eastman House, Rochester, N.Y. Gift of Mrs. Hermine M. Turner

It is not surprising that no evidence of the picture has been found in Armory Show records, as they are known to be incomplete. At any rate, Davies and his associates presumably would not have objected to the picture; along with other forms of "primitive" art, children's art was gaining favor at this time. Stieglitz had held an exhibition of children's paintings in 1912, and perhaps putting her granddaughter's picture in the Armory Show was Käsebier's way of going Stieglitz one better. She might also have been taking a leaf out of Steichen's book; he told of insinuating his fake of a Cézanne (or a Picasso) into a 291 exhibition to "test" the public's apprecia-

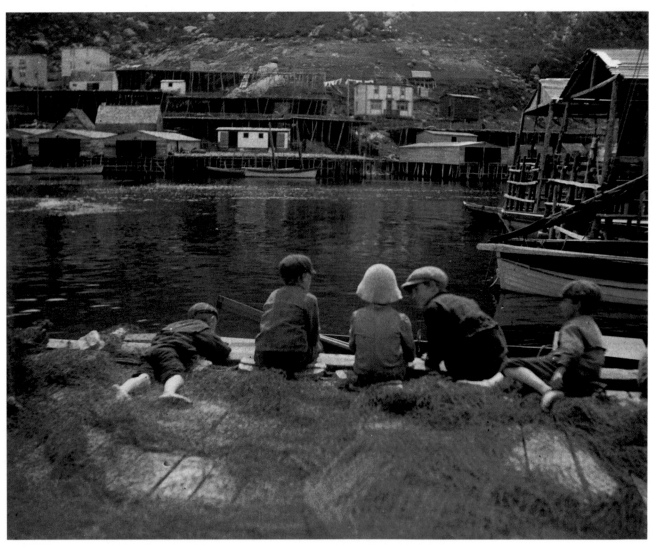

101.
Newfoundland, Petty Harbour (Wharf Rats). 1912.
Platinum print, 7⅝ × 9⅝″. University Gallery Collection,
University of Delaware. Gift of Mason E. Turner, Jr., 1979.
Photo: Butch Hulett

tion of modern art. But it was one thing to like children's art and quite another to have a real feeling for abstraction. Comparing a child's drawing to the work of mature painters suggests Käsebier's lack of understanding, if not disdain for Cubism. Likewise, she saw abstract photography as a passing fad, telling a photographic group to "bear in mind that the abstract things of today are tomorrow the quaint things of yesterday."[9]

Meanwhile, Käsebier had been allying herself with Clarence H. White, who, for many disaffected Secessionists, replaced Stieglitz as Pictorialism's leader. To fill the void left by Stieglitz, now that photography was virtually absent from 291, White organized photographic exhibitions at New York galleries, beginning in 1912 with one ambitiously aimed to illustrate the "progress of the art of photography in America," and handsomely installed by Max Weber, the painter who had hung the 1910 Photo-Secession exhibition at the Albright Art Gallery.[10] Despite falling out with Stieglitz later that year, Weber continued to champion his photographs. Weber

also admired Coburn's and White's work, and may have helped to select pictures for the 1912 show: nearly all suit his taste for unmanipulated prints. Exhibitors whose names had often been associated with Stieglitz included Eva Watson Schütze, George Seeley and Karl Struss, as well as Coburn, whose photographs of the western United States were shown. *Wharf Rats* (101) was typical of the eight Käsebiers there: most had been made since 1910; none predated 1905, and none were painterly.

Over the years, Weber's and Käsebier's paths crossed, perhaps at Pratt, where Weber studied with Dow, perhaps at 291, after Weber returned from studying European modernism abroad, and certainly at the White School in Maine, where Weber taught art appreciation. Because Weber stood for straight photography (his aversion to Steichen's handworked photographic technique was one of the sticking points between him and Stieglitz), he could not have wholeheartedly endorsed Käsebier's methods. Yet with her boundless sympathy for promising but poor young artists, she seems to have been responsible for introducing him to Coburn, who made various efforts on Weber's behalf.[11]

Käsebier's work, old and new, appeared in two other exhibitions that White arranged. An "International Exhibition of Pictorial Photography" in 1914 included about eighty prints by Europeans as well as Americans; a Newfoundland print was one of the Käsebiers shown. In 1915 Käsebier's classic *Red Man* hung among fifty-seven prints in "An Exhibition of Pictorial Photography," mostly by younger American photographers. These little-noted exhibitions provided continuity between the 1912 exhibition and the founding of the Pictorial Photographers of America in 1916.[12]

Clarence White's efforts at promoting photography through exhibitions and publications pale beside Stieglitz's, but White's forte was teaching, which Stieglitz eschewed. Although White had taught photography at Columbia University since 1907, his quiet, undogmatic guidance really began to make its mark after the opening of his School of Photography in Maine (1910) and New York (1914). Like the painter Gustave Moreau, White owes his renown as a teacher to a talent for letting students develop their own bents: Margaret Bourke-White, Laura Gilpin, Dorothea Lange, Paul Outerbridge, Ralph Steiner, and Doris Ulmann all studied with him.

White's willingness to see artful photographs reproduced alongside text in mass-circulation publications (an attitude at odds with Stieglitz's philosophy of showing only in galleries or fine magazines) set a precedent for documentary photography of the thirties and photojournalism of the forties and fifties. Until recently, historians have considered Stieglitz the more progressive of the two, because he rejected soft-focused pictorialism and advocated photographic modernism: straight, sharp-focused, high-contrast pictures favoring machine and city images. Today, however, White's laissez-faire attitude to the medium, his lack of "objection to anybody using any method that he pleases providing that the result is convincing," has placed him in the forefront by making him seem a precursor of post-modernism.[13]

Because her versatility set an example, Käsebier was an asset to White's faculty. Here was a photographer who had conducted a portrait business, sold pictures to magazines, and exhibited in salons. Moreover, she adhered to no one photographic style, although, true to the premises of Pictorialism, her variations grew from her will to express her feelings about what she saw. To White's many female students, she was a model "taking woman": amusing, enthusiastic, and encouraging, as well as visually talented. Käsebier did not teach on a regular basis but gave occasional sessions that would now be called master classes, beginning in 1913, at White's

The babies sit on the street.
Nothing happens.

They hang the washing
on the fences.

Like a pencil drawing

Fishing boats.

Quidi Vidi.

4. The magnificent ruggedness of the rocky coast line charmed the eye. Delighted with

The Harbor of St. Johns.

The entrance to the harbor of St. Johns is a natural gateway. In former time a heavy chain was fastened from shore to shore to keep out invading french war ships.

The anchor to which this chain was attached remains. Although an historic spot it is seldom

Above and opposite:
Newfoundland Trip 1912. Platinum prints on 13 × 8″ page. Collection Mason E. Turner, Jr. Photo: Jack Bungarz

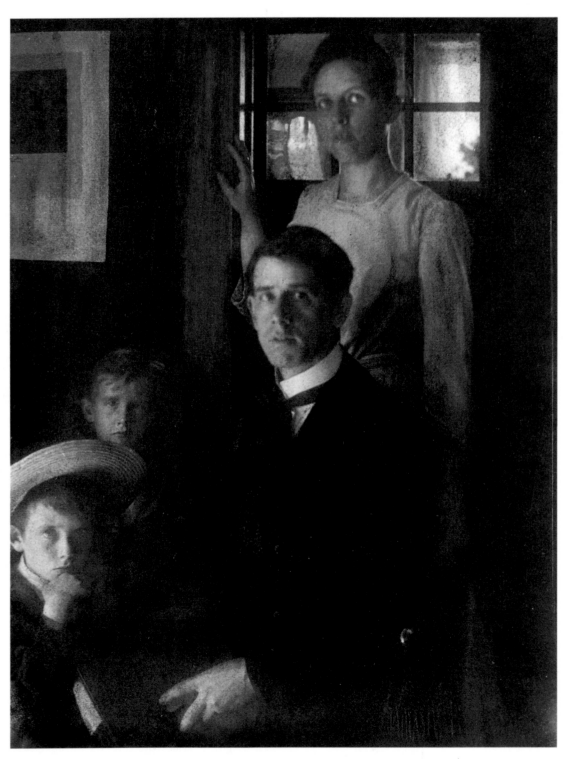

103.
Clarence H. White and Family. 1908. Platinum print from
1902 negative. 8¹⁄₁₆ × 6³⁄₁₆". The Metropolitan Museum of
Art, New York. The Alfred Stieglitz Collection, 1933
(33.43.418)

104.
Sunshine in the House (Clarence H. White and Family). 1913. Platinum print, 7⅝ × 7¼".
Collection, The Museum of Modern Art, New York. Gift of Edward Steichen

summer school in Georgetown, Maine. (Even after White's death in 1925, Käsebier continued to welcome students from the White school to her apartment/studio.[14])

It was no coincidence that White's summer school was just down the road from F. Holland Day's place. Over the dozen or so years since Day had broken with Stieglitz, he had kept up with Käsebier and White. During a summer visit to Day, the Whites had become so enamored of the Georgetown area that they bought a modest summer home there. In 1913, Käsebier and students stayed nearby, at the turreted, gray-shingled Seguinland Hotel.[15] When the White and Ruyl families visited Day's new chalet-style home (which had just replaced a more modest house) Käsebier made some of her most complex, compelling compositions, pictures that bring her career in portraiture and expressive photography to a new level.

Although Käsebier made some photographs of White alone, she considered her pictures of him with his family more significant and successful, later choosing two of them to be shown at her 1929 retrospective (103, 104). The earlier and more formal of these, made in White's Newark, Ohio, home in 1902, grouped the family in a triangular pattern—seated and standing—and further unified them by compressing them in a shallow space. Typically for Käsebier, the children are close by their parents but looking towards the camera.

The later portrait, *Sunshine in the House,* is a tour-de-force of composition, lighting, and group portraiture. It shows the Whites—who had by 1913 become a family of five—in a sunstreaked room at Day's house. The contrast of light and dark in an emotionally intense interior is an outgrowth of pictures of her own family in Oceanside and Waban (94, 95, 97). The heightened interest in geometric, particularly diagonal, forms that characterizes her Newfoundland pictures of the previous summer recurs here. Casual though the grouping seems, Käsebier must have calculated the psychological effectiveness of letting a slash of sunshine split the grown sons from their parents and younger brother.

By posing Clarence White with his wife and children, Käsebier differentiated him from his photographic colleagues. Of the leading American pictorialists, only White's family was close-knit. Stieglitz's marriage to Emmeline was a failure almost before it began.[16] In 1907 Frank Eugene caught the almost palpable alienation between Alfred and Emmeline when he photographed the two sitting at opposite ends of a garden bench, barely touching (Naef, fig. 288). Steichen's elegant but psychologically cool double portrait (Naef, plate 59) shows Stieglitz's ambivalence about fatherhood. Stieglitz seems to turn his back on his daughter, even while linking his arm in hers. Steichen's own first marriage ended in divorce, Käsebier's was flawed, Keiley and Day remained single, and Coburn lived abroad after he married.

By contrast, the Whites' marriage was in every sense a partnership. Jane White was the model for many of her husband's most famous early photographs; the children were his frequent subjects, too (55). Later, when Mrs. White ran the business end of the Clarence White School, she "held everything together by sheer hard work, sacrifice and the force of her character."[17] Whether or not one is familiar with the family, Käsebier's photographs suggest the Whites' compatibility.

Ten years elapsed between Käsebier's first photographs of Beatrice Baxter Ruyl in Newport and those she took of her in Maine.[18] However, *The Hand That Rocks the Cradle* and *The Widow* are less portraits than a consummation of the mother and child theme that Käsebier had been pursuing since the 1890s. The title of photograph 105 is significant because the notion that "the hand that rocked the cradle" might "rule the world" seemed even more probable when Käsebier made this picture than

in the mid-nineteenth century when William Ross Wallace wrote those noted lines. Froebel and the burgeoning kindergarten movement had made mothers responsible not only for the physical and moral development of their children but for their intellectual growth.[19]

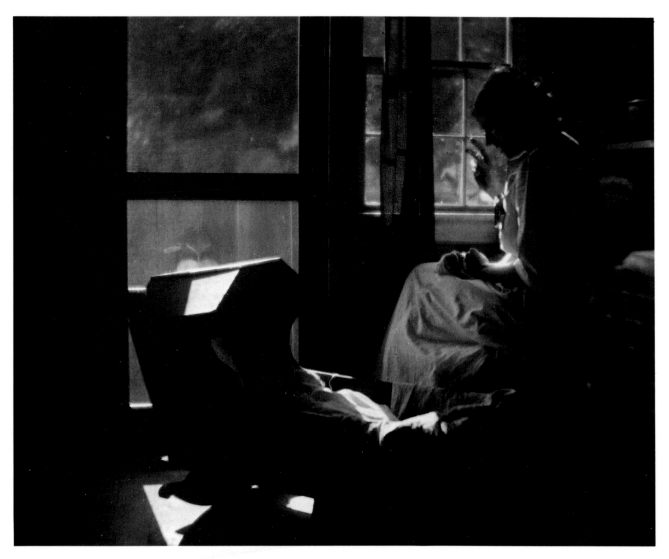

105.
The Hand That Rocks The Cradle. 1913. Platinum print,
7¼ × 9⅝". Collection, The Museum of Modern Art,
New York. Gift of Mrs. Hermine M. Turner

In Käsebier's circle, Arthur W. Dow is known to have become a convert to Froebelian concepts early in the century. He had taught a course for kindergarten teachers at Pratt, and by 1914 his involvement was so great that he addressed the International Kindergarten Union on "Color in the Kindergarten." Käsebier's later pictures continue to show Froebel's ideas in action. Among Froebel's strongest tenets was the belief that a child's education should begin at birth. He recommended finger-play games to spur even an infant's intellectual development. His idea, that what the child imitates, he or she begins to understand, was spread through books of songs and finger play, especially *Finger Plays For Nursery and Kindergarten* by Emilie Poul-

sson, which prints words and music for songs and illustrates appropriate gestures.[20]

A gesture from Poulsson's book is shown in Käsebier's photograph, *The Hand that Rocks the Cradle* (105, 106), where Beatrice Baxter Ruyl apparently recites a verse about a rabbit, simulating rabbit ears with two fingers while her daughter looks on wide-eyed and plays with her own fingers. Käsebier herself sometimes used old-fashioned finger play to engage the interest of juvenile sitters.[21]

Nearly ten years before she made *The Widow*, Joseph Keiley remarked that Käsebier used sitters to "express the pictorial conception that they have awakened in her imagination." Calling Ruyl a widow was a conceit, as her husband appears in other photos from the same sitting (one is at the Chicago Art Institute). Whether the idea and title preceded or followed the photograph, the theme seems to have been provoked by newsworthiness of widows for several years leading up to 1913. From about 1910 on, newspapers and magazines reported efforts to provide for fatherless families. By 1912, President Theodore Roosevelt publicly advocated pensioning dependent and indigent widows; by mid-1913, thirteen states had enacted pension plans for widows. On Sunday, April 13, 1913, when Käsebier's portrait of Mrs. Lydig (61) appeared in one section of *The New York Times*, an editorial in another section favored widow's pensions.[22]

Virtually anyone who read a newspaper or magazine at that period would have been aware of the growing interest in the plight of widows—and Käsebier was known to read three newspapers a day. Impoverished widows who could not support their children without working faced a heartrending situation: while employed away from home at industrial jobs they could not tend their children. Mothers were thus forced to relinquish children to inferior care in foster homes and institutions. Sometimes these children were even adopted by others. Families were often fragmented; brothers and sisters were separated from each other, as well as from their mother. Like the widow whom one magazine described as obsessed by the fear that her children would be taken from her,[23] Käsebier's *Widow* looks out with anxious eyes, clinging to her child in a pose uncharacteristic of Käsebier's mothers.

Käsebier's photograph could also illustrate the thoughts of a financially comfortable young widow who said that while society was indulgent to a "grass widow"—a woman living apart from her husband—an actual widow "is very often made to feel as though her widowhood were in some subtle ways an offense against the world, especially if she is in any degree young and sees years of solitude stretching away before her."[24]

Topical though widows were, Käsebier drew on a nineteenth-century pictorial tradition of showing a widow (or a woman who might soon become one) waiting anxiously in a dim interior. One example of this tradition that Käsebier must have known was Virginie Demont-Breton's *Husband at Sea*. As an artist, Demont-Breton would have interested Käsebier, not only because she was the daughter of the painter Jules Breton, but because her ideas about motherhood accorded with Käsebier's. Demont-Breton called maternity "the most beautiful, the healthiest glory of women . . . the inexhaustible source whence feminine art draws its purest inspiration."[25]

However, the composition of Käsebier's picture imparts a psychological intensity that lifts it from nineteenth-century sentimentality into the age of anxiety. It is immediately obvious that the shadowy, empty seat suggests the husband's absence and that the infant's presence does not dispel the loneliness implied by the dark enclosure of the room and the viewless window (which Käsebier had opaqued by drawing either on a negative or on a print that she later copied). More subtle is the

106.
L. J. Bridgman. "The Rabbit" from "A Little Boy's Walk" in Emilie Poulsson, *Finger Plays for Nursery and Kindergarten*, 1893. Music Division, The New York Public Library for the Performing Arts, Astor, Lenox and Tilden Foundations

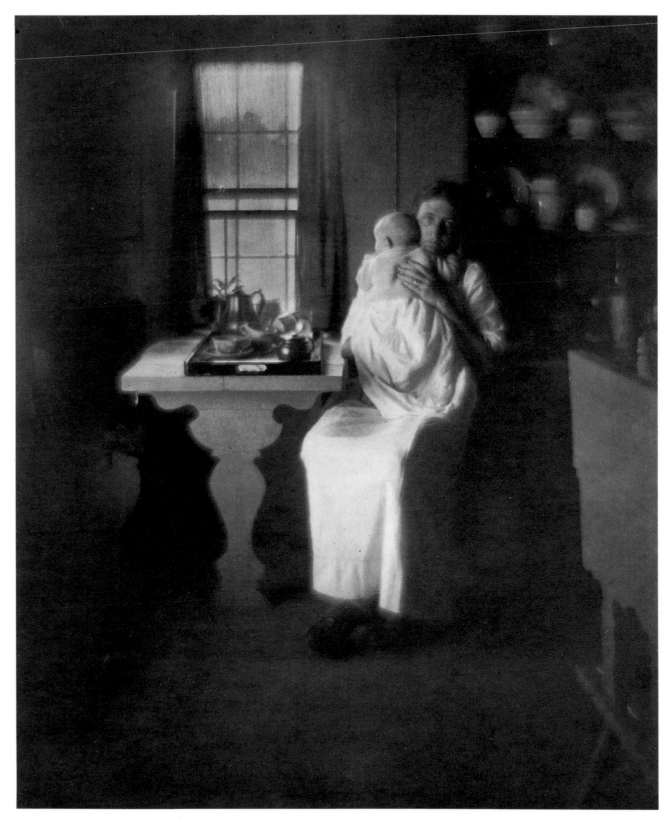

107.
The Widow. [1913]. Platinum print, 8⅞×7¼", Collection,
The Museum of Modern Art, New York. Gift of Mrs.
Hermine M. Turner

sophisticated and challenging construction of this picture whose ambiguous space contributes to an effect that has been called upsetting, even menacing.[26]

Since Käsebier had never pictured widows before 1913, it is reasonable to assume that her interest in the subject was provoked by its timeliness. Perhaps Käsebier's own widowhood made her susceptible to the topic, but her photograph is not autobiographical. At 57 in 1909, Käsebier had been released, rather than confined, by her husband's death. Especially during the teens, Käsebier felt personally involved with the events of her day and intertwined personal vision and public matters, as she did in *The Widow*. At the outset of World War I, she interpreted her dream of marching feet as a vision or premonition of Germany's invasion of Belgium. About the same time, she sent a note to her friend and client, publisher of the *Times* of London, Lord Northcliffe, concerning the war. At least two photographs were evocatively titled in response to the war: *The Refugee* and *In Times of Peace*.[27]

The titles of Käsebier's photographs (like those of many of her colleagues) were usually meant to add symbolic resonance to a picture. But Käsebier's titles are more puzzling than most, and sometimes her meaning seems as elusive as it is allusive. With its horizontal screenlike format, silhouetted animal profiles, soft landscape and shallow space, *The Pathos of the Jackass* reflects the style and mysterious lyric mood of Arthur B. Davies's early paintings. Yet Käsebier said it was "not a picture of cows and a jackass. Nor of country either. It's a picture of an old man, too old to work, turned out among a lot of women to die. See that young Jersey heifer peeking around the tree? Well, you'll always find a pretty young heifer to flirt with an old jackass."[28]

Obscure though the title is, it challenges viewers to see the photograph as more than a pastoral landscape. If Käsebier's cynical message is indecipherable to an uninformed onlooker, the isolation of the jackass is not.

With the outbreak of war, Baron de Meyer came to New York to work for Condé Nast and may have been instrumental in publishing photographs by Käsebier (as well as others from the old Stieglitz circle) in *Vanity Fair*. Clarence White's friend Heyworth Campbell, the art director of Condé Nast from 1910 to 1923, was another probable go-between.[29]

"If there is a new photographic field, trust Mrs. Käsebier to find it," crowed the chic magazine of arts and fashion, oblivious that she had been making silhouette portraits, on and off, for more than two decades.[30] Three *Vanity Fair* silhouettes of John Murray Anderson and his wife were new, but one picture of a young woman had been reproduced twenty years before in the *Monthly Illustrator!* However, the popularity of silhouette designs in commercial art during the teens made Käsebier's silhouettes, recent or not, seem up-to-date.

One of Käsebier's last important celebrity portraits, of Mabel Dodge, was published in *Vanity Fair* (108). When Käsebier took the picture in late 1914 or early 1915, the wealthy Mrs. Dodge was one of Greenwich Village's leading lights, known for conducting a salon of radical artists, writers and intellectuals at her home on lower Fifth Avenue. Several years before, while an expatriate leading a luxurious life in a villa overlooking Florence, Mabel Dodge had become the subject of a verbal portrait by one of her guests: Gertrude Stein. That "Portrait of Mabel Dodge at the Villa Curonia," whose cryptic and fragmented imagery has been compared to contemporary Cubist painting, brought fame (or notoriety) to both women. Copies were distributed at the Armory Show; it also appeared in *Camera Work*.[31]

If Käsebier's image is unrevolutionary, it nonetheless conforms to Dodge's vision of herself at the time, as her autobiography poetically recalled how she "in long

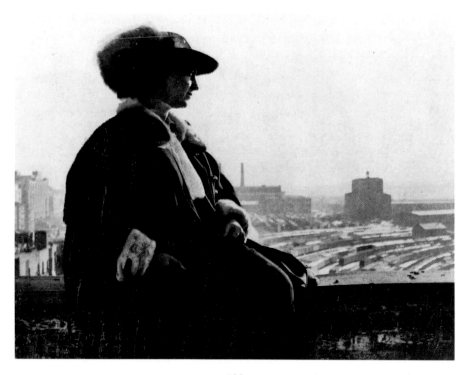

108.
Portrait of Mabel Dodge. Reproduced from *Vanity Fair,*
May 1915. Courtesy Condé Nast Publications Inc.

flowing, soft things and a hat with drooping feathers, nicely veiled, would pin a flower into fur." Differences between the avant-garde Mabel Dodge and (by then) middle-of-the-road Käsebier show most vividly in their attitudes towards the Armory Show. Käsebier's feelings about it were mixed; Dodge was a wholehearted supporter who spent a month helping to promote it. Käsebier's individualism (some would say conservatism) may also be seen in her photographs. Mabel Dodge was not the only subject whose portrait Käsebier took on the roof of a building. Yet unlike her colleagues Coburn, Karl Struss, and Paul Strand, Käsebier never used a high vantage point to shoot unpopulated bird's-eye views or cityscapes.

Realism in photography was what she advocated:

To me, photography seems to be preëminently the medium of absolute
record, with decided limitations on the imaginative side. While one may
much admire a photograph of a Breton peasant on his native heath, it gives
a jar to see him imitated, by the camera, in a Jersey meadow.[32]

Yet Käsebier did not always practice what she preached. Or, she did not consider it a breach of realism to make *obvious* alterations by hand, as she did with the highly charged image, *Yoked and Muzzled—Marriage,* in which a boy and girl, seemingly as lost in a forest as Hansel and Gretel, confront a pair of looming, inseparable oxen (110, 111). Käsebier had given up painting *per se* about 1910 but continued to mix paint with photography when it served her purposes.[33]

This picture is not only a far cry from the abstracted scenes that Paul Strand would soon be publishing in the last issue of *Camera Work*; in subject, mood and handling it was at odds with the bulk of photography coming from the White school. Perhaps it was Käsebier's convention-defying streak that spurred her to create this picture,

which she considered important enough to copyright in 1915. But it is also useful to remember that since she had first won photography contests in the 1890s, Käsebier had used photography in contrasting ways, oscillating between expressive pictures (which might be embellished by handwork) and conservatively printed snapshot-like photographs. In her last actively creative years, she swung in an even greater arc, from calculated geometric and tonal patterning to extremes of emotional expressiveness.

With wry humor, Käsebier equates matrimony to the yoking and gagging of oxen, two emasculated creatures who, inseparably, are forced to bear a weighty burden. Holding hands in a connotation of adult betrothal and marriage, a young boy and girl confront the looming oxen who may symbolize their future.

By comparing Käsebier's unmanipulated platinum print with her enhanced version of the picture, we can see how Käsebier changed the image for psychological impact. Painting on an intermediate negative, Käsebier shaded the children's garments, blackened the spotted oxen and shadowed their yoke and horns. A daylight country scene recalling the cows in *My Neighbors* or the children in *Happy Days* has become an evocative crepuscular vision whose very ambiguity is disquieting. Although the animals present no imminent threat (one is even lying down), their large shadowy presences seem to menace the children who stand immobile—in awe? in fear? in innocent wonderment? One doesn't know. But the overall message is clear: marriage means constraint.[34]

Yoked and Muzzled was not Käsebier's first photograph to suggest a dark side to marriage. Ten years before, perhaps in response to a request from Frances Benjamin Johnston who was compiling a feature on bridal photographs for the *Ladies Home Journal*, Käsebier (who ordinarily did not take wedding photographs) had created her image of an archetypal *Bride* suffused in shadow (109). But where *The Bride* was a hint, *Yoked and Muzzled* was a declaration. Although it must have been a response not only to Käsebier's own flawed marriage, but to her daughter Hermine's growing marital difficulties, Käsebier aimed for a more universal meaning.[35] The overtly cynical *Yoked and Muzzled—Marriage* as well as her portentously shadowed *Bride* should be seen as two pictures among many early-twentieth-century articles and books challenging the institution of matrimony.

Feminist writers such as Charlotte Perkins Gilman and Emma Goldman had seen most marriages as economic arrangements that enslaved not just the wife or husband but both. A woman pays with "her name, her privacy, her self-respect, her very life 'until death doth part.' Man, too, pays his toll," said Goldman, "but he feels his chains more in an economic sense." Käsebier's imagery recalls Gilman's description of marriage as an "unlovely yoke"[36] which hampers a woman's freedom. Conversely, Käsebier's evocative family portrait, *Harmony* (45), showed a happy couple who stand apart, even while facing each other and sharing a common interest. Their son sits nearby but does not cling; he is evidently contented to be close to his parents but spunky enough to eye the photographer with curiosity.

Because Käsebier was not in the forefront of feminism, her sympathy to the movement has gone unnoticed. Yet she played a part in attaining the modern freedom of women that she rejoiced in towards the end of her life. Letting actions speak more loudly than words, she had long shown feminist affinities. She was an advocate of dress reform, of comfort in women's clothing. A few years after observing that French peasant women could teach a lesson in healthful dress because while laboring "like men in the fields . . . their muscles are never hampered by the

109.
The Bride. 1905 or before. Gum bichromate print, 10⅜ × 7¾". Collection, The Museum of Modern Art, New York. Gift of Mrs. Hermine M. Turner

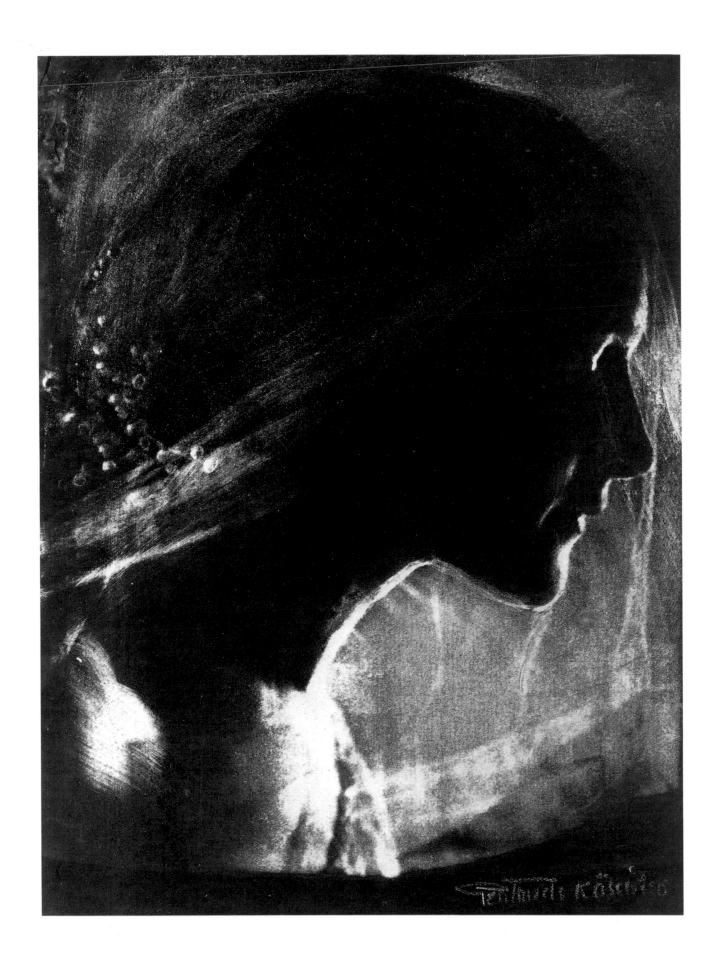

presence of whale-bone and steel," Käsebier went from conventionally corseted matron to being a photographer so "utterly careless of dress or appearances" that she might "emerge suddenly from the dark room into a group of fashionably-dressed patrons . . . enveloped in a voluminous, badly stained developing apron." As she aged, her loose individualistic attire included pale gray silk Chinese blouses, Chinese jackets, black broadcloth skirts that reached her ankles, and a cape over all (113, 114).[37]

More significantly, she had affirmed her right to freedom in marriage, by traveling and working apart from her husband. She worked, not only for economic independence but like many women of her day—and not only artists—for self-expression. Early in her career she encouraged "women of artistic tastes to train for the unworked field of modern photography." In addition to encouraging individual women photographers throughout her career, she was a founder of the Women's Federation of the Photographers' Association of America in 1909 and was for some years a supporter of that organization.[38]

In light of her attitudes, *Yoked and Muzzled—Marriage* is no mere personal commentary on marriage and independence; it is an expression of prevailing feminist attitudes to marriage.

Perhaps it is a measure of Clarence White's optimism and quiet determination that he formed the Pictorial Photographers of America (PPA) in 1916 when Europe had already been at war for two years and the United States was at the brink. Both 291 and *Camera Work* ceased to exist in 1917 after the U.S. joined the fight, but the PPA survived. Käsebier's position as honorary vice-president recognized her "contribution to the art of photography." Her actual involvement was occasional and limited but supportive. For instance, she lent fifteen of her photographs to the large historical exhibition at the National Arts Club that accompanied the formation of the PPA, an exhibition that included such rising stars as Imogen Cunningham and Doris Ulmann (exhibiting under her married name, Doris U. Jaeger).[39]

Käsebier's loan balanced old favorites (like *Blessed Art Thou Among Women, Black and White, The Bat, The Silhouette, The Red Man,* and a portrait of Rodin) with new pictures, including *Yoked and Muzzled—Paralleled* (as it is called here) and *The Sunshine in the House* (110, 104), prompting a critic to observe that

> No one could possibly show her absolute independence of tradition or of formulae. If ever that elusive autographic quality that critics so insist upon as necessary to real works of art could be found in a photograph it can be found in her prints. If any proof were required of the power of the camera to express personality Mrs. Käsebier's work would be enough.[40]

Complaining that "the war and after war strain just about wiped me off the map," Käsebier closed her apartment/studio in 1920 and moved to her daughter Hermine's home in New Jersey. But retirement ill-suited her, and within a year she was back on her own in an apartment with a small photography studio at 123 Waverly Place, just off Washington Square in the heart of Greenwich Village.[41]

The Village was in its heyday as America's artistic capital, but Käsebier was not an active participant. For many years she had been deaf; during the twenties she became increasingly lame and was often housebound. After being "knocked senseless" by a taxicab in 1923, she visited Hermine again for a few months. When Hermine's marriage to William Turner ended in divorce a year later, Hermine returned to New York to care for her mother and to carry on the portrait business

110.
Yoked and Muzzled—Marriage.
1915 or before. Gum bichromate print, 8¾ × 11¾". Library of Congress, Washington, D.C.

111.
Yoked and Muzzled—Marriage.
1915 or before. Platinum print, 4¾ × 6¾". Library of Congress, Washington, D.C.

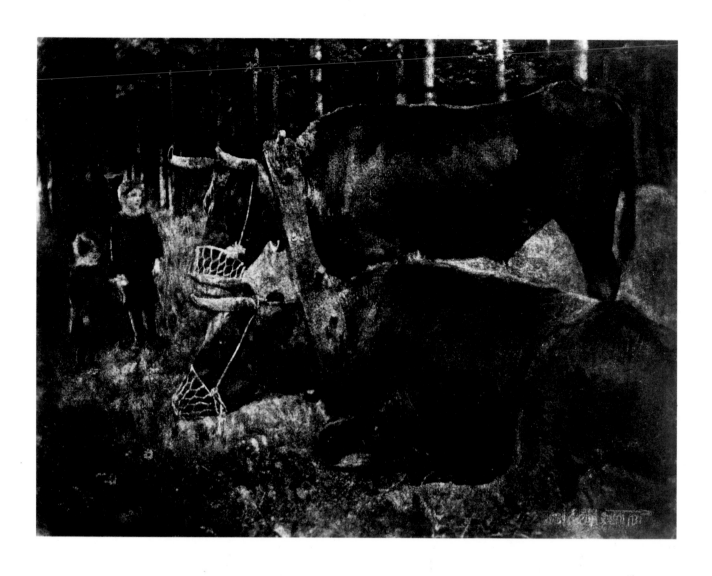

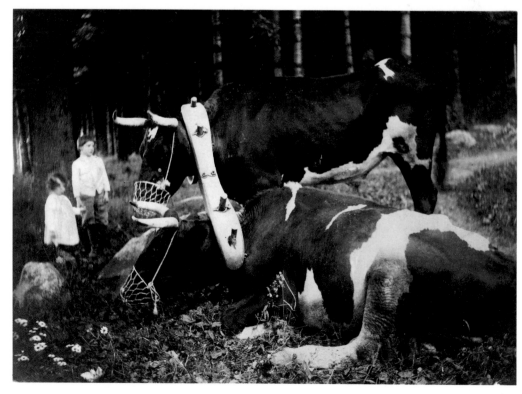

(114), and they soon took a more capacious apartment nearby at 171 West 12th Street. Later, Hermine's daughter, Mina, joined her; together they supported themselves in photography until the second World War, when materials became scarce. [42]

During the twenties, young photographers continued to seek Käsebier's counsel, as they had for years. Imogen Cunningham, en route home from Europe about 1910, had made a point of meeting Käsebier, because early in the century a reproduction of *Blessed Art Thou Among Women* had inspired Cunningham—then still a high school student in Seattle—to become a photographer. It was typical of Käsebier's thoughtfulness that after Paul Strand visited her in 1912 or 1913 she sent him a platinum printed Newfoundland scene as a Christmas greeting. Many years later, both photographers recalled Käsebier as nice, warm and encouraging, although Cunningham observed that Käsebier tended to boss Hermine in the studio, and Strand felt that Käsebier offered less trenchant photographic criticism than Stieglitz had. [43]

For Laura Gilpin, Consuelo Kanaga and Clara Estella Sipprell, who became well-known during the 1920s and 1930s, Käsebier's friendship and example were more meaningful than any specific precedent, although Kanaga particularly admired Käsebier's independence from her husband. Of the three, Laura Gilpin, who shared Käsebier's passion for Colorado and for Native Americans, knew Käsebier best. While studying at the Clarence White School during 1916–1917 she frequently visited Käsebier. Letters that Käsebier wrote after 1918 when Gilpin returned to Colorado brim with encouragement and practical advice. As Gilpin later said, Käsebier "inspired me to go ahead." [44]

While visiting New York in 1922, Edward Weston made a pilgrimage to her place, and found

> her conversation brilliant—her sense of humor delicious—and her bearing noble—I asked her if I might bring my camera along—she answered "Yes, there's a fine landscape out the window!" She finally consented to sit for me—adding—"but I make a miserable subject—I have never had a good portrait." [45]

That same year, Käsebier gave a talk to the Pictorial Photographers while more than two dozen of her photographs hung at the Art Center, an exhibition space that the PPA shared with other New York-based graphic arts organizations. Years of absence from New York exhibitions made her pictures seem new again, she told Gilpin, who had shown Käsebier's photographs along with her own at the Denver Public Library in 1921. [46]

To the benefit of historians, letter-writing was one of the pleasures of Käsebier's later life. Her notes to Gilpin as well as to her old friend, F. Holland Day, have become the prime sources about her life during the 1920s. Letters to both show Käsebier's absorption in reworking and enlarging a carte-de-visite photograph of Abraham Lincoln, a picture that Käsebier's son had uncovered around 1900 in an abandoned trunk in an about-to-be-demolished hotel in Brooklyn. Käsebier cherished the photograph and its inscription (apparently made by a Civil War soldier whose sentiment outran his literacy): "linclin the Presadent he giebt to me." [47] Not only was Käsebier untroubled by the anachronism of printing photographs of a man who had died when she was not yet in her teens; she believed that her version of the old photograph was sufficiently original to copyright it. She had magnified the wallet-sized photograph to eleven-by-fourteen inches, retouched it in several places, and printed it in platinum. The photograph shows a great deal of handwork,

especially in the beard, but that was not all Käsebier's doing. The carte-de-visite that Käsebier owned was a variant of a still earlier photograph, taken in 1858, when Lincoln was clean-shaven. In 1861, that picture was cropped and updated by giving Lincoln a rather crudely drawn-in beard. Käsebier improved on the beard, adding some highlights. She also shaded in the pale background and lightened Lincoln's jacket to emphasize his face and eyes.[48]

Characteristic prints are brown-toned platinum on matte paper and are unusually blurry from hyperenlargement. Although the image carries at a distance, it seems less successful to viewers today than it did to Käsebier and her contemporaries, when a copy was purchased by the Library of Congress and it was published in a Lincoln's birthday issue of the *Outlook*, as well as on the cover of *The New York Times Magazine*.[49]

Although her adaption of the photograph seems similar to the appropriation of others' work, so typical of post-modernists, it should be understood that Käsebier's interest lay in Lincoln himself, not merely in reworking an old photograph. She was partial to photographing great and accomplished men, and Lincoln's gaunt face intrigued her. Käsebier's Lincoln portrait must be considered not as an aberration, but as a sequel to her earlier likenesses of Rodin, Stieglitz and other eminent men.

112.

The Pathos of the Jackass. [1912–1916]. Gum bichromate print, 5½ × 13". Collection, The Museum of Modern Art, New York. Gift of Mrs. Hermine M. Turner

Moreover, Käsebier's fascination with Lincoln and others' appreciation of her portrait typified the era; interest in Lincoln reached an all-time high between about 1890 and 1930, when numerous biographies, including popular ones by Ida Tarbell and Carl Sandburg, were published. Käsebier's former assistant, Spencer B. Hord, exemplified that attitude when he thanked her for a copy of the photo, saying that he had always been an ardent admirer of Lincoln and had read many books about him.[50]

After 1925, Käsebier's sight began to fail, but despite her infirmities her work was not forgotten. In 1926 the Library of Congress bought fifteen of her photographs for four hundred dollars. In 1929, the Brooklyn Institute of Arts and Science (now the Brooklyn Museum) honored her with a retrospective exhibition of thirty-five photographs which illustrated the range of her work in subject and medium. She

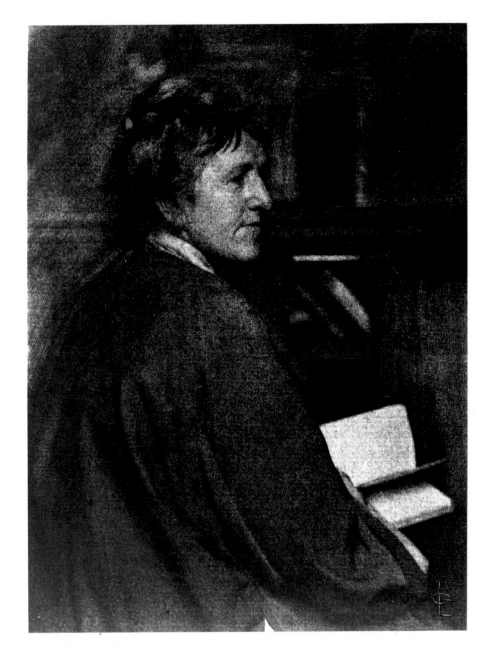

113.
Laura Gilpin. Portrait of
Gertrude Käsebier. c. 1916. Gum
bichromate print, 11⅞ × 5¾".
Courtesy of The Art Institute of
Chicago, Gift of Miss Mina Turner,
1973.53. Photograph © 1991, The
Art Institute of Chicago. All
Rights Reserved

appears to have considered these pictures—which include her most popular and
frequently reproduced images—the most representative of her career. Käsebier was
not wrong in calling the retrospective her swan song; it was the last exhibition of her
photographs during her lifetime. It is symptomatic of the shift in taste towards
modernism that the exhibition received almost no critical reaction. Yet Käsebier
remained a New York personality, a subject of interest to the press until shortly
before her death in 1934. Her wit did not desert her, despite physical disabilities and
great financial losses in the stock market crash of 1929. (These losses can only be
guessed at but must have been many thousands of dollars, considering that upon her
death her estate was valued at $80,000.) Interviews in two New York newspapers and
a series of articles in *Abel's Photographic Weekly* are informative sources summariz-
ing her life and work.[51]

Two reunions during her late years measure the devotion of old friends and her

114.
Hermine Turner. *Portrait of Gertrude Käsebier*. 1930.
Platinum print, 7⅞ × 6″. Collection the Wellesley College
Museum. Gift of Miss Mina Turner

own affection for them. They also bring the beginnings of her career full circle with its close. A visit from Samuel Lifshey—her teacher in Brooklyn so many years before—shows that age did not quiet her quick tongue or dim her powers of observation. Lifshey, who had not seen Mrs. Käsebier in some while, brought flowers when he paid a sick call after her taxi accident. While they talked of old times, she peered so intently at him that he became uncomfortable, wondering if something was wrong with his appearance.

"Got a wife, Sam?" asked Mrs. K. (He was a widower.)
"No."
More conversation.
"Got a girl?"
"No."
"Is that a new suit you have on?"
"Yes it is."
"Did you buy it to come to see me?"
"Well—yes I did."
"Well! Ever since you came in I've been trying to find the woman who was behind the crease in your trousers. At last I've found her. It's me!"[52]

More sentimental was the pilgrimage that Steichen, at his peak as a photographer for Condé Nast publications, made to her Greenwich Village apartment some time after 1926. Steichen had broken with Stieglitz a few years after Käsebier did. Becoming involved with utilitarian aerial photography during the First World War had helped to change Steichen's artistic attitudes; not long after the war he quit painting to devote himself to photographing in a crisp, modernist manner. The twenties found him aiming to reach a large audience by photographing for the printed page. As always, he succeeded with great flair.

For years, the Käsebier and Steichen families had been friendly, so his daughter, Kate, then in her twenties, accompanied him to the Käsebier-Turner apartment. "We were late—'cause Daddy was always late," she remembered about fifty years afterwards. But when Steichen spied a little flower store around the corner from the Käsebier-Turner apartment he said "Wait a minute," rushing into the shop that had a huge array of deep dark red roses. "Daddy bought two or three dozen roses," Kate Steichen recalled, and the florist started to put them in a box.

Steichen: "No—no box."
Florist: "Put 'em in paper?"
Steichen: "No, no paper."
He just paid the man, picked up the armload of red roses, and we went around the corner. . . . And there was Granny, very old then, very old, sitting in her great chair in her Chinese robe. He walked over to that old lady (he was still very much in his prime then), and he just simply laid those roses in her lap, and they clung together and they wept together, because she was his "Granny."

[Hermine] and Mina and I simply retired, and those two talked and talked and talked and talked. I don't think he saw her again, 'cause he got so involved in everything. It was a great day for Granny and it was a great day for Steichen. It really was.

But I'll never forget those red roses. Just out there, bare and beautiful and gorgeous in the lap of her blue Chinese robe.[53]

Gertrude Käsebier died at home of old age, on October 13, 1934. As one of the finest photographic portraitists of her day, she preferred looking at the ground glass to being seen in it. It is fitting that our last great color picture of her is not a photograph at all, but Kate Steichen's vivid memory of the old lady with her coronet of gray braids, ensconced in her big upholstered chair, and resplendently blanketed with roses.

Epilogue

W hile Gertrude Käsebier was studying photography in Germany during the mid-1890s, she suffered such leg and chest pains (from climbing five flights of stairs every day) that her mother-in-law called in the family doctor. He offered no sympathy, Käsebier later recalled.

I told him my heart hurt me.
He said: "Heart? HEART? . . . You have no heart!"
And what have I then?
"You have a camera box."

To the doctor's way of thinking, no normal flesh-and-blood woman of the 1890s would have abandoned her husband and housewifely duties as Käsebier had. Where the seat of emotion should have been, the physician, with heavy-handed humor, found a mere mechanical device.

Years later, the doctor revised his diagnosis and congratulated Frau Käsebier on her celebrated daughter-in-law.[1] But he never came to realize that, while her camera was not in her chest, metaphorically at least, Gertrude Käsebier's heart was in her camera.

The idea of photography as an expressive medium was part and parcel of turn-of-the-century Pictorialism, but Käsebier's photographs revealed a sensibility all their own. From the start of her career she spoke of photography as an emotional art, a medium "to express what there is in me,"[2] yet she seldom explained her photographs, leaving the meaning of many tantalizingly unclear. To say (as Käsebier and others did) that her pictures concern motherhood was true but insufficient, because it did not distinguish her approach from that of others. One step towards interpreting her pictures is recognizing that many of them embody early-twentieth-century progressive attitudes towards childrearing and marriage.

But beyond that, two themes are basic to her work: the independence and solitude implicit in her belief that "the key to artistic photography is to work out your own thoughts, by yourselves." By linking some of her otherwise obscure and disparate photographs to each other and to her motherhood pictures, motifs of independence and solitude lend coherence and meaning to Käsebier's thematic work.

Käsebier's expressions of independence differ from picture to picture. In mother and child photographs, Käsebier liked to show youngsters reaching out into the world rather than clinging to their mothers. When showing children by themselves, she used a picture's composition to suggest independence. The close cropping of *Happy Days* puts children in a world of their own, free from adult interference. Conversely, *The Road to Rome* shows one small, solitary figure who seems to have the world before him in an almost unbounded landscape. One perceives that he, like the girl in *Blessed Art Thou Among Women*, is somehow on the threshold of the future.

Solitude is a theme that appears frequently in modern painting, particularly Symbolism. Symbolism permeated much of late-nineteenth- and early-twentieth-century art, and although Käsebier cannot be as closely linked to that movement as

her colleagues Stieglitz and Steichen, she did absorb aspects of it from them, as well as from DuMond, Davies, Day, Rodin, and from articles in *Camera Notes* and *Camera Work*. Indeed, the entire Pictorial photography movement around 1900 had affinities to Symbolism in its use of photography as a personal expressive medium.[3]

Käsebier would have seen reproductions at least of pictures such as Otto Eckmann's *Solitude*. Certainly she saw the portrait of F. Holland Day, titled *Solitude*, that Steichen took not long before she visited him in Paris, in 1901.[4] But while the theme of solitude is stated in those pictures, it is implicit in Käsebier's mature work. And while Käsebier was gregarious, she relished solitude that allowed her to be creative, rather than isolated. Her photographs concern both sorts.

Käsebier began to use the motif in the mid-nineties, if she (and not an editor) chose *Divinely Isolate in Mournful Thought* as the title for a photo of a young woman meditatively holding a lily.[5] Her later pictures became more specific, dramatic, and personal, suggesting the solitude of woman's suffering. Both *The Heritage of Motherhood* and *The Widow* grew from Käsebier's belief that mothers were destined to bear a burden of worry and grief alone, and both convey a woman's desperation and isolation.

Even though they appear alien to most of her other pictures, Käsebier's animal allegories concern solitude. Just as *The Simple Life* was a metaphor for her own isolation in Oceanside, *The Pathos of the Jackass* stands for the loneliness and frustration of a single jackass among heifers. Though set outdoors, both represent confinement and suggest introverted solitude. A third animal allegory, *Yoked and Muzzled*, is about the *loss* of both independence and the kind of creative solitude that Käsebier valued.

The Road to Rome, on the other hand, proves that solitude need not mean constraint. Solitary yet independent, the youngster signifies adventurous self-reliance as he is drawn towards a beckoning distant prospect. *The Bat* also illustrates solitude and self-reliance by showing a woman confronting the viewer head on, ready to move from a dark (and possibly confining) woodsy background into a clearing.[6] It would seem that *The Bat* and *The Road to Rome* signify Käsebier's own release from the confines of household life into the boundless realm of art.

Finally, however, Käsebier's pictures fascinate in part because they do defy precise explanation. Because she aimed to excite emotions through nuanced, evocative images her pictures often remain ambiguous, dreamlike, timeless. Using cryptic titles, equivocal space, soft focus, and the mossy effects of gum bichromate printing Käsebier deliberately reached beyond mere facts to communicate inchoate sensations. Her pictures should be looked at (preferably in the original) in the spirit in which they were taken and printed: with imagination and empathy.

Abbreviations

GK RECOLLECTIONS Typescript of first-person recollections written or dictated by Käsebier c. 1929. Gertrude Käsebier Papers, University of Delaware Library, Newark, Del.

MT BIOGRAPHY Undated notes (c. 1955) towards a biography of Käsebier by her granddaughter, Mina Turner. MT's notes from interviews with Käsebier's friends and associates Adèle Miller Clifton, Harriet Hibbard, Samuel I. Lifshey and Edward Steichen are identified as such. Gertrude Käsebier Papers, University of Delaware Library, Newark, Del.

MT INTERVIEW Information from a series of the author's interviews with Mina Turner, New York, 1973–1975

HT INTERVIEW Author's interview with Käsebier's daughter, Hermine M. Turner, New York, 1973

KATE STEICHEN INTERVIEW Author's interview with Kate Rodina Steichen, Wilton, Conn., Sept. 1977

AMON CARTER Laura Gilpin Collection, Amon Carter Museum, Fort Worth, Texas

AVERY Stanford White Collection, Drawings and Archives Collection, Avery Architectural and Fine Arts Library, Columbia University, New York

IMP/GEH International Museum of Photography at George Eastman House, Rochester, N.Y.

LC Library of Congress, Washington, D.C.

MASON E. TURNER, JR. COLLECTION Collection of Gertrude Käsebier's great-grandson, Wilmington, Del.

MOMA Museum of Modern Art, New York

NAEF Weston J. Naef, *The Collection of Alfred Stieglitz*

NYPL New York Public Library

NORWOOD Norwood Historical Society, Norwood, Mass.

O'MALLEY HISTORY "Descendants of Arthur Hamblen and Betsey Pettigrew." Typescript compiled by Käsebier's grandson, Charles Frederick O'Malley, 1955. Private Collection

SMITHSONIAN Division of Photographic History, National Museum of American History, Smithsonian Institution, Washington, D.C.

YALE Alfred Stieglitz Collection, Collection of American Literature, The Beinecke Rare Book and Manuscript Library, Yale University, New Haven, Conn.

Notes

N.1 Notes for pages 13–16

Chapter I

1. GK recollections, pp. 79, 87, 88. MT biography, pp. 199, 203. Henry Layne, "Pioneer Figures Who Helped Build Early-Day Golden," in *Delta and Jefferson Counties: Interviews collected during 1933–34 for the State Historical Society of Colorado, by C.W.A. Workers.* Pamphlet 354, Doc. 4, p. 95. "The Passing of the Pioneer" [Obituary of Gertrude Muncy Stanton], *The Trail* 3 (Nov. 1910): 24.
2. Joseph T. Keiley, "Gertrude Käsebier," *Photography*, March 19, 1904, p. 223.
3. GK recollections, p. 87. [Gertrude Muncy Stanton], "A Pioneer Lady's Early Recollections" in "Happy Pioneers," *Colorado Miner*, Georgetown, April 19, 1884, p. 2. U.S. Census, 1870, 20 ward, Brooklyn, N.Y., series M593, Roll 960, p. 8. Mr. and Mrs. Stanton, their son Charles, six boarders and a domestic servant lived in the Fort Greene section of Brooklyn (this census gives no addresses). John Stanton was listed as a "soda manufactory" [*sic*]. Gertrude, evidently away at school when the census was taken, was not listed.
4. MT biography, pp. 132, 224. Moravian Seminary (now Moravian Academy and Moravian College) has no record of her attendance (Joan S. Taylor, Director of Alumni Relations, Moravian College to the author, Feb. 21, 1979, and Mrs. Paul V. R. Miller, Jr., Alumni Director, Moravian Academy to Anne Tucker, Oct. 29, 1973. I am grateful to Anne Tucker for giving me a copy of this letter!) I am also grateful to Sarah W. LeCount of the Kemerer Museum of Decorative Arts, Bethlehem, for her efforts to find evidence of Käsebier or her family in Bethlehem.
5. MT interview. GK recollections, p. 91. Wilbur Fisk Stone, ed., *History of Colorado*, Vol. I (Chicago: S. J. Clarke Publishing Co., 1918), pp. 664–665. John Cree was married to Mary Boone (Shaw) Cree, who was the sister (or possibly half-sister) of Käsebier's mother, Gertrude Muncy (Shaw) Stanton. In 1860 the Crees traveled from Iowa to Colorado with Mrs. Stanton and her children. See: *Colorado Families: A Territorial Heritage* (Denver: Colorado Genealogical Society, 1981), pp. 149–150, and [Stanton], "A Pioneer Lady's Early Recollections."
6. MT and HT interview. Hermine Turner to Charles O'Malley, Feb. 15, 1961, Private Collection. According to *Lain's Brooklyn Directory* of 1871–72, Edward Kasesbier [*sic*] lived at 65 Greene Avenue. MT biography, pp. 160, 214.
7. MT biography, p. 156. MT biography, "From Mrs. Henry Clifton (Adèle Miller)," p. 15.
8. MT interview. MT biography, pp. 142, 155. Eduard Käsebier's 1868–70 passport (Private Collection) lists his occupation as "kaufmann" or merchant. He is called a bookkeeper in the *Lain's Brooklyn Directory* (1871–72, 1875–76) and the 1880 Brooklyn census.
9. GK recollections, p. 191. MT interview. MT biography, "From Mrs. Henry Clifton (Adèle Miller)," p. 15.
10. GK to Stieglitz, July 23, 1899, Yale. MT biography, "From Harriet Hibbard," p. 144.
11. Gertrude Käsebier, "Picture Making: A Talk

to the Department of Photography, Brooklyn Institute," *American Photography* 9 (April 1915): 226.

12. MT interview.

13. "Marriages: O'Malley-Käsebier," *Brooklyn Daily Eagle*, Oct. 18, 1899, p. 14. MT interview. Keiley, p. 227. Helen Lohmann, "Gertrude Käsebier—Photographer," *Abel's Photographic Weekly*, Feb. 28, 1901, p. 130.

14. Information provided by Pratt's Registrar. Walter Scott Perry, *Pratt Institute: Its Beginning and Development* (Brooklyn: Pratt Institute, 1930).

15. Pratt's Registrar records. "The Commencement," *Pratt Institute Monthly* 1 (July–Aug. 1893): 328, 330. Pratt Institute, *Department of Industrial and Fine Arts* (leaflet), 1892, p. 33.

16. *Exhibit of Women Graduates and Pupils of Pratt Institute Brooklyn, N. Y.* (Chicago: Columbian Exposition, 1893), pp. 2, 11, 13. Käsebier requested that the letter she wrote to her fellow student Miss Fletcher, beginning in Wiesbaden on May 24 and concluding in Crécy-en-Brie on June 23, 1894 (NYPL), be forwarded to her brother, Charles Stanton, in Denver and to several women, four of whom were Pratt art instructors. Re: Mary A. Hurlburt, Katherine E. Shattuck and Ida Haskell, see "Personals and Various Topics," *Pratt Institute Monthly* 1 (July–Aug. 1893): 333. Re: Lucy A. Fitch (Mrs. Dwight H. Perkins by 1894), see *Pratt Institute Catalogue 1891–92*, p. 7 and *Notable American Women*, vol. 3, pp. 52–53. Lucy Fitch was at Pratt from 1887–1891. After her marriage, she continued to teach and illustrate books; generations of children knew her Twins series, which began in 1911 with *The Dutch Twins*.

 HT interview. MT biography, pp. 16–17, 46. J.S.W., "A Holiday for Art's and Friendship's Sake," *Pratt Institute Monthly* 1 (Dec. 1892): 73–75. J.F.H., "Art Students' Fund," *Pratt Institute Monthly* 1 (Dec. 1892): 62; 2 (Dec. 1893): 110, 112.

17. Pratt Institute, *Catalogue*, 1890–91, p. 32; 1891–92, p. 33. Käsebier, "Studies in Photography," p. 269. Some of Perry's own documentary photos illustrate his book, *Egypt, The Land of the Temple Builders* (Boston, N.Y., Chicago: Prang, 1898), but the book does not specify which are his.

 "Photographic Portraiture: An Interview with Mr. H.H. Hay Cameron," *Studio*, Oct. 1893, pp. 84–89 (also pp. 68–70 on the first English photographic salon). See also, e.g., W. H. Burbank, "Amateur Photography," *Art Amateur*, 1889 (Sept., p. 80, Oct., p. 104, Nov., p. 126, Dec., p. 16) and 1890 (Jan., p. 38, Feb., p. 62, and April, p. 102), and "The Use of Photography by Artists," March 1890, p. 88.

18. See, e.g., "Gleanings from Pratt Institute Lectures," *Pratt Institute Monthly* 1 (April 1893): 194, and Elizabeth Harrison "Spiritual Moth-

erhood," *Pratt Institute Monthly* 4 (Nov. 1895): 76–79. On Haskell see *Pratt Institute Monthly* 1 (Feb. and July–Aug. 1893), pp. 122, 333. World's Columbian Exposition, *Official Catalogue*, #532. Reproduction in *Quarterly Illustrator* 2 (April–May–June 1894): 119. Royal Cortissoz, *Arthur B. Davies* (New York: Whitney Museum, 1931), pp. 34, 36. GK recollections, n.p.

19. Compare "Street in Cairo" and "Old Vienna" in Käsebier's Sketchbook, collection Mason E. Turner, Jr., with "In a Cairo Street" and "Old Vienna" in *Photographs of the World's Fair* (Chicago: The Werner Co., 1894), pp. 285, 295, 297.

20. Maud Howe Elliott, ed., *Art and Handicraft in the Woman's Building of the World's Columbian Exposition* (Chicago and New York: Rand McNally & Co., 1894). *Exhibit of Women Graduates and Pupils of Pratt Institute*, Columbian Exposition, 1893. The exhibit is also listed as item 684 in the *World's Columbian Exposition 1893 Official Catalogue Part XIV, Woman's Building*.

21. Royal Cortissoz, *Art at the World's Fair: Letters Reprinted from the Tribune* (New York, 1893), and World's Columbian Exposition, *Official Catalogue, Part X, Art Galleries and Annexes, Department K., Fine Arts* (Chicago: W. B. Conkey Co., 1893). Ruth Butler, "Rodin and His American Collectors," in *The Documented Image*, Gabriel P. Weisberg and Laurinda S. Dixon, eds. (Syracuse: Syracuse University Press, 1987), p. 94.

22. Pratt Registrar's records. *Pratt Institute Monthly* 1 (July–Aug. 1893): 334. Charles M. Kurtz, ed., *Official Illustrations from the Art Gallery of the World's Columbian Exposition* (Philadelphia: George Barrie, 1893), pp. 270, 258, 315, 317. *Pratt Institute Monthly* 2 (Feb. 1894): 180. GK recollections, p. 93. *Pratt Institute Monthly* 4 (Oct. 1895): 42. Frederick C. Moffatt, *Arthur Wesley Dow* (Washington, D.C.: Smithsonian Institution Press, 1977), p. 81. Description by Max Weber, who studied with Dow at Pratt 1898–1900, in Holger Cahill, *Max Weber* (New York: The Downtown Gallery, 1930), p. 5.

23. Stieglitz inscribed the picture, now in the Metropolitan Museum of Art: "Käsebier's first photograph/given to me by Mrs. Käsebier/1900/Stieglitz Coll."

24. Beaumont Newhall, *The History of Photography* (New York: Museum of Modern Art, 1982), p. 129.

25. Käsebier, "Studies in Photography," p. 269. Lillian Sabine, "The Women's Page: Gertrude Käsebier, of New York City," *Abel's Photographic Weekly*, Sept. 5 and Sept. 12, 1931, pp. 299, 323. "Threescore Years and Sixteen Is Ardent Exponent of Photography," *New York Sun*, Jan. 5, 1929, p. 21.

26. P. A. Wenzel to GK, postmarked March 6,

1894, NYPL. A note on this letter identifies Wenzel as the priest who helped Käsebier. Marguerite Tracy, "Shadows of the Artist's Ideal," *Quarterly Illustrator* 2 (April–May–June 1894): Käsebier illustrations 209, 218. I am grateful to Robert Sobieszek for pointing out this article and one in *Monthly Illustrator*. For terms of the contest see *Quarterly Illustrator* 2 (Jan.–Feb.–March 1894): v, and *Pratt Institute Monthly* 2 (March 1894): 222.

 See, e.g., Catherine Weed Barnes, "Photography from a Woman's Standpoint," *American Amateur Photographer* 2 (Jan. 1890): 10–13. A plan of the Camera Club of New York shows a "Women's Dark Room." *Camera Notes* 2 (Oct. 1898): 64.

 "Finest Photographs from the Herald's Fair Readers," *New York Herald*, April 15, 1894, n.p. (special insert), Collection Mason E. Turner, Jr.

27. Käsebier, "Studies in Photography," p. 269.

28. MT interview. In a letter postmarked March 6, 1894 (NYPL), Wenzel responded to Käsebier's notifying him of winning the prize. The contest was announced in the *New York Herald*, March 10, 1894, p. 9. Käsebier apparently sailed before prizewinners were announced on April 15 and learned of her success in Wiesbaden. (GK to Miss Fletcher, May 24, 1894, NYPL.) Käsebier, "Studies in Photography," p. 269.

29. GK to Miss Fletcher.

30. *Pratt Institute Monthly* 2 (March 1894): 221. "Fine Arts—A Summer Art School in France," *Pratt Institute Monthly* 3 (Dec. 1894): 82. Louis Bouché, *A Memorial Exhibition of Paintings by Frank Vincent DuMond, N.A.* (New York: Art Students League, 1951), p. 4. Charles C. Eldredge, *American Imagination and Symbolist Painting* (New York: Grey Art Gallery, New York University, 1979), p. 117. GK to Miss Fletcher.

31. Käsebier, "Studies in Photography," pp. 269–70.

32. Frank W. Crane, "American Women Photographers," *Munsey's Magazine*, July 1894, p. 408.

33. Käsebier, "Peasant Life in Normandy," *Monthly Illustrator* 3 (March 1895): 271, 272. The article, which identifies the town only as "Crécy," places it both on the banks of the Brie River and in Normandy—a physical impossibility. An editor may have confused Crécy-en-Brie with the Norman Crécy-en-Ponthieu. Käsebier, "An Art Village," *Monthly Illustrator* 4 (April 1895): 17.

34. Ibid., p. 15. Käsebier, "Peasant Life in Normandy," p. 273.

35. Käsebier, "Studies in Photography," p. 270. Robert Demachy, "Mme. Käsebier et son oeuvre," *La Revue de Photographie* 4 (July 15, 1906): 289. F. Holland Day, "Art and the Camera," *Lippincott's*, Jan. 1900, p. 85. MT inter-

view. MT biography, pp. 1, 214.

36. Käsebier, "Studies in Photography," p. 270.

37. Alfred Stieglitz, quoted in Dorothy Norman, *Alfred Stieglitz: An American Seer* (New York: Random House, 1973), pp. 29, 31. Käsebier, "Studies in Photography," p. 270.

Chapter II

1. Walter Chambers, "Called Greatest Woman Photographer, Gertrude Käsebier Is Now a Cripple," *New York Telegram*, Jan. 25, 1930, p. 2. I am indebted to Richard Hill, librarian at the NYPL Annex, for directing me to the *New York Sun* morgue Käsebier file, which contains a clipping of this article (which is not on the standard *New York Telegram* microfilm). Käsebier's friend, the photographer Consuelo Kanaga, recalled Käsebier saying that she had opened a studio because Mr. Käsebier's business had gone bankrupt. I am grateful to Anne Tucker for informing me of her 1972 interview with Kanaga in a conversation on Jan. 24, 1973.

2. Naomi Rosenblum, "Women in Photography: An Historical Overview," *Exposure* 24 (Winter 1986): 8–11, C. Jane Gover, *The Positive Image* (Albany: SUNY Press, 1988), Chapter 2, and Peter Palmquist, ed., *Camera Fiends and Kodak Girls: 50 Selections by and about Women in Photography, 1840–1930* (New York: Midmarch Arts Press, 1989), pp. 57–67 and 250–55.

3. Mary Fanton Roberts [Giles Edgerton], "Photography as an Emotional Art: A Study of the Work of Gertrude Käsebier," *Craftsman* 12 (April 1907): 88. (Hereafter cited as Roberts [Edgerton].)

4. GK recollections, p. 79. "Happy Pioneers," *Colorado Miner*, Georgetown, April 19, 1884, p. 2. Muncy Stanton's maiden name is given on her death certificate, Massachusetts, Aug. 21, 1910. Her kinship to Daniel Boone, mentioned by Käsebier, has proved impossible to trace.

5. John W. Stanton and Charles W. Stanton are listed in *Lain's Brooklyn Directory* as late as 1878–79. "At the Morgue," *Leadville Daily Democrat*, March 9, 1880. *Brooklyn Daily Eagle*, March 13, 1880, n.p.

6. GK recollections, p. 81. "Northern Notes, Georgetown," *Rocky Mountain News*, April 12, 1882, p. 3. MT biography, p. 221. "The Passing of the Pioneer," *The Trail*, Nov. 1910, p. 24. Denver city directories for Gertrude M. Stanton, 1887–1896. Her son, Charles W., was listed in Denver directories 1887–1895.

7. Lily Norton, "Business Principles for Women," *Pratt Institute Monthly* 2 (April 1894): 261.

8. Unsigned, "Photographers I Have Met: S. H. Lifshey," *Abel's Photographic Weekly*, Feb. 18, 1911, p. 134. Lifshey himself had apprenticed with the New York portrait photographer B. J. Falk. MT biography, "From Sam Lifshey," pp. 107–110, 115.

9. Käsebier, "Studies in Photography," p. 271.

10. *Boston Evening Transcript*, Nov. 10, 1896, p. 5. Cram was later to have a byline for "Mrs. Käsebier's Work," *Photo-Era* 4 (May 1900): 131–136.

11. D.M.N. [Dora M. Norton], "Art Studies in Photography," *Pratt Institute Monthly* 5 (March 1897): 222. Norton was an instructor in Pratt's Art Department. See also *Art Studies in Photography by Mrs. Gertrude Käsebier*, announcement of exhibition in Art Gallery of Pratt Institute, Feb. 1–13, 1897, and Bibliography.

12. Käsebier, *Studies in Photography*, pp. 270, 272.

13. MT interview. "Teachers, Students and Things," *Pratt Institute Monthly* 6 (May 1898): 241. William Innes Homer, *A Pictoial Heritage: The Photographs of Gertrude Käsebier* (Wilmington, Del. Delaware Art Museum, 1979), p. 59. *Annual Report of the New York Exchange for Woman's Work, 12 East 30 Street*, 1894, p. 4. "Sioux Chiefs Party Calls," *The New York Times*, April 24, 1898, p. 14.

14. Käsebier, "Studies in Photography," p. 272.

15. Roberts [Edgerton], p. 88.

16. See, e.g., Elizabeth Anne McCauley, *Likenesses: Portrait Photography in Europe 1850–1870* (Albuquerque: Art Museum, University of New Mexico, 1981).

17. MT interview.

18. See Robert F. Berkhofer, Jr., *The White Man's Indian* (New York: Vintage Books, 1979), Ellwood Parry, *The Image of the Indian and the Black Man in American Art, 1590–1900* (New York: George Braziller, 1974), Paula Richardson Fleming and Judith Luskey, *The North American Indians in Early Photographs* (New York: Harper and Row, 1986), and William Webb and Robert A. Weinstein, *Dwellers at the Source: Southwestern Indian Photographs of A. C. Vroman, 1895–1904* (New York: Grossman, 1973), pp. 9–17.

19. "Reform in Aesthetics: The Search for an American Identity (Native American)," in Wendy Kaplan, *"The Art that is Life": The Arts & Crafts Movement in America, 1875–1920* (Boston: Museum of Fine Arts, 1987), pp. 170–172.

20. "Some Indian Portraits," *Everybody's Magazine* 4 (Jan. 1901): 3–4. Käsebier's Pratt classmate, Adèle Miller [Clifton], whose family knew Buffalo Bill, may have helped to arrange the sittings. Interview with her son, Henry Clifton, Jr., Sept. 13, 1989. "Sioux Chiefs' Party Calls," *The New York Times*, April 24, 1898, p. 14. Visits c. 1900–1912 are mentioned, MT biography, pp. 40–45, however there is no evidence of visits when the troupe was in town during 1902; between 1903 and 1906 the troupe toured Europe. (Dating of performances from route books, Denver Public Library, Western History Collection.) See also GK to Day, April 12 and 29, 1899, Norwood, and "The Indian as a Gentleman," *The New York Times*, April 23, 1899, p. 20.

21. MT biography, pp. 42–44. Charles O'Malley's recollection was doubtless from Buffalo Bill's return to New York in 1907 (O'Malley history). Also see MT biography, p. 44. "Sioux Chiefs' Party Calls."

22. Chambers, "Called Greatest Woman Photographer . . ."

23. Christopher Lyman, *The Vanishing Race and Other Illusions* (New York: Pantheon Books in association with Smithsonian Institution Press, 1982), pp. 71, 72, 92–95, 110.

24. "Some Indian Portraits," p. 4. Rena Neumann Coen, "The Indian as the Noble Savage in Nineteenth Century American Art" (Ph.D. Dissertation, University of Minnesota, 1969).

25. "Some Indian Portraits," p. 7. What may have been the same incident is described somewhat differently in "Sioux Chiefs' Party Calls."

26. "Wh-o-o-op! Iron Tail and His Braves Come," *The New York Times*, Feb. 8, 1906, p. 9.

27. "Iron Tail," *Indian Helper*, Aug. 13, 1897, n.p. A 1910 payroll book shows that Iron Tail was then paid $50 a month. I am grateful to Paul Fees, Curator, for providing this information from the Buffalo Bill Historical Center, Cody, Wyoming, as well as for reading a draft of this section on Buffalo Bill's Indians.

28. J. E. Fraser to Commissioner of Indian Affairs, June 10, 1931. Copy sent to the author by U.S. Department of the Treasury, Bureau of the Mint.

29. "Outdoor Work," *Wilson's Photographic Magazine* 37 (May 1900): 219.

30. An exception may have been the sale of some through a Boston gallery. See GK to Day, July 3, 1899, Norwood.

31. The Smithsonian Institution's collection is exemplary. Some, on white cards, are inscribed "copyrighted 1898" and bear the blind stamp "Gertrude Käsebier," which she quit using about then. A later group is mounted on green- or bronze-colored paper, supported by larger greenish-gray mounts which are monogrammed "GK" in ink matching the smaller mount. A third group, mounted on black paper, bears Käsebier monogram stamps (her initials in a stylized lens stop). Some prints (c. 1910) are on white debossed mounts.

32. "Artist Receives Indians," *The New York Times*, April 14, 1901, p. 7. Henry Blackman Sell and Victor Weybright, *Buffalo Bill and the Wild West* (New York: Oxford University Press, 1955), chapters 9–13. "Some Indian Portraits," p. 15.

33. Luther Standing Bear, *My People the Sioux* (Boston and New York: Houghton Mifflin, 1928), pp. 248, 252, 253. "Some Indian Por-

traits," pp. 12, 15, 16, 21, 22, 24. MT biography, p. 40.

34. *Route Book, Buffalo Bill's Wild West, 1899,* reproduced in Sell and Weybright, p. 211. "How the Injuns Make Up," *Commercial Advertiser* (New York), April 13, 1901. Clipping in *"Buffalo Bill" Cody Scrapbook,* Buffalo Bill Historical Center, Cody, Wyoming.

35. "Some Indian Portraits," p. 12.

36. E.g., compare Käsebier's photograph of Has-no-Horses (Smithsonian) with Keiley's (Naef, plate 34). Naef, pp. 395–396. GK to Stieglitz, Aug. 21, 1901, Yale.

37. Sidney Allen [Sadakichi Hartmann], "E. S. Curtis, Photo Historian," *Wilson's Photographic Magazine* 44 (Aug. 1907): 362. Curtis, "My Work in Indian Photography," *Photographic Times* 39 (May 1907): 197.

38. See, e.g., N. Scott Momaday, Introduction, *With Eagle Glance: American Photographic Images, 1868 to 1931* (New York: Museum of the American Indian, 1982), plates 1, 2, 32, 33, 48, 50. Karl Moon, *Photographic Studies of Indians* (Grand Canyon, Arizona: El Tovar Studio, n.d.).

39. Beaumont Newhall, "Adam Clark Vroman," in *Photographer of the Southwest: Adam Clark Vroman, 1856–1916,* Ruth I. Mahood, ed. (New York: Bonanza Books, 1961), p. 13. See also Webb and Weinstein, p. 15.

40. "Persons Who Interest Us," *Harper's Bazaar,* April 14, 1900, p. 330.

41. "Bonnin, Gertrude Simmons," *Notable American Women 1607–1950,* 1, pp. 198–200 is the source of information about her not otherwise attributed below. GK to Day, April 12, 1899, and April 29, 1899, Norwood. Collection Mason E. Turner, Jr.

42. "Picture Paragraphs," *Everybody's Magazine* 3 (Nov. 1900): 489 includes an unattributed Käsebier photo of Zitkala-Ša. Zitkala-Ša studied tuition-free with Eugene Gruenberg of the New England Conservatory (Eugene Gruenberg to William A. Jones, Commissioner of Indian Affairs, Jan. 20, 1899, U.S. National Archives). See also Gertrude E. Simmons to Hon. Commissioner of Indian Affairs, Aug. 12, 1899, National Archives. Conservatory records c. 1900 are very incomplete and contain no reference to Simmons (Chester W. Williams, Dean Emeritus, N.E. Conservatory to the author, May 5, 1982). On Zitkala-Ša's life in and around Boston see Zitkala-Ša to Day (Feb. 17, Dec. 11 and 29, 1899); Louise Peabody Sargent to Day (Feb. 21, March 11 and 17, 1899); Ida Chamberlin to Day, Sept. 5, 1899; Joseph Edgar Chamberlin to Day, Sept. 18, 1899; and Alfred S. Manson to Day, Feb. 16, 1900, Norwood. William A. Gifford, former Curator, Norwood Historical Society, generously provided information about Zitkala-Ša's contact with Day and his circle.
"Impressions of an Indian Childhood,"

"The School Days of an Indian Girl," "An Indian Teacher among Indians," and "Why I am a Pagan," *Atlantic Monthly* (Jan., Feb., March 1900), pp. 37–47, 185–94, 381–86, and Dec. 1902, pp. 801–803. Republished with additional pieces by Zitkala-Ša in *American Indian Stories* (Washington, D.C.: Hayworth, 1921).

43. *Brooklyn Times, New York World, New York Musical Courier,* quoted in *The Red Man,* April 1900, p. 8. *The Red Man and Helper,* July 13, 1900, n.p. In 1900 she went to South Dakota, hoping to teach near her elderly, ailing mother (Gertrude E. Simmons to Hon. W. A. Jones, Commissioner of Indian Affairs, May 23, 1900, National Archives). She returned to Boston in 1901, then moved west. (*The Papers of Carlos Montezuma, Correspondence,* Reel 1, Division of Archives and Manuscripts, State Historical Society of Wisconsin, Madison. Dr. Montezuma was briefly engaged to be married to Zitkala-Ša.)

44. Zitkala-Ša's heritage was more complex than she let on. Her father, a white man named Felker, deserted her mother before her birth, so the girl was named after the second husband, Simmons. After a falling out with her sister-in-law, Gertrude took the Indian name Zitkala-Ša. See Dexter Fisher, "Zitkala-Ša: The Evolution of a Writer," Foreword to reprint of Zitkala-Ša, *American Indian Stories* (Lincoln, Neb., and London: University of Nebraska Press, 1985). Käsebier referred to her as Miss Simmons in writing to Day, April 12, 29 and June 12, 1899, Norwood.

45. The print is illustrated in Sotheby's, New York, sale 5043, May 11, 1983, lot 438. Another print of the same negative, as well as prints of Käsebier's other photographs of Zitkala-Ša are in the Division of Photographic History, National Museum of American History, Smithsonian Institution, Washington, D.C.

46. GK to Laura Gilpin, Sept. 1, 1923, Amon Carter. Zitkala-Ša to Day, Feb. 17, 1899, Norwood.

47. Martha Banta makes just such a comparison to Dewing's work in *Imaging American Women* (New York: Columbia University Press, 1987), p. 736.

48. One Keiley portrait of her in shirtwaist and skirt holding a sheaf of photographs is an exception (illustrated in Sotheby's, New York, sale 5766, Nov. 1, 1988, lot 308).

49. The triptych, *An American,* no. 56 in *The Catalogue of Prints, The Photographical Section, American Institute* (New York: National Academy of Design, 1898), can be identified by prints and notations that Keiley entered in his copy (Private Collection). Two parts of the triptych are illustrated as Naef, figs. 362 and 363. The third part (wrongly identified by Naef as his fig. 361) showed Zitkala-Ša looking down and to her right. Naef, p. 395, cites

sources for the variant titles of these photographs. *Asia* and *Chinese Studies* are listed and illustrated in the *American Institute* catalogue as nos. 192 and 22. *Asia* is illustrated as Naef's fig. 361.

Chapter III

1. GK to Stieglitz, Yale. The letter, dated June 11, must be from 1898. In June 1897 Käsebier was not yet at 12 East 30th Street. By June 1899, she was well acquainted with Stieglitz.

2. Alfred Stieglitz, "The Hand Camera—Its Present Importance," *The American Annual of Photography,* 1897, pp. 18–27.

3. J.T.K. [Joseph T. Keiley]; "Mrs. Käsebier's Prints (Exhibited February 15–25)," *Camera Notes* 3 (July 1899): 34.

4. P. H. Emerson, "Science and Art," in *Naturalistic Photography* (New York: Scovill & Adams, 1899). Reprinted in Peter C. Bunnell, ed., *A Photographic Vision: Pictorial Photography, 1889–1923* (Salt Lake City: Peregrine Smith, 1980), p. 11.

5. For a critical history of earlier exhibitions, especially in Philadelphia, and of the Philadelphia Salons, see Mary Panzer, *Philadelphia Naturalistic Photography 1865–1906* (New Haven: Yale University Art Gallery, Feb. 10–April 7, 1982), pp. 11–13. Articles praising the 1898 exhibition included: Charles H. Caffin, "Philadelphia Photographic Salon," *Harper's Weekly,* Nov. 5, 1898, p. 1087; "The Philadelphia Photographic Salon," *Wilson's Photographic Magazine* 35 (Dec. 1898): 529–31; and (with some reservations) Joseph T. Keiley, "The Philadelphia Salon: Its Origin and Influence," *Camera Notes* 2 (Jan. 1899): 113–32.

6. The Pennsylvania Academy of the Fine Arts and The Photographic Society of Philadelphia, *Catalogue of the Philadelphia Photographic Salon,* Oct. 24–Nov. 12, 1898, n.p. Jury members were William Merritt Chase and Robert W. Vonnoh, painters; Alfred Stieglitz and Robert S. Redfield, photographers; and Alice Barber Stephens, an illustrator who also contributed photographs to the salon.
Panzer, *Philadelphia Naturalistic Photography,* p. 14. See also William Innes Homer et al., *Pictorial Photography in Philadelphia: The Pennsylvania Academy's Salons 1898–1901* (Philadelphia: Pennsylvania Academy of the Fine Arts, March 9–April 18, 1984). "Saunterings," *Town Topics,* Oct. 20. 1898, p. 6.

7. Keiley, "The Philadelphia Salon," p. 126. Charles Caffin, *Harper's Weekly,* Nov. 5, 1898, p. 1087. See also "The Philadelphia Photographic Salon," *Wilson's Photographic Magazine* (Dec. 1898): 529–31.

8. GK to Day, postmarked Oct. 16, 1899, Nor-

wood. *Exhibition of the Society of Arts & Crafts* (Boston: Copley Hall, April 4–15, 1899), p. 16.

9. During the 1870s Image had served as a clergyman. A. H. Mackmurdo, ed. *Selwyn Image Letters*, ([London]: G. Richards, 1932), p. 36. See also "The Work of Mr. Selwyn Image," *International Studio*, 1898, pp. 4–9. I am indebted to Elizabeth Pollock, who identified the Image print on the basis of its reproduction in the April 1893 *Studio*.

10. Barbara LaSalle, whose grandmother was Agnes Lee's sister, wrote that Peggy died of "something like scarlet fever, since her surviving sister was affected by that disease at about that time, losing both hearing and most of speech for the rest of her life" (undated memo to the author, spring 1979). I first learned Mrs. Lee's name and profession from letters at Norwood (Martha Agnes Lee to Day, May 18, 1893, and Elliott R. May to Mrs. Freer, n.d., c. Sept. 1922). LaSalle, the late Registrar of the Brooklyn Museum, kindly provided more information after seeing *Blessed Art Thou Among Women* in a Käsebier exhibition there. I am grateful to Barbara Millstein of the Museum for putting her in touch with me.

 MT interview. Louise Imogene Guiney to Day, July 24, 1904, Louise Imogene Guiney Papers, LC Manuscripts Division. I am grateful to Mary Panzer for telling me of this letter.

11. An unmanipulated variant (Museum of Fine Arts, St. Petersburg, Fla.) shows Agnes Lee in profile, includes more of the landscape, and makes the site clear. The version with crucifixes is reproduced in Roberts [Edgerton]. The Detroit Institute of Art owns a print of it. Agnes Lee, "Motherhood," in *The Border of the Lake* (Boston: Sherman, French & Co, 1910), pp. 3–4.

12. See Sarah Greenough et al., *On the Art of Fixing a Shadow* (National Gallery of Art and Art Institute of Chicago in association with Bulfinch Press/Little, Brown & Co., 1989), plate 176.

13. MT interview. On Agnes Lee see also Keiley to Stieglitz, Sept. 1, 1899, Yale. Roberts [Edgerton], p. 92. Sabine, *Abel's Photographic Weekly*, Sept. 19, 1931, p. 351. Undated manuscript (c. 1915–1920) addressed "For Mrs. Vitale," NYPL.

14. MT biography, p. 137.

15. GK to Day, April 12, 1899, Norwood. See Michael Burlingham, *The Last Tiffany: A Biography of Dorothy Tiffany Burlingham* (New York: Atheneum, 1989), Chapter 4, on Louis Comfort Tiffany, and illustrations (between pp. 140 and 141) for Käsebier's portrait of "Mama Lou," Tiffany's second wife, Louise Wakeman Knox Tiffany.

16. A.S. [Alfred Stieglitz], "Our Illustrations," *Camera Notes* 3 (July 1899): 24.

17. Arthur W. Dow, "Mrs. Gertrude Käsebier's Portrait Photographs—From a Painter's Point of View," J.T.K. [Keiley], "Mrs. Käsebier's Prints," Sadakichi Hartmann, "Portrait Painting and Portrait Photography," *Camera Notes* 3 (July 1899): 22–23, 34, 16.

18. GK to Stieglitz, June 23, 1899. See also GK to Stieglitz, July 23, 1899.

19. GK to Day, June 12, 1899, Norwood. MT biography, pp. 20, "From Mrs. Henry Clifton (Adèle Miller)," and 45.

20. GK to Day, June 21, 1899, Norwood. GK to Day, July 3, 1899. GK to Miss Fletcher, NYPL. GK to Stieglitz, June 23, 1899, Yale.

21. Keiley to Stieglitz, July 13, 1899, Yale. The poet remains unidentified.

22. GK to Stieglitz, July 23, 1899, Yale. GK to Day, Aug. 29, 1899, Norwood. MT biography, p. 70, mentions that Käsebier photographed Julia Dent Grant and Elsie French (later Vanderbilt) in Newport. Neither photograph has been identified. "Princess Julia Cantacuzène, 99, Grant's Granddaughter, Dead." *The New York Times*, Oct. 7, 1975, p. 38. Princess Cantacuzène, Countess Spéransky (née Grant), *My Life Here and There* (New York: Scribner's Sons, 1921).

23. GK to Stieglitz, July 23, 1899, Yale. GK to Day, July 3, 1899, Norwood. MT biography, "From Mrs. Henry Clifton (Adèle Miller)," pp. 22–23.

24. Estelle Jussim, *Slave to Beauty* (Boston: Godine, 1981), Chapters 1–9, passim.

25. Keiley, "The Salon," *Camera Notes* 3 (Jan. 1900): 164. Mina Turner confirmed my observation.

26. Keiley to Stieglitz, Sept. 1, 1899, Yale. MT biography, "From Mrs. Henry Clifton (Adèle Miller)," p. 23.

27. GK to Lee family and Day, July 3, 1899, Norwood.

28. "Department News," *Pratt Institute Monthly* 8 (Jan. 1900): 69.

29. J.T.K. [Keiley], "Mrs. Käsebier's Prints," p. 34.

30. R. Child Bayley, "Mrs. Käsebier," *Photography*, Jan. 17, 1903, p. 63. Reprinted in *American Amateur Photographer* 15 (Feb. 1903): 78–79 and as "A Visit to Mrs. Käsebier's Studio," *Wilson's Photographic Magazine* 40 (Feb. 1903): 73–74.

31. Dow, "Mrs. Gertrude Käsebier's Portrait Photographs," p. 22.

32. See, e.g., MT biography, "From Harriet Hibbard," p. 143. Imogen Cunningham, telephone interview with the author, June 1976. See also GK to Day, Dec. 28, 1907, Norwood.

33. MT biography, p. 171. The apartment was at 342 West 71st Street.

34. See Eva Watson Schütze, "Signatures," *Camera Work*, no. 1 (Jan. 1903): 35–36.

35. MT biography, p. 120, "From Sam Lifshey." On her darkroom see R. Child Bayley, "Mrs. Käsebier," and Robert Demachy, "Mme. Käsebier et Son Oeuvre," *La Revue de Photographie*, July 15, 1906, p. 294.

 Williamina and Grace Parrish of St. Louis studied with Käsebier 1909–1911. Gillian Barrie Greenhill, "The Outsiders: The Salon Club of America and the Popularization of Pictorial Photography," (Ph.D. Dissertation, Pennsylvania State University, 1986), p. 151. See the Parrish portrait of Käsebier in Spencer B. Hord [Chippendale], "Gertrude Käsebier, Maker of Photographs," *Bulletin of Photography*, June 8, 1910, pp. 363–64, 367.

36. "The only thing I can tell you . . . is that all of them were made on slow glass negatives, for the most part 6½ × 8½ and 8 × 10. The large prints were made . . . by enlarged negatives which were then contact printed. The portraits, as well as the other subjects, were for the most part made with daylight. The studio ones were made with light from windows and skylight and reflectors, and very occasionally the addition of Cooper Hewitt light. The exposures were approximately three seconds depending on the amount of light available. The negatives were then developed individually in a tray under a red light, and prints were made on platinum paper, Japanese tissue, and gum prints were made by coating any desired paper and developing in water with a brush.

 "The cameras were view and studio cameras with Taylor-Taylor-Hobson and Cooke lenses, some soft-focus lenses for portrait work." Hermine M. Turner to Grace M. Mayer, July 31, 1962, MOMA.

 A Voigtländer euryscope lens was said to be her favorite in 1904: [Juan C. Abel], "Studio Lightings No. 1," *The Photographer*, May 7, 1904, p. 24. "Notes and Comment," *Photo-Miniature* 10 (Jan. 1912): 537 refers to her use of a Taylor and Hobson Rapid View and Portrait lens which was "noteworthy for its softness of definition, roundness and plasticity of modeling, with an accuracy of drawing which is particularly pleasing in portraiture . . ." GK to Day, April 17, 1906, and Jan. 31, 1907, Norwood, mentions receipt of Smith lenses from Demachy and Day.

 Käsebier's equipment, technique, and printing methods are also discussed by Charles G. Metzger and Debra Hess Norris in Homer, *Käsebier*, pp. 32–35.

37. Juan C. Abel, "Women Photographers and their Work," *The Delineator*, Sept. 1901, p. 409. H. Snowden Ward, "Gertrude Käsebier and Her Work," *Amateur Photographer and Photographic News*, Dec. 13, 1910, p. 591. Reprinted in *Abel's Photographic Weekly*, Dec. 24, 1910, p. 268. [Juan C. Abel], "Studio Lightings No. 1," p. 24. Roberts [Edgerton], p. 90.

38. Alvin Langdon Coburn, *Alvin Langdon Coburn, Photographer*, edited by Helmut and Alison Gernsheim (London: Faber and Faber,

1966), pp. 14–22. Alvin Langdon Coburn, "American Photographs in London," *Photo-Era* 6 (Jan. 1901): 212. *Photo Miniature*, Feb. 1903, untitled clipping in Coburn Scrapbook 1, IMP/GEH.

39. MT biography, "From Harriet Hibbard," pp. 143–44, and "From Mrs. Henry Clifton (Adèle Miller)," pp. 18–20, 26.

Chapter IV

1. Keiley, "The Salon (Philadelphia, Oct. 22–Nov. 18, 1900): Its Place, Pictures, Critics & Prospects," *Camera Notes* 4 (Jan. 1901): 192.

2. Robert Redfield to Johnston, March 29, 1899, Johnston Manuscript Collection, LC, shows that initially two of the judges in 1899 were to be painters. Apparently intervention through Stieglitz and Day brought in Käsebier and Clarence White instead. See Panzer, p. 16.

3. Käsebier, "To Whom It May Concern," *Camera Notes* 3 (Jan. 1900): 121–22.

4. The Philadelphia Salons were reviewed in foreign magazines. See, e.g., *Photographische Rundschau* 15 (March 1901): 49–55.

 [Alfred Stieglitz], "Appreciation," *Camera Notes* 3 (April 1900): 218. See also E. Lee Ferguson, "Some Random Notes on the Philadelphia Salon," *Photographic Times* 32 (Jan. 1900): 9, Keiley, "The Salon," *Camera Notes* 3 (Jan 1900): 164–165, and "Symbolism in Art," *Photo-Era* 3 (Dec. 1899): 531. MT interview.

5. Sabine, *Abel's Photographic Weekly*, Sept. 19, 1931, p. 351. See also Roberts [Edgerton], p. 92. MT interview. Keiley, "The Salon," *Camera Notes* 4 (Jan 1901): 222.

6. For example, at Die Ausstellung für künstlerische Photographie, Berlin, 1899 (reviewed in *Photographische Rundschau*, March 1899, p. 139) and at the London Photographic Salon, Sept.–Oct. 1899, Dudley Galleries, London (mentioned in *Photographische Rundschau*, Nov. 1899).

7. Johnston's Carlisle School photographs are in the Library of Congress, as are letters dating these negatives to 1901. See, e.g., R. H. Pratt to Johnston, July 6, 1901.

 Käsebier planned to attend the Carlisle graduation in the spring of 1901 (GK to Dr. Carlos Montezuma, March 4, 1901, *The Papers of Carlos Montezuma*, reel 1, State Historical Society of Wisconsin. See Bibliography for other references to Johnston.

8. Toby Quitslund, "Her Feminine Colleagues: Photographs and Letters Collected by Frances Benjamin Johnston in 1900," in *Women Artists in Washington Collections* (College Park: University of Maryland Art Gallery and Women's Caucus for Art, 1979), p. 107. Keiley to Stieglitz, July 24, 1900, Yale.

9. Quitslund, p. 115. Sadakichi Hartmann, "A Purist," *Photographic Times* 31 (Oct. 1899): 452. Ben-Yusef, "Japan Through My Camera," *Photo-Era* 12 (May 1904): 77–79.

10. On Weil see Osborne I. Yellott, "Mathilde Weil—Artist Photographer," *Photo-Era* 3 (June 1899): 323–328, C. Puyo, "L'Exposition des Artistes américaines," *Bulletin du Photo-Club de Paris*, April 1901, p. 129 and Johnston, "The Foremost Women Photographers in America: Miss Mathilde Weil," *Ladies Home Journal* 18 (June 1901): 9. Jean F. Block, *Eva Watson Schütze: Chicago Photo-Secessionist* (Chicago: University of Chicago Library, 1985), pp. 7, 14–15. Keiley, "Eva Watson Schütze," *Camera Work*, no. 9 (Jan. 1905): 23–26 and plates. Watson Schütze to Stieglitz, Dec. 12, 1904, Yale. Eva Lawrence Watson, "Gertrude Käsebier," *American Amateur Photographer* 12 (May 1900): 219–20. MT biography, "From Mrs. Henry Clifton (Adèle Miller)," p. 16.

11. Quitslund, p. 113. For Alice Austen, see Ann Novotny, *Alice's World: The Life and Photography of an American Original* (Old Greenwich, Conn.: Chatham Press, 1976). Abel, "Women Photographers and Their Work," *Delineator*, Nov. 1901 p. 751.

12. Clark to Keiley, May 25 and June 11, 1900, Yale (leaves 95 and 97 in Keiley to Stieglitz folder). World's Columbian Exposition, *Official Catalogue*, #260. Naef, pp. 298–99. Quitslund, p. 116. The Sears portraits are reproduced in Homer, *Alfred Stieglitz and the Photo-Secession* (Boston: New York Graphic Society, 1983), p. 66, and Caffin, *Photography as a Fine Art* (New York: Doubleday, Page & Co., 1901), p. 68. Vienna Camera Club catalogue, *Internationale Ausstellung Ausgewählter Künstlerischer Photographien*, Feb. 15–March 15, 1905, lists Mrs. Sears as lending *The Heritage of Motherhood*. See also Naef, pp. 428–29, and Quitslund, p. 139.

13. Quitslund, pp. 98, 107, 130. Demachy to Stieglitz, undated (c. Jan. 1901), Yale. Demachy, "L'Exposition des Artistes américaines," *Bulletin du Photo-Club de Paris* 11 (April 1901): 110. See also E. Wallon, *Photo-Gazette*, Feb. 25, 1901, pp. 61, 63.

14. *An Exhibition of Prints by the New School of American Photography Supplemented by an Additional Collection of One Hundred Examples of the Work of F. Holland Day of Boston* (London: Royal Photographic Society, 1900) lists 375 works; *Catalogue des Oeuvres de F. Holland Day et de la Nouvelle Ecole Américaine, Exposées au Photo-Club de Paris* (Paris: Photo-Club de Paris, 1901) lists 304.

15. Estelle Jussim, *Slave to Beauty*, pp. 141–42, 151–52. See also Ellen Fritz Clattenburg, *The Photographic Work of F. Holland Day* (Wellesley, Mass.: Wellesley College Museum, 1975), p. 18. GK to Day, Dec. 12, 1899, Norwood.

16. GK to Johnston, June 6, 1900, LC. Toby Quitslund kindly provided me with a copy of this letter. See also Wallon, "F. Holland Day et la Nouvelle Ecole Américaine au Photo-Club," *Photo-Gazette*, April 25, 1901, p. 103, and Puyo, "L'Exposition de M. H. Day et de la 'Nouvelle Ecole Américaine,'" *Bulletin du Photo-Club de Paris* 11 (April 1901): 120–21, 128.

17. "The New School of American Photography," *Photographic News*, Oct. 26, 1900, p. 702. "Plastic Psychological Syntheses at Russell Square," *British Journal of Photography*, Oct. 26, 1900, p. 678. Demachy, "The New American School of Photography in Paris," *Camera Notes* 5 (July 1901): 36. Puyo, pp. 119–120.

18. Juhl, footnote to Sadakichi Hartmann's article, "Ueber die Amerikanische Kunstphotographie," *Photographische Rundschau* 14 (May 1900): 93.

19. Hartmann, "On Exhibitions," *Camera Notes* 5 (Oct. 1901): 106.

20. Caffin, *Photography as a Fine Art*, p. 64.

21. MT biography, p. 202.

22. Burlingham, *The Last Tiffany*, passim, and conversation with Michael Burlingham, July 19, 1989.

23. Henry W. Lanier to Johnston, Oct. 13, 1900, LC. No prices are mentioned in Johnston's correspondence with *World's Work* between October and December 1900.

 Both *World's Work* and *Everybody's* were published by Doubleday, Page. However no records for them can now be found among the files at Doubleday. Ken McCormick (former editor who is now engaged in working on the Doubleday archives) to the author, July 27, 1988, and phone conversation, June 23, 1988.

24. NYPL.

25. See also Barbara L. Michaels, "Rediscovering Gertrude Käsebier," *Image* 19 (June 1976): 23–25.

26. Constance Drexel, "Noted Woman Photographer Prefers Men as Subjects," *Philadelphia Public Ledger*, Feb. 28, 1917, p. 4 (clipping, Collection Mason E. Turner, Jr.). Käsebier, "Studies in Photography," p. 272. MT biography, "From Harriet Hibbard," p. 148.

27. HT interview. MT biography, p. 53.

28. *An Exhibition of the work of Robert Bolling Brandegee, A.N.A., 1849–1922* (New Britain Museum of American Art, March 18–April 25, 1971), p. 11. Sarah Brandegee Brodie to Director of American Photography Exhibit, Boston Museum of Fine Arts, April 10, 1974, and to the author, Aug. 21, 1978. A variant of *Harmony* (IMP/GEH) shows the couple playing their cellos.

29. Theodate Pope, *Diary* (April 29, 1901), Hill-Stead. National Arts Club, *American Pictorial Photography arranged by the Photo-Secession*, New York, March 5–22, 1902. I am grateful to Anita Ventura Mozley for drawing the

Käsebiers at Hill-Stead to my attention.

30. Mary Cassatt's letters to Mrs. Pope and to Theodate, from 1900 to 1915, are reprinted in *Cassatt and Her Circle: Selected Letters*, Nancy Mowll Mathews, ed. (New York: Abbeville Press, 1984). Cassatt's *Breakfast in Bed* was reproduced in *Art Amateur* 38 (May 1898): 133. Käsebier may have known that it would appear in *Camera Work*, no. 3 (July 1903).

31. Roger Manvell, *Ellen Terry* (New York: G.P. Putnam's Sons, 1968), p. 297. "Illustrated Interviews: Miss Ellen Terry," *The Strand Magazine* 4 (1892): 496. *Ellen Terry and Bernard Shaw: A Correspondence*, Christopher St. John, ed. (London: Max Reinhardt, 1949), pp. 66, 92, 94–95.

"Appreciation," *Camera Notes* 3 (April 1900): 218; *Wilson's Photographic Magazine* 37 (Dec. 1900): 544; Juan C. Abel, "Pictorial Photography No. 2: The Religious Sentiment," *Delineator*, April 1902, p. 641. Tom Prideaux, *Love or Nothing: The Life and Times of Ellen Terry* (New York: Charles Scribner's Sons, 1975), p. 235. The picture cannot be located; it is not at the Ellen Terry Memorial Museum, Smallhythe Place, England (Margaret Weare to the author, Feb. 22, 1988). See also MT biography, "From Mrs. Henry Clifton (Adèle Miller)," p. 26, and Käsebier's acquaintance with Ellen Terry, p. 166.

32. Melinda Boyd Parsons, *To All Believers—The Art of Pamela Colman Smith* (Wilmington, Del.: Delaware Art Museum, 1975), n.p. I. C. Haskell, "The Decorative Work of Pamela Colman Smith," *Pratt Institute Monthly* 7 (Dec. 1897):65–67. GK to Francis Benjamin Johnston, Aug. 30, 1906, LC.

33. "Personal Paragraphs," *Amateur Photographer* Nov. 2, 1900, p. 342. *Wilson's Photographic Magazine* 37 (Dec. 1900): 544.

According to Roberts [Edgerton], p. 92, Käsebier had made 20,000 negatives by 1907. This averages to 2,000 negatives a year over ten years. If she worked only 200 days a year and made two sittings of five negatives each on those days, Käsebier would have earned $20 per day. If each subject ordered one extra print, adding $10, she would have earned $30 per day. Multiplying $30 by 200 working days would have brought Käsebier's average gross income to $6,000. Even if one-third of her negatives were complimentary or made for her own pleasure, she would have netted $4,000.

34. Bill dated Jan. 17, 1900, Yale, for prints of "mother and baby" and "Mrs. Stieglitz."

35. Lowe, p. 312.

36. GK recollections, p. 184.

37. Keiley, "The Salon," *Camera Notes* 4 (Jan. 1901): 222.

38. See e.g. *Jean-François Millet: Peasant and Painter*, translated by Helena de Kay from the French of Alfred Sensier (Boston and N.Y.: Houghton Mifflin & Co; Cambridge: River-

side Press, 1880), p. 211.

For Demachy see, for instance, *Photographic Times* 32 (Aug. 1900): 339.

39. Block, *Eva Watson Schütze: Chicago Photo-Secessionist*, p. 10.

40. On the reception of Froebel in the U.S., see Nina C. Vandewalker, *The Kindergarten in American Education* (New York: Macmillan, 1917; first published 1908), Emilie Poulsson, *Love and Law in Child Training* (Springfield, Mass.: Milton Bradley Co., 1899), especially pp. 67–105. Articles in the *Atlantic Monthly*, *Century Magazine*, *Ladies Home Journal*, etc., are cited in the bibliography of Elizabeth Dale Ross, *The Kindergarten Crusade* (Athens: Ohio University Press, 1976). Arthur Henry, "The New Spirit of Education," *Munsey's Magazine* 23 (May 1900): 147–63, includes two Johnston photographs. Käsebier entered magazine and newspaper contests during the 1890s; she later referred to magazine articles in letters to Day and Laura Gilpin (Norwood and Amon Carter). She also clipped and saved articles about herself and others (NYPL Manuscript Division and Collection Mason E. Turner, Jr.).

41. "Kindergarten Department," *Pratt Institute Record*, no. 4 (Oct. 1892): 60–61. "Kindergarten Department," *Pratt Institute Monthly* 1 (Feb. 1893): 141, and reference to Froebel p. 175; "Gleanings from Pratt Institute Lectures," *Pratt Institute Monthly* 1 (April 1893): 194, "Department of Kindergartens," *Pratt Institute Monthly* 2 (April 1894): 260–261, and "The Growth of the Kindergarten Movement," *Pratt Institute Monthly* 4 (Nov. 1895): 61–75. Käsebier, "Studies in Photography," p. 272. Sabine, *Abel's Photographic Weekly*, Sept. 19, 1931, p. 351.

42. Roberts [Edgerton], pp. 90–91. GK recollections, p. 184.

43. Roberts [Edgerton], pp. 91–92. See also Vandewalker, pp. 59–60, and "Kindergartens," *Pratt Institute Monthly* 1 (Oct. 1893): 57.

44. GK to Stieglitz, July 23, 1901, Yale. Evan Evans to the author, July 3, 1978. George Bernard Shaw, "Evans—An Appreciation," *Camera Work*, no. 4 (Oct. 1903): 13–14.

45. Edward Steichen, *A Life in Photography* (Garden City, N.Y.: Doubleday & Co., 1963), n.p. (Chapter 1, facing plate 3).

46. Steichen to Stieglitz, [1901], Yale (leaf 16).

47. Steichen to Stieglitz, [1901], Yale. Charles G. Metzger, "Käsebier's Equipment and Techniques," in Homer, *Käsebier*, p. 32. The drawing may have been a study for Steichen's oil portrait of Käsebier, mentioned in Sadakichi Hartmann's "A Visit to Steichen's Studio," *Camera Work*, no. 2 (April 1903): 27. The painting is not known to exist; Steichen destroyed most of his paintings.

48. GK to Stieglitz, Aug. 21, 1901, Yale.

49. Knox Burger gave the scrapbook to MOMA

in 1983. His father had apparently received it from his sister-in-law, Rosamund Vitale. Käsebier gave the album to the Vitale family when she spent parts of summers at their "Hilltop" estate in Great Barrington, Mass., during the teens and twenties. (Interviews with Knox Burger, 1982 and March 1989.)

The scrapbook is datable both by comparison with other 1901 photographs and by a tintype of Steichen dated 1901. In addition to twenty mounted and four unmounted portraits of Steichen which are known to be by Käsebier or can be attributed to her, the album contains an unmounted portrait of Steichen with Alvin Langdon Coburn's monogram and another that I have attributed by its monogram to Beatrice Baxter. There are also a number of unsigned drawings and clippings. I am grateful to Timothy Burgard for the loan of his unpublished paper, "Gertrude Käsebier and Edward Steichen: Portrait of a Friendship," which contains a careful analysis and catalogue of this scrapbook.

50. Hermine Turner and Kate Steichen, interviews. Delehanty and Paddock had been students at Pratt. Serbonne is actually Serbonnes, a village southeast of Fontainebleau.

51. Steichen, *A Life in Photography*, Chapter 2.

52. [Stieglitz], "Notes," *Camera Notes* 2 (Oct. 1898): 53.

53. "Gum-Bichromate Printing," *Photo-Miniature* 2 (Jan. 1901): 400–401.

54. GK to Stieglitz, Aug. 21, 1901, and postcard signed HK, GK & EJS to Mrs. Alfred Stieglitz, postmarked Munich, Sept. 17, 1901, Yale. HK was Hermine Käsebier, not Heinrich Kühn, as Elizabeth Pollock suggested in *An Exhibition of One Hundred Photographs by Heinrich Kühn* (Munich: Stefan Lennert and other galleries, 1981–82), p. 9. Steichen, *A Life in Photography*, Chap. 2, n.p. MT biography, p. 67.

Little is known about a side trip that the Käsebiers and Steichen took to Denmark. A copy photograph (Steichen Archive, MOMA) shows them on a railroad platform reading a Danish train schedule. Käsebier's proposal to photograph the king of Denmark had been rejected by the king's representative, July 23, 1901 (NYPL). See also GK to Johnston, June 6, 1901, LC.

Offizieller Katalog der VIII. Internationalen Kunstausstellung im Kgl. Glaspalast zu München 1901 veranstaltet von der "Münchener Künstlergenossenshatt" im verein mit der "Münchener Secession," June 1–end of Oct., Munich.

Chapter V

1. Margaret Harker, *The Linked Ring: The Secession Movement in Photography in Britain,*

1852–1910 (London: Heinemann, 1979).

2. Stieglitz, "The Origin of the Photo-Secession and How It Became '291,'" from "Four Happenings," *Twice-A-Year* nos. 8/9 (Spring–Summer, Fall–Winter 1942): 117. Reprinted in Nathan Lyons, ed., *Photographers on Photography* (Englewood Cliffs, N.J.: Prentice-Hall, 1966), p. 121.

3. National Arts Club, "American Pictorial Photography arranged by the Photo-Secession," New York, March 5–March 22, 1902. (Homer, *Stieglitz*, p. 53, notes that the exhibition actually ran through March 24.)

4. Stieglitz, "Origin of the Photo-Secession," p. 117; reprint, p. 121. "Artists in Photography," *The New York Times*, March 6, 1902, p. 14.

5. "The Photo-Secession at the National Arts Club, New York," *Photograms of the Year*, 1902, pp. 17, 18.

6. Sue Davidson Lowe, *Stieglitz: A Memoir/Biography* (New York: Farrar Straus Giroux, 1983), p. 115. See also Caffin to Stieglitz, Aug. 28, 1902, and Johnston to Stieglitz, Sept. 28, 1902, Yale.

7. On the printing of *Camera Work* see Christian A. Peterson, *Camera Work: Process and Image* (Minneapolis: Minneapolis Institute of Art, 1985).

8. MT interview. MT biography, "Material from Col. E. J. Steichen," p. 35. Norman, *Alfred Stieglitz: An American Seer*, p. 47. Steichen to Stieglitz, n.d. (c. Oct. 1902), Yale.

9. Jussim, p. 152, Naef, p. 120. Stieglitz to Day, Oct. 6, 1902, July 15, 1903, April 14, 1906, and Nov. 20, 1906, Yale. Day to Stieglitz, Oct. 30, 1902, Yale, and Nov. 30, 1906, Norwood, quoted by Jussim, p. 171.

10. See *Camera Work* scrapbook (Book 2), Yale.

11. Stieglitz also put *The Manger* and *Blessed Art Thou Among Women* in the portfolio *American Pictorial Photography* Series II (New York: Publication Committee, Camera Club, 1901). He used Mrs. Jameson by Hill and Adamson in *Camera Work*, no. 11 (July 1905) and no. 37 (Jan. 1912), first from a modern reprint, later from the original negative. See also Stieglitz, "The Photo-Secession at the National Arts Club, New York," p. 18.

12. Editors, "The Pictures in This Number," *Camera Work*, no. 1 (Jan. 1903): 63.

13. Frances Benjamin Johnston, "The Foremost Women Photographers of America: A Series of Beautiful Photographs Showing what American Women have done with the Camera. First: The Work of Mrs. Gertrude Käsebier," *Ladies Home Journal*, May 1901, p. 1. Johnston, "Gertrude Käsebier, Professional Photographer," *Camera Work*, no. 1 (Jan. 1903): 20.

14. Caffin, "Mrs. Käsebier's Work—An Appreciation," *Camera Work*, no. 1 (Jan. 1903): 19. Arthur Hewitt, "Camera Work (A Review),"

Photo-Era 10 (Jan. 1903): 30.

15. Stieglitz to Keiley, Feb. 8 and 15, 1905, Yale.

16. GK to Stieglitz, n.d., Steichen to Stieglitz, n.d., Yale.

17. Keiley, "Eva Watson-Schütze," *Camera Work*, no. 9 (Jan. 1905): 23.

18. *The Road to Rome* and *Black and White* were in the Käsebier-White exhibition at 291, Feb. 5–19, 1906; the latter was also in "A Collection of American Pictorial Photographs as arranged by the Photo-Secession," Carnegie Institute, Pittsburgh, 1904. *The Heritage of Motherhood* was shown at the Cincinnati Museum, Feb. 11–March 5, 1906, and the Pennsylvania Academy of the Fine Arts, April 27–May 30, 1906. Stieglitz's inscription is on the back of a copy of *The Bat* that formerly belonged to him. Metropolitan Museum of Art, New York. See also Naef, *The Collection of Alfred Stieglitz*, p. 391.

A now unidentifiable *Nude*, listed as number 109 in the *Catalogue of the Philadelphia Photographic Salon*, Oct. 24–Nov. 12, 1898, is the other Käsebier nude known to me. Steichen, *A Life in Photography*, n.p. (Chapter 3), mentions reproductions that Stieglitz owned.

19. [Stieglitz], "Our Illustrations," *Camera Work*, no. 10 (April 1905): 50.

20. E. Wallon, "Le Salon," *Photo-Gazette*, May 25, 1904, pp. 132–33.

21. "Art Photography by Mrs. Käsebier," *Boston Herald*, March 8, 1904, p. 7. I am grateful to William A. Gifford for drawing this article to my attention. Kenneth Grahame, "The Roman Road," in *The Golden Age*, illustrated by Maxfield Parrish (London: John Lane: and New York: The Bodley Head, 1900), pp. 162–63. Reprint, Edinburgh and New York: Paul Harris, 1983. Käsebier titled another 1903 photo of her grandson *The Golden Age*.

22. Grahame, pp. 169, 174–75.

23. July 1894, pp. 211–19. Mina Turner recalled poring through back copies of *The Yellow Book* in the attic storeroom of her grandmother's studio at 315 Fifth Avenue, c. 1912 (MT biography, p. 169).

24. Chambers, "Called Greatest Woman Photographer . . ." GK to Laura Gilpin, Sept. 1, 1923, Amon Carter.

25. Biographical information derives from correspondence and interviews with Mrs. Ruyl's daughters, Ruth Woodbury and Barbara Daugherty, June–Sept. 1988, from John William Leonard, ed., *Woman's Who's Who of America* (New York: The American Commonwealth Co., 1914), p. 209, and from "Denver Girl Has Been Successful," *Denver Times*, Sept. 21, 1902, p. 15.

26. The sketch, also titled *Black and White*, belongs to Mason E. Turner, Jr. The laundress is reproduced in Chapter III of J. P. Mowbrays, "The Making of a Country Home," *Everybody's Magazine*, April 1901, p. 355.

27. MT biography, "From Mrs. Henry Clifton (Adèle Miller)," p. 29.

28. See *The Collection of Baron De Meyer*, Sotheby Parke Bernet, N.Y. (catalogue 4437M, Oct. 20, 1980), pp. 54–60.

29. GK to Day, July 6, 1905, Norwood. MT biography, p. 139.

30. Johnston to her mother, Frances A. Johnston, Aug. 24, 1905, LC. "Brief Biographies: Miss Frances Benjamin Johnston of Washington, D.C, and New York," *The Photographer*, May 2, 1905, p. 9. Johnston, "Gertrude Käsebier, Professional Photographer," p. 20.

31. Johnston to her mother, Aug. 24, 1905, LC. Philippe Jullian, *De Meyer*, edited by Robert Brandau (New York: Alfred A. Knopf, 1976), p. 30. "Studio Stories," *The Photographer*, Nov. 21, 1905, p. 53. Steichen to Stieglitz, n.d. (c. Oct. 1906), Yale. See also Steichen to Stieglitz [Nov. 1909], leaf 257, and Keiley to Stieglitz, March 26, 1909, Yale.

32. Johnston to her mother, Aug. 24, 1905, LC.

33. GK to Stieglitz, n.d. [Aug. 1904], Yale.

34. GK (in Newport) to Day, postmarked July 3, 1899, Norwood. She had exclaimed similarly to Miss Fletcher from France in 1894, NYPL.

35. Johnston to her mother, Aug. 24 and 29, 1905, LC.

36. "Threescore Years and Sixteen Is Ardent Exponent of Photography," *New York Sun*, Jan. 5, 1929, p. 21.

Shaw to Coburn, April 17, 1906. Quoted in Coburn, *Alvin Langdon Coburn, Photographer*, p. 40. The six Käsebier letters and twelve photographs in the archives of the Musée Rodin, Paris, were long inaccessible. Her daughter and granddaughter owned Rodin's letters to Käsebier (now in the Manuscript Division, NYPL) as well as four Rodin drawings and a sculpture that he gave to her as well as Käsebier snapshots of Rodin's studio (now all in MOMA).

37. On Rodin and photography, see Albert E. Elsen, *In Rodin's Studio: A Photographic Record of Sculpture in the Making* (Oxford: Phaidon Press in association with the Musée Rodin, 1980), Kirk Varnedoe, "Rodin and Photography," pp. 202–47 in *Rodin Rediscovered*, edited by Albert E. Elsen (Washington, D.C.: National Gallery of Art, 1981), and Hélène Pinet, *Rodin: Sculpteur et les Photographes de son Temps* (Paris: Philippe Sers, 1985). See also Rodin's statement in George Besson, "Pictorial Photography—A Series of Interviews," *Camera Work*, no. 24 (Oct. 1908): 14, and Georges Grappe, "Rodin et la Photographie," *L'Art Vivant*, no. 181 (Feb. 1934): 60.

De Meyer (in fluent but imperfect French) to Rodin, n.d., Musée Rodin.

38. John Murray Anderson, as told to and written by Hugh Abercrombie Anderson, *Out Without My Rubbers—The Memoirs of John Murray Anderson* (New York: Library Publishers,

1954), p. 52. Copyright certificate for five Rodin portraits dated January 19, 1906, NYPL. "Threescore Years and Sixteen . . . ," p. 21.

39. Milton W. Brown, *The Story of the Armory Show* (New York: Abbeville Press and Joseph H. Hirshhorn Foundation, 1988), pp. 122–24. Frederic V. Grunfeld, *Rodin: A Biography* (New York: Henry Holt & Co., 1987), pp. 395–96.

 "Threescore Years and Sixteen . . . ," p. 21. Käsebier recollections, p. 76.

40. Frederick Lawton, *The Life and Work of Auguste Rodin* (New York: Scribner's, 1907), p. 276. On Rodin's attitudes towards women see, e.g., Grunfeld pp. 392, 407.

41. MT biography, "From Mrs. Henry Clifton (Adèle Miller)," p.24.

 MT biography, p. 218. Elsen, *In Rodin's Studio*, p. 184. Lawton, p. 155. See also "Rodin on Posing," *Wilson's Photographic Magazine* 44 (Aug. 1907): 345, reprinted in *Photographic Journal of America* 52 (Oct. 1915): 471. GK to Day, May 7, 1907, Norwood.

42. Albert E. Elsen, *Rodin* (New York: Museum of Modern Art, 1963), pp. 173–78. See also Elsen, *The Partial Figure in Modern Sculpture* (Baltimore: Baltimore Museum of Art, 1969), p. 15. HT interview. R. Child Bayley, "Mrs. Käsebier," *American Amateur Photographer* 15 (Feb. 1903): 78–79.

43. Roberts [Edgerton], p. 93. Joan Vita Miller and Gary Marotta, *Rodin: The B. Gerald Cantor Collection* (New York: Metropolitan Museum of Art, 1986), pp. 76–91, and Elsen, *Rodin*, pp. 88–105. I am grateful to Jane Mayo Roos for reminding me of the Balzac parallel and for her helpfulness in reading an early version of my section on Käsebier and Rodin.

44. Lillian Sabine, "The Woman's Page: Gertrude Käsebier, of New York City," *Abel's Photographic Weekly*, Sept. 12, 1931, p. 323. HT interview.

45. Elsen, *In Rodin's Studio*, p. 109.

46. I am grateful to Hélène Pinet of the Musée Rodin for identifying the bust. On Rodin's tactile sense, see Friedrich, pp. 11, 514, and Isadora Duncan, *My Life* (New York: Boni and Liveright, 1927), p. 90.

47. Elsen, *In Rodin's Studio*, pp. 28–29.

48. These prints are in the Musée Rodin, Paris. A variant printed on silk is in IMP/GEH. Elsen, *In Rodin's Studio*, p. 23.

49. See, e.g., plate 6, Coburn, plate 15, Steichen, and p. 159 in Newhall, *The History of Photography*.

50. Steichen, Chapter 2, n.p. Besson, p. 14. Rodin to GK, Dec. 30, 1912, NYPL. GK to Rodin, Jan. 23, 1913, Musée Rodin. Käsebier would have been surprised to learn that experts now consider the sculpture to be a studio piece, rather than one created by Rodin's own hand (Kirk Varnedoe to the author, Jan. 12, 1990).

It is pertinent to note that the gift followed Rodin's breakup with the American-born Claire de Choiseul, who, from 1907–1912, controlled his business affairs and raised his prices, while promoting sales among Americans. "La Duchesse" (as she was known) would have looked askance at Rodin's making a gift to an American woman. See Ruth Butler, "Rodin and His American Collectors," in Gabriel P. Weisberg and Laurinda S. Dixon, eds., *The Documented Image* (Syracuse: Syracuse University Press, 1987), pp. 104–108.

51. Johnston to her mother, Aug. 16, 1905, LC. "Studio Stories," *The Photographer*, Nov. 21, 1905, p. 53. Judith Cladel, *Auguste Rodin, l'Oeuvre et l'Homme* (Brussels: Librairie Nationale d'Art et d'Histoire, 1908), p. 14, quoted by Daniel Rosenfeld, "Rodin's Carved Sculpture," in *Rodin Rediscovered*, p. 90.

52. GK to Rodin, Jan. 26, 1906, Musée Rodin, and Rodin to GK, April 6, 1906, NYPL. E.g., Käsebier gave the portrait now in the Metropolitan Museum to her Pratt schoolmate, Adèle Rollins Miller Clifton, as a wedding gift in 1908. Undated manuscript in unidentified hand (c. 1906), NYPL.

53. A.S. [Stieglitz], "Our Illustrations," *Camera Notes* 3 (July 1899): 24. Rodin to GK, April 6, 1906, NYPL.

54. "Maj. William Cooke Daniels, Merchant, Soldier and Author, Dies in Buenos Aires," *Denver Times*, March 19, 1918, p. 1. "Colorado Camera Club," *Denver Sunday Times*, April 8, 1900, p. 21.

55. Johnston to her mother, Sept. 26, 1905, on letter begun Sept. 22, 1905, LC. GK to Stieglitz, Aug. 21, 1901, Yale.

56. GK to Day, April 17, 1906, Norwood. Demachy, "Mme. Käsebier et son oeuvre," *La Revue de Photographie*, July 15, 1906, pp. 289–95. GK to Day, April 17, 1906, Norwood.

57. Stieglitz's correspondence files at Yale are so complete that gaps must indicate that no letters were received.

Chapter VI

1. "Photo-Secession Notes," *Camera Work*, no. 14 (April 1906): 48. Homer, *Alfred Stieglitz and the Photo-Secession*, p. 118.

2. See "The Advancement of Photography as an Art," *New York Herald*, Literary and Art Section, Jan. 21, 1906, p. 4, and Roland Rood, "The Little Galleries of the Photo-Secession, *American Amateur Photographer* 17 (Dec. 1905): 566–69.

 "Art and Artists," *The Globe and Commercial Advertiser*, Feb. 7, 1906, p. 6. See also "The New Photography," *The Evening Post*, Feb. 9, 1906, p. 7. A catalogue of the exhibition, which lasted from Feb. 5–19, is in *Scrapbook 4*, "291 Gallery," p. 25, Yale.

 Roland Rood, "Pictorial Photography in

America," *Wilson's Photographic Magazine* 43 (December 1906): 537, reprinted from *Photograms of the Year 1906*, pp. 5–9.

3. Stanford White to Rudolf Eickemeyer, Jr., May 14, 1903, Avery.

4. GK to Stanford White, n.d., Avery (letter dated by its position in White's correspondence file).

5. Stanford White to GK, Sept. 28, 1903, Avery.

6. MT biography, p. 62. GK to Stanford White, n.d. (letter dated by its position in White's file) and Jan. 4, 1904.

7. Stanford White to GK, Jan. 20, 1904, GK to Stanford White, May 3, 1904, Avery. Stanford White to GK, July 8, 1904. Signed original letter, NYPL. Copy, Avery. Stanford White to GK, Jan. 19, 1906, Avery.

8. Roberts [Edgerton], p. 91. Lawrence Grant White to GK, May 21 and June 1, 1921, NYPL.

9. Stanford White to GK, Sept. 28, 1903, Avery. Leland M. Roth, *The Architecture of McKim, Mead & White 1870–1920: A Building List* (New York and London: Garland Publishing, Inc., 1978), p. 89. Sheet from Käsebier studio guestbook signed by Rita de Acosta Lydig in 1903, NYPL. For another recommendation of Käsebier, see Stanford White to Lewis Chanler, Esq., Feb. 4, 1905, Avery. Frank Crowninshield, "An Elegante of Another Era," in *Appreciations of Rita de Acosta Lydig*, with notes on an exhibition held at The Museum of Costume Art, International Building, Rockefeller Center, New York, March 12, 1940, n.p.

10. The painting behind her is apparently *Portrait of an Actor* by John Jackson, R.A. See *Oil Paintings by European and American Masters from the Estate of the Late Rita de Acosta Lydig*, New York, Plaza Art Galleries, May 10, 1927.

11. Rood, p. 537. Käsebier's negative of this photograph (LC) is identified as Josephine Brown, whom White brought to Käsebier. The Josephine Brown clipping file, Theater Collection, Lincoln Center Library, NYPL outlines her progression from child prodigy violinist to ingenue actress. The Stanford White archive at Columbia University's Avery Library includes a doctor's bill for her dated June 1, 1906, as well as a bill from Davis and Eickemeyer dated Aug. 28, 1906, for "3 dozen photogravure sepia" photographs of Josephine Brown, at $40 per dozen.

 The Black Hat may be the seated profile portrait of Nesbit in the Boston Museum of Fine Arts. It is not the *Portrait Miss N.* (Naef, fig. 343), which is misidentified as Evelyn Nesbit.

12. MT biography, p. 61, and Michael Macdonald Mooney, *Evelyn Nesbit and Stanford White: Love and Death in the Gilded Age* (New York: William Morrow, 1976), pp. 46–47, 57, 64.

13. Gerald Langford, *The Murder of Stanford White* (Indianapolis and New York: Bobbs-

Merrill, 1962), pp. 24–25 and passim.

14. See, e.g., Stanford White to Rudolf Eickemeyer, March 16, 1900, Oct. 12 and Oct. 21, 1901, July 15 and Sept. 30, 1902; White to Pach Bros., Jan. 12, 1904; Davis & Eickemeyer to White (bill), Aug. 28, 1906, Avery.

Dorothy Dix, "Don't Judge Evelyn," *Philadelphia Bulletin*, dateline Jan. 9, 1908, clipping in Evelyn Nesbit Scrapbook 2, page 33, Robinson Locke Collection, Vol. 359, Lincoln Center Theater Collection, NYPL. The whereabouts of this book, if it still exists, is unknown.

15. On Eickemeyer's photographs see Mary Panzer, *In My Studio: Rudolf Eickemeyer, Jr. and the Art of the Camera 1885–1930* (Hudson River Museum, Yonkers, 1986). Perhaps *In My Studio* inspired Harry Thaw to call Stanford White "The Beast." Roth, pp. 331–332, writes that after their marriage, Thaw repeatedly forced Evelyn Nesbit to recount a tale of being drugged and deflowered by "The Beast."

Although professional discretion often kept Käsebier and other photographers from identifying clients by name when portraits were shown publicly, it is curious that Käsebier titled the picture of a celebrity *Miss N*. On Greuze see, e.g., Robert A. Sobieszek, *Masterpieces of Photography from the George Eastman House Collections* (New York: Abbeville Press, 1985), p. 214.

16. Roberts [Edgerton], "The Younger American Painters: Are They Creating a National Art?" *Craftsman* 13 (Feb. 1908): 512–32. Ira Glackens, *William Glackens and the Ashcan Group*, (New York: Crown, 1957), p. 87. Caffin, "Philadelphia Photographic Salon," *Harper's Weekly*, Nov. 5, 1898, p. 1087.

17. John Sloan, *John Sloan's New York Scene*, edited by Bruce St. John (New York: Harper & Row, 1965), p. 180 (from diary entry Jan. 4, 1908), and pp. 132–33 (from diary entries May 28, 1907, and June 1, 1907). The photographs are now in the Delaware Art Museum, Wilmington.

18. See, e.g., Davies to GK, March 15, 1924, NYPL. On the *Craftsman* portraits see also Barbara L. Michaels, "Rediscovering Gertrude Käsebier," *Image* 19 (June 1976): 20–32. GK recollections, n.p. HT and MT, interviews. See also Royal Cortissoz, *Arthur B. Davies* (New York: Whitney Museum, 1931), pp. 14, 31, where Käsebier is listed as owning *St. Brigid*, 1895, 12 × 6" and *Phantasies*, 1899, 13 × 16". (Cortissoz, p. 31). Two paintings are now in the possession of her descendants, Mason E. Turner, Jr., and Laura Shevlin.

19. Archives of American Art, Ferargil Galleries Collection, frame 796: "Complete Prices of Davies Sale," *Art News*, April 20, 1929. Brooks Wright, *The Artist and the Unicorn: The Lives of Arthur B. Davies 1862–1928* (New City, N.Y.: Historical Society of Rockland County, 1978), pp. 43–47.

20. The pictures are signed O'Neill Latham, as Rose called herself during her marriage to Gray Latham. See Rowena Ruggles Godding, *The One Rose* (Albany, Calif., 1972), p. 15. On O'Neill see also *Notable American Women* I, pp. 650–651, Alexander King, "Profiles: Kewpie Doll," *New Yorker*, Nov. 24, 1934, pp. 22–26, and George Kummer, *Harry Leon Wilson* (Cleveland: Press of Western Reserve University, 1963), pp. 20, 36–39, 60–62.

21. It is now among the Käsebier negatives at the LC.

22. "Danced Assembly Ball as in Days of 1840," *The New York Times*, April 19, 1906, p. 13. "Society at Home and Abroad," *The New York Times*, April 15, 1906, Part 4, p. 7, refers to this Assembly Ball as the "crinoline ball." See also "Past Glories Revived," *New York Tribune*, April 19, 1906, p. 7, and "Saunterings," *Town Topics*, April 12, 1906, p. 3. Five negatives of the Gerson sisters are now in the LC. Virginia and Minnie's sister, Alice ("Toady"), married William Merritt Chase. See Katharine Metcalf Roof, *The Life and Art of William Merritt Chase* (New York: Charles Scribner's Sons, 1917), Introduction by Alice Gerson Chase, passim., and Ronald G. Pisano, *William Merritt Chase* (New York: Watson Guptill, 1979). On Virginia Gerson, see Bertha E. Mahony, Louise Payson Latimer, and Beulah Folmsbee, *Illustrators of Children's Books 1744–1945* (Boston: The Horn Book, 1947), p. 312. Joan Gaines, whose mother, Eulabee Dix, was a friend of the Gerson sisters, also provided information about them.

23. The silhouette by J. B. Kerfoot was reproduced in *Camera Work*, no. 8 (Oct. 1904). The painting behind Dix (now in the possession of Käsebier descendants) is an oil portrait of Käsebier signed by one E. B. Smith. The identity of Smith has yet to be established.

24. Joan Gaines, interview, Oct. 1988. Käsebier portraits of Eulabee Dix are in the Art Institute of Chicago as well as in private collections. An oil portrait of her by Robert Henri, *Lady in Black Velvet (Mrs. Eulabee Dix Becker)*, 1911, is in the High Museum of Art, Atlanta, and she also appears in John Sloan's *Yeats at Petitpas*, 1910, Corcoran Gallery of Art.

Yeats is quoted in William M. Murphy, *Prodigal Father: The Life of John Butler Yeats* (Ithaca, N.Y., and London: Cornell University Press, 1978), p. 615.

25. Other exhibitions that year included Cincinnati Museum, Feb. 11–March 5, 1906, Pennsylvania Academy of the Fine Arts, April 30–May 27, 1906.

26. Day to Stieglitz, April 4, 1902; Watson Schütze to Stieglitz, Dec. 12, 1904; GK to Stieglitz, Feb. 3, 1911; White to Stieglitz, May 15, 1912, Yale.

27. See, e.g., Keiley to Stieglitz, June 22, 1904; Steichen to Stieglitz, c. Nov. 1906 (leaf 197) and 1908 (leaf 135); de Meyer to Stieglitz, Nov. 10, 1908, Yale.

28. Stieglitz to Johnston, Aug. 6, 1900, LC. Stieglitz to Kühn, Oct. 14, 1912, Yale. A.S. [Alfred Stieglitz], "Our Illustrations," *Camera Notes* 3 (July 1899): 24. Stieglitz to Keiley, Nov. 14, 1901, Yale.

29. GK to Day, Jan. 7, 1907, Norwood.

30. White to Stieglitz, June 14, 1907, Yale. "Notes from Everywhere," *Photographer*, May 21, 1907, p. 54, and photograph and caption May 28, 1907, p. 69.

31. MT interview. MT biography, "From Col. Edward J. Steichen," p. 32.

32. Keiley, "Gertrude Käsebier," *Photography*, March 19, 1904, cover, 223–227, 237.

33. GK to Day, Dec. 7, 1907, Norwood.

34. Roberts [Edgerton], pp. 87–88.

35. Caffin, "Emotional Art (After Reading the 'Craftsman' April 1907)," *Camera Work*, no. 20 (Oct. 1907): 32.

36. Roberts [Edgerton], p. 91. On the portrait see also Paul R. Baker, *Stanny: The Gilded Life of Stanford White* (New York: The Free Press and London: Collier Macmillan, 1989), pp. 176, 252, 376 and reproduction.

37. Caffin, "Emotional Art," pp. 33–34.

38. Ibid., p. 34.

39. GK to Day [Dec. 7, 1907], Norwood.

40. Jonathan Green, *Camera Work: A Critical Anthology* (Millerton, NY: Aperture, 1973) p. 13.

41. E.g., J. Nilsen Laurvik, "The New Color Photography," *Century* 75 (Jan. 1908): 322–330, and Keiley, *Photographische Kunst in Jahre 1908*, pp. 113–59. GK to Day, Dec. 28, 1907, Norwood, concerning the *Century* article noted above.

42. GK to Day, Dec. 7, 1907, Norwood. *The New York Times*, Oct. 22, 1907, p. 1, and Oct. 23, 1907, p. 1. "Here & There," *Abel's Photographic Weekly*, Dec. 14, 1907, p. 16. MT biography, "From Harriet Hibbard," p. 149. "The Photo-Secession Galleries: The Members' Exhibition," *Camera Work*, no. 21 (Jan 1908): 45.

43. See Borglum in *World's Work*, March 1902; Twachtman in *Craftsman*, June and Sept. 1908; Beach in *Studio Light*, Nov. 1911; and Perrine in *Craftsman*, April 1907. On Käsebier's purchase of a Perrine landscape, see Lolita L. W. Flockhart, *A Full Life: The Story of Van Dearing Perrine* (Boston: Christopher Publishing House, 1939), p. 161; I am grateful to Prof. William Gerdts for drawing this to my attention. National Arts Club, "Special Exhibition of Contemporary Art," New York, Jan. 4–25, 1908.

44. De Meyer to Stieglitz, Nov. 10, 1908, Yale.

45. *John Sloan's New York Scene*, p. 132.

46. GK recollections, pp. 74–75, 184. The Princeton University Museum and the Smith College Museum of Art own Northcliffe portraits; a

silhouette of him belongs to Mason E. Turner, Jr.

47. GK recollections, p. 184. See also Lowe, *Stieglitz: A Memoir/Biography.* pp. 100, 126, and 110–111.

48. Lowe, pp. 132–133. "The Photo-Secession Members' List," *Camera Work,* no. 26 (April 1909): 43.

49. Stieglitz to Kühn, March 1, 1909, translated typescript, Yale.

50. Steichen to Stieglitz, n.d., leaf 111, Yale (letter dated 1908 by Yale, but content suggests 1909). "Notes on the Dresden Exposition— Awards," *Camera Work,* no. 28 (Oct. 1909): 48. Keiley to Stieglitz, Aug. 6, 1909, Yale. "The Rochester Record: Phillips versus Käsebier," *Photographic Progress* 1 (Aug. 1909): 89–90. Keiley to Stieglitz, July 13, 1909, and July 21–22, 1909, Yale.

51. Harker, *The Linked Ring,* pp. 122, 184, 188. "1910 Kodak Advertising Contest: Third Prize—Professional Class by Gertrude Käsebier," *Studio Light and the Aristo Eagle,* Jan. 1910, p. 9. "Women Photographers," *Bulletin of Photography,* Nov. 10, 1909), p. 292. "Women Photographers Organized," *Abel's Photographic Weekly,* July 17, 1909, p. 23. "The Women's Section of the Photographers' Association of America," *Abel's Photographic Weekly,* Sept. 18, 1909, p. 117. Käsebier also exhibited at the convention of Professional Photographers, Rochester, N.Y., July 1909 (*Studio Light and the Aristo Eagle,* July 1909, pp. 10–12).

52. Eduard Käsebier's death date is incorrect in his *New York Times* obituary, Dec. 18, 1909, p. 13. Nassau County records give the date as Dec. 17. Gertrude Muncy Stanton died Aug. 21, 1910, according to an obituary in *The Trail: A Magazine for Colorado,* Nov. 6, 1910, p. 24. She had been living with the Turner family in Waban, Mass., at the time of her death (MT interview). MT biography, p. 164.

53. MT interview. MT biography, p. 139. Charles Wagner, *The Simple Life* (New York: McClure, Phillips & Co., 1901). J. P. Mowbray, "Going Back to the Soil," *World's Work* 1 (Jan. 1901): 267–277. J. P. Mowbray, "The Making of a Country House," *Everybody's Magazine* 4 (Feb.–June 1901): 99–115, 239–53, 347–58, 418–29, 609–20 and 5 (July–Sept.): 65–76, 145–53, 365–73. (The final installments of the story, in October and November, contain no Käsebier illustrations.) Mowbray was one of Andrew Carpenter Wheeler's pen names; he was best known as Nym Crinkle, a theater critic. Wheeler's diaries at the New-York Historical Society mention neither Käsebier nor the articles she illustrated.

54. MT biography, p. 139.

55. Eugenia Parry Janis, "Her Geometry," in *Women Photographers* (New York: Harry N. Abrams, 1990), pp. 10–11.

56. MT biography, p. 198.

57. Mary P. Ryan, *Womanhood in America* (New York and London: Franklin Watts, 1983), p. 212, mentions "Let the Children Live Their Own Lives," in the December 1899 *Ladies Home Journal* as well as an article in the January 1900 issue that says a child "must be taught independence early."

58. [Sidney Allan] Hartmann, "Exhibition of Secessionists at Buffalo Museum," *Abel's Photographic Weekly,* Nov. 19, 1910, p. 227. Stieglitz to GK, May 21, 1910, Yale. Buffalo Fine Arts Academy/Albright Art Gallery, "International Exhibition of Pictorial Photography," Nov. 3–Dec. 1, 1910. *Academy Notes* 5 (Oct. 1910), special issue of *Albright Art Gallery Bulletin.*

59. GK to Stieglitz, May 28, 1910, Yale.

60. Anthony Bannon, *The Photo-Pictorialists of Buffalo* (Buffalo: Albright-Knox Art Gallery, Oct. 3–Nov. 8, 1981).

61. Keiley, "The Buffalo Exhibition," *Camera Work,* no. 33 (Jan. 1911): 27.

62. Walter Bertling, "The Albright Art Gallery Exhibition," *Photo-Era* 26 (Jan. 1911): 16.

63. Stieglitz to GK, Dec. 19, 1910, and her undated reply on the same sheet. GK to Stieglitz, Feb. 3, 1911, Yale.

64. Stieglitz to GK, Feb. 7, 1911, Yale.

65. Stieglitz to Selma Stieglitz Schubart, Oct. 4, 1909, Yale.

66. The exhibit was held at the Free Public Library, Newark, under the auspices of the Newark Museum Association, April 6 to May 4, 1911. "News and Notes," *Bulletin of Photography* 8 (April 19, 1911): 254.

Typed bills like these sent to Coburn and his mother were undoubtedly sent to all Secession members as annual dues bills. (Stieglitz to A. L. Coburn and Mrs. F. Coburn, leaf 217, 218, Yale.)

67. Clarence H. White to Day, Nov. 13, 1911, Norwood, quoted in Jussim, p. 187. GK to Stieglitz, Jan. 2, 1912, Yale.

68. Stieglitz to GK, Jan. 4, 1912, Yale. About her showcase, see *Abel's Photographic Weekly,* Dec. 30, 1911, p. 414. Imogen Cunningham recalled that Käsebier wore a "big blinder" when they met in 1910; she thought the infection had been caused by touching the eye after handling platinum paper. Cunningham, telephone interview with the author, June 10, 1976.

69. GK to Stieglitz, Jan. 6, 1912, Yale. Stieglitz, however, could not contain his acrimony or criticism. See, e.g., Stieglitz to Kühn, May 22, 1912, and Stieglitz to R. Child Bayley, April 29, 1912, Yale.

Chapter VII

1. For instance, the following have been reproduced since 1973: *The [War] Widow* of 1913 in Szarkowski's *Looking at Photographs* and Anne Tucker's *The Woman's Eye,* which also contains *Portrait of Clarence White and His Mother* (1913); *The Refugee* (c. 1915), titled *Woman in Hat* in Ben Maddow, *Faces; The Hand That Rocks the Cradle* of 1913 in Patricia Hills, *Turn-of-the-Century America; Mrs. R. Nursing Baby* of 1913 in Homer, *Käsebier.* The Newfoundland photographs (whose date was known) were exhibited at IMP/GEH in 1974. Eugenia Janis chose to write about the billiard game photograph before knowing its date.

2. MT interview. Anderson, *Out Without My Rubbers,* pp. 36, 52. "Anderson, John Murray," *Who's Who in America* 28 (Chicago: Marquis Publications, 1954–55), p. 64. James Stewart Morcom, interview, 1976.

3. Anderson, pp. 20, 36–37. Troy and Margaret West Kinney, *The Dance* (New York: Frederick A. Stokes Co., 1914), p. 52. "Who Is John Murray Anderson," *The New York Times,* April 25, 1920, clipping in NYPL Lincoln Center Theater Collection. "Mrs. Fish Has Dance Evolved to Take Place of Criticized Tango," *New York Herald,* Jan. 23, 1914, p. 9. "Teachers, Students and Things," *Pratt Institute Monthly* 2 (Dec. 1893): 110 and (March 1894): 213.

4. Käsebier writes of "having a call to do some work in Newfoundland," in her undated manuscript (c. 1915–1920), addressed "For Mrs. Vitale," NYPL. *Newfoundland Trip 1912,* Collection Mason E. Turner, Jr. Käsebier's handwritten commentary on twenty-four numbered sheets of unbound white paper is interspersed with her platinum prints and sketches. IMP/GEH owns the most complete collection of Käsebier's 8 × 10" Newfoundland photographs.

5. *Newfoundland Trip 1912,* pp. 7–8. See also: "Enthusiasm from Mrs. Käsebier," *Bulletin of Photography,* Sept. 18, 1912, p. 419–20.

6. "Art at Home and Abroad," *The New York Times,* Oct. 13, 1912, Part 7, p. 7.

7. Davies to GK, March 17, 1913, NYPL. Exactly what she lent remains a puzzle. The Armory Show catalogue numbers 1015 and 1016 indicated that Käsebier lent seven drawings and one bronze *Figure of Man* by Rodin. However, a letter in the Kuhn Papers says that no Rodin sculpture appeared in the exhibit.

There is no evidence that Käsebier ever owned more than four Rodin drawings. However, two Rodin drawings listed under her name were sold from the show. See Brown, *The Story of the Armory Show,* 1988, pp. 310–11.

8. MT biography, pp. 173–74.

9. Conversation with Milton W. Brown, Sept. 6, 1989. *A Life in Photography,* Chapter 4, mentions Cézanne; MT biography, "From Col. Edward J. Steichen," p. 36, says the picture was a

Picasso. "Picture Making: A Talk to the Department of Photography, Brooklyn Institute," *American Photography* 9 (April 1915): 226. A typescript (NYPL) dates the talk to Feb. 13, 1914.

10. Between 1910 and its closing in 1917, the only photography exhibitions at 291 were Steichen (1910), De Meyer (1911–12), Stieglitz (1913), and Paul Strand (1916). *An Exhibition Illustrating the Progress of the Art of Photography in America* (New York: Montross Art Galleries, Oct. 10–31, 1912).

11. *The Reminiscences of Max Weber*, Oral History Research Office, Columbia University, 1958. Interview by Carol S. Gruber, pp. 82–88, 275–78. A photograph by Gertrude L. Brown, reproduced in Homer, *Käsebier*, p. 29, shows Käsebier with Weber at the White School in Maine. Käsebier's calling card introducing Weber is microfilmed between letters from Coburn to Weber (Reel 69–85, Max Weber Archive, Archives of American Art).

12. Temple Scott, "Photography at the Ehrich Galleries," and Edward R. Dickson, "Notes on Pictorial Photography," *Platinum Print* 1 (March 1914): 2–5, 10. See also "Art Notes," *The New York Times*, Jan. 22, 1914, p. 10; Paul L. Anderson, "The International Exhibition of Pictorial Photography," *American Photography* 8 (April 1914): 184–189; and White to Coburn, July 20, 1913, IMP/GEH.

 An Exhibition of Pictorial Photography (New York: Print Gallery, Dec. 1–18, 1915). See also the unsigned review, "Pictorial Photographs at the Print Gallery," *Photo-Era* 36 (Jan. 1916): 45. The Print Gallery was part of the Ehrich Galleries.

13. Bonnie Yochelson, "Clarence H. White Reconsidered: An Alternative to the Modernist Aesthetic of Straight Photography," *Studies in Visual Communication* 9 (Fall 1983): 29–30, 40.

14. Jane White to F. H. Day, Feb. 11, 1930, IMP/GEH.

15. White mentions Käsebier's presence to Coburn, July 20, 1913, IMP/GEH. The register of the Seguinland Hotel (now Greyhavens), Georgetown, shows that Käsebier arrived July 18; no departure date is given. Clara Estella Sipprell had arrived July 6; her portrait of Käsebier undoubtedly dates to this summer.

 According to Mrs. Clarence H. White, Jr., Day's "Chalet," which replaced a more modest house, was opened in 1913 (interview, Aug. 1978).

16. Lowe, pp. 100–105, 134.

17. Maynard P. White, *Clarence H. White* (Millerton, N.Y.: Aperture, 1979), p. 14.

18. The pictures can be dated to 1913 by the age of the infant (interview with Barbara Ruyl Daugherty, Sept. 1988). *The Hand That Rocks the Cradle* was published in *American Photography* 8 (June 1914): 327. *The Widow* was

published in *The Outlook,* June 14, 1916, and listed similarly in the catalogue of Käsebier's 1929 retrospective. However, it seems to have been erroneously retitled *The War Widow* by Hermine Turner when she donated a copy to The Museum of Modern Art.

19. Sheila M. Rothman, *Woman's Proper Place* (New York: Basic Books, 1978), pp. 99, 103.

20. Frederick C. Moffatt, *Arthur Wesley Dow (1857–1922)* (Washington: Smithsonian Institution Press for the National Collection of Fine Arts, 1977), pp. 108, 147–48, footnote 245. Dow, "Beginnings," 1912 introduction to *Composition* (New York: Doubleday Doran, 1931), p. 5. *Composition* was first published in 1899. Poulsson, *Finger Plays for Nursery and Kindergarten* (Boston: Lothrop, Lee & Shepard, 1893), music by Cornelia C. Roeske, illustrated by L. J. Bridgman.

21. "Talk on Art. Mrs. Käsebier, a Prominent Artist Visiting Clarence White, of Hudson Ave., Talks Interestingly of Her Profession," *Newark* (Ohio) *American Tribune*, Aug. 13, 1902, clipping in Stieglitz scrapbook, Yale.

22. Keiley, "Gertrude Käsebier," *Photography*, March 19, 1904, p. 226. *Reader's Guide to Periodical Literature* and *The New York Times Index* show scant interest in widows from 1900–1910; between 1910 and 1913 interest mushroomed. E.g., between 1905 and 1909 *Reader's Guide* has only six entries for widows and none for widow's pensions. For 1910–1914 there are one-and-a-half columns referring to "Pensions for Widows." [Editorial], *The New York Times*, Feb. 2, 1912 p. 8. "Thirteen States Now Have Laws Pensioning Mothers," *The New York Times*, May 11, 1913, Section 5 (Magazine), p. 2. "State Aid for Widowed Mothers," *The New York Times*, April 13, 1913, Section 3, p. 6. Mrs. Lydig, reproduced in Section 5, p. 13.

23. MT biography, p. 9. [Editorial], *The New York Times*, Feb. 2, 1912, p. 8. Alice Maxwell Appo, "House Bill No. 626: A First Step Toward the Endowment of Motherhood," *Colliers*, Aug. 17, 1912, p. 20.

24. "The Crime I Committed When I Became a Widow," *Ladies Home Journal*, March 1, 1911, p. 13.

25. *Magazine of Art* 12 (December 1889): 417. Käsebier could have seen this issue at Pratt; it also contained an article on Millet, one of her favorites. The picture was also reproduced in the July 1899 *Brush and Pencil*. No evidence shows whether Käsebier was familiar with examples such as *The North West Passage* by John Everett Millais. See also Susan P. Casteras, *Images of Victorian Womanhood in English Art* (Rutherford, N.J.: Fairleigh Dickinson University Press and London: Associated University Presses, 1987) on paintings of widows. Clara M. White, "A Western Art Collection," *Brush and Pencil* 4 (July 1899):

184.

26. John Szarkowski, *Looking at Photographs* (New York: Museum of Modern Art, 1973), p. 56. In Henry Turner Bailey's cogent analysis, repeated interruption of lines in *The Widow* disquiet the viewer and signify the "interrupted life." *Photography and Fine Art* (Worcester, Mass.: Davis Press, 1918), p. 121.

27. HT interview. Also MT biography, "From Mrs. Henry Clifton (Adèle Miller)," pp. 14–15. Copy of note from GK to Northcliffe dated Sept. 1914 and reply from Northcliffe dated Sept. 9, 1914, NYPL. See also Käsebier, "Picture Making," *American Photography* 9 (April 1915): 224 on the newly-instituted income tax. *The Refugee* is reproduced in Maddow, *Faces. In Times of Peace* is in Homer, *Käsebier*.

28. MT biography, "From Mrs. Henry Clifton (Adèle Miller)," p. 25.

29. Caroline Seebohm, *The Man Who Was Vogue: The Life and Times of Condé Nast* (New York: Viking Press, 1982), p. 195. Yochelson, p. 32. For Käsebier's 1917 New Year's card to Mr. and Mrs. Campbell, see *Catalogue Six: Photo-Secession* (Washington D.C.: Lunn Gallery/ Graphics International Ltd., 1977), no. 246.

30. "Five Striking Silhouettes by Gertrude Kasebier," *Vanity Fair*, March 1915, p. 34.

31. Lois Palken Rudnick, *Mabel Dodge Luhan: New Woman, New Worlds* (Albuquerque: University of New Mexico Press, 1984), pp. 43–51, 67, 70. *Camera Work*, Special Number (June 1913): 3–5.

32. Mabel Dodge Luhan, *Movers and Shakers: Volume Three of Intimate Memories* (New York: Harcourt, Brace and Company, 1936), p. 41. Rudnick, pp. 66–67; Brown, *The Story of the Armory Show*, 1988, p. 95. Käsebier, "Picture Making," p. 225.

33. MT biography, "From Mrs. Henry Clifton (Adèle Miller)," p. 16. See also Homer, *Käsebier*, p. 36, note 19.

34. Käsebier varied the title to make her meaning increasingly clear. The image was copyrighted as *Yoked and Muzzled, Find the Parallel*; it was subsequently sold to the Library of Congress as *Allegory: Marriage*. I have chosen to use the final title from the catalogue of Käsebier's 1929 retrospective: *Yoked and Muzzled—Marriage*.

35. Käsebier's photograph was not included in "The American Girl as a Bride," photographs collected by Frances Benjamin Johnston, *Ladies Home Journal*, June 1906. See also Johnston to Mr. Gilbert Bacon, Nov. 30, 1904, and Mrs. C. F. Conly to Johnston, Nov. 25, 1904, LC.

 Around 1910 in Waban, Mass., Hermine Turner confided her marital problems to her friend and neighbor, Mrs. Cotton, according to her daughter, Mrs. Phyllis Cotton Hamilton. Mrs. Hamilton also recalled that, as a youngster, her brother mentioned the abusive manner in which Hermine was treated by her

husband (interview with Mrs. Hamilton, July 29, 1987). This information was confirmed by Kate Steichen, who was a close friend of the Turner family for many years (phone interview, Feb. 9, 1988).

36. Emma Goldman, "Marriage and Love," in *Anarchism and Other Essays* (New York: Mother Earth Publishing Association, 1910), p. 234. See also Ida M. Tarbell, *The Business of Being a Woman* (New York: Macmillan, 1912), p. 57 (originally published in *American Magazine*). Charlotte Perkins Gilman, *Women and Economics* (Boston: Small, Maynard & Co., 1898), p. 91.

37. Chambers. Käsebier, "Peasant Life in Normandy," pp. 271–72. Keiley, 1904, p. 227. MT interview. "Called Greatest Woman Photographer, Gertrude Käsebier Is Now a Cripple," *New York Telegram*, Jan. 25, 1930, p. 2. On reform of women's clothing, see Helene E. Roberts, "The Exquisite Slave: The Role of Clothes in the Making of the Victorian Woman," *Signs* 2 (Spring 1977): especially pp. 558, 567–68.

38. Gilman, p. 157. "Women Photographers Organized," *Abel's Photographic Weekly*, July 17, 1909, p. 23, "The Women's Section of The Photographers' Association of America," *Abel's Photographic Weekly*, Sept. 18, 1909, pp. 177–218; "Women Photographers," *Bulletin of Photography*, Nov. 10, 1909, p. 292; Mary Carnell, "The First Annual Meeting of the Federation of Women Photographers," *Abel's Photographic Weekly*, Sept. 3, 1910, p. 108; and "Enthusiasm from Mrs. Käsebier," *Bulletin of Photography*, Sept. 18, 1912, pp. 419–20.

39. *Pictorial Photographers of America*, Yearbook (New York, 1917), pp. 8, 10. Käsebier was listed as Honorary Vice-President in *Pictorial Photography in America* 1–5 (1920, 1921, 1922, 1926 and 1929, when the publication ceased). National Arts Club, New York, "An Exhibition of Photography Held Under the Auspices of the American Institute of Graphic Arts," Oct. 4–Nov. 10, 1916. See also *Platinum Print* 3 (Oct. 1916): 15, and *Bulletin of the Brooklyn Institute of Arts and Sciences*, May 6, 1916, p. 311, concerning a solo exhibition of Käsebier's earlier in 1916.

40. Unsigned. "Photography in the Making," *Photographic Journal of America* 53 (Dec. 1916): 505.

41. GK to Day, Dec. 27, 1920; Dec. 22, 1921, Norwood.

42. GK to Laura Gilpin, March 12, 1923, Amon Carter. MT interview and GK to Day, Dec. 22, 1921, Norwood. Mina Turner to Pat Costello, March 5, 1973. Private Collection.

43. Cunningham, phone interview, June 1976. See also *Imogen Cunningham: Photographs*, Introduction by Margery Mann (Seattle and London: University of Washington Press, 1970), n.p. Paul Strand, phone interview, June 1973. See also Naomi Rosenblum, "Paul Strand: The Early Years, 1910–1932," (Ph.D. Dissertation, City University of New York, 1978; Ann Arbor: University Microfilms, 1979), p. 32.

44. Phyllis Fenner, longtime friend of Sipprell, to the author, July 12, 1978. Wallace Putnam, Consuelo Kanaga's widower, telephone interview with the author, April 1978. See also Margaretta Mitchell, *Recollections* (New York: Viking Press, 1979), pp. 158–60. Laura Gilpin, telephone interview with the author, April 1977.

45. Edward Weston to Johan Hagemeyer, n.d., "Weston to Hagemeyer: New York Notes," *Center for Creative Photography*, no. 3 (Nov. 1976): 9. No Weston portrait of Käsebier can now be found (Mary Anne Redding, Center for Creative Photography, Tucson, Ariz., to the author, Oct. 11, 1988).

46. GK to Gilpin, Dec. 15, 1922, and Jan. 16, 1923, Amon Carter. Also see *Bulletin of the Art Center* 1 (Nov. 1922): 61. Martha A. Sandweiss, *Laura Gilpin: An Enduring Grace* (Fort Worth: Amon Carter Museum, 1986), pp. 36, 43, 322, note 10.

47. MT interview. "Lincoln's Gift to an Unknown Soldier," *Outlook*, Feb. 7, 1923, pp. 249, 252.

48. Two Käsebier negatives of Lincoln are extant: an 8 × 10″ (IMP/GEH) and a 12 × 14″ (LC).

Charles Hamilton and Lloyd Ostendorf, *Lincoln in Photographs* (Norman, Okla.: Univ. of Oklahoma Press, 1963), pp. 20, 260. MT biography, pp. 151–52.

49. *Outlook*, Feb. 7, 1923, p. 252. *The New York Times Magazine*, Feb. 10, 1929, cover.

50. GK to Laura Gilpin (Jan. 25, 1925, Amon Carter): ". . . do buy the Pictorial Review for February. It has a corking article by Albert Edward Wiggam entitled 'The Beauty of Lincoln. An Appreciation'" (pp. 10–11, 48, 50, 66).

Spencer B. Hord to GK, Aug. 8, 1929, NYPL. Hord [Chippendale] describes his experience in Käsebier's studio in "Gertrude Käsebier, Maker of Photographs."

51. GK to Gilpin, Dec. 23, 1926, Amon Carter. M. A. Roberts, Chief, Division of Accessions, Library of Congress to GK, Feb. 25, 1926, NYPL. The sculptor Brenda Putnam, who was a friend of Laura Gilpin and Käsebier, helped to bring the purchase about; her father, Herbert Putnam, was the Librarian of Congress from 1899 to 1939.

"Threescore Years and Sixteen Is Ardent Exponent of Photography," *New York Sun*, Jan. 5, 1929, p. 21, reprinted in *Photo-Era* 62 (March 1929): 131. O'Malley family history. Chambers, *New York Telegram*, Jan. 25, 1930, p. 2. Sabine, "The Women's Page: Gertrude Käsebier, of New York City," *Abel's Photographic Weekly*, Sept. 5, 12, 19, 26, 1931, pp. 299, 323, 351, 379.

52. MT biography, "Lifshey—continued," pp. 134 –135.

53. Kate Steichen interview.

Epilogue

1. GK recollections, n.p. Käsebier's photographs were exhibited in Wiesbaden's "Erste Internationale Ausstellung für Künstlerische Bildnis-Photographie," April 26–May 26, 1903.

2. Roberts [Edgerton], p. 90. See also Käsebier, "Studies in Photography," p. 270, and Johnston, "The Foremost Women Photographers of America: The Work of Mrs. Gertrude Käsebier," p. 1.

3. Dennis Longwell, *Steichen, The Master Prints, 1895–1914* (New York: Museum of Modern Art and Boston: New York Graphic Society, 1978). Sarah Greenough, "How Stieglitz Came to Photograph Clouds," pp. 151–165 in Peter Walch and Thomas Barrow, eds., *Perspectives on Photography: Essays in Honor of Beaumont Newhall*, (Albuquerque: University of New Mexico Press, 1986). Eldredge, *American Imagination and Symbolist Painting*.

4. See Eckmann in "The Secessionists of Germany, *Studio* 4 (March 1895): 24–28; *A Life in Photography*, plate 17. See also *Solitude: Inner Visions in American Art* (Evanston, Ill.: Terra Museum of American Art, Sept. 25–Dec. 30, 1982).

5. *Quarterly Illustrator* 3 (April–May–June 1894): 218.

6. The image of a woman who seduces and degrades men was prevalent in contemporaneous European painting. However, this picture could not have been meant to represent woman as vampire, because there is no evidence that Käsebier (or Clarence White, who had proposed making the image) had an affinity for such pictures—and Käsebier's feminist attitudes would have been antipathetic to such imagery.

Selected Bibliography

MANUSCRIPT COLLECTIONS

Note: Occasional misspellings in manuscripts by Gertrude Käsebier have been corrected in the text of this book.

Newark, Del., University of Delaware Library. Gertrude Käsebier Papers
>Recollections by Käsebier and biographical information written and compiled by her family

Wilmington, Del. Collection Mason E. Turner, Jr.
>Käsebier Newfoundland Journal and other memorabilia

Fort Worth, Tex. Amon Carter Museum of Western Art
>Käsebier letters to Laura Gilpin

Madison, Wis. State Historical Society of Wisconsin, Division of Archives and Manuscripts
>Letter to Carlos Montezuma

New Haven, Conn. Yale University. Alfred Stieglitz Archive, Collection of American Literature, Beinecke Rare Book and Manuscript Library
>Käsebier-Stieglitz correspondence, as well as references to Käsebier in letters by others. Scrapbooks containing Photo-Secession catalogues and clippings of reviews

New York, N.Y. Columbia University. Stanford White Collection, Drawings and Archives Collection, Avery Architectural and Fine Arts Library
>Copies of White's letters to Käsebier

New York, N.Y. New York Public Library, Manuscript Division.
>Käsebier letter from abroad, 1894, a later undated memoir, autographs, letters from Auguste Rodin, and other materials.

Norwood, Mass. Norwood Historical Society
>Käsebier letters to F. Holland Day and other letters to Day

Paris, France. Musée Rodin
>Käsebier letters to Rodin. Also correspondence from Steichen and de Meyer

Washington, D.C. Library of Congress, Manuscript Division
>Käsebier letters to Frances Benjamin Johnston

BY GERTRUDE KÄSEBIER

"Peasant Life in Normandy." *Monthly Illustrator* 3 (March 1895): 269–275.

"An Art Village." *Monthly Illustrator* 4 (April 1895): 9–17.

"Studies in Photography." *Photographic Times* 30 (June 1898): 269–272. Reprinted in Peter C. Bunnell, ed. *A Photographic Vision: Pictorial Photography, 1889–1923*. Salt Lake City: Peregrine Smith, 1980.

"To Whom It May Concern." *Camera Notes* 3 (Jan. 1900): 121–122.

"Attracting Customers to the Studio: A Public for Every Class of Work." *British Journal of Photography*, Oct. 14, 1910, p. 777.

"Praise from Mrs. Käsebier." *Bulletin of Photography*, Feb. 8, 1911, p. 91.

"Enthusiasm from Mrs. Käsebier." *Bulletin of Photography*, Sept. 18, 1912, pp. 419–420.

"Picture Making: A Talk to the Department of Photography, Brooklyn Institute." *American Photography* 9 (April 1915): 224, 226.

ABOUT GERTRUDE KÄSEBIER
(Listed chronologically)

[Cram, Ralph Adams?]. "Exhibition of Photographic Studies by Mrs. Käsebier at the Camera Club." *Boston Evening Transcript*, Nov. 10, 1896, p. 5.

"Artistic Photography. Exhibit by Mrs. Gertrude Käsebier at Pratt Institute." *Brooklyn Daily Eagle*, Feb. 13, 1897, p. 7.

"Society Women Pose." Clipping, Collection Mason W. Turner, Jr., identified as *World*, Feb. 13 [1897].

D.M.N. [Dora M. Norton]. "Art Studies in Photography." *Pratt Institute Monthly* 5 (March 1897): 221–223.

"Art Studies at the Pratt." *Brooklyn Standard Union*, Feb. 1, 1897, p. 2.

Southwick, Jeanie Lea. "Out and About: New York's New Artist in Portrait Photography." *Worcester Daily Spy*, Feb. 23, 1898, p. 4.

"Sioux Chiefs' Party Calls. The Indians Make Daily Visits to the Studio Where They Were Entertained at Ten." *The New York Times*, April 24, 1898, p. 14.

"The Indian as a Gentleman. Those of the Wild West Are Most Chivalrously Inclined as Shown at a Reception and 'Show' Party." *The New York Times*, April 23, 1899, p. 20.

Dow, Arthur W. "Mrs. Gertrude Käsebier's Portrait Photographs." *Camera Notes* 3 (July 1899): 22–23.

Hartmann, Sadakichi. "Portrait Painting and Portrait Photography." *Camera Notes* 3 (July 1899): 13–19.

Stieglitz, Alfred. "Our Illustrations." *Camera Notes* 3 (July 1899): 24.

Keiley, Joseph T. "Mrs. Käsebier's Prints." *Camera Notes* 3 (July 1899): 34.

Cram, R. A. "Mrs. Käsebier's Work." *Photo-Era* 4 (May 1900): 131–136.

Hartmann, Sadakichi. "Gertrude Käsebier." *Photographic Times* (May 1900): 195–199.

Watson, Eva Lawrence. "Gertrude Käsebier." *American Amateur Photographer* 12 (May 1900): 219–220.

"Some Indian Portraits." *Everybody's Magazine* 4 (Jan. 1901): frontispiece, 3–24.

"Artist Receives Indians. Mrs. Käsebier Invites Children, Friends to Meet a Contingent from Buffalo Bill's Show." *The New York Times*, April 14, 1901, p. 7.

Demachy, Robert. "L'Exposition des artistes américaines." *Bulletin du Photo Club de Paris* 11 (1901): 106–113.

Caffin, Charles H. "Mrs. Käsebier and the Artistic-Commercial Portrait." *Everybody's Magazine* 4 (May 1901): 480–495. Included in *Photography as a Fine Art*. New York: Doubleday, Page & Co., 1901. Reprinted: Hastings-on-Hudson, N.Y.: Morgan & Morgan, 1971 and New York: Amphoto, 1972.

Johnston, Frances Benjamin. "The Foremost Women Photographers of America: The Work of Mrs. Gertrude Käsebier." *Ladies Home Journal* 18 (May 1901): 1.

Abel, Juan C. "Women Photographers and Their Work." *Delineator* 58 (Sept. 1901): 406–411.

"Unsere Bilder," *Photographisches Centralblatt* 7 (Nov. 1901): 491–492 and reproductions 482–497.

"Talk on Art. Mrs. Käsebier, a Prominent Artist Visiting Clarence White, of Hudson Ave., Talks Interestingly of Her Profession." *Newark* (Ohio) *American Tribune*, Aug. 13, 1902. Clipping in Stieglitz scrapbook, Yale.

Caffin, Charles H. "Mrs. Käsebier's Work—An Appreciation." *Camera Work*, no. 1 (Jan. 1903): 17–19.

Editors. "The Pictures in This Number." *Camera Work*, no. 1 (Jan. 1903): 63.

Johnston, Frances Benjamin. "Gertrude Käsebier, Professional Photographer." *Camera Work*, no. 1 (Jan. 1903): 20.

Bayley, R. Child. "Things Photographic in the United States of America: Mrs. Käsebier." *Photography* 15 (Jan. 17, 1903): 63. Reprinted as "A Visit to Mrs. Käsebier's Studio." *Wilson's Photographic Magazine* 40 (Feb. 1902): 73–74, and as "Mrs. Käsebier." *American Amateur Photographer* 15 (Feb. 1903): 78–79.

Slater, Sarah E. "Profitable Industries for Women: Photography." *New Idea Woman's Magazine* 10 (Feb. 1904): 28–31.

"Art Photography by Mrs. Kasebier." *Boston Herald*, March 8, 1904, p. 7.

[Abel, Juan C.] "Studio Lightings No. 1." *The Photographer*, May 7, 1904, p. 24.

Keiley, Joseph T. "Gertrude Käsebier." *Photography*, March 19, 1904, cover, 223–227, 237. Reprinted: *Camera Work*, no. 20 (Oct. 1907): 27–31.

"Gertrude Kaesebier at the Photo-Secession." *Photo-Era* 16 (March 1906): 215.

Demachy, Robert. "Mme. Käsebier et Son Oeuvre." *La Revue de Photographie*, July 15, 1906, pp. 289–295.

Roberts, Mary Fanton [Giles Edgerton]. "Photography as an Emotional Art: A Study of the Work of Gertrude Käsebier." *Craftsman* 12 (April 1907): 80–93. Reprinted: *Image* 15 (Dec. 1972): 9–12.

Caffin, Charles H. "Emotional Art. (After Reading the 'Craftsman,' April, 1907.)" *Camera Work*, no. 20 (Oct. 1907): 32–34.

Lohmann, Helen. "Gertrude Käsebier—Photographer." *Abel's Photographic Weekly*, Feb. 20, 1909, p. 130.

Menard, Cyrille. "Les maîtres de la photographie: Gertrude Käsebier." *Photo-Magazine* 6 (June 6, 13, 1909): 177–192.

Hord, Spencer B. [Chippendale]. "Gertrude Käsebier, Maker of Photographs." *Bulletin of Photography*, June 8, 1910, pp. 363–367.

Ward, H. Snowden. "Gertrude Käsebier and Her Work." *Amateur Photographer and Photographic News*, Dec. 13, 1910, pp. 590–591. Reprinted: *Abel's Photographic Weekly*, Dec. 24, 1910, pp. 267–268.

"Art and Bread and Butter Photography." *Studio Light* 3 (Nov. 1911): cover, 2–5, 9, 13, 18, 22.

"Five Striking Silhouettes by Gertrude Käsebier." *Vanity Fair*, March 1915, p. 34.

Eggers, George William. "Gertrude Käsebier's Portrait of Lincoln." *The Allied Arts*, no. 2 (Dec. 1921): xviii.

"Current Events Pictorially Treated." *Outlook*, June 14, 1916, pp. 366–369.

"Lincoln's Gift to an Unknown Soldier." *Outlook*, Feb. 7, 1923, pp. 249, 252.

Todd, F. Dundas. "My Photographic Reminiscences." *Abel's Photographic Weekly*, Jan. 12, 26, 1924, pp. 30–31, 80–81.

"Two Photographic Portraits by Mrs. Gertrude Käsebier." *Bulletin of the Brooklyn Institute of Arts and Sciences*, Dec. 15, 1928, pp. 118, 125.

"Threescore Years and Sixteen Is Ardent Exponent of Photography." *New York Sun*, Jan. 5, 1929, p. 21. Reprinted as "Gertrude Käsebier Is Interviewed," *Photo-Era* 62 (March 1929): 129–130.

Hervey, Dr. Walter L. "Gertrude Käsebier—Photographer." *Photo Era* 62 (March 1929): 131–132.

Chambers, Walter. "Called Greatest Woman Photographer, Gertrude Käsebier Is Now a Cripple." *New York Telegram*, Jan. 25, 1930, p. 2. Clipping in *New York Sun* morgue, NYPL

Sabine, Lillian. "The Women's Page: Gertrude Käsebier, of New York City." *Abel's Photographic Weekly*, Sept. 5, 12, 19 and 26 1931, pp. 299, 323, 351, 379.

"Mrs. G. E. Käsebier Dead at Age 82." *The New York Times*, Oct. 14, 1934, Section 1, p. 32.

"Mrs. Käsebier, Photographer, Is Dead at 82." *New York Herald Tribune*, Oct. 14, 1934, p. 28.

"Gertrude Stanton Käsebier, 1852–1934." *Pictorial Photographers of America Bulletin*, Nov. 1934, pp. 1, 4.

"Camera Pioneer." *Art Digest*, Dec. 1, 1934, p. 10.

[Obituary]. *American Photography* 28 (Dec. 1934): 786.

[Obituary]. *Professional Photographer*, Nov. 5, 1934, p. 239.

"George Eastman House Special Issue." *Album* 6 (July 1970): cover, 22–25, 45.

Notable American Women, 1607–1950. 1971. S.v. "Gertrude Käsebier," by Peter C. Bunnell.

Reed, Melissa. "Prints and Negatives of Gertrude Käsebier." *Image:* 15 (Dec. 1972): 2–8.

Holm, Ed. "Gertrude Käsabier's [*sic*] Indian Portraits." *The American West*, July 10, 1973, pp. 38–41.

Britannica Encyclopedia of American Art. [1973]. S.v. "Käsebier, Gertrude Stanton (1852–1934)," by Dennis Longwell.

Tucker, Anne. *The Woman's Eye*. New York: Alfred A. Knopf, 1973, pp. 2, 6–7, 13–27.

Tyler, Douglas E. "Gertrude Stanton Käsebier: A Brief Consideration of Her Role in the Growth of Photography." *SECAC Review* 7 (Spring 1974): 18–23.

O'Mara, Jane Cleland. "Gertrude Käsebier: The First Professional Woman Photographer, 1852–1934." *Feminist Art Journal* (Winter 1974–75): 18–21, 23.

Bunnell, Peter C. "Gertrude Käsebier." *Arts in Virginia* 16 (Fall 1975): 2–15, 40.

Women of Photography. Essays by Margery Mann and Anne Noggle. San Francisco: San Francisco Museum of Art, April 18–June 15, 1975.

Michaels, Barbara L. "Rediscovering Gertrude Käsebier." *Image* 19 (June 1976): 20–32.

Tighe, Mary Ann. "Gertrude Käsebier Lost and Found." *Art in America* 65 (March 1977): 94–98.

Quitslund, Toby. "Her Feminine Colleagues: Photographs and Letters Collected by Frances Benjamin Johnston in 1900." In Josephine Withers. *Women Artists in Washington Collections*. College Park, Md.: University of Maryland Art Gallery and Women's Caucus for Art, Jan. 18–Feb. 25, 1979.

Homer, William Innes. *A Pictorial Heritage: The Photographs of Gertrude Käsebier*. Wilmington, Del.: Delaware Art Museum, March 2–April 22, 1979.

Rather, Susan W. "Gertrude Käsebier's Expression of the Woman's Experience." *University of Delaware News*, Sept. 1979, p. 20.

Michaels, Barbara L. "Gertrude Käsebier: Her Photographic Career 1894–1929." Ph.D. Dissertation, City University of New York, 1985.

Keller, Judith. *After the Manner of Women: Photographs by Käsebier, Cunningham, and Ulmann*. Malibu, Calif.: J. Paul Getty Museum, September 6–December 31, 1988.

Janis, Eugenia Parry. "Her Geometry." In Constance Sullivan, ed. *Women Photographers*. New York: Harry N. Abrams, 1990.

MONOGRAPHIC STUDIES

Coburn, Alvin Langdon. *Alvin Langdon Coburn, Photographer*. Edited by Helmut and Alison Gernsheim. London: Faber and Faber, 1966.

Weaver, Mike. *Alvin Langdon Coburn: Symbolist Photographer*. New York and Rochester: Aperture and International Museum of Photography at George Eastman House, 1986.

Imogen Cunningham: Photographs. Introduction by Margery Mann. Seattle: University of Washington Press, 1970.

Curtis, Edward S. *The North American Indian*. Vol. 3: *The Sioux*. [Seattle, Wash.]: E. S. Curtis [Cambridge: Mass.: The University Press], 1908.

———. *The North American Indians: A Selection of Photographs by Edward S. Curtis*. Introduction by Joseph Epes Brown. New York: Aperture, 1972.

Lyman, Christopher M. *The Vanishing Race and Other Illusions: Photographs of Indians by Edward S. Curtis*. New York: Pantheon Books in association with Smithsonian Institution Press, 1982.

The Photographic Work of F. Holland Day. Introduction and Catalogue by Ellen Fritz Clattenburg. Wellesley, Mass.: Wellesley College Museum, 1975.

Jussim, Estelle. *Slave to Beauty: The Eccentric Life and Controversial Career of F. Holland Day*. Boston: David R. Godine, 1981.

Jay, Bill. *Robert Demachy 1859–1936: Photographs and Essays*. London: Academy Editions and New York: St. Martin's Press, 1974.

Robert Brandau, ed. *De Meyer*. Biographical essay by Philippe Jullian. New York: Alfred A. Knopf, 1976.

Green, Nancy E. *Arthur Wesley Dow and His Influence*. Ithaca, N.Y.: Herbert F. Johnson Museum of Art, Cornell University, 1990.

Moffatt, Frederick C. *Arthur Wesley Dow (1857–1922)*. Washington, D.C.: Smithsonian Institution Press for the National Collection of Fine Arts, 1977.

Anderson, Jeffrey W., and Ferguson, Charles B. *The Harmony of Nature: The Art and Life of Frank Vincent DuMond, 1865–1951*. Old Lyme, Conn.: Florence Griswold Museum, 1990.

Sandweiss, Martha A. *Laura Gilpin: An Enduring Grace*. Fort Worth: Amon Carter Museum, 1986.

Daniel, Pete, and Smock, Raymond. *A Talent for Detail: The Photographs of Miss Frances Benjamin Johnston, 1889–1910*. New York: Harmony Books, 1974.

Doherty, Amy S., "Frances Benjamin Johnston 1865–1952." *History of Photography* 4 (April 1980): 97–111.

Glenn, Constance W., and Rice, Leland. *Frances Benjamin Johnston: Women of Class and Station*. Introduction by Anne E. Peterson. Long Beach, Calif.: California State University Art Museum and Galleries, 1979.

Johnston, Frances Benjamin. *The Hampton Album*. Introduction and note on the photographer by Lincoln Kirstein. New York: Museum of Modern Art, 1966.

Elsen, Albert E., editor. *Rodin Rediscovered*. Washington, D.C.: National Gallery of Art and Boston: New York Graphic Society, 1981.

Grunfeld, Frederic V. *Rodin: A Biography*. New York: Henry Holt & Co., 1987.

Longwell, Dennis. *Steichen, The Master Prints, 1895–1914*. New York: Museum of Modern Art and Boston: New York Graphic Society, 1978.

Steichen, Edward. *A Life in Photography*. Garden City, N.Y.: Doubleday & Co., 1963.

Bry, Doris. *Alfred Stieglitz: Photographer*. Boston: Museum of Fine Arts, 1965.

Greenough, Sarah, and Hamilton, Juan. *Alfred Stieglitz Photographs and Writings*. Washington, D.C.: National Gallery of Art and New York: Callaway Editions, 1983.

Lowe, Sue Davidson. *Stieglitz: A Memoir/Biography*. New York: Farrar Straus Giroux, 1983.

Norman, Dorothy. *Alfred Stieglitz: An American Seer*. New York: Random House, 1973.

Bunnell, Peter. *Clarence H. White: The Reverence for Beauty*. Athens, Ohio: Ohio University Gallery of Fine Art, 1986.

Homer, William Innes, ed. *Symbolism of Light: The Photographs of Clarence H. White*. Wilmington, Del.: Delaware Art Museum, 1977.

White, Maynard P. *Clarence H. White*. Millerton, N.Y.: Aperture, 1979.

Yochelson, Bonnie. "Clarence H. White Reconsidered: An Alternative to the Modernist Aesthetic of Straight Photography." *Studies in Visual Communication* 9 (Fall 1983): 25–44.

GENERAL REFERENCES

Anderson, Paul L. *The Fine Art of Photography*. Philadelphia and London: J. B. Lippincott, 1919.

Aries, Philippe. *Centuries of Childhood*. New York: Alfred A. Knopf, 1962.

Bannon, Anthony. *The Photo Pictorialists of Buffalo*. Buffalo, N.Y.: Media Study, 1981.

Banta, Martha. *Imaging American Women*. New York: Columbia University Press, 1987.

Buerger, Janet E. *The Last Decade: The Emergence of Art Photography in the 1890s*. Rochester, N.Y.: International Museum of Photography at George Eastman House, 1984.

Bunnell, Peter C., ed. *A Photographic Vision: Pictorial Photography, 1889–1923*. Salt Lake City: Peregrine Smith, 1980.

Callen, Anthea. *Women Artists of the Arts and Crafts Movement 1870–1914*. New York: Pantheon Books, 1979.

Corn, Wanda. *The Color of Mood: American Tonalism 1880–1910*. San Francisco: M. H. De Young Memorial Museum and the California Palace of the Legion of Honor, 1972.

Doty, Robert M. *Photo-Secession: Photography as a Fine Art*. Rochester, N.Y.: George Eastman House, 1960. Reissued as *Photo-Secession: Stieglitz and the Fine Art Movement in Photography*. New York: Dover, 1978.

Green, Jonathan. *Camera Work: A Critical Anthology*. Millerton, N.Y.: Aperture, 1973.

Greenough, Sarah; Snyder, J.; Travis, D.; and Westerbeck, C. *On the Art of Fixing a Shadow: One Hundred and Fifty Years of Photography*. Boston, Toronto and London: National Gallery of Art and the Art Institute of Chicago in association with Bulfinch Press/Little, Brown & Co., 1989.

Harker, Margaret. *The Linked Ring: The Secession Movement in Photography in Britain 1892–1910*. London: Heinemann, 1979.

Harris, Ann Sutherland, and Nochlin, Linda. *Women Artists: 1550–1950*. New York: Alfred A. Knopf, 1977.

Hartmann, Sadakichi. *The Valiant Knights of Daguerre*. Edited by Harry W. Lawton and George Knox. Berkeley: University of California Press, 1978.

Hills, Patricia. *Turn-of-the-Century America*. New York: Whitney Museum of American Art, 1977.

Homer, William Innes. *Alfred Stieglitz and the American Avant-Garde*. Boston: New York Graphic Society, 1977.

————. *Alfred Stieglitz and the Photo-Secession*. Boston: New York Graphic Society, 1983.

Lerner, Gerda. *The Majority Finds Its Past: Placing Women in History*. New York: Oxford University Press, 1979.

Lunn Gallery, Graphics International Ltd. *Catalogue 6: Photo-Secession*. Essays by Peter Galassi. Washington, D.C., 1977.

Naef, Weston J. *The Collection of Alfred Stieglitz: Fifty Pioneers of Modern Photography*. New York: Metropolitan Museum of Art and Viking Press, 1978.

Newhall, Beaumont. *The History of Photography*. New York: Museum of Modern Art, 1982.

O'Neill, William L. *Everyone Was Brave*. Chicago: Quadrangle Books, 1969.

Panzer, Mary. *Philadelphia Naturalistic Photography, 1865–1906*. New Haven: Yale University Art Gallery, 1982.

Christian A. Peterson. *Camera Work: Process and Image*. Minneapolis: Minneapolis Institute of Arts, 1985.

Photography Rediscovered: American Photographs, 1900–1930. Essay by David Travis. New York: Whitney Museum of American Art, 1979.

John Pultz and Catherine B. Scallen. *Cubism and American Photography, 1910–1930*. Williamstown: Sterling and Francine Clark Art Institute, 1981.

Rosenblum, Naomi. *A World History of Photography*. New York: Abbeville Press, 1984.

Rothman, Sheila M. *Woman's Proper Place*. New York: Basic Books, 1978.

Ryan, Mary P. *Womanhood in America*. New York: New Viewpoints, 1979.

Stieglitz, Alfred. *Camera Work: A Pictorial Guide*. Edited by Marianne Fulton Margolis. New York: Dover Books, 1978.

Szarkowski, John. *Looking at Photographs*. New York: Museum of Modern Art, 1973.

————. *Photography Until Now*. New York: Museum of Modern Art, 1989.

Index